T0389393

Anatomy of the Medical Image

Clio Medica

STUDIES IN THE HISTORY OF MEDICINE AND HEALTH

VOLUME 104

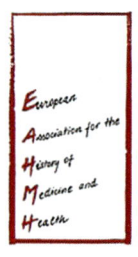

The titles published in this series are listed at *brill.com/clio*

Anatomy of the Medical Image

Knowledge Production and Transfiguration from the Renaissance to Today

Edited by

Axel Fliethmann and Christiane Weller

BRILL

LEIDEN | BOSTON

Cover illustration: Martin Karrasch, Vergänglichkeit/Transience, 2015. © Martin Karrasch

Library of Congress Cataloging-in-Publication Data

Names: Fliethmann, Axel, editor. | Weller, Christiane, 1962- editor.
Title: Anatomy of the medical image : knowledge production and
 transfiguration from the renaissance to today / edited by Axel
 Fliethmann, Christiane Weller.
Description: Leiden ; Boston : Brill, 2021. | Series: Clio medica ; vol.104
 | Includes bibliographical references and index.
Identifiers: LCCN 2021031645 (print) | LCCN 2021031646 (ebook) | ISBN
 9789004406759 (hardback) | ISBN 9789004445017 (ebook)
Subjects: LCSH: Medicine–Philosophy. | Human body (Philosophy)–History.
Classification: LCC R723 .A535 2021 (print) | LCC R723 (ebook) | DDC
 610.1–dc23
LC record available at https://lccn.loc.gov/2021031645
LC ebook record available at https://lccn.loc.gov/2021031646

Typeface for the Latin, Greek, and Cyrillic scripts: "Brill". See and download: brill.com/brill-typeface.

ISSN 0045-7183
ISBN 978-90-04-40675-9 (hardback)
ISBN 978-90-04-44501-7 (e-book)

Contents

Acknowledgements

This volume owes much to the vibrant intellectual discussions that took place at the international conference, *The Anatomy of the Image: Perspectives on the (Bio)medical Body in Science, Literature, Culture and Politics*. The conference was organised by the editors and hosted at Monash University in Melbourne, 16–18 February 2017.

Several of the chapters of this volume were initially presented as papers at this conference, but the editors would also like to thank all the other participants of the conference as their contributions have helped in shaping this volume and giving it direction.

The conference and the publication would not have succeeded without the generous support of the Arts Faculty and the School of Languages, Literatures, Cultures and Linguistics at Monash University.

The editors particularly would like to thank the Ian Potter Foundation for its generous support for the international keynote speakers.

Illustrations

Notes on Contributors

Axel Fliethmann

is Associate Professor in European Languages in the School of Languages, Literatures, Cultures and Linguistics at Monash University, Melbourne. He is a fellow of the Australian Academy of the Humanities and has published widely on media philology and visual cultures. His publications include *Stellenlektüre.Stifter. Foucault* (2001), *Texte über Bilder. Zur Gegenwart der Renaissance* (2014). He is co-editor of *Limbus: Australisches Jahrbuch für germanistische Literatur- und Kulturwissenschaft / Australian Yearbook of German Literary and Cultural Studies*.

Michael Hau

is Associate Professor in Modern European History at Monash University. He has published extensively on the history of medicine and the body. His most recent book, *Performance Anxiety: Sport and Work in Germany from the Empire to Nazism*, has appeared with the University of Toronto Press in 2017. Currently he is working on a collaborative research project on the history of meritocracy in post-war Germany and Japan.

Birgit Lang

is Associate Professor in German at The University of Melbourne, Australia. She is the recipient of the collaborative ARC Discovery Project, *Visual Evidence: Sex Research in Germany (1890s-1930s)*, funded by the Australian Government (with Katie Sutton, ANU). She has published widely on the German and Austrian history of sexuality, on exile and translation studies. Her recent co-authored monographs include *What is Translation History? A Trust-Based Approach* (with Andrea Rizzi and Anthony Pym) (2019) and *A History of the Case Study: Sexology, Psychoanalysis, Literature* (with Joy Damousi and Alison Lewis) (2017). She is series co-editor of *Translation History* (Palgrave).

Carolyn Lau

is Postdoctoral Fellow at the Department of English at The Chinese University of Hong Kong. She is currently co-editing an upcoming edited collection on the fictions and narratives of the symbiosis between humans, machines, and nature. Her research explores the potentialities of the human body in speculative literature and film.

Heikki Lempa

is a Professor of Modern European and German History at Moravian College. His interests are in German cultural and social history, the history of

emotions, the body, education, masculinity, and honor. His most recent works include a forthcoming book *Spaces of Honor. Making Civil Society in Germany, 1700-1914* (2021) and (co-edited with Derek Hillard and Russell Spinney) *Feelings Materialized. Emotions, Bodies, and Things in Modern Germany* (2020). Currently he is working on an edited volume *Staging Authority* and on a book-length monograph on the German practices of dancing, sports, and medicine in a global context, 1700-1914.

stef lenk
is an assistant researcher for the PathoGraphics project at the Free University, Berlin (2016-2020). She is interested in the practical application of academic research in graphic novels and illness narratives and is also a comic artist whose work has been exhibited at festivals throughout Europe and internationally. Her work can be seen at steflenk.com. She has an MSc Medical Art from the University of Dundee and also works as a freelance graphic designer and medical illustrator.

Joanna Madloch
is a scholar, writer and photographer currently based in New Jersey, USA, where she teaches at Montclair State University. She received her PhD in Humanities from the University of Silesia in Poland. Her scholarly work concentrates on the intersections between pictorial and textual phenomena and she is currently working on a book dedicated to the depiction of the photographer as a contemporary embodiment of the trickster archetype.

Barry Murnane
is Associate Professor in German at the University of Oxford, and Fellow and Tutor at St John's College. He has published widely on Gothic literature since the eighteenth century, including a monograph on Franz Kafka, *Verkehr mit Gespenstern* (2008), and two co-edited volumes, *Populäre Erscheinungen* (2011) and *Popular Revenants* (2012). He is also interested in the relationship between literature and scientific discourses more generally, especially those between literature and pharmacy, and held a fellowship at the Science Museum in London (2016) to conduct research into pharmacy's role as a "laboratory" of modernity.

Jill Redner
is an independent scholar, based in Melbourne. After teaching English Literature at the University of Melbourne, she turned to interdisciplinary research in Peace Studies and Memory Studies. She is co-author of a book on the Cold War, and of numerous articles in the fields of literature, politics, art, and the

history of ideas. Her main research interest at present is in the contribution of religious dissent to new scientific thought during the Dutch Golden Age.

Claudia Stein

is Associate Professor in the history of medicine and science at the History Department at the University of Warwick. She works on the history of the body and disease, visual and material culture of science and medicine, and the history of biopower from the early modern period to today. She is currently writing a monograph on the history of human nature from the Renaissance to Modernity. She also has a special interest in the theories and methods of history writing and recently edited and contributed to *The Cultural History of Medicine in the Renaissance* (2020) (together with Elaine Leong).

Elizabeth Stephens

is an Australian Research Council Future Fellow and Associate Professor of Cultural Studies in the Institute for Advanced Studies in the Humanities at the University of Queensland. She is the author of three monographs: *Normality: A Critical Genealogy* (2017), co-authored with Peter Cryle; *Anatomy as Spectacle: Public Exhibitions of the Body from 1700 to the Present* (2011); and *Queer Writing: Homoeroticism in Jean Genet's Fiction* (2009). Her Future Fellowship examines practices of experimentation as a site of collaboration between the arts and sciences, from the nineteenth-century scientific laboratory to contemporary experimental art.

Corinna Wagner

is Associate Professor in Literature and the History of Art at the University of Exeter. She is also a photographer and creative writer. Her research interests include the relationship between medical history and the arts, the body in art, the history of photography, and Victorian Gothic literature and architecture. She has co-edited *The Oxford Handbook to Victorian Medievalism* and *A Body of Work: An Anthology of Poetry and Medicine* (2015). Her books include *Pathological Bodies: Medicine and Political Culture* (2013) and *Art, Anatomy, and the Real* (2021). Her next project, about water and the body, combines alternative photography and creative non-fiction.

Christiane Weller

is Associate Professor in European Languages in the School of Languages, Literatures, Cultures and Linguistics at Monash University, Melbourne. She has published widely on German travel writing and expeditions reports, contemporary German fiction and psychoanalytic theory, as well as on psychiatric art

and psychosis and writing. She is the author of *Das fremde Ich. Begegnungen im pazifisch-australischen Raum* (2015) and the co-editor of *Kosmopolitische Gedankenwelten / Cosmopolitan Imaginings* (2019) and of *Limbus: Australisches Jahrbuch für germanistische Literatur- und Kulturwissenschaft / Australian Yearbook of German Literary and Cultural Studies*.

Introduction

Axel Fliethmann and Christiane Weller

A small photograph shows a medical student who, with a slightly mischievous smile, is looking directly through the camera lens at the observer. In front of him lies the dead body of a man of undefined age. The student in his white coat is dissecting the neck of the cadaver. The head seems to be almost severed from the body; the upper torso has been worked on, as well as the right hand. The skin on the face is tight; sunken eyes, cheekbones protruding, while the lips have receded. No body fat left. There is a strange similarity between the smile of the doctor-in-training and the quietly triumphant smile of the dead man. The room in which this intimate scene takes place is flooded with light, with three windows visible and three overhead lamps. The white coat seems to channel the light down to the dead body. The delicate touch of the student's hands transfers the light via the knife further to the dissected neck. A dark wooden cupboard, a timber door in the back wall, and the high window on the left-hand side are reminiscent of Johannes Vermeer's interiors,[1] with the precision in the way the image is arranged and a similar uneasiness despite the reassuring smile of the medical student.

The picture was given to a young woman in Germany; on the back is a German dedication "Meiner lieben ...," "To my dear ...," then a Flemish name, an address, and the date 26 July 1945. One might think it a peculiar gift to a friend, or confidante. A strange gift in strange times, maybe. The addressee, a medical student herself, was working in Bergen-Belsen at the time. She was working there for the British, conscripted to help with the transition of concentration camp survivors into the newly established emergency hospital, delousing, washing, and powdering the diseased and the dying in the so-called "Human Laundry," which operated between mid-April to mid-May, 1945. The young man

1 In his paintings of interiors, Vermeer used a very similar composition with light flooding in through high windows from the left, well-defined wall spaces as backdrop and the body and/ or face of the human figure(s) angled towards the observer as if interrupted in their activity. Some art historians argue that the almost photographic detail and precision of Vermeer's paintings is due to his use of the camera obscura (e.g. Philip Steadman, *Vermeer's Camera: Uncovering the Truth Behind the Masterpieces* (Oxford: Oxford University Press, 2001), and Philip Steadman, "Allegory, Realism, and Vermeer's Use of the Camera Obscura," *Early Science and Medicine* 10, no. 2 (2005): 287–314), which at the same time produces the effect that the scene is "staged" and the human figure is a prop standing uneasy among the various other intricate objects.

FIGURE 0.1 Dissection by medical student (for legal reasons only showing
 detail), ca. 1945
 SOURCE: PRIVATE COLLECTION

from Belgium must have met her there. Belgian medical students had relieved
a team of British students in May 1945 to help to care for the former internees.[2]

The image of this dead body tended by the smiling young medical student
in a light-filled room must have communicated something; something which
spoke of the uncanny normality of medical practice at a time when normality
would have been hard to come by; an evocation of Rembrandt's paintings of
the "Anatomy Lessons" perhaps too and of the many representations of med-
ical professionals which followed in its wake.[3] Perhaps it is a suspension of
time, possibly reassuring the recipient that the decaying body—at least in the
instance of the section captured in the photo—is singular, particular, notewor-
thy. A dead body which is not discarded thoughtlessly but prudently explored.
The knowledge of the object—i.e. the dissected body from which the doctor-
in-training is supposedly learning—transposed into the image—i.e. the photo
passed on from a Belgian medical student to a German medical student—
transmits a knowledge, which is through its iconographic determination not
only inextricably linked to its wider historical and social context, but also to

2 See Tim vande Veegaete, *Naweeën van een concentratiekamp. De humanitaire missie van Bel-*
 gische studenten geneeskunde te Bergen-Belsen (PhD dissertation, Ghent University, 1989).
3 Rembrandt's "Anatomy Lessons" are well known to serve as a template for subsequent depic-
 tions of sections in the professional medical context. For an investigation into dissection
 photography see also John Harley Warner and James M. Edmonson, *Dissection: Photographs*
 of a Rite of Passage in American Medicine, 1880–1930 (New York: Blast Books, 2009), and in this
 volume the contribution by Madloch.

the specificity and materiality of the medium, i.e. the small printed photograph with its inscription on the back. The image as it is captured in this small photographic postcard therefore produces an excess which goes beyond the conventional representation of the medical professional. It inserts the public discourse of medicine into the format of private correspondence and attests to the uneasiness or uncanniness of living after the catastrophe. The specificity of such image circulations depicting the medical body, the "knowledge-gain" via these transfers, or better the absorption, accumulation and dispersion of knowledge in the transmission and transfiguration processes is what this book is interested in.

Since W.J.T. Mitchell coined the "pictorial turn" to describe a shift in cultural studies towards visual parameters,[4] scholarship has increasingly recognised the impact of visual technologies in processes of knowledge formations. A plethora of subtle approaches to address visual forms between media theory, cultural studies, and historical perspectives had been produced at the time, especially in the field of art history.[5] Around the same time in Germany, a particular brand of Visual Studies, titled "Bildwissenschaft," was launched by leading art historians Hans Belting and Horst Bredekamp, which has since also produced a broad spectrum of scholarship into visual formats and their impact on epistemological questions at large.[6] Viewed from a disciplinary angle, these

4 "Whatever the pictorial turn is, then, it should be clear that it is not a return to naïve mimesis, copy or correspondence theories of representation, or a renewed metaphysics of pictorial "presence": it is rather a postlinguistic, postsemiotic rediscovery of the picture as a complex interplay between visuality, apparatus, institutions, discourse, bodies, and figurality. It is the realization that *spectatorship* (the look, the gaze, the practices of observation, surveillance, and visual pleasure) may be as deep a problem as various forms of reading (deciphering, decoding, interpretation, etc.) and that that visual experience or "visual literacy" might not be fully explicable on the model of textuality" (W.J.T. Mitchell, *Picture Theory: Essays on Verbal and Visual Representation* (Chicago: University of Chicago Press, 1994), 16).

5 Some stellar and influential projects in this regard were Svetlana Alpers, *The Art of Describing. Dutch Art in the Seventeenth Century* (Chicago: University of Chicago Press, 1983); Georges Didi-Huberman, *Devant l'image. Questions posées aux fins d'une histoire de l'art* (Paris: Minuit, 1990); Mieke Bal, *Reading "Rembrandt": Beyond the Word-Image Opposition* (Cambridge, UK and New York: Cambridge University Press, 1991); Barbara Maria Stafford, *Body Criticism. Imaging the Unseen in Enlightenment Art and Medicine* (Cambridge: MIT Press, 1991); and Victor Stoichita, *L'Instauration du Tableau: métapeinture à l'aube des temps modernes* (Paris: Meridiens Klincksieck, 1993).

6 See, for example, Hans Belting, *Bild-Anthropologie. Entwürfe für eine Bildwissenschaft* (München: Fink, 2001); Horst Bredekamp, *Theorie des Bildakts. Frankfurter Adorno-Vorlesungen 2007* (Frankfurt/M: Suhrkamp, 2010); and Horst Bredekamp, Vera Dünkel and Birgit Schneider, eds., *The Technical Image: A History of Styles in Scientific Imagery* (Chicago: University of Chicago Press, 2015). A formidable overview from the perspective of art history is Alexander Marr's "Knowing Images," *Renaissance Quarterly* 69, no. 3 (2016): 1000–1013.

approaches were responding to an increasing acknowledgement that the role of communication media and formats, their materialities and functionalities, had been neglected in traditional humanities. This disregard had resulted in a one-dimensional reliance on the written word and the notion that images only serve as mere illustrations. And it was only the advancement of Media Studies as a new university discipline since the 1960s that slowly forced the hand of hermeneutical, historical, philosophical, sociological, scientific, and philological approaches to the cultural sphere to open up to questions of "technical materiality" and to the impact of the "material hardware" of communication tools on the hermeneutical "software" in cultural studies.

Subsequently, particularly in the Anglosphere, the field of Visual Studies has seen a meteoric rise in the 1990s to witness an accelerated establishment of this new discipline across universities (Visual Studies or Visual Cultural Studies),[7] which opened up visual paradigms to all formats and functions of imagery, from the technical, to the practical, and the popular image in cooperation and confrontation with art history and its traditional focus on the canonical image as fine art. New Visual Studies approaches across central Europe on the other hand were mostly dispersed and integrated into traditional disciplines, with the exception of the aforementioned "Bildwissenschaften" (which nonetheless relied on theoretical frameworks derived from art history and literary theory). Despite the different disciplinary pathways Visual Studies has taken,[8] the scholarship they produced has undeniably shaken up traditional disciplines within the humanities by compelling them to engage seriously with the cultural impact of visual formats and figurations in reference to knowledge formations. And the shared theoretical problem at their core here could be summarised in the question of what constitutes "epistemic images"?

The asymmetrical relationship in Western thought between word and image and the supposed supremacy of words over images is well documented, as can be seen from biblical iconoclasm to the Enlightenment's grounding in mathematics and texts.[9] Today, in light of the growth of film, television, and the

7 For early introductions into the budding field see, for example, Jessica Evans and Stuart Hall, eds., *Visual Culture: The Reader* (London: Sage, 1999); and Nicholas Mirzoeff, ed., *The Visual Culture Reader* (London and New York: Routledge, 1998).

8 For a detailed overview see Jane Kromm and Susan Benforado Bakewell, eds., *A History of Visual Culture. Western Civilization from the 19th to the 21st Century* (Oxford and New York: Berg, 2010).

9 The early modern period has always been treated as exceptional in regard to the impact of new images as knowledge forms *sui generis*. See for a broad overview, for example, Barbara Maria Stafford, *Artful Science. Enlightenment, Entertainment and the Eclipse of Visual Education* (Cambridge: MIT Press, 1994).

digital image in the twentieth century, we partly re-live the period starting with the Renaissance where for the first time material images were given genuine— not merely subservient illustrating—powers in knowledge formations. This growing impact of images on knowledge formation in general was addressed in the *paragone* debates of the time but can also be seen in the development of the visual paradigm of anatomy within medicine, to the grounding of philosophy in optical frameworks and the emblem book as bestseller in moral education.[10]

Re-evaluating the impact of visual forms on knowledge formations today has become again a ubiquitous exercise in cultural analysis. And the question, what constitutes epistemic images, has been circulated from different angles, all of which echo the core theoretical implications of Mitchell's "pictorial turn." Sybille Krämer, for example, has approached the epistemology of images by attempting to free the image from its paradigm of "realism" and to explain its constructedness with Derrida's "grammatology" in mind. Krämer looks at epistemic images from an operative point of view, where images "translate non-sensual and abstract content into embodied spatial relations."[11] While Krämer's deconstructive attempt tries to "translate" Derrida's lucid reflections on writing (*écriture*) into the specificities of visual forms, Christoph Lüthy and Alexis Smets have suggested a direct relationship to be found between texts and images: the epistemic image is in their view "expressing a theory."[12] While both approaches take their cues from a textual paradigm, Lorraine Daston chooses a more restrictive description focusing on material images as "depicting the object of scientific inquiry" and "replacing it."[13] But all attempts ascribe epistemological truth to the image by either relating it to its proximity to language (Krämer), to theory (Lüthy, Smets), or to natural objects (Daston). While this is a neat classification of theoretical positions, our volume shows that in

10 For rhetorical similarities in treating the text-image distinction between the early modern period and the twentieth century see Axel Fliethmann, *Texte über Bilder. Zur Gegenwart der Renaissance* (Freiburg: Rombach, 2014).

11 "[...] unsinnlich abstrakte Inhalte werden im Bild als räumliche Relationen verkörpert" (Sybille Krämer, "Operative Bildlichkeit. Von der 'Grammatologie' zu einer 'Diagrammatologie'. Reflexionen über erkennendes 'Sehen,'" in *Logik des Bildlichen. Zur Kritik der ikonischen Vernunft*, eds. Martina Hessler and Dieter Mersch (Bielefeld: transcript, 2009), 94–122, here 105).

12 Christoph Lüthy and Alexis Smets, "Words, Lines, Diagrams, Images: Towards a History of Scientific Imagery," *Early Science and Medicine* 14, no. 1–3 (2009): 398–439, here 399 FN2. See for an overview, Marr, "Knowing Images," here esp. 1005.

13 Lorraine Daston, "Epistemic Images," in *Vision and Its Instruments: Art, Science, and Technology in Early Modern Europe*, ed. Alina Payne (University Park, PA: Pennsylvania State University Press, 2015), 13–35, here 17. See for an overview Marr, "Knowing Images," here esp. 1005–1006.

the practice of scholarship those methodological and theoretical approaches often overlap, oscillating between positions which understand the epistemic image in reference to the natural object, as well as in reference to theoretical implications and linguistic discourse. The results of these productive intersections and methodological "impurities" will be further explored and documented in this volume.

To recapitulate, over the past thirty years, there has been a growing interest in visual paradigms across cultural spheres and in particular more recently we have seen a more general determination towards establishing the roles of epistemic images as equally foundational in the general economy of knowledge formations.

Given the growing interest in visual cultures in general it is noticeable that particularly in the field of medicine the examination of images as foundational to knowledge production has played a lesser role. The drive that art historians have generated towards a broader understanding of visual formats outside the canon of fine art, as well as their pursuit of a Renaissance ideal where art and science meet in the concept of *techne*, did not find a similar initial spark in interest within the medical sciences. Within the core discipline itself, the acknowledgement of an intellectual agency of visual technologies as an epistemic determining force within research is more philosophical than operable. Despite images having mostly been seen only as illustrations serving the scientific text,[14] in medical historiography there has been a growing interest in the image. Initially, scholarship regarding medical history followed in the dominant methodological framework of the sociological laboratory research of Latour, Woolgar, Knorr-Cetina, and Dumit.[15]

While those early works have investigated aspects of visual technologies in the context of medical science,[16] these aspects were in most cases subjugated

14 Although a growing impact of visual technologies over the last thirty years has been noted, see, for example, Wolfgang Uwe Eckart and Robert Jütte, *Medizingeschichte. Eine Einführung* (Köln and Wien: Böhlau, 2007), 57. A history of linking medicine and technology—which is very useful despite not being particularly interested in the epistemological constructedness of knowledge formation through machines—can be found in Rolf Winau, ed., *Technik und Medizin* (Düsseldorf: VDI-Verlag, 1993).

15 Bruno Latour and Steve Woolgar, *Laboratory Life: The Social Construction of Scientific Facts* (Beverly Hills, Calif. and London: Sage Publications, 1979); Karin Knorr Cetina, *Die Fabrikation von Erkenntnis. Zur Anthropologie der Naturwissenschaft* (Frankfurt/M: Suhrkamp, 1991); Joseph Dumit, *Picturing Personhood. Brain Scans and Biomedical Identity* (Princeton: Princeton University Press, 2004).

16 See, for example, Dumit, *Picturing Personhood*, 6: "The cultural and visual logics by which these images persuade viewers to equate person with brain, brain with scan, and scan with diagnosis are also the subject of this book."

to social agencies that defined processes in medical laboratories. Only in the context of specific medical histories have visual paradigms been addressed more stringently. While generic approaches such as Roy Porter's edited *Cambridge History of Medicine* and German Berrios and Roy Porter's *History of Clinical Psychiatry*[17] are more traditionally organised—the latter, for example, classifying disorders framed by "clinical" and "social" parameters—we can find lucid interpretations of visual paradigms in medical historiography mostly in specialised accounts, which noticeably focus on the early modern period. Here, it has been especially anatomy studies and iatrochemical analysis in the context of the new herbal books, where links between visual paradigms and knowledge formation were investigated.[18]

In this context, Renée van de Vall's and Robert Zwijnenberg's edited volume, *The Body Within. Art, Medicine and Visualization* (2009), stands out by not only systematically asking "whether present day medical visualization techniques mark a significant shift in the experience of bodily interiority"[19] but also by framing this question within different historical contexts. Contributions of *The Body Within* thus follow various cultural and technological contexts and elucidate a number of aspects, questioning "how bodies are—scientifically, artistically, discursively, institutionally—mediated," that is, technologically constructed, for example, via a microscope, and then "mediatized," i.e. "communicated to an audience larger than the microscopist alone."[20] In doing so, all contributions of *The Body Within* are framed by the body's exterior/interior distinction, which in visual terms often relates to the paradox that we ascertain knowledge about the invisible body through its visual representation only. This is based on the supposition that there is *one* body which is constructed by the different historical and media related renderings of that distinction. The contrasting hypothesis of our volume is that even in medical

17 Roy Porter, ed., *The Cambridge History of Medicine* (Cambridge: Cambridge University Press, 2006); German E. Berrios and Roy Porter, eds., *A History of Clinical Psychiatry. The Origin and History of Psychiatric Disorders* (London: Athlone Press, 1995).

18 See, for example, Jonathan Sawday, *The Body Emblazoned. Dissection and the Human Body in Renaissance Culture* (London and New York: Routledge, 1995); and Sachiko Kusukawa, *Picturing the Book of Nature. Image, Text, and Argument in Sixteenth-Century Human Anatomy and Medical Botany* (Chicago and London: University of Chicago Press, 2012). For a more general approach see Lorraine Daston and Katharine Park, *Wonders and the Order of Nature 1150–1750* (New York: Zone Books, 2001). Currently in preparation for print is Dominic Olariu's excellent work on herbal books, *Botanische Illustrationen vor Brunfels. Pflanzenkultur und Pflanzenstudium in Kräuterbüchern des 14. – 16. Jahrhunderts*.

19 Renée van de Vall and Robert Zwijnenberg, eds. *The Body Within: Art, Medicine and Visualization* (Leiden and Boston: Brill, 2009), 3.

20 Vall and Zwijnenberg, *The Body Within*, 5.

knowledge formations there is not *one* body but *many*. The contributions of this volume circle around the anatomical, pathological, gendered, imagined, and consumed body. Those body configurations are constructed by dialogical transfer processes between visual media formats and the various discourses or discourse patterns. Jill Redner and Michael Hau, for example, investigate *anatomical* structures and their exchange with early modern religious or twentieth-century ideological discourses. Elizabeth Stephens and Heikki Lempa address the gendered body; Stephens through the gaze of a female modeller, and Lempa by way of the sculpted or fashioned male body between classical stature and physical exercises. Corinna Wagner, Carolyn Lau and Christiane Weller focus on the *pathological* body. More precisely, Wagner relates de Vall's interior/exterior paradox by looking at the distinction between outer appearance and inner emotional state, while Lau explores the pathological body by tracing the influences on what constitutes the pathological within the colonial space in nineteenth-century China intersecting with "imported" European style portrait painting. Finally, Weller analyses the pathological body by addressing the triangle of the (veiled) psychotic, the creative, and the psychiatric deciphering processes. The *imagined* body is addressed by Axel Fliethmann comparing the medical discourse on pathology of imaginations with the material depiction of anatomical images. In Joanna Madloch's contribution, a very different approach to the imagined body is pursued, focusing on the exchange between professional identity and photographic self-stylisation. Stef lenk's creative contribution then shows how an imagined and imaginary or fabricated body is subsequently produced within the artistic process. The chapters referring to the *consumed* body encompass Claudia Stein's analysis of consumption strategies of the body in the public sphere driven by mass media images and economic deliberations. Birgit Lang explores how the pathological body is consumed by forensics, criminology, and public art, and Barry Murnane addresses both the consumed and imagined body as presented by the mass medium of television as imagined uncanny biomachines.

While the *Anatomy of the Medical Image* also focuses on inter-sections between medical history, Visual Studies, and the epistemic image, it goes beyond the body's exterior/interior paradox by tracing narratives that circulate between image, body, discourse in arts and science. Our investigation of the pictorial turn and its broader implications offers the more generally interested reader and in particular the reader of medical history a line of critical inquiry into the role images play in knowledge formation; how they constructed, depicted, and informed but also how they manipulated and subverted knowledge. Naturally, in this field, many aspects are still to be discovered, longer term perspectives to be tackled, interdisciplinary dialogues to be attempted.

To allow readers easier access to the volume, we decided to opt for a chronological rather than a systematic ordering of chapters. However, we hope that readers will be able to discern the underlying systematic approach and bring the various chapters into conversation with each other.

1 The Epistemology of Anatomy and Aesthetics

When Benjamin A. Rifkin proposes, in *The Art of Anatomy*, that both medical students and arts students are most deeply concerned with the human body, he concludes that their point of departure can only be a book, namely "the illustrated anatomy."[21] The reality of the body is therefore—at least according to Rifkin—always already translated into the image of an anatomy before it becomes in turn again accessible to medicine and art. Art, medicine, the body and its visual representation are tightly interwoven. That said, one can also approach the topic from another angle, asking not so much how art creates and conceives the anatomical body which informs medicine, but how the image is dissecting what we think we know about the body and medicine, or differently, in which way the image itself is open to dissection. Is the image of the body telling us less about the real body and more about the process of imagination, as it inserts the body into the realm of a cultural fantasy, which changes according to new historical, political, and social parameters? Or is this image subverting or questioning the body since it develops a narrative which exceeds the limitations of a depiction grounded in science?

In the first section of this volume titled "The Epistemology of Anatomy and Aesthetics," we will address the question of how the depiction of the body, informed by anatomy, is drawn into aesthetic dialogue and philosophical circulation, thereby moderating, enhancing, and possibly distorting scientific knowledge of the body. The two "Anatomy Lessons" by Rembrandt can serve as a case in point, since they open up the field of the conflicting philosophical debates questioning the divide between body and mind and/or soul in the Netherlands of the seventeenth century. "The Anatomy Lesson of Dr Nicolaes Tulp" (1632) asks: do we see to believe? "The Anatomy Lesson of Dr Johannes Deyman" (1656) asks: can we believe what we see? This interrogation of science and religion finds its focus in the double image of the cadaver as *corpus delicti* and as *corpus Christi*: in these images of death, do we see man

21 Benjamin A. Rifkin, "The Art of Anatomy," in *Human Anatomy. Depicting the Body from the Renaissance to Today*, Benjamin A. Rifkin, Michael F. Ackerman and Judith Folkenberg (London: Thames & Hudson, 2017 [2006]), 6–68, here 7.

in the image of God or God in the image of man? Jill Redner's contribution looks at the historical context, focusing on how the body as an object of text-bound scientific investigation is reflected and how in the twenty-four years between Rembrandt's "Anatomy Lessons," his art underwent profound changes regarding stylistic, iconographic, and technical aspects. These changes can be traced to debates questioning the role of the intellectual controversies regarding Descartes's mechanistic natural philosophy, which took place precisely between the productions of Rembrandt's two "Anatomy Lessons." The second one translates unsettling ambiguity and both religious and scientific doubt into the painting, creating a visual reference point to Cartesian thought.

Continuing the section on "Anatomy and Aesthetics," Axel Fliethmann, like Redner, takes Vesalius's autopsy and anatomical illustrations as a point of departure, in this case in reference to Leonardo. This chapter attempts to elucidate the intersections between visual culture, medical discourse, and pathologies of imagination in the early modern period and argues that pathological imaginations are, on the one hand, being framed as deficiencies, being measured against a physiologically defined normality of the human body. This is exemplified using Platter's *Observationes* from 1614 and Vesalius's understanding of anatomical depictions as truthful representations of the body. In this context, the "precision" of anatomy as a new visual medical paradigm depends on the "precision" of the printed illustrations. On the other hand, pathologies of imagination (and not poetic licence) could surprisingly be read as affording Renaissance man, for the first time, the opportunity to break away from any form of powerful and controllable oversight, be it enforced by religion, natural philosophy, or pictorial technology through "imaginative" self-constitution, here exemplified by Girolamo Cardano's autobiography from 1575–76 and Leonardo's understanding of the medical image not as representation but as construction of truth.

The section concludes with two contributions now focusing on three-dimensional images of the body. Elizabeth Stephens's chapter discusses the oeuvre of Anna Morandi Manzolini (1714–1774), one of the most celebrated anatomical modellers of her day, who specialised in medical moulages. The emergence of modern styles of medical modelling in the second half of the eighteenth century represented in Morandi's moulages is indicative of the changing cultural status of anatomy at the time. While Stephens looks at the anatomical models as a product of an unsettled zone where the arts and sciences intersect and diverge, she argues that aesthetic (modelling) practices had reached a pivotal position and gained historical agency in enabling change; modelling itself had become the means by which anatomical discoveries were made and the exhibition of these objects then further changed conditions in which anatomical research was conducted.

Stephens's observation of the aesthetic gaze is a gendered gaze as she investigates the role of the female between profession, science, and aesthetics, Heikki Lempa, on the other hand, gives us a striking example of the male gendered gaze between aesthetics and gymnastics, focusing on the anatomy of the sculpture and the shaping of the male body in living practice through "modelled" exercise. The point of departure in Lempa's investigation of physical exercise books is also not so much the medical "book" of anatomy but the study of the aesthetic and artistic body as it presents itself, for example, in Winckelmann's appraisal of antique sculpture. The exterior of the ideal body is thereby superimposed onto the real body of the athlete. Lempa investigates the modelling of student bodies in the Schnepfenthal institution in eighteenth-century Germany, which was a time when physical exercise was already an integral part of traditional medical therapy and dietetics. In the 1790s, Johann Christoph Friedrich GutsMuths's *Gymnastik für die Jugend enthaltend eine praktische Anweisung zu Leibesübungen* (1793) established a schema and model of bodily motions that provided pupils with a canon of physical exercise. GutsMuths's taxonomy set new standards for physical exercise, for the bodily conduct, and, in fact, for the art and image of bodily movement drawing on both the antique model but also on an imagined Germanic type. Hereby, GutsMuths goes beyond the mere transposition of the ideal body into the real body; it is the body in motion and the modes of movements which are developed in dialogue with aesthetic regimes at the time to create a notion of classic German masculinity.

All the chapters of the first part, presenting examples from the sixteenth to the eighteenth centuries, already chart the complexity and diversity of medical bodies as it focuses on the anatomical, the gendered, and the imagined body in regards to aesthetics and the artistic realm; from Rembrandt's paintings to Cardano's poetics of individuation, and from the sculptured female body to the male sculpture set in motion and appraised by a discerning male gaze. All contributions attest to the early stages of the contested claim that images genuinely enable and affect knowledge production via processes of aestheticisation.

2 Identity and Visual (De)Formation

In the second part of this volume, we will explore the notions of "Identity and Visual (De)Formation." The image of the medical body, or the medical image of the body, creates avenues for the construction of identity which depart from or supersede the anatomic model established in early modern depictions.

Increasingly, the body loses its metaphysical or religious clout and, while the body might be deformed or abnormal, the portrayed subject shifts further towards individual recognition. It may oscillate between the formation of a professional type (e.g. medical students who document their training by posing with the dissected cadaver) or the patient or scientific specimen who is afforded identifiable markers and deformations. The portrait of a subject—of the patient or medical practitioner—attests to a polyvalent and complex construct which is embedded in the ideology of its time. Colonial and racial motivations inform the depiction of the European and non-European sitters, while the emotional expressiveness or the psychological state of the subject—as understood according to ever-changing scientific parameters—are another reference point in creating moments of identification and subjectivation.

The contributions of the second section begin with Corinna Wagner's exploration of the exterior body to understand the unseen, intangible interior and understand the material body—the muscles, bones, and nerves—in relation to the discourse on emotional life. The nineteenth-century studies of Sir Charles Bell (*Essays on the Anatomy of Expression in Painting*, 1806), the French neurologist Guillaume Duchenne de Boulogne (*The Mechanism of Human Facial Expression*, 1862), as well as of Charles Darwin (*The Expression of the Emotions in Man and Animals*, 1872), and Frederick Treves (*The Elephant Man and Other Reminiscences*, 1923) navigate uneasily between notions of eighteenth-century sensibility and nineteenth-century materialism. They point to the paradox of facial expression produced by external manipulation and the insistence of a connection between facial expression and emotional interiority, feeding into debates on the anthropological difference.

The contributions of Joanna Madloch and Carolyn Lau revisit functions of the portrait in Western and Eastern cultural contexts. Madloch's chapter analyses nineteenth-century photographs of medical professionals and how the technology forges a professional identity. She examines a range of photographs created between the 1840s and 1900s, which depict medical professionals posing with skulls and skeletal parts and elucidates how these images served as popular icons for the medical profession in the 1800s. Photographs of formal lectures and of dissections including those serving as images of "rite of passage" for medical students complement the analysis. These "dissection pictures" evoke—in stark contrast to the "Anatomy Lessons" by Rembrandt—a familial relationship between the medical students and the cadaver, in which the latter is in turn "personalised" by attributing him or her with a certain social role.

Carolyn Lau's contribution provides an insight into the dialogue between the Eastern and Western conception of portrait painting by analysing the works of renowned trade painter Lam Qua (1801–1860), who was specialising

in oil portraits of local and foreign dignitaries in Late Qing China. From 1836 to 1852, he produced 114 medical portraits for American missionary doctor Peter Parker depicting Chinese patients suffering from deformities and bulging tumours. His work served as evidence of curability and resilience and destabilised derogatory accounts of national and racial health. The human body is visualised as a holistic entity in Lam's empathic but meticulously drawn medical portraits, which can be characterised by a paradox as the images seem to address something of the personal identity of the patient portrayed and at the same time adhere to the Western gaze of depicting diseases "impersonally" for the purpose of general knowledge application, thus rendering the medical imaging to conjure up a complex notion of authenticity and appropriation, legitimacy and autonomy, likeness and objectivity in semi-colonial modernity. The slippage between the representation of self, paramount in a Western-style portrait, and the impersonal focus on the medical case is thereby refracted once more in these paintings by a Chinese artist.

The last chapter of this section offers a unique perspective from visual artist stef lenk. Lenk's contribution presents work from her artistic practice, examining the emancipatory possibilities of a pathography of mental illness. The work proposes to conceptualise illness not so much along medical or scientific lines, but as a creative and phantasmatic response to one's own suffering. Using drawing as a mode of thinking and the literary technique of magic realism in an interdisciplinary context, lenk creates a graphic narrative of anxiety based on personal experience with the illness. Complementing the artwork is a curatorial examination, which explores the process and assesses the outcome of the work, i.e. the benefits of using magic realism (in relation to other graphic illness narratives) and how the creative process can reinstate biographical authority over a situation where the unseen effects of mental illness can be debilitating.

The second section of this volume encompasses three historical contributions presenting nineteenth-century examples of different body constructions. While Wagner and Lau demonstrate how different pathological bodies are constructed by photographic evidence and linguistic discourse in the West and by holistic portrait painting and Western scientific subversion in the East, Madloch observes how the portrait in the West has been utilised for professional identity construction. This in turn ties in with lenk's contribution which captures a unique perspective on the imagined body by exploring her own artistic image-production in times of psychological crises. All chapters in this section provide insight into how identities are feeble constructions, situated between visual media formats, assumed notions of body normalcy and aberration, and individuation markers, which depend on professional and/or national positionings.

3 Power, Consumption and the Pathological Body

The final section of this volume addresses the "Consumption of the Pathological Body." The images of the deformed, diseased, disabled, or mutilated body enter circulation beyond the confines of medical and aesthetic interests. The shock appeal of the abject body draws the economic, criminalistic, political, and sociological gaze. This negotiation of otherness thrives on the difference between normality and abnormality, between healthy and unhealthy bodies and minds, to question, modify, or re-establish power structures.

The section opens with Claudia Stein's acute observations of the relationship between Wilhelmine Germany's new and celebrated experimental laboratory sciences and political economy. Historians have rightly pointed out that the "laboratory revolution" overlapped with the nation's late industrialisation and the explosion of consumer culture, and they have traced the close relationship between the new knowledge of the body (and its visual representations) and the new strategies and practices of its commercialisation. What has gone unnoticed, however, is that the reigning German economic theory of the time was deeply at odds with the vision of universal scientific human nature propagated by the experimental sciences. Stein argues that the Munich "poster struggle" of 1900 needs to be seen not only as a struggle over the representation and popularisation of the new biomedical body, but also as an expression of the tension between different visions of modern economic man. And when envisaging today's enthusiasm for the collaboration between the life sciences, biomedicine, biotechnology, and political economy, and incessantly being "sold" the vision of a universal biological consumer, the German turn-of-the-century debates over economic man remind us that the links between our versions of the biomedical body and economic theory and practice might be less universal and less durable than we are inclined to think.

Michael Hau's contribution traces the relationship between medicine, politics, and capitalism, exploring the utilitarian approach to human life in 1920s and '30s Germany. The chapter addresses the role of political ideology, focusing on Walther Jaensch's visual diagnostic regime using "capillary microscopy," which promised to diagnose children and youths with "developmental inhibitions" at a massive scale. Jaensch successfully positioned himself as a researcher on the verge of developing new therapies for feebleminded people, who threatened to become an allegedly intolerable burden on the Weimar welfare state. During the Nazi period, he successfully reinvented himself as a racial hygienist by convincing influential medical leaders that his ideas were a valuable complement to the negative eugenics of Nazi bio-politics. So-called "constitutional therapy," he claimed, could turn genetically healthy people

with "inhibited mental development" into fully productive citizens and therefore could make a valuable contribution to Nazi performance medicine.

Birgit Lang's chapter also investigates an early twentieth-century German scenario, proposing that the socially disrupted and brutalised German society post-World War I and the appeal of the psychiatric discourse at the time led to an almost pathological fascination with sexually motivated murders. The new evidentiary practice of photography crossed the line into popular culture and inspired particularly visual artists in the Weimar era. Since the beginning of the twentieth century, criminologists have worked with photographs of murder victims, crime scenes, and mugshots as evidence and training materials. They aimed to contain the violence of this visceral new photographic imagery through carefully crafted case narratives. Visual artists, on the other hand, transposed this fragmented criminalistic imagery, focusing on the immediate aftermath of the sex murder as the most common motif. Their "collages" reinserted the murderer into the scene and asked pertinent questions about the artist and his followers as voyeuristic onlookers that disturbingly complemented photographic criminalistic truth.

Christiane Weller's chapter explores the fractured interplay between psychiatric art, or "Outsider Art," and its psychiatric frame. Here, the visual material produced by the artist-patient gives rise to the portrayal of mental anguish, ready to be transposed into the consumerist world of the art market via the various psychiatric art collections. The chapter questions the interest and rationale behind those psychiatric art collections, both in Europe and in Australia (e.g. from the Prinzhorn Collection in Heidelberg and the Dax Centre in Melbourne). As part and extension of the psychiatric or medical discourse, these "psychiatric" or psychotic artworks are supposedly manifesting an aberration which can be classified and categorised in terms of a psychiatric diagnosis of the artist-patient. The pathology of the artist is therefore a precondition for the art collection and is kept alive as a guarantor for the work of art in which it apparently finds notable expression. Taking Derrida's notion of the archive as a point of departure, Weller suggests that the collection—in establishing order, sense, and narrative—attempts to formulate a very specific relation between its exhibits and psychiatry as a system and practice of medical knowledge. The artwork on the one hand attests to a clinical knowledge which grounds psychiatry as a discipline. On the other hand, the artwork seems to subvert any systemisation of medical knowledge and escapes the limits of diagnosis and psychiatric framing and ultimately resists totalising consumption.

The section and the volume conclude with Barry Murnane's investigation into conceptualisations of the posthuman in relation to imagining the biomedical body, drawing on the BBC series *In the Flesh* as exemplary epistemological

model. *In the Flesh* develops a horrifying scenario of biomedical intervention within neoliberal medical culture, deploying the figure of the zombie to address concerns relating to regenerative surgery and contemporary discourses of the posthuman. In the series, surgical intervention and pharmaceutical treatment become powerful tools of socio-economic normalisation, generating chemically adapted bodies as uncanny, undead biomachines, which call into question established concepts of life, death, and selfhood. The chapter introduces the imagining of the biomedical body as uncanny and interrogates the biopolitical and theoretical contexts behind this representation within the framework of current conceptualisations of the posthuman. The focus shifts to investigate the presence of biomedical, anatomical imaging in the series as a medium by which this Gothic imaginary is anchored in the already uncanny nature of neoliberal medical culture. The chapter therefore concludes that the fictional bodies and their stories in *In the Flesh* open up to scrutiny the constructivist epistemological function of medical and imaging technologies of today more generally.

All contributions in this last section focus on twentieth and twenty-first-century developments. Those of Stein and Murnane present examples of mass media (public advertisements at the start of the twentieth century and television series in the twenty-first century) playing their role in defining and constructing the consumed body in relation to economic "ideology" or to the posthuman condition. Lang also addresses the consumed body but from the angle of public displays of the shock arising from the interchange between forensic photography of murder scenes and their artistic renderings. Finally, Weller, like Lang, presents an example of expert discourse, albeit in this case not forensic but psychiatric, whereby the pathological body is constructed between professional psychiatric discourse and artistic expression of the psychotic patient. This in turn leads to a subversion of the psychiatric discourse, highlighting once more the initial constructedness of the pathological body.

Our book addresses the role of visual imagery in different historical and systematic contexts. Common to all chapters is the attempt to exemplify how different medical bodies were constructed by changing interplays between media formats, linguistic discourses, as well as historical and cultural predispositions, and most importantly how the visual formats themselves play a determining role in the knowledge formation about medical bodies: from the anatomy of the image as specific to the art of painting and sculpture (Redner, Fliethmann, Stephens, Lempa, Lau) and the strategic use of imagery in mass media (Stein, Murnane), from photography within certain professional discourses like psychology and criminology (Wagner, Madloch, Lang) to the creative

and subversive quality of the image in twentieth- and twenty-first-century art productions (lenk, Weller) and the microscopic imagery and its ideological appropriation (Hau).

All chapters in this volume subscribe to the premise that images are "man-made" forms depicting, creating, and constructing knowledge ensembles alongside linguistic discourse, and which in turn impact on and moderate their respective historical and cultural environment. The wide range of contributions will allow for intricate and multifaceted readings of the interplay between imagination and the medical body and will contribute—beyond any narrow systemisation—to the theoretical re-imaginings and contemporary understanding of medical images.

PART 1

The Epistemology of Anatomy and Aesthetics

∵

Rembrandt and the Dutch Cartesians: The Medical Body and the Body of Christ in the Anatomy Lessons

Jill Redner

1 Introduction

Rembrandt depicted the human body as an object of scientific investigation only twice: in the famous group portraits featuring lessons given by the Prae-lectors of Anatomy for the Amsterdam Surgeons' Guild.[1] Both works raise the question of how Rembrandt's vision reflects scientific understandings of the medical body in his time. "The Anatomy Lesson of Dr Nicolaes Tulp" (1632), which depicts a dissection of the lower arm and hand, has been the subject of two monographs, by William Heckscher and William Schupbach, followed by numerous minor studies.[2] "The Anatomy Lesson of Dr Johannes Deyman" (1656), a brain dissection, has received far less attention, perhaps because it was damaged by fire in 1723 and is incomplete. After Schupbach, who provided an authoritative account of how contemporary science, then known as natural philosophy, may have influenced the Tulp painting, scholars interested in the history of ideas have tended to look for terms that could encompass both paint-ings. Similarities of subject, genre, and social purpose justify this approach. Both paintings record a climactic moment in a series of public dissections performed over the course of three days on the corpse of a criminal who had just been hanged. These anatomy lessons, held at the end of January each year, were great ceremonial occasions; they were attended by paying guests, who included Amsterdam regents, visiting dignitaries and elite physicians, as well as members of the Surgeons' Guild. Both paintings were understood at the time as examples of the same genre, in which an historical event provides an occasion

1 See Norbert Middelkoop, Petria Noble, Jørgen Waldun and Ben Broos, *Rembrandt under the Scalpel: The Anatomy Lesson of Dr Nicolaes Tulp Dissected* (Mauritshuis, the Hague: Six Art Promotion Amsterdam, 1994) for an overview of all the anatomy paintings from 1601 to 1758 described in the Archives of the Amsterdam Surgeons' Guild.

2 See William S. Heckscher, *Rembrandt's Anatomy of Dr Nicolaas Tulp* (Washington Square: New York University Press, 1958); and William Schupbach, *The Paradox of Rembrandt's "Anatomy of Dr Tulp"* (London: Wellcome Institute, 1982).

for a group portrait, like the famous "Nightwatch" of 1642. Such similarities are significant but, as we shall see, application of a common framework of ideas to the paintings has led to conflation of their iconography, anachronistic interpretations of the earlier Anatomy Lesson and—despite many fine insights into the paintings—obscured the processes involved in cultural absorption of new thought about the medical body in the period between the paintings.[3]

In the twenty-four years between Rembrandt's Anatomy Lessons, his art underwent profound changes—stylistic, iconographic, and technical. And though the Dutch Republic was relatively stable by comparison with the surrounding states embroiled in religious war, momentous cultural changes were also taking place. Historian Jonathan Israel points to contemporary innovations in science and philosophy and their impact on struggles over religion as decisive: "By the late 1640s, a sea-change had taken place in Dutch intellectual life."[4] Israel is referring to the effects of the historical process known as "the scientific revolution," largely accomplished in the course of the seventeenth century.[5] In Israel's view, the Dutch Republic figured prominently in this process and he argues that it was the early widespread reception of Descartes's mechanistic natural philosophy, amid furious controversy in the 1640s, that gave Dutch scientists a common mathematical-mechanical language for their investigations and propelled the cultural absorption of the new ideas.[6] The theological arguments provoked by Descartes's mechanistic physiology played a major

3 See Gary Steiner, "The Cultural Significance of Rembrandt's "Anatomy Lesson of Dr. Nicolaas Tulp,"" *History of European Ideas* 36, no. 3 (2010): 273–279. Steiner cites numerous examples of the anachronistic tendency to "project our own fully secularised sensibilities back onto the 17th century." Nevertheless, he treats the first half of the seventeenth century as one moment in "the historical process of secularization" and suggests that both Francis Bacon and René Descartes be regarded as influences on Dr Tulp, though Descartes's ideas had been shared with only a few Dutch intellectuals before publication in 1637. See also J. Lenore Wright, "Reading Rembrandt: The Influence of Cartesian Dualism on Dutch Art," *History of European Ideas* 33, no. 3 (2007): 275–291, for an example of conflation of the iconography of the two paintings. Wright sees both the Tulp and the Deyman corpses as Christ-like, though the Tulp cadaver was probably modelled, as Heckscher suggests, on one of the "Drunken Peasants in an Inn" by Adriaan Brouwer. See *Rembrandt's Anatomy*, 17, 36 and Plate II-2b.

4 Jonathan I. Israel, *The Dutch Republic: Its Rise, Greatness, and Fall 1477–1806* (Oxford: Oxford University Press, 1998), 889.

5 Seventeenth-century natural philosophers built in complex ways on investigations by sixteenth-century philosophers, mathematicians, anatomists, and iatrochemists. See Hugh Kearney, *Science and Change 1500–1700* (London: Weidenfeld and Nicolson, 1971) for a useful summary of the contribution of sixteenth-century thinkers to the Scientific Revolution.

6 See Israel, *The Dutch Republic*, 581–587. See also Gary Hatfield, "Descartes' Physiology and Its Relation to his Psychology," in *The Cambridge Companion to Descartes*, ed. John Cottingham (Cambridge: Cambridge University Press, 1998), 335–370.

part in this process of cultural change, because religious beliefs shape the way the body is represented even when—as corpse on the dissection slab—it functions as a scientific object.[7] In the following discussion I accept Schupbach's account of the medical and theological ideas available to Tulp in 1632, argue these are clearly pre-Cartesian, and concentrate on constructing a framework of ideas for the enigmatic Deyman Anatomy Lesson which, unlike the earlier Lesson, *can* be interpreted in the light of Cartesian views of the body, as these were influential by mid-century in Rembrandt's intellectual milieu.

Cartesianism took several different forms in the Dutch Republic, as we shall see, but it was the positive reaction of Dutch medical practitioners and theorists to Descartes's radical reconception of the medical body that initiated the reception: it was his *physiology* that inspired his Dutch contemporaries first. This may not be widely understood, because historians of science generally look back at this early period from the perspective of Locke's and Newton's later achievements, and emphasise the aspects of Descartes's thought that these great thinkers accepted, namely the epistemology and the mathematisation of Nature, disregarding the physiological theories that were later superseded.[8] But as Dutch historian of medicine, G.A. Lindeboom insisted, one cannot appreciate Descartes's contribution to science without taking his medical theories into account: "Descartes stimulated scientific medicine by the truths he expounded as well as by the conspicuous errors in his assertions."[9] Cartesianism also has a place in the history of theology, evident in the way the responses of theologians interacted with those of natural philosophers when they encountered Descartes's ideas in the Dutch academic context. Descartes's challenge to received Aristotelian-Scholastic conceptions of the mind-body relation sent shock waves through Dutch academies in the 1640s because this

7 Religious beliefs are particularly resistant to change when deep-seated fears of the body are involved, its inner workings remain mysterious, and the causes of its vulnerability to disease, decay, and pain are not well understood. Rina Knoeff discusses the tenacity of such fears and their effect on medical theorisation in "Animals Inside: Anatomy, Interiority and Virtue in the Early Modern Dutch Republic"; see Renée van de Vall and Robert P. Zwijenenberg, eds., *The Body Within. Art, Medicine and Visualization* (Leiden: Brill, 2009), 31–50.

8 Mihnea Dobre and Tammy Nyden, eds., in *Cartesian Empiricisms (Studies in History and Philosophy of Science 31)* (Dordrecht: Springer, 2013) argue against the longstanding emphasis on the opposition between Locke's empiricism and Descartes's rationalism in standard Histories of Philosophy, which has led to overemphasis on Descartes's metaphysics and epistemology at the expense of his physiology and psychology. See Chapter 1 for an overview.

9 See G.A. Lindeboom, *Descartes and Medicine* (Amsterdam: Rodopi, 1979), 1. See also Tad M. Schmaltz, "The Early Dutch Reception of *L'Homme*," in *Descartes's Treatise on Man and Its Reception*, eds. Delphine Antoine-Mahut and Stephen Gaukroger (Dordrecht: Springer, 2016), 71–90. Schmaltz regards Descartes's *Treatise on Man* and the related essay "Description of the Human Body and all its Functions" as the key to his physiology.

philosophic tradition was basic to university education in law, medicine, and divinity. However, we are not looking at a simple condemnation of new ideas in the name of religion, on the model of the Catholic Inquisition—the revolutionary speed of Descartes's Dutch reception was partly due to the positive responses of influential Calvinist theologians.[10]

What was new about Cartesian physiology? Gary Hatfield states this clearly:

> Where previous physiologists had invoked powers, faculties, forms, or incorporeal agencies to account for the phenomena of living things, Descartes would invoke only matter in motion, organized to form a bodily machine.[11]

Descartes explained his aims succinctly in the following passage:

> I will now try [...] to give such a full account of the entire bodily machine that we will have no more reason to think it is our soul that produces in it the movements which we know by experience are not controlled by our will than we have reason to think that there is a soul in a clock which makes it tell the time.[12]

Descartes believed that if his contemporaries would only stop "attributing to the soul functions which depend solely on the body and the disposition of its organs," there would be great benefits for medicine.[13] He wanted medical scientists to set aside the Aristotelian concept of the sensitive bodily soul so they could study animals and the human body *in its animal nature* as autonomously functioning systems. Though "his physiology may be seen as a straightforward translation of selected portions of previous physiology," the "mechanistic idiom" was new.[14]

10 Theo Verbeek, *Descartes and the Dutch: Early Reactions to Cartesian Philosophy 1637–1650* (Carbondale and Edwardsville: Southern Illinois University Press, 1992). See also Aza Goudriaan, "Descartes, Cartesianism, and Early Modern Theology," in *The Oxford Handbook of Early Modern Theology, 1600–1800*, eds. Ulrich L. Lehner, Richard A. Muller and A.G. Roeber (Oxford: Oxford University Press, 2016), 533–549, for an account of the positive and negative responses to Cartesianism by theologians across the different Christian confessions.

11 See Hatfield, "Descartes' Physiology and its Relation to his Psychology," 340.

12 "Description of the Human Body," Preface, cited in *The Philosophical Writings of Descartes*, vol. 1, eds. and trans. John Cottingham, Robert Stoothoff and Dugald Murdoch (Cambridge: Cambridge University Press, 1997), 315.

13 Cottingham et al., *Philosophical Writings*, 314.

14 See Hatfield, "Descartes' Physiology and its Relation to his Psychology," 343. Numerous other commentators point out Descartes's debt to traditional Galenic physiology. See

2 Approaches to the Paintings

Rembrandt's painting of the Tulp Anatomy Lesson is not an accurate visual record of the scene he witnessed in the anatomical theatre. The cadaver stretched out at an oblique angle across the bottom of the picture plane is intact, apart from its left arm, implying that the lesson on the arm was the first to be given in the course of the three-day surgical festival. In reality Aris Kindt would have already been disembowelled, and his chest cavity opened before his arm was dissected. Patrons collaborated closely with artists in commissioned portraits, so we can assume that Dr Tulp wished the painting to focus exclusively on the moment when he lifts the flexor muscles and tendons of the cadaver's arm and raises his own left hand to demonstrate the movement of the fingers controlled by this musculature. As a result, the hand became the "subject" of the composition in more than the medical sense.

FIGURE 1.1
Woodcut, attributed to Johann Stephan von Kalkar, portrait of Vesalius from his *De humani corporis fabrica*, 1543, xi, engraving
SOURCE: METROPOLITAN MUSEUM OF ART, NEW YORK (CC0 1.0)

Lindeboom, *Descartes and Medicine*, 67–83. Others discuss the likely influence of sixteenth-century predecessors such as the physician, Jean Fernel. See Margaret A. Boden, *Mind as Machine: A History of Cognitive Science* (Oxford: Clarendon Press, 2006), 59. However, most commentators generally agree with Hatfield's assessment of Descartes's innovative transformation of earlier ideas.

FIGURE 1.2 Rembrandt van Rijn, "The Anatomy Lesson of Dr. Nicolaes Tulp,"
ca. 1632, oil on canvas, Mauritshuis, The Hague
SOURCE: COMMONS.WIKIMEDIA

It allowed Tulp to highlight his debt to Andreas Vesalius, renowned for his
dissections of the arm and hand. But, as we shall see, this choice also enabled
Rembrandt to elevate the hand to the status of master symbol in the painting's
iconography.

All the surgeons watching are in a state of suspense: three are gazing intently
at Tulp's hand; another looks up startled from reading a list of the participants'
names; two are staring at a large book partly in shadow at the corpse's feet; only
the figure standing at the back of the group looks directly out at the audience
and points to the body of the dead man. The faces of the surgeons, the upper
half of the corpse and Tulp's face and hands in the centre of the composition
are all illuminated. Dressed in black robes and hat the doctor is a commanding
presence. The striking contrast between his animated figure, seated upright
and the dull greenish-white cadaver lying prone below him, has led some com-
mentators to see the painting as an expression of faith in the power of the new
science of anatomy to "triumph over the egotistical ignorance of sin," trans-
forming the fear aroused by the sight of a condemned sinner, suffering this
final public humiliation in death, into admiration for the new knowledge.[15]

A contrary line of interpretation has been influential since the mid-1980s.
The fact that none of the seven surgeons gathered around Dr Tulp are actually

15 Heckscher, 1958, Chapter XVI, 117–121, sees it as the victory of *Sapientia* over *Malitia*.

looking at the corpse, has led some critics to interpret Rembrandt's treatment of the lesson ironically. The surgeons focus either on the body part being dissected, the sign made by the doctor's hand, or the open textbook on display—and as a result fail to "see" the body as a whole. This is taken as a prophetic hint that modern science would go on to destroy the body's corpo*reality* by treating it first as a mere object, then as an abstraction.[16] Such interpretative moves, though anachronistic, have opened up new critical perspectives, suggesting ways to construct "Rembrandt" as "our" contemporary. Unfortunately, however, they have also distracted scholars from the task of evaluating Rembrandt's relations to his own contemporaries.[17]

Even scholars who are not intent on discovering premonitory signs of their own critique of post-Enlightenment medical science in the Tulp painting have argued that Descartes's ideas must have been "in the air" in 1632, because he was living in Amsterdam at the time and performing private anatomical dissections on animals. We find reports of a long-lost sketch of Descartes by Rembrandt, used to justify belief in a personal relationship between them. Others attempt to detect Cartesian influence on Rembrandt's representation of the human subject as early as 1632.[18] All such accounts suffer from a failure to engage with the intellectual context in Holland before 1637, at a time when Descartes's research was still in progress, unpublished, and only known in fragments to a select circle of intellectuals.[19]

16 For example, Francis Barker, *The Tremulous Private Body: Essays on Subjection* (London and New York: Methuen, 1984), 73–85; and W.G. Sebald, trans. Michael Hulse, *The Rings of Saturn* (New York: New Directions, 1998), 12–19. Barker takes his cue from Michel Foucault's comments on Descartes's famous "Cogito ergo sum" from the *Meditations on First Philosophy* (1641), but does not mention *The Birth of the Clinic*, trans. A.M. Sheridan Smith (London: Tavistock, 1973), in which Foucault discusses the scientific or clinical "gaze." It is not clear how Foucault would have reacted to application of this concept to an early seventeenth-century painting, as he sees this new perspective on the body as a product of late eighteenth-century medical science.

17 For insight into the historical origins of what Foucault refers to vaguely as "the clinical gaze" one might consider the work of Hermann Boerhaave (1668–1738), the Dutch iatrochemist and botanist who founded a new clinical approach based on mechanistic principles. His works published in the 1720s and 1730s made him internationally famous. See Rina Knoeff, *Herman Boerhaave: Calvinist, Chemist and Physician* (Amsterdam: Edita KNAW, 2002).

18 Mariet Westermann discusses the belief that Descartes's sheer presence in Amsterdam in the early 1630s suggests that his ideas were known, in *Rembrandt* (London: Phaidon, 2000), 13. See Howard White, "Rembrandt and the Human Condition," *Interpretation* 4, no. 1 (1974): 17–37, for the legend of a personal connection between artist and philosopher.

19 Rembrandt's patron, Constantyn Huygens, Secretary to the Prince of Orange, knew Tulp through a mutual friend, Caspar Barlaeus, but recent research has shown that Huygens was sceptical about Descartes's physiological theories until 1635. See Lawrence Nolan, ed.,

One must ask what natural philosophy could have influenced Dr Tulp's self-conception as Praelector of Anatomy in 1632 and how contemporary physiology figures in the iconography of the painting. For detailed, relevant analysis of this kind, it is necessary to return to Schupbach. After considering a range of early modern theorists likely to have influenced Dr Tulp's understanding of anatomy, he agrees with Heckscher that Tulp's "homage" to Vesalius is obvious, but argues that renowned anatomist Andreas Laurentius (1558–1609), physician to Marie de Médicis and a strong influence on Tulp's teacher at Leiden, Pieter Paaw, was also a source of inspiration. Like Vesalius, Laurentius was pursuing new empirical research into the structure and function of bodily parts, but he was also deeply immersed in the philosophic and medical legacy of Aristotle and Galen (CE. 129–217), whose work Vesalius had revived in the 1530s. It was this combination of classical and early modern views of the human body that Laurentius absorbed and, according to Schupbach, lie behind Tulp's particular fascination with the hand. Aristotle wrote: "God has provided us with two inner instruments with which we use outer instruments, the hand for the body and the intellect for the soul ... So the soul is as the hand." Galen affirmed that God gave man the hand to serve multiple creative purposes and Laurentius saw Vesalius's demonstrations of the intricate workings of the hand as proof of the beauty and wisdom of God's design.[20] It is this deeper significance of the hand in the Aristotelian tradition that gave it iconic value for anatomists, comparable to that of the heart, and ensured that its dissection would be understood in religious as well as scientific terms.

The religious implications of the iconography of the hand in the Tulp painting are carefully explicated in Schupbach's analysis. The surgeon at the back looks directly out at us, pointing to the body on the slab, stressing the traditional Christian message: *memento mori* at the very same moment that Tulp is using his hand to demonstrate God's design. The Anatomy Lesson teaches us to "know ourselves" as mortal and limited, and at the same time invites us to wonder at the power of the new science to show us God in this body, His creation. Rembrandt would have assumed that the work of his hand as artist was also validated in this way. Renaissance art had expressed similar beliefs, as in Michelangelo's Sistine Chapel depiction of God's hand touching Adam's at the

The Cambridge Descartes Lexicon (Cambridge: Cambridge University Press, 2016), entry on Huygens.

20 Schupbach, *Paradox*, 56. See citations from Aristotle, Problemata XXX.5 (955b 23) and De Anima III.8 (432 a1). See Galen, "On the Usefulness of the Parts of the Body" (*De Usu Partium Corporis Humani*), vol. 2, trans. Margaret Tallmadge May (Ithaca, NY: Cornell University Press, 1968), 727.

Creation. The hands of artist, physician, and the chastened everyman we see in the corpse combine. Thus the painting can be interpreted as a bravura demonstration of the harmonious workings of art, science, and religion. There are two different moral emphases: a positive view of the body as vital, beautiful, and proof of the divine spark in humankind, and a negative view of it as corrupt and doomed to die. Both emphases are religious. The study of human anatomy is clearly more aligned with the positive religious vision here, but there is no suggestion that medical exploration itself is unsettling religious belief or promoting scepticism. There is still no hint of the tension that would develop in the course of the seventeenth century as natural philosophers and theologians struggled to redefine the relation between religious and scientific perspectives. As we shall see, the conflict over Descartes's mechanistic view of the body that broke out in Holland in the 1640s was one of the main forces driving change in that relationship.

By the time Rembrandt came to paint the Anatomy Lesson of Dr Johannes Deyman, tensions over this shifting relation between scientific and religious perspectives had surfaced in the broader culture.

FIGURE 1.3
Rembrandt van Rijn,
"The Anatomy Lesson
of Dr. Deyman,"
1656, oil on canvas,
Hermitage Amsterdam,
Amsterdam
SOURCE: COMMONS.
WIKIMEDIA

The anatomist, who towers darkly above the corpse in 1656 as his hands perform a delicate brain dissection, shares centre stage with the corpse which, with a sense of shock, we cannot fail to recognise as a "Christ." Unlike Aris Kindt in the Tulp Lesson, this corpse, Joris Fonteyn, otherwise known as Black Jack, has been fully disembowelled, yet his body is still a powerful, almost living presence and the face which we cannot avoid seeing at the centre of the painting registers pain and shame. Dramatically foreshortened, the corpse

FIGURE 1.4
Andrea Mantegna,
"The Lamentation over
the Dead Christ," ca.
1490, tempera on canvas,
Pinacoteca di Brera,
Milan
SOURCE: COMMONS.
WIKIMEDIA

is reminiscent of the figure in Mantegna's famous "Lamentation of Christ" (ca. 1480).[21]

If this is Christ, it is Christ following his Deposition from the cross at the darkest moment in the Christian story. Who would dare dissect His brain, even in the name of scientific progress? The painting has aroused religious sentiment in viewers from diverse critical traditions. Thinking of Titian, Kenneth Clark comments: "Rembrandt has given his central figure the pathos and solemnity of a *Pietà*." And Christopher White sees the scene as hieratic: the Praelector "proceeds with all the solemnity of a priest celebrating the Mass." But there is a gaping hole in the belly of this "Christ," a darker, deeper wound than those of the Crucifixion. The image is disturbing; may even seem sacrilegious.

The cold, detached stare of the assistant surgeon, Matthias Calkoen, and his studied nonchalance, right hand on hip, as he holds the empty skull pan of the Christ-like corpse in his left hand, strengthens the profound unease stirred by these iconographic associations.[22] Nevertheless, the painting was accepted and displayed beside the Tulp in the Surgeons' Guild Chamber, where it was admired by Catholics and Calvinists alike. Rembrandt's contemporaries do not seem to have been troubled by his adaptation of sacred images.

21 The central foreshortened "Christ" figure was probably also modelled on Orazio Borgianni's 1615 Caravaggesque version of "The Lamentation"; described in James A. Ganz, *Rembrandt's Century* (Munich, London and New York: Delmonico Books, 2013), 109.
22 See Eugen Holländer, *Die Medizin in der klassischen Malerei* (Stuttgart: Ferdinand Enke, 1913), 54–66; and Simon Schama, *Rembrandt's Eyes* (New York: Knopf, 1999), 603–605. See Kenneth Clark, *Rembrandt and the Italian Renaissance* (London: John Murray, 1966), 95; and Christopher White, *Rembrandt* (New York: Thames and Hudson, 1984), 164.

Clearly, interpretation must account for the puzzling interaction of religious and scientific perspectives in the composition, which are not simply opposed here, any more than in the earlier Tulp Anatomy. However, Rembrandt's use of explicit Christological imagery in conjunction with a brain anatomy at a time when, thanks to Descartes, the brain was central to disputes over the relation between body and soul suggests that Cartesian natural philosophy is relevant to analysis of this Anatomy Lesson.

3 **Early Responses to Cartesian Physiology: Body versus Mind and Reason versus Revelation**

As Cartesian mechanism affected contemporary understandings of the body, promoting redefinition of the mind-body relation and provoking intense debate about the powers and limits of reason, the reactions of theologians were as significant as those of physiologists and philosophers. While natural philosophers argued about the relation between body and mind or soul, theologians discussed the issue in terms of its implications for established doctrine about the relation between Reason and Revelation. As Wiep van Bunge has shown, some Calvinist theologians reacted with predictable hostility to Cartesianism, but others—equally devout Calvinists—began to debate the use of natural reason in matters of faith, especially in biblical interpretation.[23] This widened divisions within the Calvinist Church, as orthodox theologians feared their members might emulate the subjective readings of scripture common among Pietists and other dissenting Protestant minorities.[24] Though recent scholarship has shown that Rembrandt was not a dissenter,[25] his own biblical

23 See Wiep van Bunge, "Cartesian Hermeneutics," in *From Stevin to Spinoza: An Essay on Philosophy in the Seventeenth-Century Dutch Republic* (Leiden: Brill, 2001), 74–83.

24 According to Andrew C. Fix, in *Prophesy and Reason: The Dutch Collegiants in the Early Enlightenment* (Princeton: Princeton University Press, 1991), dissenting Dutch Protestants, called "Collegiants" because they met in small study groups called colleges, were labelled "enthusiasts," and suspected of being anti-Trinitarian Socinians, by their critics. Fix shows how they transmitted *both* Christian rationalism and pietism into the eighteenth century. Dutch Cartesians are thought to have attended their meetings, Utrecht physician, Lambertus Van Velthuysen, for example (see G.A. Lindeboom, *Dutch Medical Biography: A Biographical Dictionary of Dutch Physicians and Surgeons 1475–1975* (Amsterdam: Rodopi, 1984), 2038; and van Bunge, *From Stevin to Spinoza*, 79–80); though the Collegiants were typically Mennonites, Quakers, and only occasionally the more radical Socinians.

25 Rembrandt had numerous Mennonite patrons and would have been aware of the Collegiants, but his religious convictions were Pauline Calvinist and he would not have been drawn to this radical anti-Church circle. See Shelley Perlove and Larry Silver, *Rembrandt's*

FIGURE 1.5
Rembrandt van Rijn, "Self-
portrait as the Apostle
Paul," 1661, oil on canvas,
Rijksmuseum, Amsterdam
SOURCE: COMMONS.
WIKIMEDIA

interpretations became increasingly personal from about 1650, and by 1661, when he painted the great Self-Portrait as The Apostle Paul, he was clearly thinking deeply about the relation between Reason and Revelation, the two "lights" shining in the darkness for the doubting apostle, as he looks for inspiration in reading the scripture.

There were other influences on Rembrandt's religious vision, as we shall see, but Dutch Cartesianism was significant and can help elucidate the unsettling effect of the combined religious and medical imagery of the Deyman painting. Schupbach's study of the natural philosophy that probably influenced Dr Tulp has clarified the pre-Cartesian background to the earlier painting. And there is a wealth of knowledge about Rembrandt's religious vision, in general.[26] Yet there is no study of the intersecting religious and scientific contexts of the later Anatomy Lesson that takes the intellectual reception of Cartesianism in the Dutch Republic into account and asks how Descartes's followers and their opponents mediated this reception. This is unfortunate because detailed

Faith: Church and Temple in the Dutch Golden Age (University Park, PA: Pennsylvania State University Press, 2009), 6–7, for criticism of the myth about Rembrandt as a Mennonite.

26 See especially the studies of Rembrandt's religious iconography by German scholars, Christian and Astrid Tümpel, which have influenced Rembrandt scholarship in English as well since the 1980s. See also Perlove and Silver in their indispensable study, *Rembrandt's Faith*, cited above.

knowledge of the intellectual milieu can compensate for the paucity of information about Deyman—who died young, leaving no published works—and also discourage implausible interpretive moves prompted by the incomplete state of the painting.[27] Fortunately, enough is known to allow reconstruction of Deyman's medical and religious views from the context and to suggest how these influenced Rembrandt's composition.[28]

Like the Tulp, the Deyman painting records the praelector's self-conception as a follower of Vesalius by referencing his seminal work on anatomy, *De humani corporis fabrica libri septem*. The Tulp refers to the frontispiece for Chapter 1 in the first and second editions (1543 and 1555), which shows Vesalius dissecting the hand;[29] the Deyman recalls the title print used for both editions, in which Vesalius stands to the left of a foreshortened female corpse, located in the centre of the picture, with a skeleton rising ominously behind her.

In the Deyman painting the doctor replaces the skeleton exactly, possibly reflecting his sense of medicine as working toward mastery over death. His Lesson acknowledges Vesalius also by its visual reference to the brain illustration in the *Fabrica*.[30] But Rembrandt's treatment differs significantly from this model, as the head is tilted up to reveal the cadaver's face—thus making it the focal point of the composition. Comparison with Rembrandt's other late religious works can provide insight into his vision here. Freely adapting the source suggested by his patron, he integrates the corpse with the anatomist looming above it in a conjoined figure, a dyad, to form the vertical central axis of the composition. Conventionally used to depict Madonna and Child, the dyad suggests an intimate relation between Dr Deyman and the Christ-like corpse at a

27 The fact that Deyman's face is not visible due to the damage has led some scholars to treat his assistant Calkoen as his representative. But Calkoen was neither a physician nor someone versed in theoretical medicine. Members of the Surgeons' Guild were highly skilled craftsmen; they were not qualified doctors and were unlikely to have been involved in discussions about physiology. As guild foreman, Calkoen has a prominent position in the front of the canvas, because this was his due in the group portrait. He does not stand for the anatomist, let alone for medicine.

28 For key social networks around Deyman, see Gary Schwartz, *Rembrandt: His Life, His Paintings* (New York: Viking, 1985). See also Jonathan Sawday, *The Body Emblazoned. Dissection and the Human Body in Renaissance Culture* (London and New York: Routledge, 1995), 156–158, who believes the anatomy of the brain may have been topical among Amsterdam anatomists in 1656, because this was the year Descartes's "Passions of the Soul," describing the brain as the seat of the rational soul, was translated from French into Latin and Dutch.

29 See Andreas Vesalius, *De humani corporis fabrica libri septem* (Basel: Johannes Oporinus, 1543 and 1555), the title print and the frontispiece for Chapter 1. Both are reproduced in Middelkoop et al., *Rembrandt under the Scalpel*, 21–28.

30 It is one of many medical illustrations by Johann Stephan von Kalkar in these early editions of Vesalius's *Fabrica*.

FIGURE 1.6 Woodcut, after Johann Stephan von Kalkar, used as title page in
 Vesalius, *De humani corporis fabrica libri septem* (Basel: Johannes
 Oporinus, 1543 and 1555)
 COURTESY OF THE WELLCOME COLLECTION (CC BY 4.0)

moment that recalls the Deposition from the Cross. Rembrandt's late works
return repeatedly to the Crucifixion, so iconographic comparison with these
works is warranted. When Rembrandt draws on Christian iconography he does
more than illustrate scripture; he varies details in iconic scenes to create a new
moral emphasis—selecting certain elements, changing or ignoring others, so

the differences provide clues to his interpretation.[31] This suggests that as well as noting the reference in the Deyman Anatomy to Mantegna's "Lamentation of Christ," we should identify key changes of detail. Rembrandt's references to his own works are also revealing, as details that recur across his works indicate themes important to him and provide insight into his personal beliefs.[32]

The following discussion combines insights from the art historical literature with analysis of the reception of Descartes in Rembrandt's intellectual milieu. My aim is to identify the interplay between medical and religious ideas relevant to the later painting. I do not discuss critically how professors of theoretical medicine, natural philosophers, and theologians actually interpreted Cartesian ideas, as this would require specialist knowledge across several fields, but look at contextual factors at play in individual and institutional responses to these ideas. The processes of intellectual change in Holland were unlike those in most other European states because of commitment to civic pluralism and the limits this placed on the power of the Calvinist Church.[33] Intellectual dissent fomented by the promotion of Cartesianism in Dutch universities in the 1640s fed into religious dissent and was distorted by it.[34] It is against this background that the range of meanings available to Rembrandt can best be identified, interpretation of the second Anatomy Lesson suggested, and its difference from the first appreciated.

4 Dutch Cartesianism

As we shall see, the disputes aroused by Descartes's mechanistic conception of the body had immediate impact on leading theorists of medicine in mid-century

31 Christian Tümpel, "Ikonographische Beiträge zu Rembrandt," *Jahrbuch der Hamburger Kunstsammlung* 13 (1968): 95–126; Christian and Astrid Tümpel, *Rembrandt: Images and Metaphors* (London: Haus Publishing, 2006).

32 Jan Bialostocki, "A New Look at Rembrandt Iconography," *Artibus et Historiae* 5, no. 10 (1984): 9–19; Robert W. Baldwin, ""On Earth we are Beggars, as Christ Himself was": The Protestant Background of Rembrandt's Imagery of Poverty, Disability, and Begging," Konsthistorisk tidskrift/Journal of Art History 54, no. 3 (1985): 122–135. See also Julius Held, "A Rembrandt Theme," *Artibus et Historiae* 5, no. 10 (1984): 21–34.

33 See Israel, *The Dutch Republic*, 889–933. Israel explains how broader political conflicts played into the intellectual debates over Cartesianism, as the orthodox Calvinists sought to augment the power of their factions in city councils by exploiting tensions between the Prince of Orange and the cities, over which he had limited authority. See also van Bunge, *From Stevin to Spinoza*, 83–93, on the political consequences of the debates over Cartesianism.

34 See Israel, *The Dutch Republic*, 887–899; Verbeek, *Descartes and the Dutch*, 1–12; and van Bunge, *From Stevin to Spinoza*, 83–93.

Holland. Descartes was close to completing his first great work, *The Treatise of the World and of Man*, in 1633 when he heard that Galileo had been condemned by the Inquisition for demonstrating that Copernicus's heliocentric cosmology was more than a mathematical hypothesis. Deeply alarmed, though he was safe in Holland, Descartes decided against publication. A Copernican, but also a sincere Catholic, he hoped his philosophy would eventually be acceptable to the Church. During the previous year he had shared theorems on light refraction from his *Dioptrics* in private, but only began to consider publication after meeting Constantyn Huygens in 1635.[35] Huygens, Secretary to the Prince of Orange, diplomat, distinguished poet, art connoisseur, and (until a disagreement in 1633) Rembrandt's most important patron, befriended Descartes and persuaded him to publish a summary of ideas from the *Treatise* in the *Discourse on Method* in 1637, together with *Essays on Optics, Meteorology and Geometry*. This was followed in 1641 by his metaphysics in the *Meditations on First Philosophy*, then by *Principles of Philosophy* in 1644 and *The Passions of the Soul* in 1649.

The method of systematic doubt—according to which only ideas that are intuitively conceived as "clear and distinct" by the rational mind represent truths—and the ontological mind-body dualism outlined in Parts 2 and 4 of the *Discourse*, then elaborated in Parts 2 and 6 of the *Meditations* were controversial in intellectual circles, even among Descartes's supporters.[36] But the medical ideas introduced in Part 5 of the Discourse were more readily accepted. Henricus Regius, Professor of Theoretical Medicine at Utrecht University, who was already interested in the work of Pierre Gassendi and William Harvey, took from Descartes what he could accommodate, namely his physiology not his metaphysics, and developed his own mechanistic ideas in the early 1640s.[37] At the Leiden State College and the University, philosophers

35 Huygens attended Descartes's lecture on the mathematical proofs of light refraction at
 the home of Jacob Golius, Professor of Arabic and Mathematics at Leiden University, in
 April 1632. However, at this time he was not impressed by Descartes. He and Golius both
 believed Descartes's theorems about light refraction were based on those of Willebrord
 Snellius, the famous Leiden physicist. See C. De Pater, "Experimental Physics," in *Leiden
 University in the Seventeenth Century*, eds. Th.H. Lunsingh Scheurleer and G.H.M. Posthu-
 mus Meyjes (Leiden: Brill, 1975), 309–328.

36 See Geoffrey Gorham, "Mind-Body Dualism and the Harvey-Descartes Controversy," *Jour-
 nal of the History of Ideas* 55, no. 2 (1994): 211–234, here 229, for a neat paraphrase: "I can
 clearly and distinctly conceive of mind apart from everything except conscious thought,
 so thought must be the only thing essential to the mental substance. Similarly, I can
 clearly and distinctly conceive of body independently of any property, including thought,
 except extension, so that extension is the only necessary property of body." For negative
 reactions specifically to Descartes's metaphysics by intellectuals interested in his other
 ideas, see Schmaltz, "The Early Dutch Reception," 74.

37 Verbeek, *Descartes*, 9 and 13–19.

Adriaan Heereboord and Johannes de Raey took up Cartesian physics and epis-
temology from the mid-1640s, while theologian Abraham Heidanus explored
Descartes's metaphysics, focusing on his proofs for the existence of God and
the individual Soul.[38] Both philosophers and theologians saw the implications
of Cartesian dualism for a new understanding of the relation between natural
reason and revelation. At least three distinct strands of Cartesianism were thus
evident by mid-century: physiological/medical; rationalistic/philosophical;
and ecclesiastical/biblical.[39] All were attacked by a group of orthodox Calvinist
theologians, known as the "precijsians," under the leadership of the Rector of
Utrecht University, Gisbertus Voetius, who campaigned first against Descartes
personally, till his departure for Sweden in 1649, then for the next quarter of a
century against every form of Cartesianism in the Dutch Republic.[40]

The battle lines were drawn first at Utrecht University in 1641. Regius focused
on Descartes's study of how bodily sensations are transmitted to and from the
brain. In one sense this was a conservative theory as Galen had maintained
that the brain rather than the heart was the controlling centre of the human
nervous system. But it was new in its treatment of the stimulus-response
mechanism where reflexes are concerned, firstly because this reaction is
autonomous: there is no sensitive (Aristotelian) soul in this machine-body;
and secondly because it circulates: the stimulus travelling up one set of nerves
to the brain's pineal gland, then down a different set of nerves in response.
The pineal gland was doubly important for Descartes because it allowed him
to solve the problem of how the mind communicated with his soulless body-
machine. Descartes believed that sensations create patterns on the surface of
the pineal gland, which are interpreted by the mind as ideas when conscious-
ness enters, and willed actions are performed. The pineal gland thus has a new
importance for Descartes: as the interface between mental and physical activ-
ity, it becomes the seat of the soul.[41]

38 See Aza Goudriaan, "Die Rezeption des cartesianischen Gottesdenkens bei Abraham
 Heidanus," *Neue Zeitschrift für Systematische Theologie und Religionsphilosophie* 38, no. 2
 (Jan. 1996): 166–197.
39 Willem J. van Asselt, *The Federal Theology of Johannes Cocceius* (Leiden: Brill, 2001), 84–85.
40 See J.A. van Ruler, *The Crisis of Causality: Voetius and Descartes on God, Nature and
 Change* (Leiden: Brill, 1995), 262, who writes that in 1641 Voetius "foresaw and rejected"
 most subsequent theological defences of mechanistic natural philosophy. See Thomas
 McGahagan, *Cartesianism in the Netherlands 1639–1676: The New Science and the Calvinist
 Counter-Reformation* (PhD dissertation, University of Pennsylvania, 1976), for a compre-
 hensive account of this controversy.
41 See "The Passions of the Soul," in *Philosophical Writings*, Cottingham et al., Article 32,
 340, in which Descartes explains "How we know this gland is the principal seat of the
 soul." See Hiram Caton, *The Origin of Subjectivity. An Essay on Descartes* (New Haven: Yale

Regius grasped just how radically Descartes had reconceived the mind-body relation.[42] Agreeing that there is only one soul, called "mind," and that bodily dispositions are merely material, he went further: arguing that as the effects of mind are only evident in bodily action, mind can be studied as "a mode of the body."[43] In short, Regius twisted Descartes's views in a materialist direction—while claiming he did not deny the soul is incorporeal and immortal, but accepted it as a mystery revealed by scripture. Regius also asserted that there may be only an accidental union in man of mind and body. Descartes was furious. He had used his method of doubt to prove the existence of God, the independence of mind from body and the immortality of the soul, so he disowned Regius.[44] The Voetians rejected Regius's "fideist" defence, knowing it was commonly the recourse of free-thinking Christians, who used natural Reason to explore dubious hypotheses about nature, while avowing complete faith in God and the revealed truths of the Bible. For them, scepticism implied atheism. They blamed Descartes and persuaded the City Council to ban Cartesian teaching at Utrecht University in 1643, though the edict was largely ignored.[45]

University Press, 1973), 88–97, esp. 90–91, for Descartes's concept of the brain and the nervous system. According to Caton, Descartes retained the concept of "animal spirits" from Galenic medicine but reconceived the spirits as fluids flowing along nerve tubes, as if in a hydraulic system, to and from the brain (91). See also Dennis L. Sepper, *Understanding Imagination: The Reason of Images* (Dordrecht: Springer, 2013), 321–329, who argues that Descartes's search for "new possibilities and consequences in the old nerve- and spirit theory" led to a new definition of the role of imagination in his psychophysiology. See also Axel Fliethmann, "Pathologies of Imagination and Medical Visual Culture in Early Modern Times," for comments on how Descartes, Spinoza, and Leibnitz partially anticipated the later Kantian notion of imagination as "essentially and fundamentally productive before it is reproductive" (this volume).

42 The *Treatise on Man* and "The Description of the Human Body and all its Functions" were not published until the 1660s, well after Descartes's death in 1650, but summaries appeared in other works as from 1637. Regius may have seen parts of the unpublished *Treatise*; he certainly knew the summaries of these views in *The Discourse on Method*, Part Five; also Discourses Four and Five of the *Optics*, published together in 1637. See also *Principles of Philosophy* (1644), Part Four, Articles 188–198, on the brain and the senses; also *The Passions of the Soul* (1649), Articles 30–35, for discussion of the relation between body and soul, and the pineal gland as the seat of the soul. All texts are included in Cottingham et al., *Philosophical Writings*.

43 See Schmaltz, "The Early Dutch Reception," 45 and 72–90, for discussion of Regius's mechanistic model and his differences with Descartes.

44 See Delphine Bellis, "Empiricism without Metaphysics," in *Cartesian Empiricisms*, Dobre and Nyden, 151–183, for an excellent account of how Regius learnt from Descartes but developed an independent theory of knowledge that denied Descartes's notion of God-given innate ideas.

45 Verbeek, *Descartes*, 17 and 32–33.

Since freedom of intellectual enquiry was only questioned if views contrary to Calvinism were publicly expressed, the hostile reception to Cartesianism seems excessive.[46] But a recent schism in the Public Church, which had started at Leiden University early in the century over different interpretations of the doctrine of pre-destination, had not healed.[47] Jacobus Arminius (1560–1609) and his followers, later called Remonstrants, argued for a moderate interpretation, and were expelled from the Church following the Synod of Dordrecht in 1618–19, bringing a strict orthodox group, "precijsians" like Voetius, to power. Remonstrants were imprisoned, exiled or simply dismissed—some finding positions in nearby Amsterdam, where the precijsians had less support.[48] The latter formed a militant minority within the Church, dedicated to protecting and furthering the Reformation in the face of this dangerous "revisionism." To complicate matters for the precijsians, many members of their own Church regretted the split and sympathised with the Remonstrants. Thus, a liberal, non-doctrinaire group of Calvinists, who were receptive to new ideas and wanted more freedom in expressing their faith, remained within the Public Church. Remonstrants and their sympathisers within the Church were prominent among Descartes's early supporters, and clustered in Amsterdam where they also controlled the City Council for most of Rembrandt's life. Many of his patrons, including Deyman, as we shall see, and Rembrandt himself, were either Remonstrants or liberal members of the Public Church.[49] This was the minefield into which Descartes stepped when his theories began to attract attention in the early 1640s.

46 See Israel, *The Dutch Republic*, 637–645, "The Limits of Tolerance." Support for the Orthodox was limited. They represented only approximately 30% of the population; Catholics varied from 20–30%; dissenting Protestants, mainly Mennonites, Pietists and others such as Jews made up the rest.

47 See Verbeek, *Descartes*, 1–12.

48 The headmaster of Rembrandt's school, Hendrick Zwaedercroon, soon to marry Rembrandt's sister, resigned in protest; leading Remonstrant scholars, the poet Caspar Barlaeus and the historian of religion, Isaac Vossius, subsequently became founding Professors at the Amsterdam Athenaeum, one of several new pre-university city colleges in the Republic, founded in 1632. See Dirk van Miert, *Humanism in an Age of Science: The Amsterdam Athenaeum in The Golden Age, 1632–1704* (Leiden and Boston: Brill, 2009), 45–67 and 331–334, on the Remonstrants, who became so numerous and politically influential in Amsterdam that they were able to establish their own Seminary.

49 See Schwartz, *Rembrandt*, 132–142 and 146, for elucidation of the Remonstrant role in Amsterdam City politics. See van Miert, *Humanism*, 334, for details about Remonstrants interested in Descartes, especially Étienne De Courcelles, theologian at the Remonstrant Seminary, who is credited with the first Latin translation of Descartes's *Discours de la méthode* (1637).

The hostility of the Voetians was multifaceted.[50] Their main assault was on Descartes's challenge to the Aristotelian-Scholastic tradition, however, for this was just as divisive in Theology as in Theoretical Medicine and Philosophy. Doctrinaire theologians suspected that Descartes's view of the body as inert matter—stripped of the *anima* or soul with which Aristotle had endowed it— contradicted faith in the resurrection of the body and its ultimate reunification with the soul. And they thought Descartes's method of doubt would undermine the Scholastic view that natural Reason—rightly applied—always confirms the Truths of Revelation.[51] They feared an alliance between Cartesians and their old adversaries, the Remonstrants, who had rejected the doctrine of the resurrection of individual human bodies propounded by the Calvinist Church.

The second major battle broke out in Leiden over Descartes's method of doubt. In 1645 Heereboord attempted to teach the Cartesian method by getting students in Logic to dispute different positions on the relation between reason and revelation. He was attacked by the Voetian theologian, Jacobus Revius, Rector at the States College—also an influential preacher and poet—for supposedly promoting scepticism. The argument spread to Leiden University, where authorities considered banning Cartesianism altogether. De Raey intervened, arguing that Descartes's philosophy is compatible with some aspects of Aristotle and that all philosophers should be taught, without considering the theological implications. This was known as the "separation thesis."[52] But this "separation" was hardly reassuring for the Voetians. They insisted that Cartesian doubt was not just a method, and Revius wrote an anti-Cartesian tract, claiming that Cartesians doubted that "there are material bodies" and therefore that "Christ had a body and that he suffered."[53] This opposition persisted, increasing in the 1650s.

50 See Ernestine van der Wall, "The Religious Context of the Early Dutch Enlightenment: Moral Religion and Society," in *The Early Enlightenment in the Dutch Republic, 1650–1750*, ed. Wiep van Bunge (Leiden: Brill, 2003), 39–57. Der Wall explains that fundamental Christian definitions of the moral society were at issue, threatening the precijsians' control of social mores, the position of theology as superior to philosophy in the university and the precijsians long-held ambition to establish theocracy in the Dutch States.

51 The view that Descartes's method of doubt fostered scepticism and led to atheism was widespread; as was suspicion of his mind-body dualism. Goudriaan, *Descartes*, treats these objections as "transconfessional." For the Remonstrant rejection of the ultimate reunion of the individual body with the soul, see Verbeek, *Descartes*, 17, 55, and 71.

52 De Raey was following Descartes's own strategy in this; see Goudriaan, *Descartes*. See also Alexander Douglas, "Spinoza and the Dutch Cartesians on Philosophy and Theology," *Journal of the History of Philosophy* 51, no. 4 (2013): 567–588.

53 Jacobus Revius, *Methodi Cartesianae* (Leiden: P. Leffen, 1648), cited in Verbeek, *Descartes*, 50.

Liberal Calvinist theologians insisted that Descartes's systematic doubt was designed to answer scepticism, not encourage it. At Leiden, Heidanus wrote a tract defending Descartes against Revius. He was supported by distinguished Professor of Theology, Johannes Cocceius.[54] Cocceius was not a Cartesian, but like Heidanus wished to free theology to some extent from Aristotelian scholasticism and from doctrinaire interpretations of scripture.[55] For him, natural Reason was no threat to Revelation, but rather an essential tool for distinguishing between the Christian mysteries—the unquestionable truths of scripture—and merely historical or heuristic material in the Bible. His followers would later adapt Cartesian ideas directly. Revelation was a *fact* for them, but no particular interpretation of its *content* was authoritative. As Ernestine van der Wall elucidates, some Cocceians went on to argue for example, that: "We should not accept anything as true in theology before we conceive clearly and distinctly that it has been revealed by God."[56] The Voetians, who claimed such authority for the Public Church were predictably hostile but could not prevent the spread of this idea, which became the focus of religious debate in the Dutch Republic for the next thirty years.[57]

5 Deyman and His Intellectual Milieu

Interest in Cartesianism spread beyond the universities in the late 1640s, particularly among liberal Calvinists and Remonstrants, who constituted the intellectual and political elite. Many were members of a select circle of writers at Muider castle, near Amsterdam, the *Muiderkring*, often visited by

54 Cocceius, one of the most important religious thinkers of the seventeenth century, is credited with founding the first hermeneutic approach to Biblical scholarship, combining close comparative internal study of sacred texts with philological and historical analysis. His influence is still felt today, as in the work of Karl Barth.

55 Hans W. Frei, *The Eclipse of Biblical Narrative: A Study in Eighteenth and Nineteenth Century Hermeneutics* (New Haven: Yale University Press, 1974), 46–49.

56 See Ernestine van der Wall, "Cartesianism and Cocceianism: A Natural Alliance?," in *De l'humanisme aux Lumières, Bayle et le protestantisme. Mélanges en l'honneur d'Elisabeth Labrousse*, eds. Michelle Magdelaine et al. (Paris: Voltaire Foundation, 1996), 445–455, here 454. The followers of Cocceius included biblical historians, philologists and learned Christian Hebraists. Although they professed orthodox Reformed beliefs, early followers of Cocceius were millenarians, like the dissenting Protestants, awaiting the Second Coming in the 1650s.

57 It took the Voetians until 1676 to finally ban both Cartesianism and Cocceianism, following the collapse of the liberal consensus in the major cities, due to military invasion by the French, which brought the Stadholder, William III, who supported the Orthodox Calvinists, to power. See McGahagan, *Cartesianism*, 321–338.

Descartes's supporter, Constantyn Huygens. Tulp, Remonstrant historian and poet, Caspar Barlaeus, humanist scholar and dramatist, Jan Six, and poet, Jeremias De Decker, all close to Rembrandt at different points in his life, also belonged.[58] The same names appear in another elite circle, at the Amsterdam theatre.[59] This was Deyman's milieu. As the son of a high-ranking naval officer, he belonged to the regent class; he was a liberal, not a strict Calvinist, married to Maria Bas from a prominent Remonstrant family.[60] He had close social ties to both Tulp and Jan Six.[61] He was considered a "learned man," having studied first at Leiden and then completed his medical PhD at Angers in 1642.[62] He was the protégé of Dr Samuel Coster, Head Physician at St Pieter's Hospital, Amsterdam, succeeding him in 1653, the same year he replaced Tulp as Praelector of Anatomy and became Inspector for the Amsterdam College of Medicine.[63] Coster, a poet-playwright, was involved in both the Amsterdam Theatre and the *Muiderkring*. Through his relations with Coster, Tulp, and Six, whose library contained Descartes's works, Deyman would have been well aware of the intellectual interests of both groups. By the mid-1650s members of this elite intellectual network would also have known the work of Huygens's son Christiaan, a brilliant Cartesian mathematician and astronomer.[64] Descartes's mechanistic physics and his physiology had received wide exposure by this time. Deyman's choice of a brain anatomy for his Lesson almost certainly reflects intense interest in Descartes's view of the pineal gland as the only interface between mental and physical functions. Though Deyman's views are not known, there is indirect evidence of his sympathy for Cartesian physiology in the Dedication

58 See Hans Kauffmann, "Rembrandt und die Humanisten vom Muiderkring," *Jahrbuch der Preußischen Kunstsammlungen* 41 (1920): 46–81.

59 See Schwartz, *Rembrandt*, 261, on this group, which called itself the "Brotherhood of Painters," or "The Union of Apollo and Apelles."

60 See Deijman, Jan, #452 and Bas, Claes, #150, "The Montias Database of 17th Century Dutch Art Inventories," The Frick Collection. www.research.frick/org/montias/browserecord.php.

61 Tulp's daughter married Six in 1653 and Deyman's daughter would marry Six's nephew a generation later.

62 B.W.Th. Nuijens, "Het ontleedkundig onderwijs en de geschilderde anatomische lessen van het Chirurgijns Gilde te Amsterdam, in de jaren 1550 tot 1798," in *Jaarverslag von het Koninklijk Oudheidkundig Genootschap te Amsterdam, 70* (1928): 45–90, https://www.dbnl.org/tekst/_jaa017192801_01/. Anniversary Lecture at the Seventeenth General Meeting of the Amsterdam Surgeons' Guild. See also Lindeboom, *Dutch Medical Biography*, entry on Deyman, Johannes.

63 See Lindeboom, *Dutch Medical Biography*, 438.

64 See Israel, *The Dutch Republic*, 903: "Christiaan Huygens (1629–95) pursued a comprehensive approach to physics, mathematics and technology, based on the Cartesian tradition, seeking the mechanistic principles which lay behind the visible world." He developed a giant telescope that enabled him to observe the rings of Saturn in 1655.

of a book by Gerardus Blasius in 1666, *Anatome Contracta.*[65] Deyman is linked with the renowned German iatrochemist and anatomist, Franciscus Sylvius dele Boë, who conducted brain anatomies at Leiden, and generally supported Harvey's and Descartes's theories; the others mentioned are Regius (discussed above), and Florentius Schuyl, Professor of Medicine at Leiden and author of the first Latin translation of Descartes's *Treatise on Man* (1662).[66]

Rembrandt's most important patron at this time was the scholar-poet, Jan Six.[67] Six had political ambitions and like Deyman was dependent on Burgomaster Tulp's favour. This triumvirate was probably behind the choice of Rembrandt to paint the second Anatomy Lesson.[68] By choosing to present himself exploring the brain in his inaugural Anatomy Lesson, Deyman must have been aware that this would align him publicly with natural philosophers who supported Cartesian physiology, like Regius and Sylvius; by *replacing* Death in the image inspired by the title page of Vesalius's Fabrica, he may have been hinting that, like Descartes, he believed medicine could defer death.[69] Death is present in the image far more graphically than in any traditional *memento mori*, however, and the moral is difficult to discern: should viewers see themselves in the condemned thief who was perhaps beyond salvation or identify with the Christ, half-hidden in the corpse, who promises redemption?

6 Cultural Effects

We can locate the intersection of scientific and religious thought mid-century here. Cartesian natural philosophers around Heereboord and De Raey and theologians led by Heidanus and Cocceius at Leiden University had agreed to the official separation of their disciplines. They would address different aspects of Descartes's thought, following his suggestion that reason and faith should

65 See Schupbach, *Paradox*, 81.

66 See Lindeboom, *Dutch Medical Biography*, alphabetical entries, for details on the work of these scientists. Blasius was influential in the 1660s, after becoming the first Professor of Medicine at the Amsterdam Athenaeum and founding a group dedicated to the study of comparative anatomy, the *Collegium privatum Amstelodamense*, which included Jan Swammerdam, famous for his observations on insect physiology, using a microscope.

67 Rembrandt illustrated Six's play, *Medea*, and made a portrait etching of him in 1647 and a major oil painting in 1654 which were widely admired. Rembrandt's failure to repay a loan Six had guaranteed led to their estrangement in 1656.

68 Schwartz, *Rembrandt*, 280.

69 This aspiration was not the commonplace of medical ethics then that it has since become. See Lindeboom, *Descartes and Medicine*, 97–100. In fact, Descartes's critics considered it a sign of his ungodly hubris.

be considered separately because they sought different truths. It was not so simple, however. Even liberal-minded Calvinist theologians were uncertain about which passages in the Bible could bear reinterpretation without threatening Revelation. Perhaps passages that assumed the sun circled the earth, and were therefore a stumbling block for the modern Copernican view, could be treated as metaphoric? A door had been opened, which within ten years would embolden some thinkers to make Philosophy the judge of the truth of Scripture.[70] This was a step too far for Cartesian theologians in the 1650s, but the implications of the new biblical hermeneutics were grasped by intellectuals outside the universities and entered the public arena in the mid-1650s, thanks primarily to a series of pamphlets written by Leiden physician, former student of Regius, Lambertus van Velthuysen (1622–1685), who was active in City politics, sympathetic to religious dissenters, and intent on containing the influence of the doctrinaire Voetians. His skill in biblical exegesis enabled him to defend Copernicanism from a strictly Calvinist viewpoint. According to van Bunge, "Velthuysen compared the Cartesian revolution to the Reformation."[71] The controversy aroused widespread public anxiety. Could there be conflict after all between the lights of Reason and Revelation in interpreting scripture? Even ecclesiastical Cartesians themselves could not be sure that doubt clarified these lights, rather than clouding them?

Descartes's ideas spread quickly, particularly his explanation of how the incorporeal mind communicates with the corporeal body via the pineal gland, making it the seat of the immortal soul.[72] But even supporters, like the intellectually gifted young Princess Elizabeth of Bohemia, found his relegation of the human body to the same status as animal bodies alarming: In what sense, she asked, does the soul inhabit this body? In their correspondence Descartes sought to assure her that as long as we are alive, the rational soul is "in" our bodies, responding to its passions and causing its reactions, though this "union" is inexplicable.[73] In 1646 he gave her a small treatise on the question, which he later developed into *The Passions of the Soul*.[74]

70 Lodewijk Meyer, a radical follower of Descartes argued that philosophers should apply the method of doubt to judge the Bible. His *Philosophia Sacrae Scripturae Interpres* [Philosophy the Interpreter of Holy Scripture] (1666), prepared the way for Spinoza's rationalist deism and was so radical it even scandalised most followers of Descartes in the Dutch Republic. See van Miert, *Humanism*, 96.

71 See van Bunge, *From Stevin to Spinoza*, 78.

72 See Descartes, "The Passions of the Soul," in *Philosophical Writings*, Cottingham et al., Article 32, 140.

73 For a summary of this correspondence see Translator's Preface in *Philosophical Writings*, Cottingham et al., 325.

74 Princess Elizabeth was the daughter of King Frederick V of Bohemia, who had lost his royal seat in the Palatinate thanks to the Thirty Years' War and was living in The Hague

Independent religious thinkers, like the poet Jeremias De Decker,[75]—close to Rembrandt from the late 1630s—also expressed anxiety. His view of Cartesian dualism is not known, but he did express concern about new ideas that made faith depend on reason, and as a member of the *Muiderkring* where Descartes was discussed, must have known that Descartes said: "The seat of the passions is not in the heart."[76] He was troubled about the implications of rationalism for Christian belief in the ethical value of love. If feeling, like sensation, is first transmitted to the brain, before it can be mentally interpreted and affect the soul, its direct connection with the heart gone, how then is love "felt," how are we "moved" to seek Christ in ourselves and others and in the scriptures?[77] Calvinists, particularly those who looked to St Paul for inspiration, believed that the truths of the Bible must be approached in the spirit of love of Christ. Reason is not enough. Ecclesiastical Cartesianism seemed to be offering greater freedom in interpreting the Bible, which was welcome, but there was also a sense of loss. In his 1650 book of epigrams De Decker wrote:

> Love now consists in word and not in deed,
> Faith depends on reason, not on the Scriptures, as it used to be;
> Religion has ascended from the heart to the head.
> It now dwells in the brains, and the heart, alas, is empty![78]

Identification with the body of Christ was the basis of Christian love. The sacrament of the Eucharist represented this mysterious union.[79] Believers felt a

as a guest of Prince Frederik Hendrik. She confided in Descartes about her sadness. He counselled her to use her reason to dispel melancholy thoughts and seems to have succeeded. Despite his dualism, Descartes believed in the psychosomatic interaction of mind and body and in the therapeutic power of reason. See Lindeboom, *Descartes and Medicine*, 91–92. See also Sepper, *Understanding Imagination*, 321–322, for Descartes's correspondence with Elizabeth about *The Passions of the Soul*.

75 See Schwartz, *Rembrandt*, 340–343, for a discussion of De Decker's religious affiliations and his longstanding relationship with Rembrandt.

76 See "The Seat of the Passion is not in the Heart," in *Philosophical Writings*, Cottingham et al., Article 33, 340.

77 See Willem Adolph Visser t'Hooft, *Rembrandt and the Gospel*, trans. K. Gregor Smith (London: SCM Press, 1957), 41.

78 Epigram 153 in "Tweede Boek der Punkdichten," republished in a collection, *Alle de rym-oeffeningen van Jeremias De Decker*, by Willem Barents in 1726, cited in Visser t'Hooft, *Rembrandt l*, 99 and 143.

79 See Harry Redner, *A New Science of Representation: Towards an Integrated Theory of Representation in Science, Politics and Art* (Boulder: Westview Press, 1994), 231. Redner defines the differences between the various Protestant and the Roman Catholic views of how the sacrament of the Eucharist enables spiritual union with the Body of Christ. The Calvinist version is relevant to discussion of the "heart": "For Calvin, the partaker's share, which he

personal bond with Christ in his suffering on the Cross, which was experienced empathically as physical. Like the English metaphysicals, Dutch religious poets at this time focused on the Passion to express this personal spiritual and physical bond with Christ.[80] For this reason, objections to Descartes that raised doubts about this bond by clerics like Jacobus Revius were effective. With his furious assertion that since the *human body* was not real for Descartes, neither was *the body of Christ*, Revius tapped into deep unease about Cartesian dualism.[81] Furthermore, Revius wrote powerful poetry. Crucifixion poems like "He bore our Grief," which express guilt-stricken identification with the body of Christ in His agony as proof of a capacity for Christian love, were widely admired.[82] Christian thinkers understandably wondered how in Descartes's scheme there could be any resurrection after death for the defunct (soulless) body.[83] They might not have drawn Revius's conclusion that Cartesians denied that the body of Christ too was immortal, but Revius had pinpointed a difficulty. How could Christians identify spiritually with Christ incarnate if there was no likeness between their bodies and His?[84] How indeed was the spiritual bond with Him to be imagined, if the soul's only physical correlate was a gland in the brain?[85]

calls "Christ in us" is indispensable, for it is the Holy Spirit alone that is the active force securing entry of the sacrament into the soul."

80 Constantyn Huygens's Good Friday poems can be compared with those of John Donne. De Decker's work is in the same tradition. See Rosalie Colie, "Constantijn Huygens and the Metaphysical Mode," *The Germanic Review* 34 (1959): 59–73.

81 See Verbeek, *Descartes*, 50; Visser t'Hooft, *Rembrandt*, 27.

82 See Perlove and Silver, *Rembrandt's Faith*, 293, for the text of this poem and samples of other Passion poetry, including De Decker's "Good Friday," written in the first person and expressing complete identification with Christ on the Cross. De Decker's poems were published, together with those of Huygens in a 1651 collection, *Verscheyde Nederduytsche Gedichten,* edited by the Remonstrant, Gerardus Brandt.

83 See Verbeek, *Descartes*, 50, commenting on Revius's anti-Cartesian tract, *Consideratio*, of 1648.

84 See Louis Berkhof, *Systematic Theology* (Grand Rapids: Eardmans, 1996), 204. Theologians generally agreed that mankind had not lost the gifts of intellectual power and moral freedom at the Fall, just the wisdom and holiness that these gifts should have conferred. Protestants identified these lost gifts with Christ, through whom they would be restored to us. Human beings who display wisdom and holiness in their lives thus reflect the *imago Christi* and in this recover their full participation in the image of God.

85 The use of the empathic imagination was fostered by Pauline Calvinism, which saw it as both positive, in promoting identification with and love for the body of Christ, but also negative if it fed into illicit thoughts and desires. See Fliethmann, "Pathologies of Imagination" (this volume) for insight into the complex historical process through which early modern understandings of the positive and negative uses of the imagination became available in medical discourses and diagnoses of aberrant mental ideas.

There were no ready answers. This, I suggest, is why the untroubled Christian-Aristotelian dualism of the Tulp painting is no longer evident in the later Anatomy Lesson. Rembrandt now shows us a set of disturbing ambiguities. We see the brain, but where is the mind, how does it relate to the body laid out before us; why are the bodies of anatomist and corpse conjoined; does the condemned criminal's likeness to Christ suggest or deny the promise of human immortality?

All these anxious questions about the significance of the body of Christ and the truth of scriptural Revelation were gathered up and carried forward by another religious question in the 1650s: would the prophecy of the Second Coming of Christ, set for 1656, be fulfilled? These hopes for the millennium were not restricted to dissenting Protestant groups, who were castigated as "enthusiasts" by the Voetians.[86] Liberal Calvinists like Cocceius also believed a new and final stage in Christian history was about to dawn and that Christ would again be present among the faithful.[87] This cultural anxiety—about how our (now possibly soulless) medical bodies relate to the *corpus Christi*, about whether Reason really supports Revelation, and about the nature of the coming millennium—can, I believe, be discerned in Rembrandt's second Anatomy Lesson.

7 Rembrandt's View

Rembrandt made a sketch of the whole composition for his framer and this is helpful, but the missing faces make interpretation of the painting particularly difficult.[88]

Fortunately, there is a wealth of scholarship on the Christological aspect of Rembrandt's late religious art that can be used to interpret this damaged masterpiece. Etchings completed between 1653 and 1654, for instance, beginning with the "Presentation in the Temple in the Dark Manner" and culminating in "The Three Crosses" reveal a new philosemitic perspective in Rembrandt's reading of the Christian story.[89] We know that Rembrandt was strongly

86　See Fix, *Prophesy and Reason*.

87　See W. J. van Asselt, "The Doctrine of the Abrogations in the Federal Theology of Johannes Cocceius (1603–1669)," *Calvin Theological Journal* 29 (1994): 101–116.

88　See Middelkoop et al., *Rembrandt under the Scalpel*, 21–27, for a helpful reconstruction of the damaged Deyman painting, which the author developed with Thijs Wolzak. They use heads from well-known portraits by Rembrandt to fill in the missing heads of the surgeons viewing the lesson.

89　Michael Zell, *Reframing Rembrandt: Jews and the Christian Image in Seventeenth-Century Amsterdam* (Berkeley, Los Angeles and London: University of California Press, 2002). See

FIGURE 1.7 Rembrandt van Rijn, "Sketch of the Anatomy Lesson of Dr. Deyman," ca. 1656,
 pen, pencil and ink, Amsterdam Museum, Amsterdam
 SOURCE: AMSTERDAM MUSEUM (CC PD)

influenced by intense discussion about the Second Coming among those close
to him, in particular his Jewish patron, Menasseh Ben Israel, whose millenar-
ian text, *Piedra Gloriosa*, he illustrated at the same time as completing the etch-
ings. It is also generally agreed that although Rembrandt's interpretations of
key scenes from scripture became increasingly individual, he never stepped
outside the main Calvinist tradition, and like Calvin was preoccupied with
the question of how Old Testament prophecies are fulfilled in the New Tes-
tament. Though scholars who argue for the influence of philosemitism have
not considered the Deyman Anatomy Lesson in this context, I believe their
findings can be fruitfully applied to this painting. The 1653–54 etchings are par-
ticularly relevant, as well as two major paintings: "Jacob Blessing the Sons of
Joseph" (1656), and "The Return of the Prodigal Son" (1668). Cross-comparison
of these works enables one to glimpse Rembrandt's personal Christological

also Perlove and Silver, *Rembrandt's Faith*, 61–67, for evidence of Rembrandt's philosemi-
tic orientation in the 1650s.

iconography. Before discussing the painting in detail, I will draw some of the separate historical threads together.

This was 1656, the year the Dutch Cartesians' "separation thesis" met its first great challenge. Cartesian philosophers and theologians at Leiden University had succeeded in separating their disciplines, making "reason" the preserve of the one and "faith" the preserve of the other, without specifying which questions fell into each category, to allow for some flexibility in the use of reason. But the Voetians, aghast at the Cocceians and Cartesians' support for Copernicanism, manoeuvred the States into issuing a Decree that specified what questions could be studied in each faculty and banning the philosophy of Descartes "for the sake of peace."[90] The arguments leading up to this declaration were known to all city councils, so had wide public exposure. Deyman and Rembrandt would already have been aware of Descartes's theories through the associations outlined above, but this surprising setback for the Cartesians would have focused their attention on the issue. It is reasonable therefore to read the painting as a comment on the separation thesis.

There are two perspectives in the painting, one physiological, the other metaphysical, in keeping with this separation between reason and faith: Deyman and the surgeons look from the top down, either directly at the exposed brain or straight out at us; we look from the bottom up, at the feet and gaping hole in the belly of the executed criminal, Joris Fonteyn, then at his face hanging beneath the brain—and barely visible to those present, because of the angle of the head. Some scholars find irony here, as if Rembrandt is implying that Deyman is "blind."[91] But there is no suggestion of irony in Rembrandt's presentation of Deyman: the anatomist's figure is calm, dignified, and reverential, his hands are gentle. Totally engrossed in the lesson on the brain, Deyman seems to be guided by the light of Reason, confident that his work serves God's purposes in uncovering Truth in the natural world. He could be seen as quite properly respecting the limits of Reason, while taking Faith for granted—and thus as a fine example of the value of "separating" natural philosophy from theology—which meant *in effect* focusing on Cartesian mathematical physics and mechanistic physiology and leaving the metaphysics to the theologians, in line with the alternative approaches of Descartes's Dutch followers from Regius to Heidanus.

But 1656 was not a good year to take Faith for granted. Jewish and Christian millenarians were expecting the immediate dawn of a new religious age

90 See McGahagan, *Cartesianism*, 274–303; Israel, *The Dutch Republic*, 892–893; Verbeek, *Descartes*, 89.

91 Sawday, *The Body Emblazoned*, 149–156, discusses this "ironic" interpretation, but does not adopt it.

when they would unite in establishing a just world. In *Piedra Gloriosa* (1655), Menasseh Ben Israel had explained Jewish belief in the Messiah to Christians, according to which He is always with us though we may fail to recognise Him.[92] For Christians generally, Faith meant belief in the presence of Christ, in the world, here and now, but for devout Calvinists this was fraught with difficulty, as they followed St Paul in accepting that Christ's presence was always partly hidden thanks to the Fall. The Elect might glimpse Him, but there would be a test of recognition to pass,[93] as there was for the apostles after the Resurrection, depicted by Rembrandt in no less than nine versions of "The Supper at Emmaus."[94] Believers sought confirmation in Scripture, scrutinising passages in both Old and New Testament that promised His Coming, hoping for a share in the light of Revelation.

Rembrandt's late works focus on the messianic promise in the Scriptures and express his personal sense of urgency about the question of how the hidden Christ is to be "seen." Would the moment be private, as for Simeon in the 1654 etching, "Presentation in the Temple in the Dark Manner"?[95]

In the spirit of St Paul, Rembrandt rejects overconfidence in election: "seeing" requires a change of heart. This conviction is most powerfully expressed in his progressively darkening series of apocalyptic etchings, the *Three Crosses*; in the final state the darkness that shrouds the scene is so deep that the terrified onlookers fleeing the cataclysm disappear into it and the unrepentant thief is obliterated.[96] A single great shaft of heavenly light tears the veil, allowing a glimpse of the good thief and the awestruck, still figure of the centurion on horseback, just before his moment of conversion. But only Christ is fully illuminated—forcing viewers to dwell on his physical state, his suffering

92　　Jews were looking specifically for signs that they would be welcome everywhere—and in 1655 Menasseh left for England to secure Cromwell's support for a new law permitting Jews, expelled in the thirteenth century, to return, but the English Parliament rejected it. Exhausted and deeply disappointed, Menasseh died soon after returning to Holland.

93　　I am indebted to David Roberts, "Imago Dei" (unpublished paper), for its discussion of the "presence" versus "absence" dialectic as integral to Christian theology. I suggest above that it is at its most acute as a contradiction in Calvinist theology, because the body of Christ is only ever "present" for the Elect.

94　　See Visser t'Hooft, *Rembrandt*, 144, who links Rembrandt's last version, "Christ at Emmaus" (1661), with words from the Gospel of St Luke: "It is all silence, but in this silence the truly decisive thing happens: 'And their eyes were opened and they knew him' (24.31)."

95　　Zell, *Reframing*. A whole chapter is devoted to this etching; see 99–103.

96　　Rembrandt brought printing techniques to a new level of perfection in this series. His control of shades of darkness permitted differentiation of spiritual states. See Fliethmann, "Pathologies of Imagination" (this volume), for discussion of printing as a cultural medium in medical illustration. It was just as important in the fine arts.

FIGURE 1.8
Rembrandt van Rijn, "Presentation in the Temple in the Dark Manner," 1654, etching, Dionísio Pinheiro and Alice Cardoso Pinheiro Foundation
SOURCE: COMMONS. WIKIMEDIA

body. To truly see *this* is to experience revelation. Rembrandt's contemporaries saw these etchings as profound statements of faith in the central mystery of salvation. One of the most admired responses was from Jeremias De Decker, in his poem "Good Friday," published in 1656. It calls for close personal involvement with the face and figure of Christ and promises that those who are not "blind through envy or lack of faith would see more shine forth from him than human frailty."[97]

The question of the moment was the one that ecclesiastical Cartesians and Cocceians were intent on answering: Does the light of Reason illuminate or obscure the light of Revelation? Deyman, representing Reason, is treated respectfully. Comparison with related paintings suggests why Rembrandt joins the figures of anatomist and corpse. Deyman's hands, hovering delicately above the head of the corpse as he probes the brain, appear beneficent, not just precise. The right hand could even be performing a paternal blessing, like that of Jacob hovering over the head of Ephraim as he blesses the sons of Joseph in the great painting of the same year. This feature is also reminiscent of the father-son dyad in "The Return of the Prodigal Son," in which the father's hands soothe and bless the son kneeling before him. The soles of the son's feet

97 Visser t'Hooft, *Rembrandt*, 39.

FIGURE 1.9
Rembrandt van Rijn, "The
Return of the Prodigal Son,"
ca. 1668, oil on canvas, The
Hermitage, Saint Petersburg
SOURCE: COMMONS.
WIKIMEDIA

are exposed at the front edge of the picture plane, conveying his vulnerability, like those of the corpse in the Deyman Lesson.

The paternal doctor rising up behind the prostrate man in the Anatomy dyad is more powerful: he represents the secular Law that has condemned the criminal, but there is also an inescapable suggestion of religious law. The dark upright form of Deyman, dominating the centre of the composition is reminiscent of the Jewish temple guardian in the "Presentation in the Temple, in the Dark Manner." I see the Deyman figure, therefore, as standing somewhere between these two extremes: between the forbidding Old Testament high priest and the compassionate father of the New Testament parable. The implicit comparison makes the explicit contrast all the more shocking. If the doctor is a figure of paternal authority, he is complicit in the punishment of this erring son.

Comparison with the "Return of the Prodigal Son" also provides insight into the figure of the assistant Calkoen. Rembrandt uses the profile in his late religious art to suggest distance, typically expressing inward reflection.[98] But

98 Clark, *Rembrandt*, 168.

the profile can also suggest coldness, particularly when the figure stands at a physical distance from those at the affective centre of the scene. The jealous brother in "The Prodigal Son" is such a figure. And Calkoen, too, in semi-profile, is a disturbing element. Gazing at the exposed brain, he exudes calm self-confidence through the *sprezzatura* nonchalance of his pose, right hand on hip, as he holds the empty skull pan with his left. The contrast with the weeping faces of the women, pressed close to the body of Christ in Mantegna's "Lamentation" is striking. Calkoen's gaze returns the viewer to the corpse with a sense of dismay. From where the assistant stands, he may be able to see the eviscerated body as well as the brain, but he is definitely not looking at the *face* of the dead man. But Rembrandt positions us, the viewers, so that we look straight at it: floating darkly above the body, it is where our gaze comes to rest.[99]

Is this the face of Christ? It is more realistic than the stylised Christ-face in Mantegna's painting, despite the fact that what looks like long hair framing Fonteyn's face is actually the folded skin of his scalp. The torso is also more reminiscent of late Renaissance's more realistic treatments of Christ's upper body than of Mantegna's. Though the criminal's hands are alarmingly large—an effect of the foreshortening but also a reminder of his violent history—his handsome shoulders could have been painted by Titian, Tintoretto, or Veronese, the latter's "Christ Crowned with Thorns" (1582–85), for example, with its gold flesh tones and darkly suffering face.[100] But what the face resembles more is Rembrandt's own study (ca. 1650), a head simply called "Christ."[101]

No crown of thorns, no wounds on hands or feet, Rembrandt does not declare this anatomy subject *is* Christ, which would smack of blasphemy; rather he asks us to see Christ *in* the condemned sinner and to grasp that this means his soul may have been saved. So, the image is ambiguous: this is and is not Christ. And for the viewer the ambiguity is painful, especially as the Calkoen figure displays apparent indifference. To view the painting is to experience doubt. Is

99 Rembrandt's use of perspective to exactly position his viewer is one of his most remarkable techniques for guiding our interpretation of a scene. In "Jacob Blessing the Sons of Joseph," for example, he brings us close to the side of Jacob in his bed, so we share in the intimacy of this moment of loving familial harmony, unspoilt by Jacob's unexpected preference for the younger son Ephraim over the older son Manasseh. See Perlove and Silver, *Rembrandt's Faith*, 103.

100 See David Rosand, "Titian's Dutch Disciple," in *Rembrandt and the Venetian Influence*, eds. Kenneth Clark, Frederick Ilchman and David Rosand (New York: Salander-O'Reilly Galleries, 2000), 9–22.

101 See Arthur K. Wheelock Jnr, with Peter C. Sutton, *Rembrandt's Late Religious Portraits* (Chicago: University of Chicago Press, 2005), 91. This is one of a series of heads of Christ, painted between 1645 and 1655. See also Schwartz, *Rembrandt*, 284.

FIGURE 1.10
Rembrandt van Rijn, "Head
of Christ," ca. 1650, oil on oak
panel, Philadelphia Museum of
Art, Philadelphia
SOURCE: COMMONS.
WIKIMEDIA

it purely religious doubt, in contrast with supposed scientific certainty? Doubt, under the influence of Descartes, had become central to scientific enquiry, and was an active process, a method of self-critical reasoning. Calkoen cannot be seen as representative of the thinker. By comparison with the deeply meditative gaze of the philosopher in Rembrandt's "Aristotle Contemplating a Bust of Homer" (1653), for example, Calkoen's expression is unreflective. He is attentive but passive, a mere observer in contrast to Deyman who commands the investigation. But he can perhaps be seen as representative of anyone who is unable to *feel*, and therefore to *see*, Christ. Rembrandt's use of the compositional device of the dyad invites us furthermore to consider the implications of Deyman's stance—not Calkoen's—for the questions of faith raised by the partly hidden, partly revealed presence of Christ in the body to which he is conjoined in the scene. Probing the brain—perhaps seeking the pineal gland, then so controversial because of Descartes's claim that it was the seat of the soul—Deyman is unable to see the Christ-like face beneath his hands. The scientific quest is not irreligious; quite the contrary, it serves God's purposes. But Rembrandt is showing us that natural reason does not of itself yield revelation: the two lights are distinct. At the same time, he is acknowledging that the anatomist, respectfully intent on his study of human nature, may unwittingly reveal Christ's presence in another human being.

At this point the divergent perspectives of Reason and Faith begin subtly to merge. Like his friend De Decker, Rembrandt refuses to separate thinking from feeling, clearly believing that compassion is the key to religious vision. Standing with him at the foot of the anatomy table, as if below the bier on which the dead Christ lies, we are literally at the cadaver's feet. Rembrandt challenges us to think about what we see, ask ourselves "What if this were Christ: would we recognise Him?" St Paul warns that Christ will appear under a veil, in the "humble form of the flesh": Christ's incarnation is itself a veil (Isaiah, IV). Perhaps sin and shame too are veils.[102] After all, Christ was a condemned and executed criminal. Just as De Decker asks the readers of his Good Friday poem to see more in Christ crucified than "human frailty," Rembrandt asks his viewers here to see more than frailty in Joris Fonteyn. His face—thrust forward on a neck broken by the hangman—seems to float unsupported beneath the anatomist's hands, a two-dimensional image printed on a black background, again a veil. The twisted mouth suggests suffering, averted eyes suggest shame, but the expression overall is inscrutable. Is Christ present or absent in this corpse?[103] The images provoke constant re-scrutiny, requiring us to reason *with* doubt, not against it. For Rembrandt, Revelation is in the eye of the thinking-feeling beholder.

As a whole, then, the painting holds out the possibility that Reason can both expose human nature to new forms of scrutiny in the process of scientific investigation and also assist those seeking Revelation to find Christ in challenging situations. Both the Cartesian natural philosopher studying the brain and the believer striving to see Christ reappear in the darkness of this historic moment could use Reason constructively. Their perspectives were different but compatible. By accepting Cartesian doubt as a method of profound meditation on faith, ecclesiastical Cartesians were cooperating with Cocceians in giving Reason a greater role in interpreting Scripture. Among them were millenarians who may, like Rembrandt, have felt that the darkness of the present time was a necessary condition for the emergence of a new age. The challenge was to discern the *imago Christi*, not in oneself, but in other human beings. The moment was short-lived. Millennial hopes would fade by the end of the 1660s and in the next decade—following the collapse of the liberal consensus on which the Dutch Golden Age was founded—theological struggles over Cartesianism would intensify.

102 See Baldwin, "On Earth we are Beggars."

103 Roberts, "Imago Dei" (unpublished paper), interprets the relation between Rembrandt's two Anatomy Lessons in the light of this dialectic of presence and absence.

This opposition delayed, but could not prevent, cultural absorption of Cartesian concepts in medical and theological discourses. In exploring how Rembrandt and his patron Dr Deyman responded to the controversy that by 1650 had become "a major issue in high culture,"[104] I have attempted to show that only by looking closely at the impact of Descartes's ideas at key moments in their reception is it possible to see how they were interpreted—accepted, criticised, and adapted—in culturally significant ways. These ranged from acceptance of the mechanistic model in physiology by medical theorists who rejected Cartesian metaphysics, to selective adaptation of the metaphysics by theologians who were questioning traditional conceptions of the relation between Reason and Revelation. Institutions—the universities, the Dutch Calvinist Church and its Remonstrant dissenters—were involved in the process of mediation. But so were the traditional visual arts, not least in the work of the greatest painter of the period, Rembrandt, who was able to bring some of the most urgent religious and scientific questions of the time into sharp focus in the Anatomy Lesson of Dr Johannes Deyman.

104 See Israel, *The Dutch Republic*, 586.

Pathologies of Imagination and Medical Visual Culture in Early Modern Europe

Axel Fliethmann

1 Introduction

Aesthetic theories around 1800 have overwhelmingly coined our modern understanding of imagination as being essential to the human condition.[1] We since seem to have brushed aside any theological prejudice of pre-modern eras towards imagination, which, with few exceptions, had viewed imagination as a passive and negative force for spiritual seduction and moral aberration. And within this master narrative, early modern medicine has featured mostly as a special case, focusing in particular on the "monstrous" female imagination.[2] However, at the same time the medical discourse addresses "monstrous" female imagination, we also find that imagination has been gradually given more general consideration in intellectual deliberations, starting noticeably in

1 Imagination at this time was established as a positive, productive, individual, and mostly artistic creativity. And there is no denying the pivotal role Immanuel Kant's *Critique of Judgement* (1790) played, as Dennis Sepper pointed out in his comprehensive history on imagination viewed from a philosophical perspective: "In the Western conceptual topology of imagination, Kant is the first to systematically explicate imagination as essentially and fundamentally productive before it is reproductive" (Dennis L. Sepper, *Understanding Imagination. The Reason of Images* (Dordrecht: Springer, 2013), 371). See also Patrick Harpur, *The Philosophers' Secret Fire: A History of the Imagination* (London: Penguin, 2002); Joseph Anthony Mazzeo, ed. *Reason and the Imagination: Studies in the History of Ideas, 1600–1800* (New York: Columbia University Press, 1962); and Hans Dieter Huber, "Bildhafte Vorstellungen. Eine Begriffskartographie der Phantasie," in *Visuelle Netze. Wissensräume in der Kunst,* eds. Hans Dieter Huber, Bettina Lockemann and Michael Scheibel (Ostfildern-Ruit: Hatje Cantz, 2001), 165–216. For the disciplinary history on imagination and poetics see Karlheinz Barck, *Poesie und Imagination. Studien zu ihrer Reflexionsgeschichte zwischen Aufklärung und Moderne* (Stuttgart and Weimar: Metzler, 1993); Silvio Vietta, *Literarische Phantasie: Theorie und Geschichte. Barock und Aufklärung* (Stuttgart: Metzler, 1986); and Dietmar Kamper, *Zur Geschichte der Einbildungskraft* (München: Carl Hanser, 1981).

2 For a very good overview of the history of imagination in the context of early modern medicine see Irmgard Müller and Daniela Watzke, "Gebrauch und Missbrauch der Einbildungskraft in der Medizin des 17. und 18. Jahrhunderts," in *Ordnungen des Imaginären. Theorien der Imagination in funktionsgeschichtlicher Sicht,* ed. Rudolf Behrens (Hamburg: Meiner, 2002), 89–115.

the humanist circle of neo-platonic thinkers around Marsilio Ficino in Florence at the end of the fifteenth century.

I will argue in the following that philosophical and aesthetic narratives about the history of imagination have mostly neglected to question the impact of visual technologies in shaping the concept. My contribution here forms part of a wider research project I am currently pursuing, which seeks to elucidate the intersections between visual culture, medical discourse, poetics, and philosophical aesthetics in the early modern period (1500–1750), with the aim of demonstrating how the concept of imagination has been circulated between, and rejected or adopted by, different discourses. Of particular interest to me here, in the longer term, is to fill a gap in current scholarship, which addresses the role of medicine and its visual culture, in particular debates about "pathologies of imagination"[3] in regard to philosophical and aesthetic conceptualisations of imagination. While fifteenth- and sixteenth-century poetics in Italy (Cristoforo Landino, Julius Scaliger), Germany (Konrad Celtis), England (Sir Philip Sidney) and France (Pierre de Ronsard, Joachim du Bellay) make no significant mention of imagination as a creative force outside its strict adherence to the *imitatio*-ideal, the picture changes slightly in the late sixteenth century. More dramatic shifts occur in the early seventeenth and again in the eighteenth century. And the questions I try to find answers to are, why, when, and particularly how did changes in the shaping of the concept of imagination occur?

The historical context, to which I refer here, roughly begins with Marsilio Ficino's influential *De Vita Libri Tres* (1497) and Gianfrancesco Pico della Mirandola's ambivalent and inaugural monograph on the topic, *De Imaginatio* (1501), to Thomas Fienus's *De Viribus Imaginationis Tractatus* (1608), Robert Burton's *The Anatomy of Melancholy* (1621), and Nicolas Malebranche's *De la*

3 A case in point here is the erudite work Daston and Park have written about the widespread debates on "wonders" from the Middle Ages to the Enlightenment. As erudite as their approach to the topic is, when discussing the concept of imagination Daston and Park only follow the well-established *topos* of "the artist's fantasia as a creative power that imitated or even rivalled that of God." This commonplace in scholarship about sixteenth-century poetics is often relied on with little reference undertaken in regard to primary sources; see Lorraine Daston and Katharine Park, *Wonders and the Order of Nature 1150–1750* (New York: Zone Books, 2001), here 210–212.

For a focus on the modern period cf. James Phillips and James Morley, eds. *Imagination and Its Pathologies* (Cambridge and London: MIT Press, 2003). I use the term "pathologies of imagination," which seems to embrace more accurately what the medical discourse at the time considered as mental disorders such as *phrenitis, mania, dementia, furia*, and *melancholia*. The best historical overview is still provided by Michael Kutzer, *Anatomie des Wahnsinns. Geisteskrankheit im medizinischen Denken der frühen Neuzeit und die Anfänge der pathologischen Anatomie* (Hürtgenwald, Stuttgart: Guido Pressler, 1998).

recherche de la vérité (1674), and ends with the controversies between Daniel Turner (1714) and James Blondel (1729) about whether or not "pathologies of imagination" can be attributed to bodily functions alone, and Joseph Addison's seminal *The Pleasures of Imagination* (1711).

A project of this nature has to include several cross-disciplinary fields of knowledge,[4] and for that reason alone, this contribution needs to be programmatic in its approach. For my purpose here I have selected Felix Platter's *Observationes* (1614) and Girolamo Cardano's autobiography *De Vita Propria* (1576) as two telling examples of different medical approaches to describe pathologies of imagination, both in noticeable opposition to Christian dogma, both still focusing on the dangers of imagination. What interests me here in particular is whether or not we can read Platter's and Cardano's writings about imagination from a media philological[5] perspective. While Platter and Cardano themselves make no direct mention of material images as influential parameters for their descriptions of imagined pathologies, we can safely assume that material images had a fair influence on their understanding of how forms of imagination might function. Felix Platter, for example, one of the founders of pathological anatomy, had copied in his *De corporis humani structura et usu* (1583) the anatomical pictures from Vesalius's *De humani corporis fabrica libri septem* (1543). However, despite differences between his and Vesalius's usage of the images, Platter makes no direct reference to the debates about anatomical images in his *Observationes* (1614), which seem to account for pathologies of imagination as a strictly separate field of interest.[6] Cardano, on the other hand,

4 Of particular importance here are the debates on melancholia, enthusiasm, natural magic, and particularly debates on the demon/genius. In parts I can also rely here on my monograph *Texte über Bilder. Zur Gegenwart der Renaissance* (Freiburg: Rombach, 2014). The book pursued the text-image distinction as it has been played out rhetorically within the medium of texts across various fields in the early modern period. The book's theoretical framework tried a new approach in Visual Studies—media philology—to address today's role of philology in the context of a growing interest in visual media formats. The theoretical premises and beginnings of the work date back to the time when Belting, Bredekamp, and others had established "Bildwissenschaften" as a new paradigm in Visual Studies, which was mostly defined by perspectives derived from the discipline of art history. See, for example, Hans Belting, *Bild-Anthropologie. Entwürfe für eine Bildwissenschaft* (München: Fink, 2001); Horst Bredekamp, *Theorie des Bildakts. Frankfurter Adorno-Vorlesungen 2007* (Frankfurt/M: Suhrkamp, 2010); and Horst Bredekamp, Christiane Kruse and Pablo Schneider, eds. *Imagination und Repräsentation. Zwei Bildsphären der Frühen Neuzeit* (München: Fink, 2010).

5 Media philology is interested in accounting for the medium scholarship operates within when addressing "other" media in their research; see, for example, Axel Fliethmann, "Word and Image: Framing Philology," *Thesis Eleven: Critical Theory and Historical Sociology* 89 (2007): 43–57.

6 For the differences in the usage of images by Vesalius and Platter see Sachiko Kusukawa, *Picturing the Book of Nature. Image, Text, and Argument in Sixteenth-Century Human Anatomy and Medical Botany* (Chicago and London: University of Chicago Press, 2012), 241–247.

had seen some of Leonardo's anatomical sketches and praised them for their "beauty" but judged them harshly as "useless" for medical purposes.[7] While Platter appears to the reader as partly rejecting Vesalius's approach to the epistemological image and Cardano as ignoring Leonardo's approach entirely, I want to show that despite their opposing stances we could very well detect the impact of new visual technologies on their writings. For this purpose, I will later introduce Vesalius's and Leonardo's usage of epistemological images briefly as two opposing vantage points being pursued at the time.

Felix Platter's *Observationes* (1614) are widely accepted as introducing the first systematic approach to describing all forms of "mental illnesses" known at the time. Without resorting to a theological framework to explain them, the following case is presented to the reader: Ever since his childhood and for a good part of his adult life, a man was convinced that he hosted an unwanted guest in his abdomen: a frog.[8] He thought he had swallowed the frog while dipping his head into a small creek, and was "invaded" by frogspawn. Throughout his adolescence and early adult life no therapy and no evidence to the contrary could convince him that it was impossible for an intestinal frog to have survived in any living body. The man later studied medicine and became a doctor himself, but his frightful imaginations persisted. Finally, after a lifetime of therapeutic efforts, he was "cured by discourse," it seems, as he suddenly accepted "all these rational explanations" that had been given to him by his doctor, Felix Platter, throughout the years.[9]

Most of the cases Platter describes under the umbrella term of "melancholia hypochondriaca" can be viewed as mediated forms of imaginations gone astray; a wife, for example, who imagines killing her husband in her *dreams* by spearing his body; or a husband who financially ruins his family as a result of excessive *literary readings*, which had convinced him that he must at all costs find the philosopher's stone; or a woman, who—after incessantly revisiting the site of slaughtered pigs' intestines—imagines that she is carrying rubbish around within her body.[10] From today's perspective, Platter's *Observationes* seem remarkably straightforward when addressing pathologies of imagina-

7 See Kusukawa, *Picturing the Book of Nature*, 6.

8 For the *topos* and forms of the depiction of the frog in the history of the sciences see Bernd Hüppauf, "Der Frosch im wissenschaftlichen Bild," in *Frosch und Frankenstein. Bilder als Medium der Popularisierung von Wissenschaft*, eds. Bernd Hüppauf and Peter Weingart (Bielefeld: transcript, 2009), 137–164.

9 Felix Platter, *Observationes. Krankheitsbeobachtungen in Drei Büchern. I. Buch: Funktionelle Störungen des Sinnes und der Bewegung* [1614] (Bern and Stuttgart: Verlag Hans Huber, 1963), 60.

10 See Platter, *Observationes*, 56–62.

tion, in that he accepts the narratives his patients offer him as accurate and truthful. Following the discursive lines of the physiological paradigm, which governed the medical knowledge of the time,[11] he takes the "reported" imaginations of patients as the "representative" truth of an anomalous physiological reality located within the human body. They represent to Platter what is "truly" wrong with the affected mind measured against notions of physiological "realities."[12] But Platter's approach of measuring pathologies of imagination purely against a physiological reality of the body is neither simply overcoming the earlier theological prejudice, which held imagination to be responsible for facilitating the seduction of the sinful body, nor can Platter's *Observationes* stand for the epistemological split between body and mind, which would later form the basis for the Enlightenment episteme. Only then could imaginations be regarded as a force entirely detached from any given physiological condition of the body. For Platter, the core idea that determines imagination and its pathological "deformations" is the representational character of the imagination.

2 Pathology of Imagination: The Case of Girolamo Cardano (1501–1576)

Before addressing visual technologies in the medical realm, I want to roughly outline the historical context, to elucidate what is at stake in the case of Girolamo Cardano, who most likely gave us the first professional account of pathologies of imagination or, to use modern terminology, self-diagnosed mental disorders.[13]

In classical philosophy, imagination was deemed the lowest of the mental faculties, but described in neutral terms as pivotal to the function of memory. For example, Aristotle determines *phantasia* (Latin *imaginatio*), while different from the operations of the mind and of sensory perception, as a necessary connection between both spheres, mediated through images: "For imagination

11 Despite the rise of the new paradigm in medical knowledge that emerged through the visual disciplines of anatomy and the new herbal book, Galenic physiology remained the unquestioned authority in conjunction with the Hippocratic doctrine on humors.

12 John Locke later defined the "violence of their imaginations" as a force which made the mad take their "fancies for realities"; see John Locke, *Essay Concerning Human Understanding* [1689] (New York: Dover, 1959), 207.

13 Margery Kempe has also been mentioned as a possible first case, but it was always deemed an ambivalent case between "mystic women" or "madwoman"; see Vivian Nutton, "The Rise of Medicine," in *The Cambridge History of Medicine*, ed. Roy Porter (Cambridge: Cambridge University Press, 2006), 46–70, here 69.

is different from either perceiving or discursive thinking, though it is not found without sensation, or judgment [...]."[14] And as our psyche operates through forms, not through the things themselves, its imaginations are thought to be without matter: "For images are like sensuous contents except in that they contain no matter."[15] The topical description of *phantasia (imaginatio)* linking mind and body, abstract intellect, and sensual perception has been remarkably stable throughout history. Christian theology in particular has continued to describe *imaginatio* primarily as an interface between body and mind. However, in line with Christian doctrine, for which the body was a sinful entity and the bearer of fleshly temptations, *imaginatio* was ascribed negative qualities. Augustine, following Aristotelian thought, asserts: "All these sensations are retained in the great storehouse of the memory, which in some indescribable way secretes them in its folds [...]. The things which we sense do not enter the memory themselves, but their images are there ready to present themselves to our thoughts when we recall them."[16] However, not all images for the purpose of memory are representations of sensory perceptions: spoken language seems to be exempt. Although we remember the image of sounds, which make the words, the meaning of those words is not perceived through the senses, but seen purely by the mind without the need of an image.[17] Therefore, the truth according to Augustine cannot be represented in an image. Consequently, imagination is seen solely as a service to reason, and reason itself as the proper vehicle of God's word, because God has created everything through his "word alone."[18] The short circuit between spoken words, reason, and faith has prevented images and imaginations from gaining more relevance other than as a serving role for the memory or the mind at best, or, as the iconoclasts of the Reformation emphatically claimed, as the devil's device for seducing our minds at worst.[19]

14 Aristotle, *De Anima*, in *The Works of Aristotle*, vol. III (Oxford: Oxford University Press, 1931), 427b.

15 Aristotle, *De Anima*, 432a.

16 Augustine, *Confessions* (London: Penguin Books, 1961), 214–215.

17 Augustine, *Confessions*, 216–217.

18 Augustine, *Confessions*, 258.

19 For more detail on word-image relations in Early Modern Times see Axel Fliethmann, *Texte über Bilder. Zur Gegenwart der Renaissance* (Freiburg: Rombach, 2014). For a comprehensive account on early modern iconoclasm see Norbert Schnitzler, *Ikonoklasmus: Bildersturm. Theologischer Bilderstreit und ikonoklastisches Handeln während des 15. und 16. Jahrhunderts* (München: Fink, 1996). A special case could be made with regards to the visions of Saints, but despite the positive role, which was ascribed to the power of imaginations, here they were confined strictly by religious doctrine. Hans Belting also noted that

What happened between the theological prejudice and the re-definition of imagination as a positive individual, productive, and—especially within the realm of aesthetics—creative capacity of modern man in the eighteenth century? And what role did the medical knowledge about pathologies of imagination play?

Before the advent of print in the mid-fifteenth century, material images, in contrast to the concept of the mental image, did not attract the serious attention of epistemology; the pursuit of truth relied unchallenged on the discursive medium of the word. Therefore, Pico's *De Imaginatione* should be read not only in defence of the Holy Scripture and against an alleged loosening of moral standards through an unleashed imagination, but also as a discursive reaction to the contemporary proliferation and dissemination of material images as a direct result of the print revolution. As such, Pico in *De Imaginatione* acknowledges the image's negative impact on our psyche beyond its simple instrumentalisation as reproductive imagery for the purpose of memory.[20] Despite all the generic epistemological assumptions Pico shares with the Aristotelian concept of *phantasia* as well as with Augustine's critical commentary, there is also a clear acknowledgement of a detectable unsettling force of material imagery that more than ever before appears to pose a challenge to the modus operandi of the human faculties at the time.

It is no coincidence that within this context the word "imaginatio" (translated into German as "Einbildungskraft") was introduced into the German vernacular by the "Luther of Medicine,"[21] Paracelsus (in his *Liber de Imaginibus*, ca. 1529, published posthumously in 1572).[22] The medical discourse from then on might have played a significant—in scholarship mostly overlooked[23]—role in

visions could have been directly influenced by material images; see Hans Belting, *Bild und Kult. Eine Geschichte des Bildes vor dem Zeitalter der Kunst* (München: Beck, 2000), 460.

20 Stuart Clark also sees Pico's potential as a "moderniser" in regard to the concept of imagination; see Stuart Clark, *Vanities of the Eye. Vision in Early Modern European Culture* (Oxford: Oxford University Press, 2007), 48. Hans Dieter Huber, on the other hand, situates Pico strictly within the negative history of imagination; see Huber, "Bildhafte Vorstellungen," 178. I have looked at Pico's ambivalent position in "The Body of Imagination and the Technology of Imagery in the Renaissance and in Modernity," *Thesis Eleven: Critical Theory and Historical Sociology* 130, no. 1 (2015): 43–57.

21 Benjamin Lee Gordon, *Medieval and Renaissance Medicine* (London: Peter Owen, 1959), 59.

22 While we don't know the extent to which Paracelsus knew Ficino's works, we know that Paracelsus was very well aware of the works of Agrippa von Nettesheim, who himself had used Ficino's work extensively, borrowing quite heavily from it. For the reception context see Marsilio Ficino, *De Vita Libri Tres / Drei Bücher über das Leben*, ed., trans. and intro. Michaela Boenke (München: Fink, 2012), 8–10.

23 While the period 1500–1720 has been rather neglected outside specialist research interests in this regard, the eighteenth century has been tackled in interesting and comprehensive

influencing the philosophical debate on imagination leading up to Alexander Baumgarten's "Aesthetica" (1754–58) and Immanuel Kant's "Critique of Judgment" (1790) and the overall positive alignment of imagination with aesthetic, subjective, and consequently individual forms of judgments more broadly.

The following case of Girolamo Cardano provides some insight into the complexity of intellectual deliberations put forward by the "medical discourse" in relation to the eighteenth-century understanding of the term.

Cardano, practising medical doctor and professor at the universities of Milan and Padua, and a friend of eminent anatomist Andreas Vesalius, notes in his autobiography (1575–76), that he has composed only "bare facts" about his life and wishes to report on it without "masquerade."[24] However, in terms of style, Cardano's autobiography gives us quite the opposite: a crude mixture of self-praise and self-hate, of biographical accounts of his scholarly communications and bitter rivalry, as well as of private miracles and anecdotes of his survival against all odds, all of which is written in a hyperbolic tone, particularly when describing his academic achievements. Historical scholarship has convincingly attributed Cardano's style of writing to the tradition of biography writing,[25] rather than following Cardano's own advice of reading his autobiography as the key to all his (mostly medical) texts.[26] What makes Cardano's autobiography interesting for my line of inquiry is that his text is the first professional account of what can be described as pathologies of imagination. He confesses to his "abnormal nature" in a list of symptoms. He notes first his birth; that he was born with a full head of black curly hair, and that he was nearly soulless;[27] second, that from the age of four he observed with "stiff eyes" every morning over a period of three years images like "airy bodies" hovering above him; third,

approaches, for example, by Gabriele Dürbeck, *Einbildungskraft und Aufklärung. Perspektiven der Philosophie, Anthropologie und Ästhetik um 1750* (Tübingen: Niemeyer, 1998); and Albrecht Koschorke, *Körperströme und Schriftverkehr. Mediologie des 18. Jahrhunderts* (München: Fink, 2003).

24 Girolamo Cardano von Mailand, *Eigene Lebensbeschreibung* (München: Kösel-Verlag, 1969), 9.

25 Comprehensive views are offered by Karl A.E. Enenkel, *Die Erfindung des Menschen. Die Autobiographik des frühneuzeitlichen Humanismus von Petrarca bis Lipsius* (Berlin and New York: de Gruyter, 2008); and Guido Giglioni, "The Many Rhetorical Personae of an Early Modern Physician: Girolamo Cardano on Truth and Persuasion," in *Rhetoric and Medicine in Early Modern Europe*, eds. Stephen Pender and Nancy S. Struever (Farnham, Surrey: Ashgate, 2012), 173–193. On Cardano's literary models for his autobiography see also chapter nine in Anthony Grafton, *Cardanos Kosmos. Die Welten und Werke eines Renaissance-Astrologen* (Berlin: Berlin Verlag, 1999).

26 Cardano, *Lebensbeschreibung*, 196.

27 Cardano, *Lebensbeschreibung*, 125–126.

a reoccurring frigidity in his legs; fourth, breaking into a sweat while sleeping; fifth, that a talking "rooster" which appeared in his dreams spoke to him in a menacing fashion, a form of imagination that apparently ceased in his puberty. However, there are two further aberrations which lasted for a longer part of his life: sixth and seventh, daily he imagined a moon in the sky, an imaginary sighting that ceased with the publication of his book *Problemata*,[28] and that no blood was ever spilt when he was in a brawl; finally, eighth, that he was always saved from disaster in the end, when it seemed impossible.[29]

Cardano further describes the "magical" part of his life as something that resides within him, but while he does not know "what" it is, he wants to describe "how" it is. Here, then, he stresses in particular the voices, which invade his imaginations.[30] Most of his imaginations since his childhood referred to "real world objects," or first order observations[31] (such as castles, houses, animals, trees, or silent musical instruments). In this regard, the image of the rooster falls technically into the "first order observation" category, however, the fact that the rooster speaks menacing words to Cardano adds an aural dimension to his imaginings and with this, I suggest, an "unreal" *momentum,* "unreal" especially because to Cardano all the signs of a dream are clear and understandable to him; the signs of a dream, in Cardano's words, are "not veiled."[32]

28 With reference to the Aristotelian *Problemata* and the relationship between medical knowledge and natural philosophy, Cardano "went so far as to claim that medical knowledge was more certain than natural philosophy, which he maintained derives causes from effects, while medicine often infers effects from causes"; see Craig Martin, "Lodovico Settala's Aristotelian Problemata Commentary and Late-Renaissance Hippocratic Medicine," in *Early Modern Medicine and Natural Philosophy*, eds. Peter Distelzweig, Benjamin Goldberg and Evan R. Ragland (Dordrecht, Heidelberg, New York and London: Springer, 2016), 19–42, here 20.

29 Cardano, *Lebensbeschreibung*, 125–128.

30 Cardano, *Lebensbeschreibung*, 139. Cardano's protective genius also communicates with him, but not openly as he uses "strange signs" (204); while Cardano emphasises that he himself had always been a melancholic (232, 236), he also asserted at the same time that he knew how to treat "difficult" diseases such as epilepsy, insanity, or blindness (184). Accounting for voices from the outside, one could also look at the contemporaneous superstition that voices are a sign of someone thinking about you, which is signalled through someone being "possessed by hick-ups," see Enenkel, *Die Erfindung des Menschen*, 651.

31 For a good introduction into the concept of first and second order observations see Niklas Luhmann, *Die Wissenschaft der Gesellschaft* (Frankfurt/M: Suhrkamp, 1990), chapter two.

32 Cardano, *Lebensbeschreibung*, 204. At the same time, Cardano insists that laymen were not capable of reading dreams and that this art should be left exclusively to the professionals; some strange dream images according to Cardano are always in need of interpretation ("der außlegung bedörffen" vs. dreams, which are sent by God are not considered to be coded) (*Traumbuch Cardani. Warhafftige / gewüsse und vnbetrügliche vnderweisung*

But the rooster is not only "unreal" because he speaks; he also transmogrifies into a real, second order object, a second order observation, which allows him to address the self as a first order object.

This form of a self-address constitutes the opposite to the well-known topos of the poet inspired by the muse's voice, as here the muse speaks through the poet without enabling him to have a reflective relationship with the self and as a consequence control over "his" self (*poeta furor, mania* tradition).[33]

While in Pico's inaugural monograph, *De Imaginatio*, imagination is still traditionally framed by a hierarchical process, whereby imagination produces a real similarity between an absent physical object and its mental pictorial representation which the intellect must then make sense of, Cardano's pathological imaginations sets the rigid subject-object opposition in motion. With this *dia-logue* he affords his "self" (*himself*) the opportunity to reflect on abnormal imaginations without having to resort to an overarching Christian discourse. The rooster does not exclusively preach God's word or work, as we shall see later.

Finally, in Cardano's world every imagined aberration is controlled only by his own discourse: autobiography here is therapy. This opens avenues for deliberate self-reflective processes of individuation and self-creation similar to the way in which later the modern novel of the eighteenth century exemplifies the experiences of its bourgeois heroes.[34]

I will now turn from autobiography to autopsy in medicine in order to frame two visual strategies dealing with material images, which I will later align with Platter's and Cardano's conceptualisations of "pathologies of imagination."

3 Anatomy and Imagination

The two great pioneers of what was possible in anatomical illustration, Leonardo and Vesalius, invented or perfected virtually all the possible

/ *wie allerhandt Träum / Erscheinungen und Nächtliche gesicht / welche uns von der seelen* [...] *eingebildet und fürbracht werden. Durch den hochgelehrten Hieronymum Cardanum. Jetztunder* [...] *gantz fleissig vnd auff das treüwlichst verteütscht* (Basel: Petri, 1563) [= Somniorum Synesiorum, übersetzt von Johann Jakob Huggelin], rv and drir).

33 See Axel Gellhaus, *Enthusiasmos und Kalkül. Reflexionen über den Ursprung der Dichtung* (München: Fink, 1995), 11–12. In Renaissance rhetoric there was a refiguration of the invocation of the muses, which from that point on allowed for individual ways of speech; see Gellhaus, 77.

34 A precursor to this trajectory can be observed in the changes occurring in late sixteenth-century poetics, initiated in particular by Girodano Bruno's *Heroic Frenzies* (De Gli Eroici Furori) from 1585, written ten years after Cardano's autobiography.

methods of depiction, until the event of X-rays, scanning techniques and moving pictures. In their drawings and prints, we find "direct" pictures that aspire to transform the spectator of the illustration into a surrogate eyewitness of the dissection or the dissected part of the body.[35]

Martin Kemp's and Marina Wallace's praise of Leonardo's and Vesalius's technical accuracy focuses on the illustrations *in nuce*, but does not make reference to the wider context of Renaissance visual technologies, or discuss its contemporaneous epistemological implications. Conversely, Hartmut Böhme has described the new anatomical paradigm in medicine as "a heteronomous mixture of philological operations, religious interpretations and philosophical descriptions of nature, experimental examinations, theatrical spectacles and pictorial constructions."[36] In Böhme's description the pictorial construction forms only one, albeit important, part of the medical discourse and the new visual techniques are not celebrated with the same gusto as Kemp and Wallace do. On the one hand, one could safely assume here that Kemp's and Wallace's emphatic celebration of the new technology in pictorial representation (printed woodcuts or copperplates), which define the new anatomy, corresponds to an overall emphatic concept of science, in which the image represents, or corresponds to, the truth; on the other hand, Böhme's emphatic cultural description of visual technologies emphasises the cultural constructedness of any visual representation.

In many instances, Leonardo and Vesalius themselves emphasised one particular aspect of their respective methods: the autopsy, which both see as a methodological alternative to the overall dominant exegesis of texts to generate knowledge. However, they had different intentions in mind. Vesalius, a doctor of medicine, but also a *medicus philologus*, as Lutz Danneberg has baptised him,[37] did not conceive that his revolution of the medical gaze would be decoupled from Galen's scriptures, which still constituted (not only in Vesalius's eye) the incontestable authority in medical discourse. Vesalius's main work *De*

35 Martin Kemp and Marina Wallace, eds. *Spectacular Bodies. The Art and Science of the Human Body from Leonardo to Now* (Hayward Gallery: University of California Press, 2000), 35.

36 "[...] heterogene Mischung aus philologischen Operationen, religiösen und naturphilosophischen Deutungen, experimentellen Untersuchungen, theatralen Spektakeln und bildgebenden Verfahren, [...]" (Hartmut Böhme, *Der anatomische Akt. Zur Bildgeschichte und Psychohistorie der frühneuzeitlichen Anatomie* (Gießen: Psychosozial-Verlag, 2012), 25).

37 Lutz Danneberg, *Säkularisierung in den Wissenschaften seit der Frühen Neuzeit*, Bd. 3, *Die Anatomie des Text-Körpers und Natur-Körpers. Das Lesen im liber naturalis und supernaturalis* (Berlin and New York: de Gruyter, 2003), 19.

humani corporis fabrica libri septem (1543) is explicitly oriented towards Galen's anatomical knowledge,[38] and, according to Vesalius himself, he had no desire to fundamentally criticise his errors, after all, Galen had only used animals in his anatomical dissections.[39] Nonetheless, Vesalius also insisted that anatomical errors needed to be corrected and emphasised the importance of illustrations—the "detailed diagrams of the parts (and God grant that the printers will not ruin them!)"—for his texts, and noted: "In fact, illustrations greatly assist the understanding, for they place more clearly before the eyes what the text, no matter how explicitly, describes."[40] At the same time, he warned his students not to rely solely on anatomical illustrations as these will always be exceeded by personal experience obtained in real dissections.

Leonardo also had no reservations about Galen's authority when it came to anatomical knowledge;[41] however, for Leonardo, the role of autopsy functioned explicitly as a corrective of canonical knowledge, and once an anatomical illustration was finished, the illustration itself outperformed the observation of the empirical reality of a single autopsy: "You who believe that it is better to watch an anatomical demonstration than to look at these drawings, you would be right if one could see all the details shown in my drawings in a single figure in which, with all your talents, you will not see or get to know more than a few veins."[42]

The stark contrast between Leonardo and Vesalius regarding autopsy and anatomical illustration is poignant. While Leonardo in his oeuvre incessantly reflects on, comments on, fights for the acceptance of the image, of visual culture at large as epistemologically relevant, thereby challenging scripture and lecture as main media of the academic discourse at the time, Vesalius seems to be concerned solely with the accuracy of the illustration in relation to its depicted anatomical reality. The difference between Leonardo and Vesalius could be summarised as follows: while Vesalius uses the illustration to

38 Andreas Vesalius, *On the Fabric of the Human Body. Book I. The Bones and Cartilages* [1543], ed. William Frank Richardson in collaboration with John Burd Carman (San Francisco: Norman Publishing, 1998), lv.

39 Vesalius, *Human Body*, liiif und liv.

40 Vesalius, *Human Body*, lvi. For an excellent account of the technological, social, and economic implications regarding early modern prints, and especially regarding Vesalius's *De humani corporis*, see Kusukawa, *Picturing the Book of Nature*.

41 Robert Zwijnenberg, "Poren im Septum: Leonardo und die Anatomie," in *Leonardo da Vinci. Natur im Übergang. Beiträge zu Wissenschaft, Kunst und Technik*, ed. Frank Fehrenbach (München: Fink, 2002), 57–79, here 68.

42 *The Genius of Leonardo da Vinci. Leonardo da Vinci on Art and the Artist*, ed. André Chastel (New York: Orion Press, 1961), 125.

establish anatomy as a new master discipline in medical discourse, Leonardo uses anatomy to make a case for visual knowledge to be accepted as superior to the written word.[43] In Leonardo's *paragone* the image overall is portrayed as a form of knowledge in its own right; in Vesalius's anatomy the image is an auxiliary means, which has to correspond to the "proper" anatomical truth of the human body. Vesalius's understanding of the image is focused on representation, Leonardo's on constructedness.[44]

Do Cardano's pathologies of imagination, and the way they are depicted, have anything to do with the *paragone* debate, which has pushed for the acceptance and at times superiority of the image's epistemological value compared to other means of communication? Or do Platter's systematic accounts of his patients' pathologies of imagination have anything to do with Vesalius's anatomical paradigm, which assumes a representational function of the image as bodily truth? I am not suggesting here that Cardano's imagined rooster is caused by Leonardo's war cry to install *image making* as a "divine science,"[45] and enthrone the creator of images as the most original artist and scholar of the time. I am also not suggesting that Platter's systematic attempt to classify the pathologies of the mind, in particular those which involve uncontrollable imaginations, is directly shaped by the way in which Vesalius staked out his representational visual documentation of the human anatomy.

But even if that is true, neither should we confidently assume that there is no significant influence whatsoever of a technical paradigm on the shaping of ideas and our ways of understanding.[46] So in response to this line of

43 "[...] it [painting, AF] cannot be copied as the written word can, where the copy is worth as much as the model; it cannot be cast as sculpture can, where the copy equals the original in value, insofar as the excellence of the work is concerned. It does not produce multitudinous progeny as do printed books. Painting alone remains noble; it alone honours the author, it alone remains precious and unique und never brings forth offspring that equal it, and this uniqueness makes it more excellent than those things which are spread abroad" (*The Genius of Leonardo*, 85).

44 There are of course further visual techniques at play in Renaissance medicine. In particular, the role of the new herbal books and their construction of image-driven knowledge should be mentioned here; also the older, speculative visual technique of the uroscopy was still very much alive, whereas introspective techniques such as the ear speculum were less successful as the required light source was only developed in the nineteenth century. See on medicine and visual techniques in general, Rolf Winau, ed. *Technik und Medizin* (Düsseldorf: VDI-Verlag, 1993), and on the history of the uroscopy, Michael Stolberg, *Die Harnschau. Eine Kultur- und Alltagsgeschichte* (Köln: Böhlau, 2009).

45 *The Genius of Leonardo*, 36.

46 In media theory it is commonplace to assume that a technical paradigm partly determines our knowledge formation. This approach has only been slowly adopted into the field of medical history, albeit there are excellent examples of this approach the closer we get to

questioning we might ask, what can we derive from Cardano's rooster? Does his rooster lead us to different ways of approaching the subject?

Since antiquity the rooster has been considered one of the most important symbols to represent the medical profession. Following Asclepius, the rooster is either a sacrifice offered to Asclepius by those recovering from illness, or a symbol of vigilance. We know that Cardano was well informed about the contemporary cult of Asclepius.[47] However, in the new cultural environment of extensive image proliferation the Renaissance was witnessing, especially through the bestselling new genre of emblem books following Andreas Alciatus's *Emblematum Liber* (Augsburg 1531), the rooster subsequently took on a range of meanings: as "sexual symbol," as icon of divinity, as symbol of protection, and as a reminder to stay vigilant at all times. The most common depiction of the rooster as a symbol of vigilance places him on top of a trumpet, crowing. And the trumpet is of course most illustrative of "pheme/fama" (the Goddess of fame but also of rumour). The explosion of material images due to printing opened up an endless field for new symbolic meanings, which in time have gone beyond any individual capacity to decode. *Fama* in early modern times was given many new attributes in copperplates, woodcuts, or paintings as well as in texts. *Fama* and soap bubbles stood for rumours or madness; *Fama* with a printer represented the fame of print and the role of the publisher; *Fama* with a pen and wearing a dress covered with eyes represented the fame of the poetic writer; *Fama* could also stand for the sensational or the monstrous with various attributes.[48]

The pictorial pluralism of possible meanings in text-image emblems has over time eroded the very basis on which the mass medium of the emblem was founded: as a guide to moral orientation, in which the picture was supposed to

the present state of affairs; see, for example, Renée van de Vall and Robert Zwijnenberg, eds. *The Body Within. Art, Medicine and Visualization* (Leiden and Boston: Brill, 2009); and Joseph Dumit, *Picturing Personhood. Brain Scans and Biomedical Identity* (Princeton: Princeton University Press, 2004). Particularly the link between anatomy and pathologies of imagination has rarely been made by taking visual paradigms into account. A case in point would be the otherwise excellent contribution by Sawday on Renaissance anatomy; see Jonathan Sawday, *The Body Emblazoned. Dissection and the Human Body in Renaissance Culture* (London and New York: Routledge, 1995).

47 See Nancy G. Siraisi, *The Clock and the Mirror. Girolamo Cardano and Renaissance Medicine* (Princeton: Princeton University Press, 1997), 188.

48 See Arthur Henkel and Albrecht Schöne, eds. *Emblemata. Handbuch zur Sinnbildkunst des XVI. und XVII. Jahrhunderts* (Stuttgart and Weimar: Metzler, 1996), emblems no. 1079, 1317, 1536, 1537, 1666, 1667.

function as a clear *aide memoire*.[49] But if one image can now signify multiple meanings, the plethora of printed pictures in emblem books also freed "themselves" from being policed by "words" and thus could be re-functionalised beyond their former status as an auxiliary to the superiority of words. Cardano might have done just that with his "talking rooster emblem" as a form of self-address, and the question that arises is not only whether he could have chosen any animal (or person) to do so, but more importantly whether the talking rooster which appeared in his imaginations was intricately linked to the visual culture of its day.

To find answers we should turn to Cardano's book on dreams, the "most substantial theoretical treatise about dreams" in the Renaissance.[50] Cardano, like Aristotle, views dreams, similar to the concept of imagination itself, as a form connecting body and mind. More influential though for Cardano's comprehensive take on dreams was Synesius of Cyrene's (c.370-c.413) dreambook, which had been translated into Latin by none other than Marsilio Ficino, who added subtitles to his translation, in which he put an even more positive spin on the role of *phantasia* in dreams than Synesius himself had suggested.[51] And while Synesius had stressed the prophetic function of dreams, Cardano seems to favour an understanding of dreams as forms of individual self-expression.

What then do Cardano's books on dreams say about roosters? I found three references to the rooster in his four books on dreams, one of them explicitly referring to his childhood dream. But the description and reflection Cardano offers there is quite disappointing compared to the hyperbolic accounts in his autobiography; Cardano simply states the threatening dream and how his family had looked after him during the time those pathological imaginations persisted. And despite offering an elaborate description of dream symbols and their meanings in his books on dreams, the "rooster" only seems to appear straightforwardly as *pater dominus*, while depicted "chickens" represent all other inhabitants of a household.[52] But while the rooster's symbolism seems one-dimensional and predictable, Cardano's overall notions about the images in dreams are not one-dimensional at all. Similar to the multiple meanings the

49 See Wolfgang Neuber, "Locus, Lemma, Motto. Entwurf zu einer mnemonischen Emblematiktheorie," in *Ars memorativa. Zur kulturgeschichtlichen Bedeutung der Gedächtniskunst 1400–1750*, eds. Wolfgang Neuber and Jörg Jochen Berns (Tübingen: Niemeyer, 1993), 351–372.

50 Siraisi, *The Clock and the Mirror*, 174.

51 See, in general, for influences on Cardano's concept of dreams, Siraisi, *The Clock and the Mirror*, 177–185.

52 *Traumbuch Cardani*; see for the rooster as symbol, diij, and for Cardano's dream of the menacing rooster, ccvi.

pictures in emblem books have generated, every image in a dream is prone to attract multiple meanings.[53] And similar to the opposition in emblems between the text (symbolising the spirit) and the picture (symbolising the body), Cardano ascribes bodily causes for dreams (effected by the humors) and non-bodily causes (effected by love, hate, or thoughts, for example).[54]

While Synesius thought of the individual dream as irrelevant and strived for a cosmological dream as universal form, Cardano stresses the challenges every single dream poses and he strongly objects to placing restrictions on the rules of interpretation. On the contrary, he stresses the fluid nature of this "art form."[55] He mainly distinguishes two forms of dreams, those that are dominated by images (idols), which are supposedly clear and represent real objects, and apparitions, which can be blurry and represent human activities.

Cardano thinks of the image (idol) as the more powerful device as he deems it to be "natural" compared to the apparitions linked to underlying human passions, which he surprisingly deems artificial.[56] This preference might be owed partly to Cardano's liking of "nature prints," where inked natural objects (plants) are pressed onto a page, over the dominant use of artificial prints at the time (i.e. woodcuts and copperplate etchings).

To recapitulate, the rooster as *pater familias*[57] offered Cardano—intended or not—a textual strategy for pursuing a secular form of self-address while still allowing for religious implications being relevant. However, only the image of the rooster enabled Cardano to turn self-address into a reflective and individualised form.

On the one hand, Platter's *Observationes* framed pathological imaginations as deficiencies, measuring them against a physiologically defined reality of the human body. His understanding of imaginations could be described as bearing all the hallmarks of Vesalius's trust in the precision of anatomy as a new visual medical paradigm, which in itself partly owes its evidence to the new technologies of woodcuts and copperplates. Cardano, on the other hand, constructing

53 Feet in dreams, for example, can symbolise quite different aspects: the foundations of your house, forms of art, levels of prosperity, or joy, *Traumbuch Cardani*, lrv.

54 *Traumbuch Cardani*, v.

55 *Traumbuch Cardani*, see ccccrrij. Although Cardano also acknowledges that at the beginning of the interpretation a guiding principle would be needed, referring here to the order of elements in a dream, while the elements in themselves subsequently can take on multiple meanings, see rlviij. On the topic in general see also Markus Fierz, *Girolamo Cardano* (*1501–1576*) (Basel and Stuttgart: Birkhäuser, 1977).

56 *Traumbuch Cardani*, drriij; see Fierz, *Cardano*, 107.

57 I am not suggesting Cardano intended to describe an oedipal relation, but he certainly leaves the door open for a modernist reading here as well.

visual forms as *sui generis* knowledge in the vein of Leonardo, affords the Renaissance man the opportunity to break away from established powerful and controllable oversight, be it enforced by religion, natural philosophy, or pictorial technology through imaginative self-constitution. While the image (of the rooster) has enabled a form of self-construction as much as a construction of a "self," Cardano's pathologies of imagination have significantly, if not more than other forms of intellectual deliberation at the time, helped drive and shape the modern process of individuation.

Re-Imagining the "Birthing Machine:" Art and Anatomy in Obstetric and Anatomical Models Made by Women

Elizabeth Stephens

In the multimedia artwork "Fat Venus," an anatomical self-portrait-in-progress by the artist and former anatomical prosector, Nina Sellars, MRI technology is used to produce a series of images of the artist's internal anatomy that are composed entirely of the adipose tissue.

FIGURE 3.1 Nina Sellars, from "Fat Venus," 2017, a cross-section of the thoracic region
IMAGE COURTESY OF THE ARTIST

A series of cross-sections of Sellars's body reveal lumina and traceries that only become visible once the other anatomical systems and structures have been screened out of the image, and these cross-sections will eventually be assembled to reconstruct a whole-body figure in 3D.[1] Sellars is not the first artist to use MRI technologies as a new medium of self-portraiture; Justine

1 Nina Sellars, Fat Venus, multimedia artwork [in progress; referenced with permission of the artist].

Cooper's 2005 video piece, "Rapt," uses MRI technologies to mesmerising effect, depicting a fluid, moving, composite image of the artist's internal anatomy. However, "Rapt," while it makes visible the artist's skeletal system and organs, does not represent the adipose tissue, and as such is consistent with the way the internal anatomy is most often seen through medical imaging technologies. In order to provide clear images of bone structure, soft tissue, the vascular system, or organs, MRIS usually screen out the body's adipose tissue. In this respect, "Fat Venus" will provide a stranger and less familiar image of the body, one that makes visible the part of the anatomy that is usually erased, and which will reimagine the body as one entirely composed of fat.

Sellars's "Fat Venus" thus constitutes a critical commentary on, and intervention in, the way bodies, and particularly women's bodies, are seen and modelled in medical contexts. The title of the work itself is an explicit reference to the long tradition of representing female bodies, both in art and in medical modelling, as "Venuses."[2] Anatomical Venuses, full-length gynaecological models famed for their beauty and anatomical accuracy, were amongst the earliest modern medical models made. They were manufactured from the end of the eighteenth century until the end of the nineteenth, with the most celebrated and aesthetically striking examples produced at the end of the eighteenth century in Florence by Clemente Susini.

As feminist historians of medicine and anatomy have widely recognised, the highly aestheticised modelling of anatomical Venuses is representative of the way a medical gaze has tended to see the female body; where "general anatomy" has been most often represented using models of male bodies, female bodies are represented primarily in the context of studies of the female reproductive system and stages of foetal development.[3] In this respect, the non-reproductive anatomy of women has something in common with adipose tissue within the history of medical modelling and illustration: both have been historically rendered largely invisible by and to the medical gaze, and thus remain under- represented in its images and models. Further, the two are often closely linked; for instance, when the contemporary anatomical modeller Gunther von Hagens was criticised for his dominant use of male bodies in his famous Body Worlds exhibitions, he initially claimed that the higher fat content of female bodies

2 For a discussion of the relationship between Venuses in art and anatomical modelling, see Corinna Wagner, "Replicating Venus: Art, Anatomy, Wax Models, and Automata," 19: *Interdisciplinary Studies in the Long Nineteenth Century* 24 (2017): 1–27; and Roberta Ballestriero, "Anatomical Models and Wax Venuses: Art Masterpieces or Scientific Craft Works?," *Journal of Anatomy* 216, no. 2 (2010): 223–234.

3 Ludmilla Jordanova, *Sexual Visions: Images of Gender in Science and Medicine between the Eighteenth and Twentieth Centuries* (Madison: University of Wisconsin Press, 1989).

FIGURE 3.2
Clemente Susini, "Anatomical
Venus," ca. 1785, Museo di Palazzo
Poggi, Bologna
PHOTOGRAPH: ELIZABETH
STEPHENS

obscured their internal anatomy, making them less suitable for anatomical display, although subsequent exhibitions have included more female figures in response to this criticism.[4]

Von Hagens's comments reflect a longstanding tendency to treat fat as something that obscures or obstructs the view of the anatomy, which it is presumed to be outside of, rather than as a part of the anatomy itself. This tendency can be traced back at least as far as the rise of modern anatomy in the early modern period, as Karin and Ann Sellberg have shown.[5] It is evident visually in the history of anatomical illustration, in which the famous *écorché* (or flayed) figures by the sixteenth-century anatomist and illustrator Vesalius depict bodies stripped of skin and with an internal anatomy as "entirely devoid of fat."[6] The erasure of fat from anatomical illustrations is one continued in

4 Elizabeth Stephens, "Inventing the Bodily Interior: *Écorché* Figures in Early Modern Anatomy and von Hagens's *Body Worlds*," *Social Semiotics* 17, no. 3 (2007): 313–326.

5 Karin Sellberg and Ann Sellberg, "Fluid Fat: Considerations of Culture and Corporeality," in *Bodily Fluids*, eds. Karin Sellberg, Kamillea Aghtan and Michael O'Rourke. Special issue of InterAlia: A Journal of Queer Studies 9 (2014): 304–318, here 306.

6 Sellberg and Sellberg, "Fluid Fat," 306.

the contemporary practice of removing fat from anatomical specimens used in medical training and for museum display. Sellars notes that one inspiration for "Fat Venus" was her first-hand experience of this removal of fat from the anatomy, acquired as a former prosector preparing cadavers and body parts for demonstration in anatomy lectures. The preparatory stage in this process involved stripping the fat from the body, which was then discarded unceremoniously into a bucket under the dissection table and disposed of as waste.[7] Over the past decade, however, the status of fat within anatomical study has changed, and it has come to be redefined as an organ of the body,[8] one that in recent years has become highly prized as a potential source of a unique population of pluripotent stem cells.[9] In this respect, the changing status of fat is illustrative of the changing parameters of what is understood to constitute the anatomy, representative of the close relationship between medical ways of seeing and the limits of medical knowledge.

In its attempt to reintegrate adipose tissue into the anatomical imaginary, then, Nina Sellars's "Fat Venus" constitutes a sustained and critical feminist intervention in the anatomical imaging of the body and the medical knowledge about the body this produces. Taking "Fat Venus" as an invitation and a guide with which to explore the history of anatomical modelling of the female body that precedes it, this chapter examines anatomical models of the female body as exemplary of a dynamic and mutually constitutive relationship between the aesthetic and scientific in medical modelling over a significant period of time. Perhaps surprisingly, critical interrogations of, and interventions in, this history by women are not a recent development. Rather, as we will see in this chapter, there is a long history of such work undertaken by female anatomical modellers which can be dated to the start of modern medical modelling itself. In this chapter, I will examine this by considering the work of eighteenth-century female anatomical modellers such as Anna Morandi (1714–1774), Marie Marguerite Bihéron (1719–1795) and Angélique du Coudray (1712–1794).[10] In so doing, my purpose is to recover their contribution to obstetric modelling at the moment obstetrics was first emerging as a discipline of modern medicine,

7 In conversation with the artist.

8 Jon White, "Fat is a Beautiful Organ," *New Scientist Issue* 2873, 14 July 2012. https://www.newscientist.com/article/mg21528736-100-fat-is-a-beautiful-organ/.

9 Jacinta Bowler, "New Stem Cell Treatment Using Fat Cells Could Repair Any Tissue in the Body," *Science Alert*, 5 April 2016. https://www.sciencealert.com/new-stem-cell-treatment-using-fat-cells-could-repair-any-tissue-in-the-body.

10 Lucia Dacome provides an excellent overview of the inclusion of women in anatomical modelling and study in this period in *Malleable Anatomies. Models, Makers, and Material Culture in Eighteenth-Century Italy* (Oxford: Oxford University Press, 2017), 104–110.

and midwifery was increasingly becoming a profession dominated by men. Although all three women were well-recognised and celebrated for their scientific and medical contributions in their own day, and held prominent positions in the social and scientific communities of their time, their work remains under-examined in histories of medicine and anatomy, and, with the exception of Morandi, few examples of their models remain. I am interested in the way the models made by these women can be understood as a critical response to an emergent way of seeing the reproductive female body as a passive "birthing machine," which would continue to shape gynaecological and obstetric practice well into the nineteenth century. By examining this, I seek to show how their works were constitutive, rather than merely illustrative, of anatomical knowledge, drawing attention to the importance of the visual cultures of medicine as central to its history and knowledge-making practices.

1 The Radically Muted Aesthetics of Anna Morandi's Medical Moulages

In the middle room of the anatomy wing at the Museo di Palazzo Poggi in Bologna can be found the wax self-portrait of Anna Morandi (1714–1774), one of the most celebrated anatomical modellers of her day.[11]

Visitors enter this room through one that features the large collection of terracotta obstetric models by one of the founding figures of modern obstetrics, Giovanni Galli (1708–1782) (see Figure 4.7, below), as well as the famous "birthing machine" made by the craftsman Antonio Cartolari (1701–1779).

With its glass uterus bound with metal straps, its leather torso with flaps peeled back and thigh stumps, Cartolari's model is a striking representation of a female body reduced to its reproductive anatomy, and rendered transparent, fully visible to the medical gaze. It was customary to refer to such obstetric models as "birthing machines" in the eighteenth century. The word "machine," at this time, signified a "device or contrivance," rather than something mechanical in the contemporary sense, and it was often used in place of "anatomical model." The two "anatomical machines" by Giuseppe Salerno, dating from around 1763, still on display in the Cappella Sansevero in Naples, are perhaps the best-known existing examples of these.[12]

11 Dacome, *Malleable Anatomies*.

12 For further accounts of the role and understanding of machines in eighteenth-century anatomical modelling, see Pam Lieske, ""Made in Imitation of Real Women and Children": Obstetrical Machines in Eighteenth-Century Britain," in *The Female Body in Medicine and Literature*, eds. Andrew Mangham and Greta Depledge (Liverpool: University of Liverpool

FIGURE 3.3
Anna Morandi, wax self-portrait, ca. 1760, Museo di Palazzo Poggi, Bologna
PHOTOGRAPH: ELIZABETH STEPHENS

FIGURE 3.4
Antonio Cartolari, birthing machine, mid-eighteenth century, Museo di Palazzo Poggi, Bologna
PHOTOGRAPH: ELIZABETH STEPHENS

The room adjacent to that in which Morandi's waxwork can be found features a newly restored anatomical Venus by Clemente Susini, seen in Figure 3.2. Like all anatomical Venuses, the one housed as the Museo di Palazzo Poggi is exhibited resting on silk pillows, with long flowing hair, and pearls around her neck. Much of her internal anatomy, all carefully modelled, has been removed, so that the tiny foetus can be seen; her organs are neatly lined up by her feet. In this museum filled with anatomical Venuses and partial obstetric models, Anna Morandi's wax self-portrait provides a striking and singular eighteenth-century instance of a woman as the subject, rather than object, of anatomical knowledge. Here Morandi represents herself as the professional anatomical modeller she was. Finely dressed, wearing a pearl necklace and bracelet as well as diamond ring and earrings, she cuts an imposing figure, meeting the viewers' gaze with steady confidence. Her hand is outstretched over the brain she is depicted in the process of dissecting, although it is missing the scalpel it once

Press, 2011), 69–88; and Sheena Sommers, "Transcending the Sexed Body: Reason, Sympathy, and "Thinking Machines" in the Debates over Male Midwifery," in *The Female Body in Medicine and Literature*, Mangham and Depledge, 89–106.

held. Morandi's self-representation dissecting a brain—the part of the anatomy so closely associated with a rationality assumed to be exclusively male in the eighteenth century—is particularly significant. In contrast, the matching model she made of her husband, the medical modeller Giovanni Manzolini, depicts him dissecting a human heart: to the man is attributed the study of the passions, and to Morandi the study of the intellect.[13] And yet the string of pearls around Morandi's neck suggests a telling continuity with the anatomical Venus in the adjacent room. She would, in many ways, remain confined within the system of anatomical study and its professional regulation that relegated women, and the female body, to passive roles, as birthing machines to be operated by men. Like "Fat Venus," then, Morandi's self-portrait is explicitly designed to reposition the female body in anatomical research and practice, in ways that have much to tell us about the volatile relationship between modelling and medicine, the aesthetic and scientific, over the course of the eighteenth century.

Although her role in the history of obstetric modelling is now much less well-remembered than that of either Giovanni Galli or Clemente Susini, Anna

FIGURE 3.5
Anna Morandi, moulage of the ear, mid-eighteenth century, Museo di Palazzo Poggi, Bologna
PHOTOGRAPH: ELIZABETH STEPHENS

13 For a more detailed account of these two waxworks, see Dacome, *Malleable Anatomies*.

Morandi was one of the most celebrated anatomical modellers of her day. She specialised in medical moulages; that is, body parts moulded from wax and mounted on flat wood.

She first trained by assisting her husband Giovanni Morandi in his work, much of which was commissioned by Galli, before taking over the business after his early death in 1755. For the next two decades, she ran his former business independently, producing hundreds of detailed moulages and models single-handedly. All her moulages were mounted on boards with a distinctive blue background. She was appointed an honorary Professor of Anatomy at the University of Bologna in 1756, although this position did not allow her to teach. Instead, she gave anatomical lessons and demonstrations of her models at home, and also received commissions from anatomical museums and wealthy private collectors. She claimed to have dissected over a thousand cadavers and was widely recognised in her time to have surpassed the skill of her husband. Her field of specialisation was the sense organs, and her moulages were acclaimed for their contribution to anatomical knowledge, representing parts of the anatomy that had not been previously identified or illustrated. Many of her models were scaled to very large sizes, so that small details could be more easily seen. She is also known to have made two dozen moulages of the male reproductive system, but these have since disappeared leaving no visual trace.[14]

Morandi's position as a "lady anatomist," as Rebecca Messbarger describes her in her richly detailed *The Lady Anatomist: The Life and Work of Anna Morandi Manzolini*,[15] was not entirely anomalous in the eighteenth century. On the contrary, she was the beneficiary of a culture that increasingly allowed interested women to pursue academic study in the sciences, although they remained barred from academic professions.[16] In Bologna, Morandi had a contemporary in Laura Bassi (1711–1778), who became the first (honorary) female member of the Institute of Science in 1732, receiving her PhD and an appointment as university chair in physics the same year. Bassi was also prohibited from teaching, but she did conduct experiments at the university on the medical applications of electricity. She was also regularly invited to give the lecture at the annual Public Anatomy or Carnival Dissection, a public spectacle staged in many European cities from the mid-1500s.[17] Morandi had a second, and closer, contemporary in Marie Marguerite Bihéron (1719–1795), who was

14 Rebecca Messbarger, *The Lady Anatomist. The Life and Work of Anna Morandi Manzolini* (Chicago and London: University of Chicago Press, 2010).
15 Messbarger, *The Lady Anatomist*.
16 See also Dacome, *Malleable Anatomies*.
17 Gabriella Berti Logan, "Women and the Practice and Teaching of Medicine in Bologna in the Eighteenth and Early Nineteenth Centuries," *Bulletin of the History of Medicine* 77, no. 3 (2003): 506–535.

originally based in Paris. Bihéron took art classes at the Jardin de Roi and with Madeleine Basseport while also attending anatomy lectures.[18] Bihéron's preferred medium was leather, which she claimed resembled skin and organs more realistically than did wax.[19] By the 1750s, Bihéron had established her own "cabinet d'anatomie" in Paris and offered anatomical lectures at home. In 1759, she was invited by Sauveur-François Morand to present her work to the Académie Royale des Sciences. Morand's patronage was significant: he was a member of the Academy, and a fourth-generation physician from an eminent medical family. In 1770, she was invited to present her anatomical Venus to the Académie, and then again in 1771.[20]

Bihéron was widely praised by eminent figures of her day for her "grand talent pour le dessin et la répresentation des subjets anatomiques," as Adeline Gargam has shown.[21] Diderot is reported to have sent his daughter to Bihéron for instruction prior to her marriage. Like Bassi and Morandi, as a woman she was barred from teaching anatomy, and like Morandi she was financially and professionally independent, making a living by exhibiting and lecturing on her work. She frequently exhibited her work and lectured in London, where William Hunter was among her students. She is believed to have produced a number of anatomical illustrations for Hunter at his request.[22] Unlike Morandi, however, she did not receive any commissions for her work from established public museums or private collectors. Diderot made many efforts on her behalf to sell her collection to a wealthy patron and to secure Bihéron herself a position as an anatomical instructor of women, but in this he was not successful. As a result, despite the fact Bihéron was recognised as "parmi les ouriers les plus connus en Europe en pièces anatomiques,"[23] her collection of 129 pieces has been lost in its entirety. The short catalogue produced by Bihéron for an 1861 exhibition contains no illustrations. Neither does the much longer catalogue prepared by Morand in 1773.[24] Nothing is known of the detail or appearance of her Venus, a rare example from this period made of leather.

18 Adeline Gargam, "Marie-Marguerite Bihéron et son cabinet d'anatomie: une femme de science et une pedagogue," in *Femmes éducatrices au siécle des lumières*, eds. Isabelle Brouard-Arends and Marie-Emmanuelle Plagnol-Diéval (Rennes: PUR, 2007), 147–156.

19 Marie Marguerite Bihéron, *Anatomie Artificielle*, Paris, 24 April 1761 (Advertising catalogue), 5 p.

20 Georges Boulinier, "Une femme anatomiste au siècle des Lumières: Marie Marguerite Bihéron (1719–1795)," *Histoire des sciences médicales* 35, no. 4 (2001): 411–423.

21 Gargam, "Marie-Marguerite Bihéron," 74.

22 Jean-Pierre Poirier, *Histoire des femmes de science en France: Du Moyen Age à la Révolution* (Paris: Pygmalion, 2002); Boulinier, "Une femme anatomiste."

23 Gargam, "Marie-Marguerite Bihéron," 82.

24 Sauveur-François Morand, *Catalogue des Bronzes et autres curiosités* (Paris: Rémy, 1773).

The fate of Bihéron's collection reveals what was at stake for Morandi in securing a place for her work in the Museo di Palazzo Poggi. Without a permanent institutional home of the kind Morandi found for her moulages, even collections of recognised significance could be lost. Indeed, Morandi's is the only extant substantial collection of work by a female anatomical modeller from the eighteenth century. Her production of a wax self-portrait needs to be understood in this context, and as a deliberate act of self-promotion designed to secure a permanent institutional home for her work, to physically insert herself in this institutional space. This was especially important given that, in her own day, the status of Morandi's moulages was far from assured.[25] As Rebecca Messbarger has so persuasively shown, Morandi's moulages were aesthetically radical, breaking with the visual tradition that shaped anatomical Venuses and dominated within public anatomical museums at this time, in which anatomical models were framed aesthetically in ways that made them acceptable and appealing as public displays. Early public anatomy museums like Palazzo Poggi were intended to provide moral instruction for a general audience, rather than "to serve the specialised aims of medical science."[26] Their purpose was to "epitomise the hybrid drama of sin and science played out annually at the University's renowned Public Anatomy or Carnival Dissection."[27] To achieve this, they incorporated aesthetic elements, in order to provide a cultural and religious framework by which the significance of the bodies on display could be understood by a general public.[28] One of the founding collections of the Museo di Palazzo Poggi, for instance, was a series of *écorché* figures by Ercole Lelli, which were consistent with the style of the anatomical Venuses. These full-length figures circle the room in glass cases, posed with arms outstretched to the heavens or holding symbolic objects such as staffs and knives intended to represent their mortality. Again, although these figures are the product of skilful anatomical study and modelling, their primary purpose was not so much to teach anatomy to specialists but rather to celebrate the acquisition of knowledge they represent to a general audience.

In this context, Morandi's moulages are striking for their absence of aesthetic flourishes or cultural framing, and their focus on anatomical verisimilitude. This difference in aesthetics is directly attributable to the different audiences for which Morandi's moulages were commissioned. Much of Morandi's early

25 Messbarger, *The Lady Anatomist*.
26 Messbarger, *The Lady Anatomist*, 40.
27 Messbarger, *The Lady Anatomist*, 21.
28 Anna Maerker, *Model Experts. Wax Anatomies and Enlightenment in Florence and Vienna, 1775–1815* (Manchester and New York: Manchester University Press, 2011).

work, made with her husband, was commissioned by the obstetrician Giovanni Galli, and intended for use in the instruction of medical students. Their series of twenty terracotta obstetric models, exhibited as "birthing machines," represented different stages of foetal development, foetal positions, and birthing methods, and were designed as professional teaching aids. Galli's commission of these models was representative of, and indeed a spur to, a growing market for specialised medical models at this time, which often had less appeal as objects of public display. Unlike Susini's anatomical Venuses or Lelli's *écorchés*, which incorporated highly decorative elements and framed the anatomical body as a celebration of human knowledge, the models Anna Morandi and Giovanni Manzolini made for Galli had a much more muted aesthetic.

This makes Morandi's moulages much more recognisable today as medical models. However, as Messbarger has shown, it also made them less popular with general eighteenth-century audiences and the museum directors who commissioned and exhibited such models. As a result, where Susini's Venuses have remained celebrated and popular exhibits since their production, Morandi's work remained largely overlooked until the publication of Messbarger's own critically acclaimed study in 2010. This reveals a widespread preference for highly aestheticised forms of anatomical modelling in museums at this time, as Messbarger argues:

> The high esteem paid by contemporary critics to the clamorous and eroticised visual pageants of human flesh and mortality represented in the baroque waxworks of Gaeto Zumbo, the epic écorchés of Ercole Elli, and Felice Fontana's anatomical Venuses in contrast to the feeble acknowledgement of Manzolini's and Morandi's dispassionate wax narratives [...] reveals the critical bias against a muted bodily aesthetic rooted in verisimilitude.[29]

Morandi's moulages are not *less* aesthetic than Susini's Venuses or Lelli's *écorchés*, of course; rather, they make use of a *different* aesthetics, one tailored to their pedagogical purpose.

In prioritising their medical verisimilitude at the expense of the moral significance, however, Morandi's moulages represented "an art of science at odds with locally authorised visions of the body and thus—unlike Lelli's heroic écorchés—consigned to the periphery of Bologna's cultural establishment."[30] The dispassionate style of Morandi's moulages thus made them less appealing

29 Messbarger, *The Lady Anatomist*, 70.
30 Messbarger, *The Lady Anatomist*, 51.

to members of the general public than anatomical models produced as art or cultural objects. The aesthetics of Morandi's moulages are in this respect representative of the changing status of anatomical study at this time, and with it the relationship between aesthetics and science. We can see this by contrasting their reception with that of the anatomical Venuses made by Clemente Susini, which he began to produce around the time of Morandi's death. Susini's Venuses amply demonstrate that highly aestheticised modes of anatomical modelling remained very popular well after Morandi's day. As such, his Venuses are an exemplary case study of the ongoing importance aesthetics would have to obstetric and gynaecological models until well into the nineteenth century.

2 Anatomical Venuses and Birthing Machines: The Passive Female Reproductive Body

Anatomical Venuses were amongst the first generation of what is now generally considered the first modern medical models. They were in their own day, and remain in ours, some of the most celebrated objects produced by eighteenth-century anatomy. Full-body models designed to reveal the reproductive anatomy and placement of the foetus, anatomical Venuses were designed with a detachable torso panel that could be removed to show the internal anatomy and organs. Their celebrated anatomical precision was a result of their process of manufacture: the internal organs were moulded from dissected cadavers, and it is claimed as many as 200 bodies were required to produce each Venus.[31] Although there are earlier examples of anatomical Venuses, the most acclaimed were those manufactured by Clemente Susini under the direction of Felice Fontana at the end of the eighteenth century in the anatomy laboratory of the Natural History Museum at the University of Florence (or La Specola).[32] Because these models were produced in a workshop associated both with the University of Florence and with the public museum La Specola, the archive of Susini Venuses has been well-preserved. Susini Venuses remain on display as star exhibits in public anatomy museums including La Specola and the Josephinum in Vienna, as well as the Museo di Palazzo Poggi in Bologna.

31 Jordanova, *Sexual Visions*. Roberta Ballestriero, however, argues that anatomical Venuses were modelled on illustrations rather than actual cadavers, "Anatomical Models," 223–234, 231.

32 See, for instance, Elizabeth Stephens, *Anatomy as Spectacle: Public Exhibitions of the Body from 1700 to the Present* (Liverpool: Liverpool University Press, 2011).

Anatomical Venuses are as striking aesthetically as they are technically, incorporating ornamental details unrelated to their function as anatomical models: each is laid on a white silk sheet draped over red velvet pillows, each is posed with an arched back, mouth open, legs slightly bent, with long loose hair and a string of pearls around the neck. It is this striking style of modelling that made anatomical Venuses so appealing in their own day, and which has made them such a source of fascination ever since. For contemporary viewers, anatomical Venuses seem like the site of a rather jarring encounter between art and anatomy: their aesthetics are undoubtedly striking, and their anatomical detail impressive, but the intersection of these two things in the figure of a medical model strikes many contemporary viewers, less accustomed to seeing anatomical figures modelled with so many aesthetic flourishes, as intensely strange.[33]

Anatomical Venuses were the product of a particular cultural dynamic between art, science, and religion that was changing rapidly at the end of the eighteenth century. For this reason, their production and exhibition history allow us to see how the relationship between these cultural domains was renegotiated at this time, and to recognise the extent to which this renegotiation occurred through the bodies of women. Although they were the product of skilful anatomical study and modelling, their primary purpose was not so much to provide instruction to medical students as to celebrate the acquisition of knowledge about the anatomy to more general audiences.[34] This was achieved by incorporating aesthetic elements, in order to provide a framework by which the display of internal anatomy could become culturally intelligible.

Such framing was necessary because dissected and anatomised bodies were strongly associated with the sphere of public executions, as only the bodies of condemned criminals could be legally dissected. Anatomy occupied a fairly disreputable position in the popular imaginary as a result, as well as a peripheral one in the institutional study of medicine: practical anatomy was not taught at universities, but instead "consigned to subterranean hospital laboratories, the annual Public Anatomy, and, most commonly, professors' private homes."[35] Aesthetically pleasing models like the anatomical Venuses, which appealed to a broad audience, helped to popularise anatomy museums,

33 Joanna Ebenstein, *The Anatomical Venus: Wax, God, Death and the Ecstatic* (New York: Distributed Art Publishers, 2016).

34 Anna Maerker provides a detailed account of the cultural function of the aesthetics of anatomical modelling at this time in her study of the Florentine-based modellers in *Model Experts*.

35 Messbarger, *The Lady Anatomist*, 66.

and, in so doing, helped anatomy itself gain public acceptance as a key part of medical practice and research. Anatomical Venuses were often celebrated, and promoted, as the stars of the new public anatomy museums. They were particularly popular because they drew on familiar aesthetic traditions from the domains of art, religion, and science. As Corinna Wagner has shown, they were explicitly contextualised as part of the tradition of representing female nudes in art as Venuses, and often advertised to affluent tourists as part of a "Grand Tour of Venuses" that included Botticelli's "Birth of Venus" and Titian's "Venus of Urbino."[36] They were also consistent with visual traditions in religious art, recalling particularly the figure of "the Mater Gravida or "Our Lady of Expectations," in which a pregnant Mary was shown with the Baby Jesus visible inside the womb."[37] Finally, they drew on established visual traditions in anatomical illustration. As Jonathan Sawday has shown in *The Body Emblazoned. Dissection and the Human Body in Renaissance Culture*,[38] early modern conventions for representing *écorché* figures include depicting the dissected body as willingly opening its internal anatomy to view, a docile body passively surrendering its mysteries to the medical gaze. Venuses, with their languorous limbs and arched backs, are clearly part of this visual tradition.

It is the confluence of these existing visual and cultural traditions that shaped the modelling of anatomical Venuses and which made them legible as objects of public display. They were such popular exhibits that in the early 1800s they were toured by travelling showmen such as Signor Sarti, who marketed his "The Celebrated Florentine Anatomical Venus" as educational health exhibits.[39] The advertising brochure for a competing travelling Venus, the Parisian Venus, is characteristic of the exhibition of these figures in commercial exhibition halls, in that it devoted a large portion of its explanatory text to reassuring descriptions of the aesthetics of the exhibition:

> The exquisite beauty of the Figure—formed on the model of the Venus de Medici—is exceedingly striking, even at a first glance; but this is nothing to the perfection of workmanship, which this section of the anatomy displays. It is a study for all classes; for the young of both sexes, for husbands and fathers, wives and mothers, the healthy and the unhealthy,

36 Wagner, "Replicating Venus," 14.
37 Ebenstein, *The Anatomical Venus*, 36.
38 Jonathan Sawday, *The Body Emblazoned. Dissection and the Human Body in Renaissance Culture* (London and New York: Routledge, 1995).
39 *The Celebrated Florentine Anatomical Venus: Together with Numerous Smaller Models of Special Interest to Ladies, Showing the Marvellous Mechanism of the Human Body* (Huddersfield: n.p., n.d.).

and especially for the medical student or professor. Nor can we speak too highly of the extreme delicacy with which the whole exhibition (including all necessary explanation) is carried on. Females of the most refined sensibility will find nothing offensive obtruded on their notice; while knowledge of the most important kind is imparted in a manner of all others most calculated to impress it upon the mind.[40]

In emphasising their own adherence to wider standards of "propriety" and "delicacy," these exhibitions of anatomical Venuses also did much to establish the respectability of anatomy itself. For if advertising material for these exhibits in the mid-century focused so emphatically on their respectable and educational nature, it is precisely because these were not yet established characteristics of anatomical displays. Pamphlets such as this, together with the exhibitions they advertise, played an active role in establishing the respectability of anatomy by insisting on their suitability for spectators of the most delicate sensibilities.[41]

Anatomical Venuses thus played a key role in the changing cultural status and significance of anatomy at this time. It is particularly notable that the travelling anatomical Venus shows were staged during one of the most controversial periods in the practice of anatomy in the UK: the 1830s, in the immediate aftermath of the Burke and Hare murders in 1828, in which the two men murdered sixteen people to sell the bodies to anatomy schools. In the lead-up to the passage of the Anatomy Act in 1832, which was designed to expand the pool of corpses available for dissection to include anyone whose relatives did not object (which in practice meant the poor who died in public hospitals or workhouses), there were riots against anatomy schools. It is in this context that we can see the value of the hyper-aestheticised modelling of the anatomical Venuses. Their beauty serves to reimagine the scene of anatomisation; the dissected body here is not the final indignity in the life of the poor and suffering, but an object of care and pampering.

It is in their multiplicity of meanings that anatomical Venuses cast so much light on the relationship between aesthetics and science in the production of anatomical models. Venuses are exemplary of the way anatomical models and images do not simply illustrate or represent anatomical knowledge but are constitutive of it; the assembly of their intricately modelled internal anatomy made visible—and sometimes tactile—aspects of the reproductive

40 *A Description, Anatomical and Physiological, of the Sectional Model of the Human Body, The Parisian Venus; Comprising a Popular Account of the Parts Displayed: The Function and Uses* (Manchester: A. Burgess and Co., 1844), iii.

41 For further discussion of Sarti's Venus, see Stephens, *Anatomy as Spectacle*.

FIGURE 3.6 "Manikin of Professor Theophilus Parvin," from: J. Clifton Edgar, "The Manikin in the Teaching of Practical Obstetrics," *New York Medical Journal* (December 27, 1890), 701–09, here 705
IMAGE COURTESY OF THE WELLCOME LIBRARY

system, pregnancy, and birth that it was not possible to see otherwise. That is, the models produced rather than merely demonstrated new knowledge. At the same time, they were also the product of a specific way of seeing the reproductive female body, as a passive "birthing machine," which would continue to shape gynaecological and obstetric practice well into the nineteenth century. As Brandy Schillace has shown, nineteenth-century mechanised obstetrical models represented a pregnant body that was as passive as that of the Venuses. Dr William Smellie's "Celebrated Apparatus," for instance, was a mechanical woman, "composed of real bones, mounted and covered with articulated ligaments, muscle and cuticle,"[42] that gave birth to leather dolls; Professor Theophilus Parvin's Manikin was a fully posable figure that could be moved into different positions.

Such models are representative of the emergence and development of gynaecology and obstetrics as new fields of medical research restricted to male practitioners, and the increasing marginalisation of female midwives at this time. Despite the protestations of prominent female midwives like Sarah Stone, who argued to "Sisters of the Profession" that it was "in their power to

42 Brandy Schillace, "Of Manikins and Machines: The Evolution of Obstetrical Phantoms," Dittrick Medical History Center, Case Western Reserve University, 26 October 2017. http://artsci.case.edu/dittrick/2013/10/15/of-manikins-and-machines-the-evolution-of-obstetrical-phantoms/.

deliver all manner of Births, with ease and safety, [...] and without exposing the Lives of their Women and Children to every boyish Pretender" claiming expertise in midwifery, over the course of the eighteenth century, the field of midwifery came to be increasingly occupied by men.[43]

3 Conclusion

As the brief analyses of anatomical Venuses and Morandi's medical moulages above has sought to show, the history of anatomical modelling is representative of the changing cultural significance of the female body and knowledge about female reproductive anatomy at this time. A further example of this is provided by Giovanni Galli's collection of birthing machines, housed at the Museo di Palazzo Poggi, which demonstrates the mutually reinforcing relationship between the production of anatomical models and the status of obstetrics as a medical discipline.

At the beginning of the eighteenth century, obstetrics and gynaecology were newly emergent fields of medical research. This situation was changing rapidly during Galli's time, however; between 1732 and 1779, fourteen schools of obstetrics opened in Northern Italy alone. As a new field, notes Lyle Massey, obstetrics appealed to "the ambition of a certain class of surgeon, who sought to move to the rank of physician by staking out and claiming a newly defined arena of medical knowledge."[44] In 1757, Galli was appointed Professor of Obstetrics at the University of Bologna. Yet this flourishing of the field of obstetric modelling, and the corresponding population of anatomy museums with partial models of the female reproductive system it caused, coincided with the increasing exclusion of actual women from any active role in reproduction or birthing. The rise of obstetrics as a field of medical research and of male midwifery as a profession caused a withdrawal of the rights that had

43 Sarah Stone, *A Complete Practice of Midwifery* (London: T. Cooper, 1737), xiv. For an account of this history in Britain, see Adrian Wilson, *The Making of Man-Midwifery: Childbirth in England, 1660–1770* (Cambridge, MA: Harvard University Press, 1995). Margaret Carlyle importantly recognises that the history of midwifery in France is marked by significant differences to that of Britain, with female midwives retaining a much more authoritative role throughout the eighteenth century; see "Phantoms in the Classroom: Midwifery Training in Enlightenment Europe," *Know: A Journal on the Formation of Knowledge* 2, no. 1 (2018): 111–136.
44 Lyle Massey, "On Waxes and Wombs: Eighteenth Century Representations of the Gravid Uterus," in *Ephemeral Bodies: Wax Sculpture and the Human Figure*, ed. Roberta Panzanelli (LA: Getty Research Institute, 2008), 83–105, here 97.

FIGURE 3.7 Giovanni Galli, terracotta birthing machine, ca. 1750, Museo di Palazzo Poggi, Bologna
PHOTOGRAPH: ELIZABETH STEPHENS

FIGURE 3.8 Wax tableau of Giovanni Galli demonstrating Antonio Cartolari's "Birthing Machine" to midwives, Museo di Palazzo Poggi, Bologna
PHOTOGRAPH: ELIZABETH STEPHENS

previously been granted female midwives.[45] Galli himself, it should be noted, was a staunch supporter of female midwives, a support commemorated in a wax tableau on display in the Museo di Palazzo Poggi, which depicts Galli instructing a group of female midwives. Tellingly, he is pointing to a model of Antonio Cartolari's "Birthing Machine," while the figure of a pregnant woman is attended by a female midwife.

The original, full-size model of Cartolari's "Birthing Machine" (see Figure 3.3, above) can be found in the same room as its wax representation. Cartolari's birthing machine is representative of the larger collection of obstetric models at Palazzo Poggi—and most anatomy and medical museums of this period— in that it represents a uterus made fully visible to the gaze of the spectator.[46] There are no obstetric phantoms in Palazzo Poggi, and examples of phantoms from this period are now rare. One of the best know obstetric phantoms to remain from this period is the birthing machine of Angélique du Coudray (1712–1794).[47]

Coudray was another contemporary of Morandi, Bassi, and Bihéron. She had been accepted into the École de Chirurgie in 1740. However, when the field of surgeons was officially expanded to include obstetrics in 1743, female midwives were increasingly excluded from sites of medical training.[48] Coudray successfully petitioned for the ongoing instruction of female midwives, and eventually became a prominent public figure in France.[49] In 1759, she published a midwifery textbook, *Abrégé de l'art des accouchements*.[50] In the same year, Louis XV commissioned her to teach midwifery to peasant women in an attempt to reduce infant mortality. She travelled extensively across France into old age, training both women and male surgeons.

45 Wilson, *The Making of Man-Midwifery*.

46 As Lucia Dacome notes, Galli often blindfolded his students when using Cartolari's machine, so that they were required to learn by touch (174). However, as the wax tableau demonstrates, they were also used as visual models, and Galli himself was able to visually observe his students' hands even when inside the machine. Moreover, the modelling of the uterus from glass is consistent with an anatomical imaginary that sought to make the internal body fully visible to the medical gaze.

47 Pam Lieske notes that there are no remaining British obstetric phantoms from this period; see ""Made in Imitation of Real Women and Children,"" 73.

48 Nina Rattner Gelbart, *The King's Midwife: A History and Mystery of Madame du Coudray* (Berkeley and Los Angeles: University of California Press, 1998).

49 For an overview of Coudray's career and practice, see Carlyle, "Phantoms in the Classroom: Midwifery Training in Enlightenment Europe."

50 Angélique Marguerite du Coudray, *Abrégé de l'art d'accouchement* (Paris: la Verve Delaguette, 1759).

FIGURE 3.9 "La Machine" de Madame du Coudray, Musée Flaubert et d'Histoire de la
Médecine, registered 1778, Rouen
PHOTOGRAPH: ELIZABETH STEPHENS

It was to facilitate this work, as she noted in *Abrégé de l'art des accouche-ments*, that Coudray first devised her cloth birthing machine. This partial man-nequin was designed to provide "hands-on" instruction for local women on foetal positions and birthing techniques. Coudray notes teaching via touch—rather than verbal or visual instruction—proved much more effective for her students. Her model consists of a pumpkin-shaped abdomen and foetal dolls that can be placed in different positions, so that different birthing methods can be practised. Despite the fact that hundreds of Coudray's machines were produced, and Couldray herself was something of a celebrity for her work as a midwife, only one example of a Coudray machine now remains, on display at the Musée du Centre Hospitalier Universitaire in Rouen, France. A second, simpler model is owned by the Dittrick Museum of Medical History in Ohio.

In this way, as we have seen in this chapter, eighteenth-century obstet-ric models were "the result of rather complex and tangled sets of relations between images and bodies," as Massey has argued, and "played a crucial role in detailing how and in what ways the female body could be figured as a site of medical and scientific knowledge."[51] This is evident in the history of obstetric

51 Massey, "On Waxes and Wombs," 96–97.

modelling, and the participation in that history by female anatomical model-
lers, examined above. Such models occupied a changing cultural position in
their own time, when their combination of the aesthetic and scientific often
positioned them at the edges of what was considered the scientific or medical.
As such, they are the site of an enduringly dynamic relationship between the
aesthetic and scientific, and representative of the changing places at which
the lines between them is drawn. It is here we can see the continuity between
the history of obstetric and anatomical models made by women in the eight-
eenth century and the recent engagement with medical imaging technolo-
gies and practices of visualisation by contemporary artists like Nina Sellars,
as discussed at the start of this chapter. In their various ways, the work of all
the women examined in this chapter has actively served to reconfigure the
relationship between the aesthetic and scientific in ways that have critically
intervened in, and sought to influence, the history and practice of anatomical
modelling. By drawing attention to the constitutive role imaging practices and
aesthetic convention has played in the history of medical modelling, and by
working in the unsettled contested spaces between the arts and sciences, they
help us see the history of the relationship images and anatomy in a new light.

The Body in Motion: The Image of Man in Physical Education in Late Eighteenth-Century Schnepfenthal

Heikki Lempa

In Johann Christoph Friedrich GutsMuths's *Gymnastik für die Jugend enthaltend eine praktische Anweisung zu Leibesübungen* (1793) there are nine drawings by Johann Heinrich Lips depicting young men—girls are conspicuously absent—in different physical exercises.[1] The boys are pole vaulting, jumping over ditches, wrestling, running, throwing discus, climbing, balancing, and flying kites. The exercises are dynamic. The gymnasts look young and their bodies fit, even a bit muscular, although their hands and feet appear disproportionately small.

Eleven years later, GutsMuths produced the second edition of his opus magnum. Both the text and the drawings were substantially different. Lips's drawings were replaced with clumsier versions by the author himself. What we find in these nine new drawings are young men jumping up and down, long jumping, pole vaulting, jumping over a ditch with a pole, wrestling, climbing, exercising on a pommel horse, exercising on a hoop, and skating. While some of the exercises are dynamic and require strength, others are pronouncedly aesthetic. And the young men are not only fit but also slender, long hair flying, and faces round and delicate. Their hands and feet are, if possible, even more delicate and smaller than in the first edition. How should we understand these images of man that present themselves on the pages of GutsMuths's book? Are they images of stereotypical male bodies?

George Mosse has argued that "modern masculinity was a stereotype, presenting a standardised mental picture [...] Such a picture must be coherent in order to be effective."[2] For Mosse, the making of the image of the modern man, and particularly his stereotypical body, took place in the latter half of the

1 Hanno Schmitt, *Vernunft und Menschlichkeit: Studien zur philanthropischen Erziehungsbewegung* (Bad Heilbrunn: Klinkhardt, 2007), 216.

2 George Mosse argues for one model imposed on (German) men from the late eighteenth century onwards, in *The Image of Man. The Creation of Modern Masculinity* (Oxford: Oxford University Press, 1996), 5.

FIGURE 4.1 Pole Vaulting (Höhensprung mit dem Stab), Johann Christoph Friedrich
 GutsMuths, *Gymnastik für die Jugend* (Schnepfenthal: Buchhandlung der
 Erziehungsanstalt, 1793), 219
 SOURCE: INTERFOTO / ALAMY STOCK PHOTO

FIGURE 4.2 Pole Vaulting (Stabspringen), Johann Christoph Friedrich GutsMuths,
Gymnastik für die Jugend (Schnepfenthal: Buchhandlung der
Erziehungsanstalt, 1804), 246
COURTESY OF THE BAYERISCHE STAATSBIBLIOTHEK, MUNICH

eighteenth century. This interpretation has found further support in the history of sports and physical exercise. According to Henning Eichberg, between 1760 and 1820, physical exercise became competitive sports that focused on achievement by masculine strength and speed, and thereby became an important marker of what we call modernisation.[3] I argue in this chapter that, in the German lands,[4] there was not one singular image of the man and his body but rather a contested field of competing stereotypes that shaped what we could call the male body. These images portrayed men's bodies not only as robust and muscular but also as sensitive and beautiful. These were not exceptional, as has been claimed, but powerful images equal to the robust and dynamic masculinity. A central part of Eichberg's conclusions are based on his analysis of the gymnastics at the *Philanthropinum* of Schnepfenthal, founded in 1784 by Christian Gotthilf Salzmann. By 1800, Schnepfenthal had become one of the leading institutions of educational reform in Europe. In the German lands, it was a central site of the making of the male body image. It was here that Guts-Muths made his discoveries of physical exercise and tested them on his pupils for over fifty years between 1785 and 1839. How should we then see the images of man as presented by GutsMuths in his book? Should we see in them the pattern of achievement? I suggest that rather than achievement, a pattern of motion characterised the gymnastics of Schnepfenthal and allowed the incorporation of the ambiguous images of man, as both robust and sensitive.

In this chapter, I will first turn to the sources of the imagery of the male body in the latter half of the eighteenth century. Then I will explore the canon of gymnastic exercises instituted by GutsMuths at Schnepfenthal. Finally, I want to take a brief look at the broader implications of the Schnepfenthal gymnastics on the image of the male body in the German lands at the turn of the nineteenth century.

1 Competing Images of Masculinity in the German Lands

The educators of Schnepfenthal were exposed to a rich and complex anthropological imagery of masculinity. Salzmann was an enthusiastic advocate of the man of strength and endurance, referring often to the European settlers in

3 Henning Eichberg, *Leistung, Spannung, Geschwindigkeit. Sport und Tanz im gesellschaftlichen Wandel des 18./19. Jahrhunderts* (Stuttgart: Klett-Cotta, 1978), 55–57.
4 By "the German lands," I refer to the German lands proper, the Holy Roman Empire, and those regions and states in Europe that either spoke German—as much of Switzerland did— or were significantly and intimately influenced by it, such as Denmark or the Baltics.

America as the physical ideal comparable to the Stoics. In a story in *Der Bote*, Salzmann's widely read periodical, he allowed the protagonist to observe how an American woman "took an infant and carried him to a container filled with cold water, held him awhile above the container, dipped the child in the water, pulled him out, and dried him off."[5] Also, the noble savage had its many variations in late eighteenth-century social imagery—Joachim Heinrich Campe's children's book, *Kolumbus* (1782–88), made effective use of it[6]—depicted with either Inuits or Native Americans, yet in this case the Americans of European origin served Salzmann's purposes. GutsMuths was well aware of the shortcomings of the "noble savage." The man of nature, he observed, displayed "bodily well-being combined with the brutality of the mind."[7] He was just as incapable as his cultivated and effeminate brother of reaching the realm of true humanity. Only through the harmony of the mind and body, argued GutsMuths, could the new man become the source of culture. It was not in Rousseauian nature predating civilisation, but in the civilisation of the Greeks, that he found the complementary model for man. GutsMuths vigorously pointed out that Plato's pledge for the unity of gymnastics—education of the body, and music—education of the mind—foretold his own ideas, namely that Plato's educational ideas anticipated modern gymnastics. Greek exercises, GutsMuths argued, promoted true manliness because the Greeks saw that "pampered children become slaves as men," and because the Greeks "distinguished themselves in the beauty and harmony of the body."[8] At the same time, GutsMuths depicted another image that was even more effective than the traditional Greek image of man—the ancient tribal Germans: "So German gymnastics should therefore completely follow German ends but not wholly those of the Greeks and Romans."[9] The ancient Germans were men of nature, the physical opposite and model to GutsMuths's contemporaries. The ideal was "the unity of Germanic

5 Christian Gotthilf Salzmann, *Der Bote aus Thüringen*, vol. 5 (1792), 438–439.

6 See also how Johann Christoph Friedrich GutsMuths refers to Hurons as the models of the noble savage, in *Gymnastik für die Jugend. Enthaltend eine praktische Anweisung zu Leibesübungen. Ein Beytrag zur nöthigsten Verbesserung der körperlichen Erziehung* (Schnepfenthal: Buchhandlung der Erziehungsanstalt, 1793), 154.

7 GutsMuths, *Gymnastik* (1793), 151.

8 GutsMuths, *Gymnastik* (1793), 156–157, 168–169, 178, 184.

9 "So schmiege sich denn deutsche Gymnastik ganz an deutsche Zwecke; aber bei weitem nicht ganz an die der Griechen und Römer" (GutsMuths, *Gymnastik* (1793), 206). GutsMuths also made positive notes on Native Americans as models of vigorous men of nature, in GutsMuths, *Gymnastik* (1793), 64; see Johann Christoph Friedrich GutsMuths, *Gymnastik für die Jugend. Enthaltend eine praktische Anweisung zu Leibesübungen. Ein Beitrag zur nöthigsten Verbesserung der körperlichen Erziehung* (1804) (Frankfurt/M: Limpert, 1970), 9. Cf. Mosse, *The Image of Man*, 41–42.

physicality and power, courage and manliness (*Mannsinn*) with the culture of the heart and mind" of the ancient Greeks.[10]

The Greek and Germanic images of man travelled to GutsMuths's writings from sources that had become popular since the middle of the eighteenth century. In his writings Johann Joachim Winckelmann raised the Greek body, especially the male body, as the paradigm of physical beauty. The grace of Greek statues, argued Winckelmann, came not only from the formative genius of the sculptors, but also from the superior quality of their models. Partly this "was influenced by the mild and clear sky" of Attica, but the Greeks also had an easy and cheerful nature that displayed itself in the "practice of physical exercise from an early age" that "gave this development its noble forms."[11] Moreover, for the Greeks, the practice of gymnastics was not strenuous labour, but "exercise at gymnasia with cheer and joy," because overly strenuous exercise would produce edgy and fencer-like (*fechtermäßige*) bodies.[12] Winckelmann was not a lover of strongman culture. The parameters of his ideal body were fitness, smoothness, adroitness, and certain suppleness. Winckelmann spent the most creative phase of his life in Italy, but he was most influential in Germany. The decades following the publication of his *Gedanken über die Nachahmung der griechischen Werke in der Malerei und Bildhauerkunst* (1755) saw a feverish enthusiasm for Hellenic values and ideals. Embraced by intellectual mandarins such as Johann Kaspar Lavater and Gotthold Ephraim Lessing, and disseminated in leading periodicals of the time, the *Teutscher Merkur* and the *Göttingische Gelehrte Anzeigen*, Winckelmann's aesthetics spread in the German lands. The image of the Hellenic body, especially the male body, became a standard against which the cultural elite measured its own appearance.[13] Alongside the Hellenic standards of the body, another model made itself known. The body of the Germanic tribesman rapidly gained relevance after the 1780s.

10 GutsMuths, *Gymnastik* (1793), 54.

11 Johann Joachim Winckelmann, *Reflections on the Imitation of Greek Works in Painting and Sculpture*, trans. Elfriede Heyer and Roger C. Norton (La Salle: Open Court, 1987), 7.

12 Johann Joachim Winckelmann, "Erläuterung der Gedanken von der Nachahmung der griechischen Werke in der Malerei und Bildhauerkunst," in *Gedanken über die Nachahmung der griechischen Werke in der Malerei und Bildhauerkunst* (Stuttgart: Reclam, 1999), 84.

13 On the scholarship on Winckelmann's notion of the body, see Klaus Schneider's instructive, *Natur, Körper, Kleider, Spiel. Johann Joachim Winckelmann. Studien zu Körper und Subjekt im späten 18. Jahrhundert* (Würzburg: Verlag Königshausen & Neumann, 1994), 5–8. Mosse sees Winckelmann as the most important author of the modern male body, especially its aesthetic Greek stereotype. But by the same token, Mosse pays little attention to the tribal origins of the German male body (*The Image of Man*, 29–39).

The manifold history of old Germanic body imagery has only been sporadically researched. We are familiar with the images of the ancient German in Tacitus; we also know about the lively reception of Tacitus in the sixteenth century among the Humanists by von Hutten and Melanchthon, Pufendorf's interest in the Germanic roots of the *Reich* in the seventeenth century, and the Germanic revival around the middle of the eighteenth century, especially in Justus Möser's *Osnabrückische Geschichte*, where the ancient Germans were absorbed into an overarching historical narrative of a Germanic region.[14] But not until the 1790s do we find images of the robust German becoming a template of educational reflection. Some of the first systematic uses of Germanic imagery in education were intimately connected with the Schnepfenthal *Philanthropinum*, and especially the writings of GutsMuths. The question is how it was possible to amalgamate such different images of masculinity and male body. I suggest that this was possible because GutsMuths effectively appropriated traditional forms of physical exercise and motion.

2 Developing Regimens of Gymnastic Exercises

Wolfgang Behringer has suggested that modern bodily exercise and sports began in the sixteenth century. Not only were jousting but also floor exercises, dancing, fencing, and ball games practised in early modern Europe.[15] Nevertheless, such practice does not yield its own historical meaning. Why should we consider dancing and a ball game sharing the same historical *locus communis*, having the same historical meaning? In the early modern canon, ball games were associated with other games, such as chess, billiards, and bowling. Yet games were different from exercises, *Exerzitien*, that dealt directly with the body—and dancing did. There were two traditional categories of exercise: hygienic-dietetic and genteel. By the end of the eighteenth century, German educators added popular German strongman exercise and pentathlon, the ancient Greek exercise, to the repertoire of the *Exerzitien*.

14 See Jost Hermand's excellent overview, "Vorwort. Vom altständischen Reichsgedanken zum deutsch-nationalen Befreiungskriegspathos," in *Revolutio germanica. Die Sehnsucht nach der "alten Freiheit" der Germanen, 1750–1820*, eds. Jost Hermand and Michael Niedermeier (Frankfurt/M: Peter Lang, 2002), 1–20. On Möser's interest in the ancient Germans, see Jonathan Knudsen, *Justus Möser and the German Enlightenment* (Cambridge: Cambridge University Press, 1986), 60–61.

15 Wolfgang Behringer, "Arena and Pall Mall: Sport in the Early Modern Period," *German History* 27, no. 3 (2009): 331–334. See also Wolfgang Behringer, *Kulturgeschichte des Sports. Vom antiken Olympia bis zur Gegenwart* (München: Beck, 2012).

In early modern Germany, exercise was a part of dietetics, which was an important component of traditional medical therapy and prophylaxis. In dietetics, manipulating the so-called six non-natural things, which regulated the relationship between the body and its environment healed and maintained the body. Exercise—"motion and rest"—was one of the six non-naturals. The dietetic concern of the body was therefore not about exercising the body but making the body move either through the body itself or through an outside impact. Still in the 1790s, educators saw "motion" to include passive motion, such as taking a carriage ride, and active motion, which they divided into involuntary (heartbeat) and voluntary motion (physical exercise).[16] In the repertoire of motions, active physical exercise occupied only a small corner of the larger understanding of "motion." During the last decades of the eighteenth century, this corner started to expand, not least because of the inventions at the Schnepfenthal Institute.

Motion (*Bewegung*) had become an important component of education in the 1770s. Several progressive boarding schools, such as Marschlins (Switzerland), Dessau, and Halberstadt, recognised the educational benefits of bodily motion, be it walking—a preferred kind of motion—or as in Marschlins, dancing, fencing, music, singing, and games (including running and swimming).[17] In Schnepfenthal, the early drafts of the physical education plan followed these ideas. In his announcement of the Schnepfenthal Institute from 1784, Salzmann reported that,

The physical exercises (*körperlichen Übungen*) are

a. running, jumping, walking on a narrow beam, various games, dances, and riding connected with harmless motions of the body.
b. singing,
c. playing various instruments. I do not support the instruction in wind instruments and leave always the responsibility to the parents.
d. gardening,
e. book binding,
f. all kind of mechanical work.
g. glass grinding. This exercise I allow only for those who show some talent.
h. daily walks and regular trips.[18]

16 Gerhard Ulrich Anton Vieth, *Versuch einer Encyklopädie der Leibesübungen*, vol. 2, *System der Leibesübungen* (Berlin: Carl Ludwig Hartmann, 1795), 14–15.

17 Carl Friedrich Bahrdt, *Philanthropinischer Erziehungsplan oder vollständige Nachricht von dem ersten wirklichen Philanthropin zu Marschlins* (Frankfurt/M: Eisenberg, 1776), 41, 366–367.

18 Christian Gotthilf Salzmann, "Noch etwas über die Erziehung nebst Ankündigung einer Erziehungsanstalt," in *Ch.G. Salzmanns Ausgewählte Schriften. Mit Salzmanns Lebensbeschreibung*, vol. 2 (Langensalza: Verlag von Hermann Beyer & Söhne, 1901), 66.

In two years, this wish list of activities had been replaced with a more coherent program. Salzmann reported that there was now a designated field for gymnastics and that they did a certain canon of exercises: balancing on an elevated beam, jumping over bars, long jumping, throwing at targets, pole vaulting, fast walking or marching, and carrying loads. When the weather did not allow outdoor exercise, chamber gymnastics was performed concentrating on motions that improved carriage and bearing.[19]

The teacher who gave structure to the physical exercises was GutsMuths. Assisted by Christian Ludwig Lenz, GutsMuths started to design a repertoire of regular exercises and, in 1788, a report from the Institute mentioned that the following exercises were performed on a regular basis: competitive running, vaulting on a pommel horse, jumping over a ditch, jumping over a stick, marching, throwing at a target, assessment of distance, balancing on a beam, reading aloud on a field, lifting a weight with a bar, skating, and sledding.[20] In the early years the repertoire was a combination of exercises whose genealogy can be traced to the pentathlon of Ancient Greece (running, jumping), genteel exercises (vaulting on a pommel horse, skating, marching), or popular strongman sports (lifting weights). However, many of them were GutsMuths's own innovations or modifications, such as throwing at a target, reading aloud, and balancing. One of the exercises definitely belonged to the old dietetics of passive motion, namely sledding. But the most important feature was the idea of endless improvement and assessment. GutsMuths kept statistics of "how much each pupil could achieve and how much they improved every week."[21] The desire for endless progress in physical performance motivated GutsMuths's project. This seemed to be in contradiction with traditional dance training in which perfect pose and motion were the ideals, to the extent that some dance teachers considered dancing as applied geometry.[22]

In the 1790s, GutsMuths established a scheme of motions that provided the pupils with a canon of physical exercise. It is striking how many of the exercises were derived from dancing. Not only the jumps but also balancing, dexterity, and several exercises with rope and stick stemmed from dance movements. A closer look at the ways GutsMuths formalised the canon of physical exercise

19 Christian Gotthilf Salzmann, *Nachrichten aus Schnepfenthal für Eltern und Erzieher*, vol. 1 (Leipzig: Siegfried Lebrecht Crusius, 1786), 76–79.

20 Christian Gotthilf Salzmann, *Nachrichten aus Schnepfenthal für Eltern und Erzieher*, vol. 2 (Leipzig: Siegfried Lebrecht Crusius, 1788), 43–44.

21 "wieviel jedes Zöglings Kräfte vermögen, und wie weit sie sich jede Woche vermehren" (Salzmann, *Nachrichten aus Schnepfenthal*, vol. 2, 44).

22 Johann Pasch, *Beschreibung wahrer Tanz-Kunst, Nebst einigen Anmerckungen über Herrn J.C.L.P.P. zu G. Bedencken gegen das Tanzen* (1707) (Munich: Reimer Verlag, 1978), 16, cf. 40.

shows how dance movements and their quest for perfection of motion continued to influence GutsMuths's thinking and activities in Schnepfenthal, although he fostered the sense of competition and progress in achievement as well.

Three strategies helped GutsMuths formalise the modes of motion and create a taxonomy of physical exercises. First, the arrangement of competitions; second, the insistence on careful measurement; and third, a careful analysis of movements. We have the first account of a competition at Schnepfenthal from December 3, 1791. The weather was perfect, and students had trained enough during their daily long walks. Now "the issue was finally taken more seriously; a running track was measured exactly [...] and a formal running contest could start."[23] The results were reported as follows: Schlingemann ran half a German mile (ca. 3,500 m) in 21 minutes; Carl Ritter ran more than half a German mile in 22½ minutes, Schweizer almost 2/3 of the German mile in 24½ minutes and Werthmüller, the youngest competitor, ran 1/4 of the German mile in 12 minutes.[24] The results were not organised in a ranking order. They were hardly comparable but carefully reported: lengths were measured, and timing was in place. Rather than a competition we can see it as a series of individualised accomplishments. From July 31, 1792, we have another account that produced an important change. The contest was in pole vaults and the results were reported in the order of "how high each pupil could jump, and they were divided according to their results into three classes."[25] The first class included those who cleared 80 inches. Only Ritter could. The second class included those who cleared 60 inches and Richter, von Balthasar, Schlingemann, von Truchseß, Schweizer, Ph. Salzmann, Welker, Wetter, Born, Werthmüller und E.v. Münchhausen achieved this. The names of those who could not make 60 inches and belonged to the third class were not reported.[26] Again, the ranking did not produce an individualised ranking order but a list of achievements or groups; not the best but the minimum achievements were recorded. A year later, September 19, 1793, a running contest was organised, "in which the goal was not so much speed but endurance."[27] The results were reported from the worst to the best so that the names of the last four were not mentioned. The

23 *Nachrichten aus Schnepfenthal. Für die Eltern und Freunde der dasigen Zöglinge* (1791), 104.
24 *Nachrichten* (1791), 104.
25 *Nachrichten aus Schnepfenthal. Für die Eltern und Freunde der dasigen Zöglinge* (1792), 64.
26 *Nachrichten* (1792), 64.
27 *Nachrichten aus Schnepfenthal. Für die Eltern und Freunde der dasigen Zöglinge* (1793), 78–79.

top contenders were reported as following: "All were exceeded by *Werthmüller, v. Kotzebue, Matthäi,* who ran 23 times around the stadium and these were exceeded by Carl *Salzmann* who ran 24 times around the stadium."[28] Here was a competition; the winner was reported, his accomplishment was recorded but the following competitors were not mentioned by their individualised accomplishments. What was important, too, was the appearance of the runner. For instance, Carl Salzmann was described as having run with a "face that was almost not at all uncommonly red and his breathing was only slightly faster."[29] The competition did not make the champion, but the bearing of the competitor did.

GutsMuths did not view competition as an end in itself. It could not trump the sense of perfection and appearance of mastery so important to the performance of a movement. In the second edition of his *Gymnastik* from 1804, GutsMuths insisted that "in any exercise one should pay more attention to good, felicitous bearing than to the highest accomplishment (*Grade der Uebungen*)."[30] Competition required measurement, but rather than fostering a spirit of individual achievement and victory, it, in the final analysis, amounted to a sense of perfection, beauty, and appearance. Yet, competition required a careful analysis of motions. The exact evaluation and measurement of each individual performance presupposed a careful taxonomy of different types and degrees of exercise. Jumping, as the dominant mode, is a good example.[31] GutsMuths distinguished five different types: 1. high jumping without a vault, 2. high jumping with a vault, 3. "deep" jumping without and with a vault, 4. long jumping without and with a vault, 5. combined high and long jumping and "deep" and long jumping. Each of these categories was arranged according to the complexity of the corresponding movement. For instance, the high jumping without a vault, by far the most extensive category, consisted of elementary movements, such as plain jumping in place and jumping on one foot and genuine exercise. The difference between elementary and genuine movement was clear. The former was preparatory in nature whereas the genuine could be measured. They resulted in real performance.[32]

28 *Nachrichten* (1793), 78–79.

29 *Nachrichten* (1793), 78–79.

30 "Man sehe bey allen Uebungen mehr auf guten, trefflichen Anstand, als auf höchste Grade der Uebungen" (GutsMuths, *Gymnastik* (1804), 280).

31 See Hajo Bernett, *Die pädagogische Neugestaltung der bürgerlichen Leibesübungen durch die Philanthropen* (Stuttgart: Karl Hofmann, 1960), 70–72, who argues that GutsMuths's invention of measurability represents a capitalistic logic of achievement (*Leistung*).

32 GutsMuths, *Gymnastik* (1793), 222–225.

Measurability was GutsMuths's second strategy in organising the gymnas-
tics, and it was closely related to, in fact dependent on, simplicity.[33] Although
the forms of genuine movements, such as the high-long and deep-long jump-
ing, were complicated, their complexity was manageable because the perfor-
mance of them could be divided into their component parts. For instance,
in aristocratic exercise, vaulting on the pommel horse had been the classical
mode of a jump. For GutsMuths, it was not manageable because it contained
non-generic features: it was not a pure jump but belonged to a category that
he called balancing.[34] His new gymnastics simply could not absorb this aris-
tocratic exercise because its taxonomic principles were different. Taxonomic
incompatibility was a significant problem for GutsMuths and he tried to solve
it in the second edition of *Gymnastik* (1804) by including both dancing and
fencing.

The section on fencing received special attention. GutsMuths entrusted
its discussion to the fencing master of the University of Erlangen, Johann
Adam Karl Roux, a descendant of a famous old family of fencing instruc-
tors.[35] Roux was convinced that "all rules that the art of fencing follows, as
long as it remains within the boundaries of reason, correspond exactly with
the constitution of our body and the sword. Its first principles are derived from
general mathematics."[36] In the classical rapier, the geometrical structuring of
space determined the configurations of the exercise. The elements of fencing
stemmed from the fixed number of possible positions the fencer could take
in relation to the adversary.[37] The anatomy of the body, its strength, dexterity,
and endurance did not play a dominant role in defining the configurations of
classical fencing. Roux could thereby not transform fencing into a pure exer-
cise, as GutsMuths had required. His chapter on fencing in the 1804 edition of
Gymnastik remained faithful to the classical tradition, to the ideal of perfect
motion, which was so prevalent in another genteel exercise, dancing.[38]

33 Cf. Christiane Eisenberg, *"English Sports" und deutsche Bürger. Eine Gesellschaftsges-
 chichte 1800–1939* (Paderborn: Ferdinand Schöningh, 1999), 100.
34 GutsMuths, *Gymnastik* (1793), 233.
35 In 1798, Roux published a manual on fencing as physical exercise, *Gründliche und vollstän-
 dige Anweisung in der deutschen Fecht-Kunst auf Stoss und Hieb* (Jena: Wolfgang Stahls
 Buchhandlung, 1798), 3–4. The book contains only a short passage on the educational
 benefits of fencing.
36 Roux, *Gründliche*, 3.
37 According to Anton Friedrich Kahn the geometrical approach was in decline by the mid-
 dle of the eighteenth century; see *Anfangsgründe der Fechtkunst* (Göttingen: L. Schultze,
 1739), 31. Cf. Eichberg, *Leistung*, 67.
38 GutsMuths, *Gymnastik* (1804), 147–155.

GutsMuths went to great lengths to change the nature of dancing. He believed that "our common dances do not deserve to be recommended unconditionally as gymnastic exercise, [...] because their main content derives from love."[39] Contemporary dancing was "pretentious," "feeble," and "artificial," whereas GutsMuths's gymnastics was supposed to express true "powerful" and "flexible" manliness, i.e. the principles of morality and strong-mindedness.[40] To overcome what he considered the hopelessly effeminate features of social dancing, GutsMuths accidentally found a solution. He discovered that by attaching a rope to a small sandbag, he had an educational instrument for use in dancing. By spinning the rope in a circle at a specified height, the teacher could make the pupils jump at a certain tempo.[41] The arrangement was most convenient for single "dancers." Simple, unified, and pure movement replaced the inconvenient complexities of social dancing. GutsMuths's device had reduced educational dancing to a variation of jumping. This was exactly the opposite of what was happening in social dancing, where jumps were being replaced by sweeping steps that never lost contact with the floor. GutsMuths, however, was interested in silencing the erotic connotations of dancing and celebrating its manly, purely physical benefits. This does not mean that GutsMuths rejected the idea of exercise for women.[42] However, he rejected what he considered the feminisation of physical conduct in favour of manliness, which he held up as a moral ideal. The rules of simplicity, measurability, and anatomical utility that defined jumping in GutsMuths's new gymnastics were also applied to running, climbing, and lifting, creating a true taxonomy, or "system," of physical exercise.[43]

GutsMuths's taxonomy set new standards for physical exercise, for the bodily conduct, and, in fact, for the art and image of bodily movement. Not the anatomical constitution of the body but the modes of movement was the foundation of his taxonomy. And, as we have seen, dancing and fencing remained central practices for inspiration. This becomes even clearer when we look at

39 GutsMuths, *Gymnastik* (1793), 370.
40 GutsMuths, *Gymnastik* (1793), 372–374.
41 GutsMuths, *Gymnastik* (1804), 183.
42 GutsMuths, *Gymnastik* (1804), 273–274.
43 Games that GutsMuths had compiled in his *Spiele zur Uebung und Erholung des Körpers und Geistes für die Jugend, ihre Erzieher und alle Freunde unschuldiger Jugendfreuden* (Schepfenthal: Verlag der Buchhandlung der Erziehungsanstalt, 1796), followed pedagogical and anatomical principles. The first category, games of motion (*Bewegungsspiele*), were divided by mental and bodily faculties. The second category, sedentary games (*Ruhespiele*), were also divided according to observation, judgment, attention, memory, fantasy, taste, and reason; see GutsMuths, *Spiele*, esp. 42–46.

dancing at Schnepfenthal. It was not a central exercise in GutsMuths's manuals, but it continued to flourish as one of the foundational forms of education for Salzmann's pupils. Dancing was important because most of the students came from aristocratic families and needed dancing skills and comportment appropriate to their class. The school had hired dance master Naumann who came twice a year from Erfurt and stayed several weeks to teach dancing.[44] Riding, another aristocratic exercise, was also offered.[45] A great favourite among the students was skating on nearby ponds.[46] These exercises provided continuity with the traditional genteel exercises and they also enforced a specific configuration of bodily comportment: the movement. The impact of GutsMuths's taxonomy of gymnastic movements was significant and broad. Schnepfenthal had a continuous stream of visitors who were especially interested in gymnastics.[47] And GutsMuths's book sold well. By 1846, more than twenty new editions and translations of his *Gymnastik* had been published in German, English, Danish, Italian, Greek, and Dutch.[48]

3 Conclusion: Making the Classic German Male Body

I started my discussion with a critical note on Eichberg's statement that, between 1760 and 1830, athletics became a competitive sport. We have seen that in Schnepfenthal competition was not a goal but subjugated to a higher principle of perfection. This principle was not based on an unlimited progression in achievement but on a fulfilment of what traditionally was considered a perfect configuration of dance, riding, and fencing. In GutsMuths's hands this traditional principle was formalised and incorporated in an array of exercises. It was not necessarily a part of what has been considered the Enlightenment, a

44 See, for example, a report from October 1, 1790: "Heute Abend kam unser lieber Herr Tanz-
 und Schanzmeister Naumann aus Erfurt, um uns wieder einige Zeit im Tanzen Unter-
 richt zu ertheilen," *Nachrichten* (1790), 30. See also *Nachrichten* (1791), 42, 90; *Nachrichten*
 (1792), 87.
45 Salzmann's eldest son, Karl, was a trained riding master and, once the facilities were fin-
 ished in the fall of 1793, he started to teach riding; see *Nachrichten* (1793), 100–101.
46 When the ponds were frozen, which could happen by late November, Lenz took the stu-
 dents to the ice; see *Nachrichten* (1793), 103; *Nachrichten* (1794), 12; *Nachrichten* (1795), 18;
 Nachrichten (1796), 10, 105.
47 *Nachrichten* (1791), 108; *Nachrichten* (1792), 51–52; *Nachrichten* (1795), 83.
48 Ursula Weidig, "GutsMuths-Bibliographie," in *Festschrift zum 200. Geburtstage von Johann
 Christoph Friedrich GutsMuths* (s.l.: Ministerrat der Deutschen Demokratischen Republik,
 1959), 97–98. On the reception and influence of GutsMuths's thought, see Willi Schröder,
 Johann Christoph GutsMuths. Leben und Wirken des Schnepfenthaler Pädagogen (Sankt
 Augustin: Academia Verlag, 1996), 135–147.

movement that spread and used the new sciences to understand the world and improve human life. Too many of GutsMuths's tools had old and ancient origins to justify the use of the Enlightenment in understanding his projects. But GutsMuths's principle of perfection constituted something that we can call classic. It did not provide immediate support for the modern capitalistic competition and focus on achievement. As the sport history of the late nineteenth century shows, it provided an effective means to resist capitalistic modernisation. In the German lands, gymnastics and athletics, I argue, did not become a concomitant of what we consider modern. Nevertheless, it did become classic. It set the standards that its designers and followers considered as perennial, as having grasped and fulfilled the ultimate truth, beauty, and good. For these standards this movement became the foundation of what we could consider the classic German idea of physical exercise: *Bewegungskultur*.

In July of 1793, Friedrich von Schiller published an article on "Grace and Dignity" in *Thalia*. Inspired by Winckelmann's depiction of the Apollo of Belvedere, Schiller formulated what he considered the classic expression of the synthetic beauty. This "higher beauty" combined grace (*Anmut*) and dignity (*Würde*), the idealised female body with the idealised male body.[49] By creating an androgynous image of beauty Schiller gave a compelling alternative to the robust Germanic and hardened Stoic image of masculinity. Was GutsMuths aware of Schiller's text? The connections between Weimar and Schnepfenthal were at best tenuous and often hostile. Schnepfenthal and the *Philanthropismus* represented to Goethe, Schiller, Herder, and other members of the Weimar circle the antithesis of their vision. There is no reference to Schiller in GutsMuths's work from the 1790s and the contacts between the intellectuals of Weimar and the pedagogues of Schnepfenthal were infrequent. Goethe visited Schnepfenthal twice, and the Crown Prince of Weimar, Carl Friedrich, paid a visit with his entourage to the Institute in 1792, but there is no evidence of Schiller or Herder visiting Schnepfenthal.[50] Besides these rare visits, more personal connections to Weimar circles were established through Christian Lenz who, in 1806, settled in Weimar as the director of the local *Gymnasium*.[51] In Schnepfenthal, Lenz was a passionate classicist and a teacher of Latin and

49 Friedrich Schiller, *Sämtliche Werke*, vol. 5 (Munich: Hanser, 1959), 481.

50 *Das Gästebuch von Erziehungsanstalt Schnepfenthal*, 22.7, 1786–9.6, 1829. Museum der Salzmann-Schule, Waltershausen, does not include the entries, because the respective pages have disappeared. Less-known figures from Weimar, such as Christoph Heinrich Krüger (December 12, 1790) and Johann Christian Günther (August 13, 1793), had their entries in the Guest Book of the Institute. On Carl Friedrich's visit, see *Nachrichten* (1792), 76.

51 Johann Wilhelm Ausfeld, "Kurze Charakteristik Salzmanns," in Christian Gotthilf Salzmann, *Volks- und Jugend-Schriften*, vol. 1. (Stuttgart: Hoffmann'sche Buchhandlung,

Greek praised by Salzmann for his skills and dedication.[52] At the same time, Lenz assisted GutsMuths by being in charge of such gymnastic exercises as swimming and skating.[53] Against this backdrop of classics combined with gymnastics it is understandable that GutsMuths's embrace of Germanic imagery did not amount to the rejection of Greek ideals. In *Gymnastik* we find therefore an image of the male body that was surprisingly similar to Schiller's vision of the higher, moral beauty of the body.

In this study I have traced how the educators of Schnepfenthal developed their image of the German male body. This vision was inspired by the antagonistic ideas of the ancient Greeks and Germanic tribesmen. GutsMuths merged these ideas into a model of what I call classic German masculinity. It was an ideal that responded to the tense political situation of the early 1790s; the heightened awareness that the threat from the West was not only a threat of a different political constitution against the traditional ones in the German lands but that of a people against another people, i.e. the French against the Germans. But it was also an ideal that accommodated the political and cultural concerns ascribed to the unsophisticated and brutal habitus of the robust German, capable of insubordination, as the conservative author Ernst Brandes suggested, and Salzmann was afraid of.[54] GutsMuths diverted these concerns by resorting to the ancient Greek ideals of sensitive masculinity that Winckelmann had reformulated forty years earlier.

I have focused on the educational theories and practices in Schnepfenthal. Anne-Charlott Trepp has shown how important the model of sensitive masculinity was for German social history and its gender system.[55] The case of Schnepfenthal suggests that this model had its political underpinnings as well. Although much more research is needed on other educational institutions, family practices, and such traditional male institutions as the military

1845), 122; *Allgemeine Deutsche Biographie*, vol. 18 (Munich/Leipzig: Duncker & Humblot, 1875–1912), 272.

52 Christian Gotthilf Salzmann, *Reisen der Salzmannischen Zöglinge*, vol. 6 (Leipzig: Siegfried Lebrecht Crusius, 1793), 210. An example of the importance of the classics is the curriculum of 1796; see *Nachrichten* (1796), 41.

53 Salzmann, *Nachrichten*, vol. 2, 43–44; *Nachrichten* (1790), 18.

54 Ernst Brandes, "Ueber den verminderten Sinn des Vergnügens," *Berlinische Monatsschrift* 5 (1790): 421–475.

55 Anne-Charlott Trepp sees the new male image as a representation of emotionalisation; see *Sanfte Männlichkeit und selbständige Weiblichkeit. Frauen und Männer im Hamburger Bürgertum zwischen 1770 und 1840* (Göttingen: Vandenhoeck & Ruprecht, 1996), 25–30. See also Rebekka Habermas, who sees the new masculinity in the alignment of men and women's activities in education, in *Frauen und Männer des Bürgertums. Eine Familiengeschichte (1750–1850)* (Göttingen: Vandenhoeck & Ruprecht, 2000), 259–265.

to confirm this thesis, an interesting parallel in the years after the Napoleonic Wars shows how the dialectic of sensitive and robust masculinity retained its political potential. In the 1810s, Friedrich Ludwig Jahn incorporated the robust German male body into his gymnastics, *Turnen*, and made what has been described as the gymnastics of manliness a central part of the German male culture. Henrich Steffens and Johann August Kotzebue, eminent critics of Jahn and his gymnastics, quite correctly argued that gymnasts displayed the spirit of insubordination and were involved in and even directly responsible for a series of political provocations, especially in the Wartburgfest in 1817.[56] As a result, Scheerer proposed a return to the old dancing, fencing, and riding controlled by the state.[57] At the same time, the sensitive man was promoted by an increasing number of influential dance masters, such as Franz Anton Roller and Eduard David Helmke.[58] Once Jahn's gymnastics were banned in 1819, it seemed that the model of a robust German man had been defeated, until the 1840s when *Turnen* was reintroduced in Prussia. What these notes indicate is that in both trajectories, the image of sensitive masculinity and the ideal of a robust German man contributed to the classic German male body. There was no one singular image of the German man and his body but rather a contested field of competing stereotypes that shaped what we could define as the classic German male body.

56 Wilhelm Scheerer, *Die Turn-Fehde, oder: Wer hat Recht?* (Berlin: Krause, 1818), XV; Henrich Steffens, *Caricaturen des Heiligsten*, vol. 1 (Leipzig: Brockhaus, 1819), 411–451.

57 Scheerer, *Die Turn-Fehde*, XIV.

58 On the *topos* of the sensitive man in the nineteenth century, see Heikki Lempa, *Beyond the Gymnasium. Educating the Middle-Class Bodies in Classical Germany* (Lanham: Lexington Books, 2007), 112–162; and in the Weimar Republic, Erik N. Jensen, *Body by Weimar. Athletes, Gender, and German Modernity* (Oxford: Oxford University Press, 2010), 25–27.

PART 2

Identity and Visual (De)Formation

∴

Photography, Arrested Development, and the Facial Expression of Emotion

Corinna Wagner

In the late 1860s, Charles Darwin collected photographs of a wide variety of faces, ranging from cross-dressing actors to crying babies, as research for his third book on evolution, *The Expression of the Emotions in Man and Animals* (1872). Photographs could catch ephemeral facial movements, reveal emotional nuances, provide insight into muscular movement, capture external signs of interior life, and make it possible to compare expressions through time and across races and species. Darwin took inspiration from the French neurologist Duchenne de Boulogne, who used photography for clinical documentation in *The Mechanism of Human Facial Expression* (1862), and from the ethnologist T.H. Huxley's efforts to collect photographs of the "races" of the British empire. Darwin had hopes that, as polymath John Herschel predicted, "real life" could be captured "by a snapshot [...] in a tenth of a second."[1]

Darwin quickly became aware that the technology got in the way of capturing real life. Cameras made subjects self-conscious and cued performance. He needed subjects who were less self-aware, less constrained by social convention. Individuals with mental illness were thought to be, like children, less guarded about their emotions, and it was generally assumed that their expressions were more instinctual, more authentic, and closer in kind to those of other animals. As he recounts, Darwin's visits to "several shops in London to try to buy photographs of the insane"[2] were unsuccessful and so he turned to the neuro-psychiatrist James Crichton-Browne, director of the West Riding Lunatic Asylum at Wakefield (having been appointed three years previously, at 25 years of age). Crichton-Browne had compiled a clinical photographic

1 John Herschel, *Photographic News* (11 May 1860), qtd. in Mark Haworth-Booth, ed. *The Golden Age of British Photography 1839–1900* (New York: Aperture, 1986), 185. See also Phillip Prodger, *Darwin's Camera: Art and Photography in the Theory of Evolution* (Oxford: Oxford University Press, 2009), 78.
2 C. Darwin to J. Crichton-Browne, 8 June 1869, Classmark: DAR 143: 328; letter no. DCP-LETT-6779.

archive.[3] Thus began, in the summer of 1869, an important exchange of photographs, correspondence, and books that greatly influenced Darwin's thinking about the evolution of the emotional, behavioural, and expressive relationship between humans and animals.[4]

I am particularly intrigued by a number of photographs Crichton-Browne sent to Darwin between 1869 and 1872, some of which Darwin returned and others of which he kept. This chapter begins with a group of the retained patient portraits that Darwin filed away in two Notebooks, now held at Cambridge University Library (Figures 5.1, 5.2, 5.3). This collection of photographs serves as my starting point into an exploration of the ways that photography contributed to the facial mapping of emotional and intellectual inner life in the nineteenth century. While most of the groundbreaking studies of emotion and facial expression in this era, including those by Darwin and Duchenne, focus primarily on "normally" expressive faces, they raise questions about "abnormally" inexpressive faces, such as were featured in Crichton-Browne's photographs. If normally expressive faces "speak" a complex affective language, what words, if any, did the immobile faces of those classified as "idiots" or "cretins" speak? Or, to put it another way, borrowing the words of the pioneer of affect theory, Silvan Tomkins: if "the self lives where it exposes itself and where it receives similar exposures from others," then what kind of self was exposed on the largely fixed, impassive faces of developmentally arrested individuals?[5] And since photography was such an integral feature of studies of facial expression, how did that technology shape our understanding of the complex emotional terrain of "normal" and "pathological" facial anatomy?

1 Darwin, Psychiatric Photography, and the "Little Yorkshire Cretin"

These two photographs (Figure 5.1 and 5.2), part of a collection of five sent from Crichton-Browne to Darwin, feature the same sitter, viewed from various angles. Darwin deemed them unsuitable for *Expression* and placed them in a wrapper marked "idiots—of no use."[6] Library archivists at Cambridge have titled these images as "Patient with Tumour," while art historian Phillip Prodger

3 C. Darwin to J. Crichton-Browne, 8 June 1869, Classmark: DAR 143: 328; letter no. DCP-LETT-6779.
4 Famously, Darwin offered to name Crichton-Browne as collaborator on *Expression*, but the psychiatrist declined.
5 Silvan S. Tomkins, *Affect, Imagery, Consciousness. Volume II: The Negative Affects* (New York: Springer, 1963), 133.
6 Wrapper at DAR 53.1: C26r, contained photograph DAR 53.1: C27.

FIGURE 5.1
G & J Hall, "Patient with tumour," ca. 1870s ["Little Yorkshire Cretin," ca. 1868–69], Charles Darwin's Collection
COURTESY OF CAMBRIDGE UNIVERSITY LIBRARY

FIGURE 5.2
G & J Hall, "Patient with tumour," ca. 1870s ["Little Yorkshire Cretin," ca. 1868–69], Charles Darwin's Collection
COURTESY OF CAMBRIDGE UNIVERSITY LIBRARY

refers to this sitter as a "man with a disfiguring tumor on his neck."[7] However, I am certain that this "patient with tumour" is female, and that she is the "little Yorkshire Cretin" to whom Crichton-Browne refers in a letter to Darwin, dated 1 June 1869.[8] Thus far, the editors of the Darwin Correspondence Project—a brilliant digital archive—have not been able to identify the "little Yorkshire Cretin." They surmise that the photographs of her had been returned to Crichton-Browne in Darwin's subsequent letter of 8 June 1869—and then lost.[9]

I am fairly certain of this identification since it is supported by several pieces of evidence. First, Crichton-Browne mentioned that he enclosed exactly five photographs of the Yorkshire patient for Darwin's perusal, and as mentioned,

7 Prodger, *Darwin's Camera*, 95.
8 J. Crichton-Browne to C. Darwin, 1 June 1869; letter no. DCP-LETT-6769.
9 My gratitude to Rosemary Clarkson of the Darwin Correspondence Project for answering my initial queries. I hope this identification contributes in some small way to their important work.

Figures 5.1 and 5.2 are part of a set of five in Darwin's Notebook. Second, though one might be forgiven for being unsure of the sitter's gender, as Prodger was, Crichton-Browne's description of the "little Yorkshire Cretin" as having "many singular ways of expressing *her* emotions," including an "extraordinary manner" of showing displeasure which presented something of "an anatomical puzzle" corresponds exactly to the photographs.[10] She would throw her head back, Crichton-Browne writes, "so that the occiput rests upon the dorsal vertebræ between the scapulæ."[11] This *must* be the anatomical feat pictured in Figure 5.2 above. Third, the female sitter exhibits clear indicators of cretinism including a disfiguring goitre, stunted body, and child-like and thickened facial features. Caused by a deficiency of thyroid hormone, cretinism was endemic to limestone areas or places low in environmental iodine, from the alpine villages of Europe to Britain's Lake District, Derbyshire (thus the term "Derbyshire neck"), and the Yorkshire Dales (near Crichton-Browne's asylum at Wakefield, Yorkshire).

A third photograph (Figure 5.3), a family portrait of "imbeciles" residing in a Scottish asylum, stands out from all the photographs that feature a single subject in Darwin's collection. A closer look reveals the faint signs of cutting and pasting around the heads to make a collage. The likely intention behind such visual manipulation was to reveal a type, to make plain the "look" of arrested development. The circle of markedly similar faces in this image suggests, too, the hereditariness of idiocy while reinforcing the direct correspondence between facial expression and emotional and intellectual inner life.[12] As he consigned the little Yorkshire Cretin to the envelope marked "idiots—of no use," so Darwin deemed "the dreadful photo of the imbeciles" as unworkable for his project.[13] In spite of the lively exchange with Crichton-Browne, Darwin used only one photograph—of a female patient whose hair stood on end—in *Expression* (and it was reproduced, with changes, as an engraving).

That demarcation—"of no use"—reveals the difficulty of fitting anomalous faces into emerging models of emotional expression. Darwin had hoped these types of faces would display raw, authentic emotion, but instead he

10 J. Crichton-Browne to C. Darwin, 1 June 1869; letter no. DCP-LETT-6769; my emphasis.

11 J. Crichton-Browne to C. Darwin, 1 June 1869; letter no. DCP-LETT-6769.

12 Daniel Novak shows how Victorian photographers combined bodies into composite portraits; he quotes photographer Oscar Rejlander (a main source of photographic research for Darwin's *Expression*): "in photographing groups I should prefer to produce the figures singly [...] and combine them in printing afterwards, which can be done satisfactorily [...] without any violation of pictorial truth," in *Realism, Photography and Nineteenth-Century Fiction* (Cambridge: Cambridge University Press, 2008), 50.

13 C. Darwin to J. Crichton-Brown, 18 April 1871; letter no. DCP-LETT-7698.

FIGURE 5.3 Photographer unknown, "7 brothers and sisters imbeciles all inmates of one
 asylum in Scotland," Charles Darwin's Collection
 COURTESY OF CAMBRIDGE UNIVERSITY LIBRARY

encountered photographs of vacant, impassive and/or haphazard faces. They
could not contribute to his search for norms and universals—only "normal"
faces could do that. The unreadable or uninterpretable faces of developmen-
tally arrested individuals revealed little about the anthropological and biologi-
cal origins of normal human expression. They divulged even less about the
relationship between the inner emotional life and the anatomy and physiology
of expression. Or, so it was thought.

2 Mechanisms: Duchenne's "Photographic Electro-Physiology"

Duchenne also had little place for anomaly in *The Mechanism of Human
Facial Expression* (1862)—a book that Darwin annotated, discussed, and
exchanged several times with Crichton-Browne. Duchenne used photogra-
phy to establish accurate representations of emotion in the normal face, or
as he says, to "demonstrate the art of correctly portraying the expressive lines
of the human face."[14] The photographs (see Figures 5.4, 5.5, 5.6, below) estab-
lish a lexicon of expressions that make up a common language. The face in

14 Guillaume-Benjamin Duchenne de Boulogne, *The Mechanism of Human Facial Expression*,
 ed. and trans. R. Andrew Cuthbertson (Cambridge: Cambridge University Press, 1990), 2.

Duchenne's work is a text biologically inscribed with universal—and universally comprehended—characters.

It is worth noting that this aspect of Duchenne's research is one side of a medical career bifurcated by the normal/pathological divide. The very same year that he published *The Mechanism of Human Facial Expression*, he also published an *Album of Pathological Photographs* (1862), which portrays neuromuscular disorders, including facial paralysis. More than a functional matter, this divide also reflects beliefs about the relationship between expressiveness and thinking and feeling. Complexity of facial expression reflected emotional and intellectual complexity; inexpressiveness revealed underdeveloped emotions and limited intelligence. This foundational principle of expression was supported by photography that represented, defined, and prescribed "normal" emotional expression.

Historians of photography have identified an "under-theorized link between the *effect* and *affect* of photography" and challenge us to return to interpretive questions about the role of feelings in photography—such as those famously advanced by Roland Barthes.[15] Duchenne's striking images establish how emotions should look, while also having an affective charge in their own right. The often dramatic or exaggerated expressions of the sitter cannot help but incite a sympathetic response in the viewer (and I mean "sympathy" in its general sense, as evoking an association, as having an effect). The inclusion of the electrical apparatus and Duchenne as operator within the frame, seems calculated to incite a particular kind of affective response in the viewer (see Figure 5.4). For there is a discomfort in watching what hints at virtual vivisection or at least at a painful operation. Duchenne's apparatus recalls the dissecting knife; indeed, as we will see, it has been referred to as an electrical scalpel.

Viewers of this image witness a real-life mad scientist figure—a Frankenstein—using electricity to supplant human will. Controlling absolutely the expressive life of the face, Duchenne renders his living subject an emotional automaton. In this, Duchenne follows in the footsteps of the Italian physicists Luigi Galvani and Giovanni Aldini, the former of whom provided a model for Mary Shelley's *Frankenstein*, and the latter of whom had used an electro-stimulation technique in 1803 to reanimate the deceased limbs of an executed criminal at Newgate Prison. From the 1850s, while at the Salpêtrière Hospital in Paris, Duchenne experimented with dissection, vivisection, electricity, and photography, and used his Volta-Faraday electrical apparatus to mimic

15 Thy Phu and Linda M. Steer, "Introduction," *Photography & Culture* 2, no. 3 (2009): 235–240, here 238; my emphasis. DOI: 10.2752/175145109X12532077132194; I refer, of course to Roland Barthes's *Camera Lucida: Reflections on Photography* (New York: Vintage, 1993).

FIGURE 5.4
Duchenne de Boulogne & Adrien
Tournachon, "Terror mixed with
pain, torture," 1845–1856, printed
1862, albumen print, W. Bruce
and Delaney H. Lundberg Fund
COURTESY OF NATIONAL
GALLERY OF ART, WASHINGTON

the living nervous system. He could move a dead rabbit's facial muscles—
even after its head had been separated from its body. He could replicate living
movements in the faces of newly dead cadavers. He could also simulate neural
activity in living patients who had facial paralysis. Through these experiments,
Duchenne demonstrated that muscles did not need "a soul" to move them—
only an expert to apply electrodes to living flesh.

Duchenne labelled his own methods with suitably mechanistic terms: they
were "icono-photographic experiments" in "Photographic Electro-physiology."[16]
Since then, scholars have done likewise: for R. Andrew Cuthbertson, Duchenne
broke down "the facial mask" and for Phillip Prodger, he gave "the human face
the status of an appliance."[17] Duchenne cut up the "muscular quilt" of the face
with his "electrical scalpel," writes philosopher of science François Delaporte,

16 Qtd. in François Delaporte, *Anatomy of the Passions*, trans. Susan Emanuel, ed. Todd Mey-
 ers (Stanford: Stanford University Press, 2008), 65.

17 R. Andrew Cuthbertson, "The Highly Original Dr Duchenne," in *The Mechanism of Human
 Facial Expression*, Duchenne de Boulogne, 225–284, here 231; Prodger, *Darwin's Camera*,
 81, 90.

thereby breaking with earlier physiognomical studies.[18] Delaporte points out that Duchenne's photographs never "refer back to the model;" each of them is a "*provoked* pretext" that neither reveals the sitters' identity nor their *real* affective state.[19] As such, these are "not faces, but biological events."[20] Cuthbertson echoes this point, arguing that Duchenne "was interested in the plasticity of the mask itself and not the character behind the mask."[21]

His tools and methods may indicate a break with physiognomy, but without question, Duchenne subscribed to a longstanding physiognomical tenet: that there is direct correspondence between the exterior and interior, the face and the soul, or as the eighteenth-century physiognomist Johann Caspar Lavater put it, so gratifyingly, "between the visible surface and the invisible spirit which it covers—between the animated, perceptible matter, and the imperceptible principle which impresses this character of life upon it."[22] We know that Duchenne chose sitters who had easily manipulated faces. The shoemaker pictured in Figures 5.4 and 5.5 had a partially paralysed face, which meant that he felt little discomfort. It also meant that his passive face was easily manipulated, making him an anatomist's dream, for it was like "working with a still irritable cadaver."[23] This emphasises the mechanics of expression, but there is still something of a match between expression and self. The shoemaker's normal facial expression Duchenne remarks, was "in perfect agreement with his inoffensive character and his restricted intelligence."[24] His muscles of lasciviousness were weak because he had a "cold" temperament, had little interest in women, and was sexually inexperienced. His supposedly stunted intelligence and underdeveloped emotional life were directly reflected in his face. Only electricity could summon from his muscles the look of desire portrayed in Figure 5.5.[25] Similarly, another of Duchenne's sitters—fittingly, a sculptor, anatomical wax modeller, and accomplished mime—was of such "gentle character" that he could not activate his *procurus,* the muscle of aggression. As demonstrated in Figure 5.6 below, his *procurus* would "obey only the electrodes."[26] Jules Talrich's facial muscles reflected, shaped, or adapted to his character. Whichever, the

18 Delaporte, *Anatomy of the Passions*, 16.
19 Delaporte, *Anatomy of the Passions*, 66.
20 Delaporte, *Anatomy of the Passions*, 56.
21 Cuthbertson, "The Highly Original Dr Duchenne," 235.
22 Johann Caspar Lavater, *Essays on Physiognomy*, 3 vols., ed. Thomas Holloway, trans. Henry Hunter (London: J. Murray, 1789–98), I: 20.
23 Duchenne, *The Mechanism of Human Facial Expression*, 43.
24 Duchenne, *The Mechanism of Human Facial Expression*, 42.
25 Duchenne, *The Mechanism of Human Facial Expression*, 76.
26 Duchenne, *The Mechanism of Human Facial Expression*, 56, 58.

FIGURE 5.5
Duchenne de Boulogne & Adrien
Tournachon, "The attention attracted by an
object that provokes lascivious ideas and
desires," 1854-56, printed 1862, albumen
silver print from glass negative
COURTESY OF THE METROPOLITAN
MUSEUM OF ART, NEW YORK

FIGURE 5.6
Duchenne de Boulogne & Adrien
Tournachon, "Expression of severity,"
1854–56, printed 1862, albumen silver print
from glass negative
COURTESY OF THE METROPOLITAN
MUSEUM OF ART, NEW YORK

fact remained that the individual required the muscle's correlative personality trait or emotion to fire it. Internal, imperceptible qualities impressed themselves on external, perceptible matter.

3 Metaphysics: Duchenne's Sensibility

Scholars have often identified Duchenne's project as a break with previous studies of expression. According to Delaporte, his mechanistic approach disengaged the study of emotions from "a metaphysics of passions."[27] This may be true to a large extent, but Duchenne's findings were also greatly informed by aesthetics and by religious beliefs, and they were grounded in Enlightenment sensibility. Like his eighteenth-century forebearers, he was deeply interested in the senses, emotions, and the development of sympathy and reason. After all,

27 Delaporte, *Anatomy of the Passions*, 47.

sensibility has a dual pedigree in medical materialism and in metaphysics—and this duality underwrites Duchenne's project. Sensibility emerged from seventeenth-century anatomical and physiological studies that established the brain as the physical seat of thought, the nerves the conduit between brain and world, and the senses as the portal to that world. And, this medical knowledge merged with metaphysical questions about the movements of the soul, and about beauty and moral truth.[28]

In fact, I think readers have been mistaken to think of *The Mechanism of Human Facial Expression* as a divided text. The first two "Scientific" sections are often seen as separate from the third and last "Aesthetic" section, in which Duchenne's sitters are cast in mythical, Shakespearean and Romantic roles. Phillip Prodger, for instance, speculates that "by attempting to reinject beauty" in this last section, Duchenne sought to "legitimize" the materialist methods outlined in the first section and soften the effect of photographs that readers would find "too mechanical."[29] But I argue that Duchenne's electro-physiological and icono-photographical methods are as much a part of the "Aesthetics" section as his metaphysical, theological views are a part of the "Scientific" sections. For, in the very first pages of *Mechanism*, Duchenne credits "the spirit" as "the source of expression" and defines an emotion as a "movement of the soul."[30] Facial expression was ordained by a God who fulfilled his "divine fantasy" when he gave humans a shared language with which they could express

28 A metaphysical/mechanical or aesthetic/empirical duality of sensibility informs eighteenth-century medical writing on the senses, the nervous system and emotion, including that canonical treatise on the subject, the Swiss physiologist Albrecht von Haller's *Dissertation on the Sensible and Irritable Parts of Animals* (1755). Described by Jessica Riskin as a "sentimental empiricist," Haller wove scientific discourse—including descriptions of the horrors of dissection and vivisection—with the language of sentiment. Anatomical and physiological findings mix with sentimental accounts of his own suffering at the sights and sounds of the anguish of animals—that were experimented upon in order to understand, ironically, the workings of "sympathetic" response. See Jessica Riskin, *Science in the Age of Sensibility. The Sentimental Empiricists of the French Enlightenment* (Chicago: Chicago University Press, 2002); and Albrecht von Haller, *A Dissertation on the Sensible and Irritable Parts of Animals* (1752), *Bulletin of the History of Medicine*, intro. Owsei Temkin, 4 (1936): 651–699. See also Ildiko Csengei, *Sympathy, Sensibility and the Literature of Feeling in the Eighteenth Century* (Basingstoke: Palgrave, 2012); and Darren N. Wagner, *Sex, Spirits, and Sensibility: Human Generation in British Medicine, Anatomy, and Literature, 1660–1780* (PhD dissertation, University of York, 2013). This work builds on George Rousseau's groundbreaking studies, collected in *Nervous Acts: Essays on Literature, Culture and Sensibility* (Basingstoke: Palgrave Macmillan, 2004).

29 Prodger, *Darwin's Camera*, 92.

30 Duchenne, *The Mechanism of Human Facial Expression*, 1, 15.

the "gymnastics of their soul."[31] "Our Creator was not concerned with mechanical necessity," Duchenne insists, but gave humans a facial language that was "universal and immutable," and with which they could express the "sentiments" that reflected their "higher understanding."[32] This discourse, which recalls the culture of sensibility and reflects notions of Romantic selfhood, is everywhere in his text. So, although there is some break with the past, there is also continuity. Stéphanie Dupouy argues, I think rightly, that pre-Darwinian studies of facial expression, including Duchenne's, are informed by "sentimentalist values" that emerged in an earlier era.[33] These include a veneration for "the complexity and subtlety" of the passions, the belief that "moral hierarchies" are writ on the face, and the conviction that expression promoted "moral unity between human beings."[34]

In the section on "Aesthetics," Duchenne puts his electro-physiological and icono-photographical method to work for the purpose of discovering the expressive conditions of beauty and the physiology behind the evocative expressions portrayed in art and on the stage. He again employs sitters whose faces and gestures were especially passive. Duchenne was delighted to see how his electric wand "completely transformed" a visually impaired woman whose inability to read faces and gestures had meant that her own face lacked expressiveness (pictured below). Under Duchenne's control, and dressed "as if she were a mannequin," she was changed from a rather plain-looking individual to an expressive beauty fit to play the roles of classical, Shakespearean, and Romantic heroines.[35] In Figure 5.7, she performs as Medusa and Lady Macbeth, while in Figure 5.8, she is reborn as a nun or the lady of sorrows.

This part of Duchenne's project, and his attention to the complexity of the life stories behind expression, challenges the idea that he had no interest in the character behind the mask. Indeed, he constructs a rather elaborate romantic narrative about the life of the novice whose face expresses both sorrow and ecstatic joy:

> This upturned look [...] tells us that the young woman's spirit is being exalted by her ardent faith [...] does not her white veil and homespun dress signify that [...] she is going to renounce this world? [...] you feel

31 Duchenne, *The Mechanism of Human Facial Expression*, 19, 31.
32 Duchenne, *The Mechanism of Human Facial Expression*, 19, 28.
33 Stéphanie Dupouy, "The Naturalist and the Nuances: Sentimentalism, Moral Values, and Emotional Expression in Darwin and the Anatomists," *Journal of the History of the Behavioral Sciences* 47, no. 4 (2011), 335–358, here 346.
34 Dupouy, "The Naturalist," 346.
35 Duchenne, *The Mechanism of Human Facial Expression*, 105.

that the heart of the nun, who is perhaps leaving her dear mother and family, has not yet been withered through the exaltation of religious feelings.[36]

Such an emphasis on personal narrative and on the great dramatic themes of human history recalls a distinctly un-scientific tradition. There are, for example, revealing parallels between Duchenne's young penitent and Oscar Rejlander's photographic portraits of praying women (one is pictured here as Figure 5.9), which in turn recalls Sassoferrato's painting *The Virgin in Prayer*, 1640–50, which in turn recalls the Baroque painter Guido Reni's ecstatic Madonnas. A further comparison can also be made between Duchenne's Madonna and Paul Régnard's clinical photographs of hysterics diagnosed with religious mania (see Figure 5.10). The lines of shared influence—the recycling of religious arche-types—remind us of the entwined nature of the medical and the aesthetic, the

FIGURE 5.7
Duchenne de Boulogne, "Lady Macbeth: moderate expression of cruelty," albumen silver print from glass negative, 1854–56, printed 1862
COURTESY OF THE METROPOLITAN MUSEUM OF ART, NEW YORK

FIGURE 5.8
Duchenne de Boulogne, "The young nun: deep sorrow on the left; divine ecstatic joy on the right," 1854–56, printed 1862
COURTESY OF THE WELLCOME COLLECTION, LONDON, ATTRIBUTION 4.0 INTERNATIONAL (CC BY 4.0)

36 Duchenne, *The Mechanism of Human Facial Expression*, 107.

FIGURE 5.9
Oscar Rejlander, "The Virgin in prayer," ca. 1857, albumen print
© NATIONAL PORTRAIT GALLERY, LONDON

FIGURE 5.10 Paul Régnard, "Attitudes Passionnelles: supplication amoureuse," 1878, photogravure
DIGITAL IMAGE COURTESY OF THE GETTY'S OPEN CONTENT PROGRAM

material and the metaphysical. Duchenne's *Mechanism* is part of a long and varied intertextual tradition that included French painter Charles Le Brun's late seventeenth-century work on the expression of the passions, Lavater's eighteenth-century extended essays on physiognomy, Charles Bell's 1806 book on the anatomy of expression, Théodore Géricault's early nineteenth-century "monomaniac" portraits and German artist Carl Julius Milde's studies of the faces of the mentally ill.

There are, of course, important differences in purpose, method and style between the artistic-religious imagery of a Reni or a Rejlander *and* the clinical imagery of a Duchenne or a Régnard. The clinical photographs attest to the epistemological value of photography. Like other clinicians and medical photographers, Duchenne and Régnard compiled visual documents, an expanded body of data that would provide new insights into the biological origins of human emotion and expression, and the aetiology of disease. For some, photography was a tool that could help locate the lesions on the brains of hysterics and developmentally arrested patients.[37] Using language that echoes Lavater's statement about his great hopes for physiognomy, psychiatrist Hugh Welch Diamond expressed a similar faith in photography in 1856. The photograph could catch "in a moment the permanent cloud, or the passing storm or sunshine of the soul," which would then enable the specialist "to witness and trace out the connexion between the visible and the invisible."[38] Or, in the words of Régnard's colleague at the Salpêtrière, fellow photographer Albert Londe: "the particular sensitivity" of the "photographic plate" could "give us more than the eye, showing what the eye could never perceive."[39]

37 See, for example, John Tagg, *The Burden of Representation: Essays on Photographies and Histories* (London: Palgrave Macmillan, 1988); *The Face of Madness: Hugh W. Diamond and the Origin of Psychiatric Photography*, ed. Sander L. Gilman (New York: Brunner/Mazel, 1976); Sander L. Gilman, *Seeing the Insane* (Lincoln: University of Nebraska Press, 1996); Suren Lalvani, *Photography, Vision, and the Production of Modern Bodies* (Albany, NY: State University of New York, 1996); and Tanya Sheehan, *Doctored: The Medicine of Photography in Nineteenth-Century America* (University Park, PA: Pennsylvania State University Press, 2011).

38 Hugh Welch Diamond, "On the Application of Photography to the Physiognomy and Mental Phenomena of Insanity," *The Photographic Journal*, July 1856, rpt. in Gilman, *The Face of Madness*, 17–24, here 20.

39 Albert Londe, *La photographie dans les arts, les sciences et l'industrie* (Paris: Gauthier-Villars, 1888), 8, qtd. in Georges Didi-Huberman, *Invention of Hysteria: Charcot and the Photographic Iconography of the Salpêtrière*, trans. Alisa Hartz (Cambridge, MA: MIT Press, 2003), 33.

4 "Why does this being never Blush?": Idiots, Blushing, Shame and Sex

Duchenne's photographs were visual models that established norms of human affective expression, which had significant repercussions for how inexpressive and thus abnormal faces were categorised. Although Darwin admired Duchenne's work, he departed markedly from it, by demonstrating the permeability of the human-animal boundary. Still, Darwin also identified particular emotions and expressions which he saw as distinctly human. Moreover, as with other studies, sensibility cast a long shadow over Darwin's attempts to make sense of inexpressive faces that seemed closer to the animal.

While Darwin did not include photographs of persons with arrested development in *Expression*, he did write a fair amount about the limited emotional expression of those labeled cretins, idiots, and hysterics. He spent some time considering how the blush might be particularly instructive as a marker of expressive difference between the normal and abnormal, human and animal. The blush was the focus of debates about whether human expression was instinctive or learned, universal or culturally specific. It was also a particularly ambiguous expression, communicating everything from innocence to guilt, from a healthy modesty to psychological dysfunction.

In a letter of 28 March 1871, Darwin asked Crichton-Browne if he had "seen idiots blush?"[40] In part, Darwin's question was motivated by his reading of the physician Thomas Henry Burgess's *The Physiology Or Mechanism of Blushing* (1839). Although Darwin referred often to Burgess's work in *Expression,* he doubted Burgess's unsupported claim that congenital idiots never blushed. While "the congenital idiot is capable of exhibiting all the *instinctive* passions in a high degree," Burgess had stated, he "never evinced his sensorial feelings by Blushing."[41] From this assumption, Burgess figured that since "blushing is an impulse of the *reasoning* power," the sense-less idiot, who was motivated only by instinct, was "incapable" of blushing.[42] For Burgess, different physical, moral and psychological states gave rise to different types of blushes, including false blushes that resulted from a perversion of civilisation, an excessive sensibility. But the blush was also an emotional response that derived from rational thought and from a sophisticated moral apparatus that generated shame.

40 DAR 143: 335; letter no: DCP-LETT-7635.
41 Thomas Henry Burgess, *The Physiology Or Mechanism of Blushing* (London: John Churchill, 1839), 70.
42 Burgess, *The Physiology*, 70.

Without delving into Burgess's complex taxonomy of blushes and flushes, it is important only to note that, for all of its variability, the blush indicated, as Pamela Gilbert puts it, that "the narratives of selfhood where written on the skin."[43] Without self-awareness, there could be no blush. When rational, cognisant individuals felt shame, they blushed—thereby indicating higher faculty brain function.

In fact, the real point at stake was not whether idiots had the capacity to *express* emotion, but whether they even had an inner emotional life to express. Burgess concluded that they did not. For idiots had stunted *sensoria*, which in metaphysical terms was the seat of the soul and in material terms was the part of the brain that interprets sensory information. By way of illustration, Burgess points to the way drunkenness renders the "sensorium [...] dead to all moral impressions" so that the drunk "is perfectly insensible to the different feelings of honour, shame, disgrace."[44] When sober, the drinker can however return to the empire of reason; by contrast, the person with permanently arrested sensoria is forever exiled from that empire.[45]

To Darwin's question about whether idiots blushed, Crichton-Browne noted that his patients' faces turned "red and engorged" when they were in a rage or when faced with a tantalising meal, but that "no amount or kind of scoldings produced a similar result even in those of the higher [and] more intelligent [cl]ass" than the average.[46] Crichton-Browne answered that he had "not been able to produce a *genuine* blush in any one of them."[47] In his return letter of 7 April 1871, Darwin tactfully rebutted Crichton-Browne's view by referring to an anecdote mentioned by the German naturalist Carl Vogt in his rather objectionably titled paper, "Microcephalic Idiots or Man-Apes." The eyes of a "microcephalous idiot" patient "brightened when pleased or amused"; and when his naked body was examined, he had a "real" blush and had "tried to turn on one side."[48] This blush was evidence, Darwin wrote, that the patient "was not utterly degraded."[49] Darwin's use of the word "real", like Crichton-Browne's use of the qualifier "genuine", differentiates blushes of sensibility, self-awareness, and morality, from the flush of lower faculty passions such as rage or hunger.

43 Pamela K. Gilbert, *Victorian Skin: Surface, Self, History* (Ithaca, NY: Cornell University Press, 2019), 64.

44 Burgess, *The Physiology*, 70–71.

45 Burgess, *The Physiology*, 71.

46 3 April 1871; DAR 53.1: A30, C134-6; DAR 161: 315; DCP-LETT-7658.

47 3 April 1871; DAR 53.1: A30, C134-6; DAR 161: 315; DCP-LETT-7658; my emphasis.

48 Darwin references Carl Vogt's *Ueber die Mikrocephalen oder Affenmenschen* in his letters and in chapter 13 of *Expression*, on "Shame" and "Blushing."

49 7 April 1871, DAR 143: 336; DCP-LETT-7666

On the one end of the scale were ladies who were prone to excessive blushing because of an overabundance of sensibility; on the other were monkeys who could only "redden from passion."[50]

The blush, then, separated human from animal, and civilised from uncivilised most conclusively. For Darwin, the blush was "the most peculiar and most human of all expressions."[51] For Silvan Tomkins, the blush is evidence that nothing matters more to humans than their dignity; "above all other animals," humans insist "on walking erect."[52] In spite of all this, the blush is not so straightforward. There is another kind of "real" blush, a middle-ground blush, which, coincidentally appears often in novels of sensibility. Here is a scene from Laurence Sterne's *A Sentimental Journey* (1768): In a Paris hotel room, bathed in the warm tint of a setting sun, our man of feeling, Yorick, engages in a battle of blushes with a young *fille de chambre*. "She blush'd," Yorick recalls, and "the idea of it made me blush myself:—we were quite alone; and that superinduced a second blush before the first could get off."[53] This less virtuous blush is:

> a sort of a pleasing half guilty blush, where the blood is more in fault than the man:—tis sent impetuous from the heart, and virtue flies after it,—not to call it back, but to make the sensation of it more delicious to the nerves associated—But I'll not describe it—I felt something at first within me which was not in strict unison with the lesson of virtue I had given her the night before—.[54]

This is the blush of sexual fantasy, sensation, and a base desire "to get off," which is made all the more exquisite because it bolts ahead of the controlling grasp of sensibility and virtue. This blush appears, too, in Darwin's early Notebooks. And, as with Yorick's thoughts, Darwin's description of it is abruptly fractured, impulsively jotted down. This blush is a sort of "Erection [...] blushing is connected with sexual, because each sex thinks more of what another thinks of him [...] Hence, animals, not being such thinking people, do not blush—sensitive people are apt to blush."[55] This blush challenges human exceptionality. Stripping the veneer of civility from the blush reveals its primitive sexual origins; in

50 Darwin, *Expression*, 286.

51 Darwin, *Expression*, 286.

52 Tomkins, *Affect, Imagery, Consciousness*, 132.

53 Laurence Sterne, *A Sentimental Journey*, eds. Ian Jack and Tim Parne (Oxford: Oxford University Press, 2008), 75–76.

54 Sterne, *A Sentimental Journey*, 77.

55 Charles Darwin, *Notebooks 1836–44*, ed. P.H. Barrett (Ithaca, NY: Cornell University Press, 1987), 577.

fact, reveals it to be an "anthropocentric illusion," as Stéphanie Dupouy puts it.[56] Humans only demonstrate their exceptionality by restraining, moderating, and disciplining their appetites and the expression of their emotions.

People classified as developmentally arrested are caught, then, in a bind. If they *do* blush, it is interpreted as the flush of crude desire, a primeval sign, a failure to moderate impulse. That they *don't* blush is interpreted as a lack of moral feeling. It was generally believed, particularly in light of experiments on normal expression, that idiots and cretins did not have the anatomical, physiological capacity to experience dignity or shame. Only through artificial means, by electrical stimulation of the sympathetic nerves that caused a rush of blood to the skin, or by amyl nitrate (!), could a blush be produced in the inexpressive faces of the developmentally arrested.[57]

5 Monstrous Faces

The culture of sensibility, grounded in the medical study of physical susceptibility, bridged scientific and literary representations of arrested development. Anatomical and physiological findings about the senses, sensation, perception, emotion, and expression were integrated into literature and art. These ideas inform Honoré de Balzac's 1833 novel *The Country Doctor*, which is set in an isolated village in the Savoy Alps, where cretinism is endemic. The story concerns a military man named Genestas, who relocates to the village where he encounters a doctor tending to a patient suffering with cretinism. Having this opportunity to analyse the doctor's "physiognomy," Genestas concludes that he is "destined for great things."[58] In the very next moment, though, Genestas's gaze shifts from the doctor's "extraordinary countenance" to that of his bed-ridden patient, "a human face in which thought had never shone [...] the entirely animal face of an old cretin dying."[59] We are asked to forgive the otherwise unshakeable soldier for his revulsion, for

> at the sight of a forehead of which the skin formed a great round fold, of two eyes similar to those of a cooked fish, of a head [...] quite deprived and denuded of sensitive organs, who would not have experienced, as

56 Dupouy, "The Naturalist," 348.

57 Darwin, *Expression*, 298.

58 Honoré de Balzac, *The Country Doctor*, trans. G. Burnham Ives (Philadelphia, PA: G. Barrie, 1898), 30.

59 Balzac, *The Country Doctor*, 30, 31.

did Genestas, a sentiment of involuntary disgust for a creature that had neither the graces of the animal nor the privileges of the man, that had never had either reason or instinct, and had never heard nor spoken any species of language?[60]

Although described as having a wholly animal face, the cretin still lacks what John Ruskin termed "the vital beauty" of animals.[61] The abject, monstrous human-animal body of the cretin is evidence of insensibility, incomprehension, muteness, and also, surprisingly, even basic instincts.

Balzac's fictional cretin could be counted with a number of imaginative and real-life medical monsters who captured imaginations over two centuries. From Jonathan Swift's fictional Yahoos to the obstetrician William Smellie's conjoined twins, from H.G. Well's beast-folk of *The Island of Dr Moreau* to the famous case of Joseph (John) Merrick. In his memoirs, Dr Frederick Treves uses a language that echoes Balzac's Genastas in his description of his first encounter with the expressionless face of Merrick, exhibited in a freak show as "The Elephant Man."[62] Treves concludes that Merrick, who appears as a "loathsome insinuation of a man being changed into an animal," is insensible, without language, and incapable of higher faculty thought or feeling.[63] If the fact "that it was still human," was to his mind "the most repellent attribute of the creature" then the most repellent physical feature was the face, with its fleshy, bony growths, protruding upper jaw and mouth that appeared "a mere slobbering aperture."[64] Those who viewed Merrick's face in engravings and photographs in the late 1880s, such as the one below, were also likely to conclude that since Merrick's face "was no more capable of expression than a block of gnarled wood" so must his mind be "void of all emotions and concerns," his intellect the "blank" of an "imbecile." [65]

As has been the dramatic focus of a number of modern plays, films, and books, Treves discovers "the overwhelming tragedy" of Merrick's life: his garbled speech and monstrously expressionless face masked a "highly intelligent" man who "possessed an acute sensibility and—worst of all—a romantic

60 Balzac, *The Country Doctor*, 31.
61 See John Ruskin, *Modern Painters I* in *Works of John Ruskin*, vol. 3, eds. E.T. Cook and Alexander Wedderburn (London: G. Allen, 1903).
62 Frederick Treves, *The Elephant Man and Other Reminiscences* (London: Cassell & Co., 1923).
63 Treves, *The Elephant Man*, 2.
64 Treves, *The Elephant Man*, 1–2, 4.
65 Treves, *The Elephant Man*, 4, 8.

FIGURE 5.11 "The Elephant Man," *British Medical Journal,* April 1890
COURTESY OF THE WELLCOME COLLECTION, LONDON,
ATTRIBUTION 4.0 INTERNATIONAL (CC BY 4.0)

imagination."[66] Revealingly, this characterisation references the qualities most associated with sensibility (reason, receptivity, emotional response) and those of Romanticism (imagination, sublimity, transcendence, emotional spontaneity, aesthetic beauty). Underpinning Treves's observations is that foundational principle of sensibility: that the more exquisite one's senses and nerves, the

66 Treves, *The Elephant Man*, 8–9.

greater one's sensibility and emotional capacity. And, the greater one's sensibility, the more sophisticated one's modes of expression. The persistence of this conviction had, as we have seen, quite profound repercussions for the way the body was read, categorised, and treated.

6 "The Physiognomy of Disease:" Photographing the Cretin's Face

John Tagg, Sander Gilman, Suren Lalvani, Tanya Sheehan, and others have explored how photography was used to illustrate, diagnose, classify, and categorise bodies, while Mark Jackson has focused specifically on how photography constructed "mental defectives as a physically distinct and enduring subclass in society."[67] Recently, too, scholars have drawn attention to before-and-after images as a critical sub-genre of photography.[68] This last section investigates how before-and-after photographs of patients with cretinism were used to demonstrate how bodies and minds could be regenerated. Newly animated faces provided primary evidence for the efficacy of recently discovered treatments.

In the 1880s, many physicians insisted that photography was the key to understanding "the physiognomy of disease" and that it had the potential to become "by far the most important aspect of diagnosis."[69] This was particularly the case, Dr James Finlayson claimed, for conditions that fell between "idiocy and imbecility," including goitrous cretins.[70] Finlayson was inspired by Francis Galton's composite photographs, Paul Régnard's photographs of hysterical patients at the Salpêtrière, and by Darwin's *Expression*.[71] In 1890, Victor Horsley had demonstrated that cretin children who were injected or fed extract from a sheep's thyroid could be revivified and their development restarted. That the faces of cretinous patients became so strikingly reanimated led physicians to observe that the treatment of no other disease "lent itself so admirably to photographic display."[72]

67 Mark Jackson, "Images of Deviance: Visual Representations of Mental Defectives in Early Twentieth-Century Medical Texts," *The British Journal for the History of Science* 28, no. 3 (1995): 319–337, here 321; see FN. 37.

68 Jordan Bear and Kate Palmer Albers, eds., *Before-and-After Photography: Histories and Contexts* (London: Bloomsbury, 2017).

69 James Finlayson, *Clinical Manual for the Study of Medical Cases* (London: Smith, Elder & Co., 1886), 38.

70 Finlayson, *Clinical Manual*, 38.

71 Finlayson, *Clinical Manual*, 47.

72 William Rushton Parker, "Lantern Exhibition of Cretins illustrating the Effects of Thyroid Treatment," in *A Discussion on Sporadic Cretinism in this Country*, eds. William Rushton Parker et al. (London: British Medical Association, 1896): 1–4, here 3.

In an 1894 edition of *The British Medical Journal*, the brain surgeon and artist Dr Byrom Bramwell presented the case of a sixteen-year-old girl who had suffered from sporadic cretinism. As with Treves's account of "The Elephant Man," Bramwell's description of her has more than a touch of the Gothic. Having never been separated from her mother, the girl's first night as an inmate of the Edinburgh Royal Infirmary was extremely distressing. As her enormous tongue and permanently opened mouth prevented her from crying like "an ordinary child," she could only groan and made "inhuman-like barks."[73] Bramwell recounts how the attending physician took her up and sought a quiet place where she might be soothed. Settled into an empty delirium tremens ward, the unsuspecting doctor got his first good look at the new patient:

> He could hardly realise that he was dealing with a human being. He felt as if he were trying to soothe some strange and weird animal. The repulsive and inhuman appearance of the patient, and its brute-like roaring in the dead of night in an empty delirium tremens ward were sufficient to give most men "a turn."[74]

Bramwell's before-and-after photographs (Figures 5.12 and 5.13) portray the subsequent transformation, with thyroid treatment, from this "weird animal" whose "mental development is completely arrested" to a lively, receptive girl whose face attests to her emotional and intellectual development.[75]

As powerful as these images are, Bramwell is ultimately dissatisfied with the "before" versions, for they "give no adequate idea of the extremely repulsive appearance" of a girl whose "facial appearance and expression resembled that of a bull-dog" and who generally "looked more like one of the lower animals than a member of the human race."[76] Taken together, the "before" and "after" images fail to adequately convey the extent of physical and emotional recovery. In this case, they do not live up to the indexical, mimetic, and evidentiary promise of clinical photography.

At the same time, physician-photographers identified quite the opposite problem with before-and-after patient portraits: they exaggerated the extent of recovery. This issue surfaced in the wake of the annual meeting of the British Medical Association in July 1896, where physician William Rushton Parker's

73 Byrom Bramwell, "Clinical Remarks on a Case of Sporadic Cretinism," *British Medical Journal* (6 January 1894): 6–11, here 8.
74 Bramwell, "Clinical Remarks on a Case of Sporadic Cretinism," 8.
75 Bramwell, "Clinical Remarks on a Case of Sporadic Cretinism," 7.
76 Bramwell, "Clinical Remarks on a Case of Sporadic Cretinism," 7.

FIGURE 5.12
Byrom Bramwell, "Before view: sixteen-year-old girl with sporadic cretinism, showing enormous swelling of the tongue and mouth, etc.," *The British Medical Journal*, 1894, 8
(CC BY-NC 4.0)

FIGURE 5.13
Byrom Bramwell, "After view: representing the same girl after two months treatment," *The British Medical Journal*, 1894, 10
(CC BY-NC 4.0)

collection of before-and-after photographs of patients with cretinism were singled out and praised for showing how treatment "convert[ed] a dull, stupid, heavy, listless, often idiotic countenance into a bright, cheerful, pleasing expression," which was interpreted as clear evidence of "a rapid and very striking increase of intelligence."[77] Parker had toured Britain with a lantern show of some forty pairs of portraits of children who had undergone thyroid treatment. For the superintendent of Lancaster's Royal Albert Asylum, T. Telford-Smith, Parker's paired portraits revealed "in a way no mere verbal description could, the almost marvellous change" that had occurred: "we can see by the mere alteration in the expression of the faces that the mind as well as the body has been [...] awakened."[78]

77 "Sixty-Fourth Annual Meeting of the British Medical Association," *British Medical Journal* (1 August 1896), 2:277, 284.

78 T. Telford-Smith, "The Thyroid Treatment of Cretinism and Imbecility in Children," in *A Discussion on Sporadic Cretinism*, eds. William Rushton Parker et al. (London: British Medical Association, 1896), 4–7, here 4.

However, Edinburgh physician John Thomson urged caution as he worried that the established practice of using photographs of the face as evidence of emotional and intellectual improvement caused parents and relatives to believe they were observing rapid and profound progress in their loved ones. People were inclined to "overestimate the significance" of an "altered appearance."[79] Because "cretins look so very stupid before treatment," they were not given "enough credit for the wits they really have," Thomson wrote; then, when "the thyroid begins to free the facial muscles and lets them come nearer the surface," it seems as if the patient is brought back to life.[80]

Thomson drives something of a wedge between the affective interior and the expressive exterior. He reminds readers that, as Duchenne and Darwin had demonstrated, expressions could be involuntary and reflexive. Indeed, the facial muscles could be divorced from the emotions and detached from the self. Such observations raise the question: could it follow that the expressionless faces of cretins and those categorised as idiots may not necessarily indicate a fully arrested or degenerate emotional and intellectual life?

7 The Big Picture

This discussion is part of a much larger story about attempts to read the exterior body for clues as to the unseen, intangible interior. In all of the cases presented here, from Duchenne to Darwin to Bramwell to Parker, the face was viewed as a conduit to the inner life of the mind and the emotions. As we have seen, nineteenth-century studies of emotional expression established an influential set of principles: that the relative strength or weakness of facial muscles was directly related to character and intelligence; that facial expression was mechanical, often involuntary, and at times refused one's will; that paradoxically, expression reflected sensibility, desires, and the higher faculties; and finally, that photography could illustrate all of these principles, and reveal otherwise unseen information about emotional expression. At times, there may have been uncertainty or dissatisfaction with photographic representation, but there was also a certainty about its ability to expose the complexity of what theorists Gilles Deleuze and Felix Guattari so aptly refer to as the facial

79 John Thomson, "The Variations in, and the Limits of, the Improvement of Cretins at Different Ages under Thyroid Treatment," in *A Discussion on Sporadic Cretinism*, eds. William Rushton Parker et al. (London: British Medical Association, 1896), 7–13, here 12.

80 Thomson, "The Variations in, and the Limits of, the Improvement of Cretins," 12.

"envelope."[81] We have also seen challenges to the perception that the inexpressive face seemed only to bear witness to an impassive, vacant, and unresponsive interiority. To different degrees, Darwin, Treves, and Thomson troubled the persistent belief that facial expression directly reflected emotional and intellectual sensibility and that it necessarily accessed and reflected inner affective life.

There is an even bigger picture here about how we rely on the face for information about the subject. Deleuze and Guattari offer insights about the tenacious role of the face in processes of communication, identity formation, and understanding self and other. The face is imperialising, they argue; it is *imposed* upon us; it is the means by which we are constituted as subjects and our identities over-coded and overdetermined. We must grow into, and live up to our faces. They note that racism determines the "degrees of deviance" from the white face; we could say that normalisation determines the degrees of deviance from expressively conforming faces.[82] Deleuze and Guattari challenge our compulsion to conflate the face with "the person who speaks, thinks, or feels."[83] Can we, they ask, dismantle the face? This is perhaps impossible, particularly in light of the history of the face in photography. In the nineteenth century, photography was put to use to identify the facial features of the criminal, the hysteric, the contagious, and the abnormal. Today, photography is put to some of the same or similar uses, while countless faces proliferate continuously in social media, television and film, surveillance footage, and the digital stratosphere. Nevertheless, the question of dismantling is something to consider.

81 Gilles Deleuze and Felix Guattari, *A Thousand Plateaus*, trans. Brian Massumi (Minneapolis, MN: University of Minnesota Press), 1987, 165.
82 Deleuze and Guattari, *A Thousand Plateaus*, 176.
83 Deleuze and Guattari, *A Thousand Plateaus*, 167.

The Living and the Dead in Nineteenth- and Early Twentieth-Century Medical Portraiture

Joanna Madloch

According to Victor Burgin, a portrait is not a simple depiction of a particular person, but rather a heterogeneous representation that is understood as a complex semiotic construct, which is built on the basis of plurality of codes.[1] For centuries, the established arts catered predominantly to those who could afford commissioned work. As a result, traditional portraiture, sponsored almost exclusively by economically and socially privileged social groups, gravitated toward creating and conveying notions associated with wealth, importance, and eminence. In the 1840s, the introduction of photography, followed swiftly by its dissemination and economical affordability, made portraiture available to a larger and more economically diverse clientele. At the same time, however, despite its technical progress, the new medium severely lacked its own signifying system. This deficiency led photography toward the adaptation of existing semiotic codes.

Regardless of initial difficulties resulting from the poor photosensitivity of the first photographic plates, more than 90% of images taken during the early days of the medium were portraits.[2] Naturally, early photographic portraitists could not escape the comparison of their craft to painting, and often had to establish their position on this relationship. While some camera artists, such as Julia Margaret Cameron, used the analogy to create their own original style, and others, such as Nadar, strived to establish the new medium's visual autonomy, the majority of commercial photographers adopted painting-established ways to represent their subjects. For example, it was common practice in nineteenth-century photographic portraiture to place subjects against the generic backdrop of expansive drapery or next to a column. Such settings originated in sacral art as a primary backdrop for depicting the Virgin Mary with

1 Victor Burgin, "Looking at Photographs," in *Thinking Photography*, ed. Victor Burgin (New York: Palgrave Macmillan, 1982), 142–153, here 143.

2 John Tagg, *The Burden of Representation: Essays on Photographies and Histories* (Minneapolis: University of Minnesota Press, 1988), 43.

Child,[3] but by the late 1800s, this set-up, for the most part, lost its religious connotation and was used by photographers primarily as a vehicle to bestow an air of dignity and importance on their subjects. When this effect was often desired by middle-class patrons of photographic studios, the genre of occupational portraiture, which emerged during the nineteenth century in response to the growing specialisation of professions, required a more specific system of signification.

Naturally, the first examples of medical occupational portraits can be found in paintings. In her article titled "Medical Men 1780–1820," Ludmilla Jordanova discusses the position of the genre during the last decades before the invention of the camera. According to the author, among the most important goals of the emerging medical occupational portrait was to construct a "coherent visual response"[4] that attempted to balance the extremely negative depiction of the profession, which was already deeply ingrained in popular perception during the eighteenth and nineteenth centuries.[5] When the medical world long struggled to combat this image through professional publications that aimed to identify and isolate imposters in the medical field,[6] only the creation of the medical occupational portrait genre provided medics with a more accessible and efficient visual tool in their efforts to uphold their reputation.

One of the earliest methods used in professional portraiture to improve the stature of medical practitioners was the convention of portraying doctors as learned men. Painters attempted to secure the perception of scholarliness of their subjects by depicting them with carefully selected props conventionally associated with this notion. This included primarily medical books, charts, and a variety of profession-related illustrations. The occasional appearance of a bust of Hippocrates in the photographs alluded to the classical origins of medicine, which was intended to boost its respectability and trustworthiness. While this convention dominated most of the eighteenth century, by the end

3 Shearer West, *Portraiture* (Oxford: Oxford University Press, 2004), 25. About the use of such props in photography see also Miles Orvell, *The Real Thing: Imitation and Authenticity in American Culture, 1880–1940* (Chapel Hill: University of North Carolina Press, 2014), 90–91.

4 Ludmilla Jordanova, "Medical Men 1780–1820," in *Portraiture: Facing the Subject*, ed. Joanna Woodall (Manchester and New York: Manchester University Press, 1997), 101–115, here 101.

5 This was mostly an effect of the popularity of caricatures that commonly depicted doctors as greedy, unqualified, and dishonest "quacks." For examples, see English and French nineteenth-century caricatures in the University of Virginia collection: http://exhibits.hsl. virginia.edu/caricatures/.

6 See, for example, Homer Bostwick, *Medical Quackery: Its Origin, Cause and Cure, with Hints to Young Physicians, in Relation to the Important Subject of Consultation* (New York: T. Smith, Mirror Printing Office, 1847).

FIGURE 6.1
John Jackson after Sir Joshua
Reynolds, "John Hunter," 1813, based
on a work of 1786
©NATIONAL PORTRAIT GALLERY,
LONDON

of the 1700s, it was slowly replaced by a new approach, one that spotlighted doctors' daring dispositions.

This transformation is exemplified by a portrait of a prominent Scottish surgeon, John Hunter. The painting was created in 1786 by a celebrity portraitist, Joshua Reynolds, and the work is still easily recognisable due to the frequency with which it was copied and reproduced in various mediums.[7] In this context, it is not surprising that the latest biography of the celebrated doctor, *The Knife Man: Blood, Body Snatching, and the Birth of Modern Surgery* (2006) by Wendy Moore, also features this image on its cover.

In her lively narration, Moore depicts Hunter as an unquestionably brilliant man who, nevertheless, was also known as a notoriously difficult individual to work with, prone to fits of anger and lacking any moral objections to grave

7 In a short article titled "John Hunter's Beard," which was published in *The Royal College of Surgeons of England Bulletin* 93, no. 2 (2011), 68–70, Brian Livesley gives a short account of the history of the paintings, concentrating especially on the problem of differences between various renditions of the portrait, namely a famous physician being depicted interchangeably with and without beard. In addition, the author argues that Reynolds's portrait was created upon the personal request of a celebrated engraving artist, William Sharp, merely as an auxiliary tool for him to create a series of commercial engravings of Hunter. See http://publishing.rcseng.ac.uk/doi/pdf/10.1308/147363510X551405.

robbing as long as it supplied him with the necessary material for his studies. This account stands in contrast to the notions evoked by the image on the cover.

Reynolds portrayed Hunter in his typical Grand Manner style, which idealised the surgeon's appearance and accentuated his elite status. In the painting, Hunter's elegant face has the thoughtful, contemplative look of a serious but amiable man, and it exudes relaxed confidence. In the spirit of the eighteenth-century convention, the picture includes an anatomical atlas placed on a table next to Hunter. In addition, a human skeleton fragment, which most likely belonged to Charles Byrne, the so-called "Irish Giant," is displayed above the book.[8] Human bones are obviously carefully planted in the frame only to further emphasise the notion of the doctor's professional qualifications, already implied by the presence of books. At the same time, by depicting bones, Reynolds illustrates the notion of the doctor's boldness and the heroic nature of his endeavours.

This painting of Hunter turned out to be Reynolds's artistic and commercial success, the catalyst for the image's rise to the status of inexhaustible source of semantic codes for future portrayal of medical practitioners. Photography drew frequently from this origin, which can be illustrated by one of the oldest known photographic portraits of a medical practitioner, a full-plate daguerreotype taken circa 1848, depicting John Collins Warren, the founder member of Massachusetts General Hospital and the first Dean of Harvard Medical School.

The photograph depicts Warren from the waist up, standing behind a small, round table, which stays out of focus and serves as a surface to display meaningful props, including a foetal human skeleton as well as a large wax model of a human heart. Warren keeps his hands around the base of the skeleton's stand in a possessive yet protective gesture, which suggests both his care and "ownership" of this prop. The doctor's gaze does not face the camera, but it falls to the left side of the frame, while the skeleton seems to "look" in the same direction. This conjunction creates an additional bond between the man and the miniscule skeletal form.

Warren, most likely in his 70s when the daguerreotype was taken, stands upright in a pose alluding to power and confidence. His dress is sartorially

8 Famously, Hunter offered Byrne to pay for his body when the latter was still alive. Horrified by the idea, Byrne requested to be buried at sea, but when he died in 1783, the resourceful surgeon bribed the undertaker and snatched the corpse. Hunter revealed that he owned the bones years later. In this context, the display presented in the portrait can be seen as an exhibit of a trophy. For more information see, for example, Ludmilla Jordanova, *Defining Features: Scientific and Medical Portraits 1660–2000* (London: Reaktion Books, 2000), 120.

FIGURE 6.2
John Collins Warren, MD, ca.
1848, full plate daguerreotype
©STANLEY B. BURNS, MD &
THE BURNS ARCHIVE

lavish and consists of multiple layers, including a cloak cap, which is casually draped on his shoulders. This item of Warren's dress seems particularly excessive, given that the daguerreotype must have been taken in an indoor studio. In an effort to compensate for the poor photosensitivity of the plates, these early studios required lots of light and were usually uncomfortably hot. In this context, the cloak can be interpreted as an essential part of the doctor's costume, worn in this image chiefly for the purpose of signification. This costume, together with Warren's demeanour, make the first Dean of Harvard Medical School appear more like a Romantic hero, with all implication to his nobility and efforts for achieving greatness, than a nineteenth-century medical doctor—a figure which the general public did not associate with such dignified notions. The large model of a human heart, an organ traditionally associated with the emotional aspect of life, further supports the idea of the doctor's generosity and selflessness.[9]

9 Warren was portrayed with an image of a heart before the 1848 daguerreotype. An oil
 painted portrait of the then young doctor holding a drawing depicting a human heart was
 created by Gilbert Stuart, a painter often named to be the "Father of American Portrai-

This aura of intrepidity surrounding Warren is even more evident when the viewer realises that in the 1840s the photographic subject was forced to endure minutes of immobility required by the daguerreotype technique's long exposure time. Not only, however, is the photograph extremely sharp, which testifies to the fact that the doctor did not move during the exposure, but his facial expression does not indicate any symptoms of stiffness or distress, which are so characteristic of early photographic portraits. In addition, while Warren's left eye is partially hidden in the shadow of his deep eye socket, his right one catches light and sparkles with liveliness, which stands in contrast with the dead glare displayed by models in the majority of early photographic portraits. All these features make the work of the anonymous daguerreotypist a perfect example of an image that captures the subject's spirit, provides information about his occupation, and conveys an array of positive meanings associated with both his individual characteristics and traits related to his profession. Most of the existing nineteenth- and twentieth-century photographs belonging to this genre do not achieve this level of artistic or semiotic quality, and they remain "likenesses" rather than "portraits" of people who can be identified as "medical doctors."[10]

Back when professional portraits were taken predominantly in the generic, neutral settings of the studio, and doctors posed for portraits in their street clothes, information about the sitter's medical profession was conveyed solely through the use of props, which were typically a variety of human skeleton parts. Out of the 38 formal medical portraits published in *Stiffs, Skulls and Skeletons: Medical Photography and Symbolism* by Stanley B. Burns and Elizabeth A. Burns, only one image, a photograph of a phrenologist taken in New York in 1875, is devoid of the presence of human bones, while 35 out of 38 images include a cranium. This frequency secures the skull's place as an indispensable prop in professional medical portraiture.

The depiction of the human cranium claims a long tradition in fine arts, and its symbolic role in professional medical photographic portraits is rooted in art history. Not only is the skull among the most broadly used symbols in the arts, but it is also one of the most ambiguous ones. As noted by philosopher

ture" in 1812. The painting was then copied by Stuart's official copyist, James Frothingham. In the 1860s, the portrait was engraved by S.A. Schoff and published on the cover of the first volume of *The Life of John Collins Warren, M.D.* (Boston: Ticknor and Fields, 1860) by Edward Warren.

10 In his analysis of the notion of portrait as a method of social (self)-identification, Bernard Berenson uses both terms, "likeness" and "effigy." See Bernard Berenson, "The Effigy and the Portrait," in *Aesthetics and History in the Visual Arts* (New York: Pantheon, 1948), 190–200, here 199–200.

Julia Kristeva, when death is unpresentable by definition, because it is what representation seeks to control to produce and fix signification,[11] the image of a skull, often accompanied with two crossed bones, has served as the iconic symbol of death for centuries. In medieval art, skulls are especially abundant in images associated with dying, and are commonly used in funeral imagery. Also, since the Middle Ages, Christian saints are often depicted in the company of skulls. For example, Saint Jerome, usually portrayed as a studious man surrounded by books, appears in numerous paintings within arm's reach of a human cranium.[12] Since the end of the sixteenth century, when the image of a clean, dried-out skeleton replaced the decaying and worm-infested figure of *transi*, the depiction of a grinning skull was widely promoted as *memento mori* in the popular genre of *vanitas*.

Ambiguity of the skull's symbolism is best exemplified by the fact that it serves as an icon of death, while also recognised as an indication of its defeat. This notion was popularised by Calvary scenes, in which the skull of Adam was placed at the foot of Christ's cross. According to this interpretation, the presence of Adam's skull at the exact time and place of Christ's death symbolises the final triumph over original sin and, consequently, victory over death, which was brought upon humanity by the transgression of Adam and Eve.[13] The presence of Adam's skull in Calvary scenes, however, points out notions besides the simple dichotomy of life and death. It also evokes the link between death and knowledge.

This concept was promoted by a medieval tale featured in Jacobus de Voragine's *Golden Legend*.[14] According to the story, the cross used in Christ's crucifixion was built with wood directly linked to the Tree of Knowledge.[15] Through his death on this particular cross, Christ rehabilitated the knowledge that led to Adam's demise, and by this act, he also definitely conquered death. The

11 Julia Kristeva, "Holbein's Dead Christ," in *Black Sun: Depression and Melancholia*, trans. Leon S. Roudiez (New York: Columbia University Press, 1989), 105–138.

12 See, for example, works by Albrecht Dürer (1514 and 1521), Palma il Giovane (1595), Caravaggio (1605–1606), and Lionello Spada (1610), just to name a few.

13 In the early Christian tradition, it was believed that the earthquake, which occurred at the moment of Christ's death created a crack that exposed Adam's skull and allowed Christ's blood to drip on it. In the story, Christ's blood washed away Adam's sin and granted him salvation. See, for example, Fra Angelico's *The Crucifixion* (ca. 1420–23).

14 *Golden Legend* was compiled circa 1260, and it was reedited numerous times. However, it was so widely read and copied in the Middle Ages that over a thousand manuscripts survived to the present day.

15 In this tale, after Adam's death, his son, Seth, buried him and planted on his grave a branch of the Tree of Knowledge, which was given to him by Archangel Michael. The tree, which grew from the branch, was cut to provide material for the Temple of Solomon, but it was rejected and abandoned until it was used to make Christ's cross.

FIGURE 6.3 A skeleton, contemplating a skull: lateral view, 1940, photolithograph, after a woodcut,
1543
COURTESY OF THE WELLCOME COLLECTION, LONDON, ATTRIBUTION 4.0 INTER-
NATIONAL (CC BY 4.0)

presence of Adam's skull in these images provides a visual reminder of this particular connection, but in Renaissance art, the association between knowledge and Adam's skull transfers to the idea of the skull as a symbol of knowledge in general.

In her article, titled "The Turn of the Skull: Andreas Vesalius and the Early Modern Memento Mori," Rose Marie San Juan discusses a woodcut titled *Skeleton Contemplating a Skull* from Andreas Vesalius's *On the Fabric of the Human Body* (1543) as an example of the semiotic conversion from the simple duality of life and death, to the rethinking of death as a learning point for life. According to the author, the early modern practices of dissection and anatomical imagery not only brought the human body out of obscurity, but they actually "shifted the terms of visibility under which the body would now be understood."[16] In this context, the entire skeleton, but chiefly the skull, stopped being associated exclusively with death and became perceived as an object related to learning. According to San Juan, skeletons were so widely used in dissection classes that in sixteenth-century English, the word "an anatomy" started to be used as a synonym for "skeleton," and a cranium became the most perceptible symbol associated with medical education.

Early photographic medical portraiture reinforces this notion. For example, an anonymous tintype portrait of a medical student dated circa 1875 features a young man in the company of bones arranged in a way that clearly indicates the *memento mori* convention. The presence of the skull still serves as a reminder of human mortality; however, it also suggests that the medical student in the picture studied the secrets of death, and this knowledge enables him to successfully battle the eternal enemy. The self-assured expression of the young man, who stares sternly at the camera with one hand resting on a book and the other holding a rib bone, which once again can allude to Adam, reaffirms this interpretation of the image.

In occupational medical photographic portraits, skulls frequently do not appear as passive objects, but models interact with them in a variety of forms. In group photographs, which started to be produced in the 1850s, the cranium sometimes occupies a central place in the composition, which suggests that it is not merely a prop, but rather a subject of the image. Men and, less often, women, who just began to appear in medical photographs by the 1880s,[17] are

16 Rose Marie San Juan, "The Turn of the Skull: Andreas Vesalius and the Early Modern Memento Mori," *Art History* 35, no. 5 (2012): 958–975, here 964.

17 While Elizabeth Blackwell was the first woman in America to graduate from medical school in 1849, and in Europe there are records of female physicians dating back as early as the 1700s, no records of their professional portraits exist.

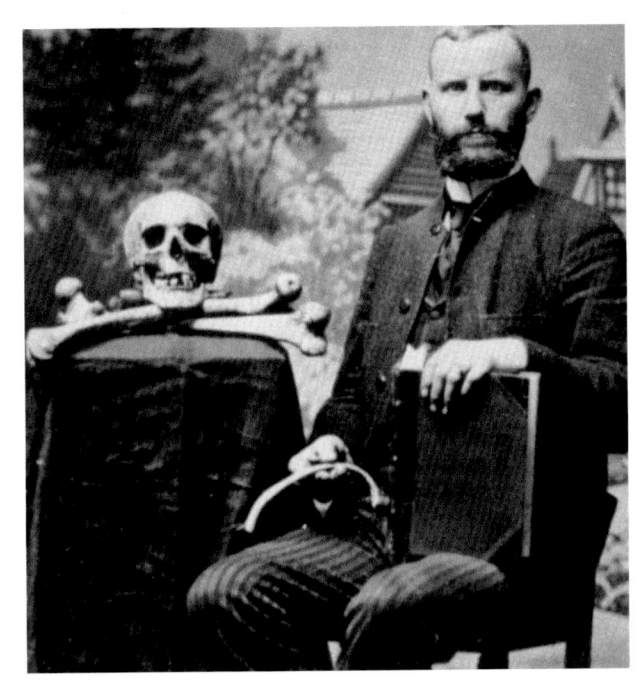

FIGURE 6.4
Medical student with
skull and crossed bones,
ca. 1875, tintype
©STANLEY B. BURNS,
MD & THE BURNS
ARCHIVE

holding a skull in their hands, pointing at it, and studying it. In some photographs, a skull seems to acquire some degree of "character" and starts to be treated with a reverence that is usually reserved for living creatures. For example, the cabinet card of a Viennese medical student (circa 1888) portrays a man sitting at a desk, with medical charts displayed in the room and a cranium in his hand. The subject, sitting in half profile, appears not to pose for the photographer nor pay attention to the camera, but rather gives the impression of engaging in a dialogue with the skull, which returns the man's attentive and amicable look with a friendly grin of its own.

This pose can be interpreted as an allusion to Hamlet's soliloquy with the skull of Yorick, but also to Vesalius's *Skeleton Contemplating a Skull*, and consequently read as an allegorical image in which the dead, acting as agents of knowledge, share their secrets with the living. Such formulation explains the reverence with which skulls are treated in most of the early photographic occupational portraits. In addition, according to Jordanova, the decorum of arrangements presented in early occupational portraits was strongly associated with the main goals of the genre, which were to secure professional identity of medical practitioners and establish a positive image of the profession. In this context, the solemnity of the sitter, together with his merit and education, which are established by use of the props, must be recognised both as a representation of the profession and as one of the essential building blocks of

FIGURE 6.5
Viennese medical student
with charts and skull, ca. 1888,
cabinet card
©STANLEY B. BURNS, MD &
THE BURNS ARCHIVE

middle-class ideology, which dominated the group identity of an extremely socially diverse body of medical practitioners in the nineteenth century.[18]

In addition to perfectly earnest images, however, the body of early photographic occupational portraits contains photographs that seemingly defy the professional solemnity of the genre. For example, an ambrotype image taken circa 1858 depicts a subject identified as Doctor Belden of New York City posing next to a table supporting a cranium and bones. While at first glance, this setting appears to be a typical one for the genre, the fact that a skull has a large cigar placed between its jaws disturbs the established code and alters one's perception of the picture.

Today, Doctor Belden's portrait can be read in a variety of ways, ranging from juvenile drollery to a grievous disrespectfulness toward human remains. Either case would disqualify the portrayed New York doctor as a serious professional. In the nineteenth century, however, when the standards of dealing with

18 Jordanova, "Medical Men 1780–1820," 104.

FIGURE 6.6
Dr. Belden, New York City, ca.
1858, ambrotype
©STANLEY B. BURNS, MD &
THE BURNS ARCHIVE

human remains differed significantly from what is deemed acceptable today, such displays of playfulness signified the medic's "intimacy" with death and his ability to conquer it. This notion became a dominant element of code used in dissection portraits, which started to appear in the 1880s and slowly replaced studio-based occupational portraiture, outlasting it by two decades.

As noted by the authors of *Stiffs, Skulls and Skeletons*, dissection photography occurs in two major models. The first variant typically consists of a large group of students appearing with their professor. Such photographs are usually carefully composed and executed by a professional photographer, who took them on location, mostly in large anatomical theatres. These images bear a strong resemblance to pictures displayed in fifteenth-century anatomical treatises, Renaissance drawings of dissection class lessons, and early seventeenth-century oil paintings, including works by Aert Pietersz and Rembrandt van Rijn. According to Samuel Burns and Elizabeth Burns, such "official" dissection photographs were used for both educational and documentary purposes, but most importantly, they served as valuable promotional materials for medical schools by advertising their wealth of supplies during times when cadavers were scarce.[19]

19 Stanley B. Burns and Elizabeth A. Burns, *Stiffs, Skulls, and Skeletons: Medical Photography and Symbolism* (Atglen, PA: Schiffer, 2014), 49.

The second variant of dissection images are pictures portraying students with a cadaver, but with no professor in the frame. Most of these photographs are dated between the 1880s and 1920s, and, as noted by John Harley Warner in the introduction to the book *Witnessing Dissection: Photography, Medicine, and American Culture*, "their sheer ubiquity is remarkable."[20]

Despite the abundance of the images belonging to the second variant of dissection photographs, they constitute a coherent genre. Students in them are usually displayed in groups of ten or less, and they typically pose in their street clothes, only sometimes covered with any protective gear. The cadavers, almost universally displayed on a table in the front of the men, are in advanced stages of decomposition. At least one of the students in the picture is often smoking, since tobacco smoke helped to mitigate the smell of decaying bodies.

These "informal" dissection pictures were taken on location, frequently with hand-held cameras, by both professional and amateur photographers. They are also mostly an American phenomenon. This can be explained by

FIGURE 6.7 Eastern states students in Baltimore, ca. 1915
©STANLEY B. BURNS, MD & THE BURNS ARCHIVE

20 John Harley Warner, "Witnessing Dissection: Photography, Medicine, and American Cul-
 ture," Introduction to *Dissection: Photographs of a Rite of Passage in American Medicine:
 1880–1930*, eds. John Harley Warner and James M. Edmonson (New York: Blast Books,
 2009), 7–29, here 11.

the fact that unlike in Europe, where medical education was strictly organised and controlled, the training of physicians in the United States was not university based and "consisted of a two-year apprenticeship with a physician and then some courses at a medical school, which until about 1910, was often a small local proprietary establishment."[21] In this situation, anatomy classes were often the medical students' only hands-on experience, and dissection room photographs served as "rite of passage"[22] documents, singular "evidence" of one entering the professional field. For identification purposes, sometimes students in the pictures appeared with the symbols of their native states written on their smocks, and their names were either listed in the image or written on the back of the photograph.

There is a certain paradox to dissection photographs: their abundance stands in strong contradiction with the fact that, from a legal standpoint, they serve as a testimony to crime.[23] In light of the lack of regulations that would have provided schools with legal ways of obtaining cadavers for medical training, most of the bodies used in anatomy classes were secured by grave robbing, which was often coordinated by the professor and executed by the students. In this context, dissection room photographs display students who not only share the harrowing experience of the hands-on anatomy lesson, but who are also partners in crime. This paradox is even more extrusive in cases when dissection photographs were made for public viewing and turned into *cartes de visite*, cabinet cards, and postcards, produced with the intention to send them as greetings for the celebration of major Christian holidays.

While these postcards are most likely perceived by a modern viewer as an odd joke, many dissection room photographs are intentionally humorous. This macabre, dark, or gallows humour[24] is often achieved by means of crossing the boundary between life and death. Skeletons, which are ubiquitous in anatomy classroom scenes, play a chief role in breaking the taboo. They are frequently depicted as "persons" and posed in a variety of roles, including "one of

21 Burns and Burns, *Stiffs, Skulls, and Skeletons*, 25.

22 This term is used both by the authors of *Stiffs, Skulls, and Skeletons* and by John Harley Warner and James M. Edmonson, the writers of *Dissection: Photographs of a Rite of Passage in American Medicine*.

23 See James S. Terry, "Dissection Room Portraits: Decoding an Underground Genre," *History of Photography* 7, no. 2 (1983): 96–98.

24 So-called "gallows humour" has been present in medicine since the emergence of the first medical practices, and it always attracted the attention of both medics and people outside the medical world. The main ongoing discussion concerns ethical problems associated with this form of humour. See Katie Watson, "Gallows Humor in Medicine," *The Hastings Center Report* 41, no. 5 (2011): 37–45.

FIGURE 6.8 Our dissection classmate, ca. 1895
©STANLEY B. BURNS, MD & THE BURNS ARCHIVE

the students," "students' best friends," or as "patients."[25] In other images, these roles could be also fulfilled by the cadaver.

Many of these dissection photographs were created as part of the fraternity-building ceremonies or hazing rituals, commonly practised in American medical schools.[26] In addition, such whimsical treatment of human remains underlines the status of the cadaver as an unidentified "stiff." This dehumanisation of human remains is further reinforced in these scenes by the addition of humorous inscriptions related to the fate of the cadavers, which often included puns and other forms of verbal playfulness.[27]

25 Skulls and skeletons were also often used ironically in the nineteenth- and twentieth-century art which was not related to medicine. See, for example, Edvard Munch, *Self Portrait with Skeleton Arm*, 1895.

26 As noted by Stanley Burns and Elizabeth Burns, bodies, skeletons, and skulls have been commonly used as props also by nonmedical fraternal organisations and various arts associations in their community-building rituals; see Burns and Burns, *Stiffs, Skulls, and Skeletons*, 237.

27 Among the most popular were such captions as: "She/He Lived for Others, but Died for US," "Rest in Pieces," or "Her/His Loss is our Gain."

The conditions surrounding the treatment of the cadaver stemmed directly from the societal norms during the times when these photographs were produced. A dissection class, as depicted in photographs, was a space of strict segregation, where female students took anatomy classes separately from men, and students of colour were farther separated from white men and women. At the same time, in American photographs, the cadavers used in dissections were mostly of African American people and they were used regardless of the students' gender. While, according to Warner, images depicting dissectors as hunters posing with their trophies aimed to convey a "sense of robust, vigorous manhood"[28] in the face of fin-de-siècle masculinity crises, dissection photographs in which the only person of colour besides the cadaver is the janitor document both the racial and economic discrimination that was pervasive in late nineteenth- and early twentieth-century medical education.[29]

Finally, medical occupational portraits, including dissection-room photographs, also illustrate the development of photography. Images produced before the 1850s are daguerreotypes, while those dating from the 1860s and 1870s are mostly ambrotypes and tintypes. Starting in the 1860s, professional portraits were also produced as albumen prints in *carte de visite* format, followed by cabinet card style. Most of the photographs lack any written information about the photographer, and only on rare occasions is the name of the studio advertised on the photograph's border. This demonstrates the photographer's position as a mere craftsman who, with the help of a mechanical device, has captured the likeness of the sitter. In this sense, as noticed by Tanya Sheehan in *Doctored: The Medicine and Photography in Nineteenth-Century America*, photography and medicine seemed to be natural allies. Not only did both professions battle unfavourable reputations, but they were often confused and compared with other disciplines, with a camera perceived as one of "the instruments of tooth extraction, which were popularly associated in the nineteenth century with physical torture, decapitation, or even death."[30]

28 Warner, "Witnessing Dissection," 13.
29 Janitors in these photographs remain anonymous, however, Warner mentions a porter named Grandison Harris who was a slave jointly owned by seven members of the Medical College of Georgia. After emancipation he continued working for the school as a paid employee and became a recognisable figure in Augusta society. Another porter recognised by name is Chris Baker, who for years worked at the Medical College of Virginia, Richmond, and appears in numerous photographs taken at that school. See Warner, "Witnessing Dissection," 20, 63, 69 and 139.
30 Tanya Sheehan, *Doctored: The Medicine and Photography in Nineteenth-Century America*, (University Park, PA: Pennsylvania State University Press, 2011), 53.

In this sense, the professional goal of the late nineteenth- and early twentieth-century photographers who created medical occupational portraits was not just to help construct a more positive impression of the medical profession, but also to establish their own professional standing. The body of medical professional portraits eventually became part of a collective photographic portfolio that constituted the place of photography as a more trustful representational tool and allowed it to dominate visual imagination for decades to come.

Picturing Pathology: An Affirmative Reading of Lam Qua's Medical Portraiture

Carolyn Lau

After consecutive humiliating defeats in the First Opium War (1839–1842) and Second Opium War (1856–1860), the declining Qing dynastic government of China conceded to unequal trade terms that forcefully opened up the country's vast interior. The Treaty of Nanking (1842) signed by China and the United Kingdom ceded Hong Kong Island to the British and established five treaty ports, including the South China city of Canton (today's Guangzhou). Canton had been monopolising China's trade with the West when it was made an exception by Emperor Qianlong in an edict that closed off all ports to foreign investors in 1757. Canton became a unique enclave of cultural, linguistic, and racial differences. While the legalised trade of opium made the narcotic the most sought-after product in the city, one cultural commodity was also very popular among foreign traders and visitors: trade paintings. As China's response to the fashion of *chinoiserie* in nineteenth-century Europe and America, trade paintings were "executed by professional Chinese artists in Western media and technique [and] produced purely as saleable items to meet the need of the Western visitors who wished to bring back home a pictorial record"[1] of the unfamiliar and remote China.

Appealing to Western taste, Chinese painters originally trained in classical styles highly distinctive from Western pictorial representation in terms of form, technique, and subject matter switched from the calligraphy brush to paintbrush. As perspective and chiaroscuro were unfamiliar to Chinese painters in the late Qing dynasty, the trade paintings they produced in oils and watercolours often look flattened and distorted in the composition of sceneries and depiction of human figures. Nevertheless, these "Westernised Chinese style of painting"[2] as stylised images of stereotypical Chinese subjects or exotic postcard scenes were in high demand in the treaty port of Canton. This prompted

1 Laurence C.S. Tam, "Preface," *Late Qing China Trade Paintings*, ed. Laurence C.S. Tam (Hong Kong: Hong Kong Museum of Art, 1982), 6, here 6.

2 Joseph S.P. Ting, "Late Qing China Trade Paintings," in *Late Qing China Trade Paintings*, ed. Laurence C.S. Tam (Hong Kong: Hong Kong Museum of Art, 1982), 8–11, here 8.

the establishment of many successful painting workshops that operated on a streamlined production model in Canton, Hong Kong, and Macau. These workshops, run by master artists of Chinese traditional painting, employed hundreds of apprentices to reproduce images of China and its people as imagined and seen through the eyes of a foreigner.

Lam Qua (1801–1860), whose name was Guan Qiaochang, was one of the most successful and well-known artists of his time. Unlike most of his contemporaries who fell into obscurity after the rise of photography and quick demise of the trade painting industry, Lam remains historically significant for the series of strange and memorable medical portraits completed in 1836–1852, in partnership with the American missionary doctor Peter Parker. Today, Lam Qua's medical portraits are important artefacts of transcultural scientific and artistic encounters. The painter worked within a racially and culturally foreign system of Western medical science and fine art. Lam also radically adopted the medium of oil painting, previously a monopoly of the elite, in his images of Chinese disfigured by tumours. The portraits overturn hierarchical and oppressive class and racial relationships between the patient, practitioner, and the image maker. Lam Qua's series of medical portraits problematises the power of medical imaging and scientific knowledge production in a global context.

In 1835, Lam Qua became the first Chinese artist to exhibit his works at the Royal Academy in London. He was the only known Chinese pupil of George Chinnery (1774–1852), the most accomplished English artist to have visited and worked in China in the nineteenth century. Chinnery studied under Sir Joshua Reynolds at the Royal Academy schools and was steeped in the Grand Manner oil portraiture tradition. As Chinnery's pupil, Lam Qua distinguished himself among the trade painting practitioners for his exceptional mastery of the technical and stylistic aspects of oil painting, so much so that there were cases where a painting by Lam was wrongly attributed to Chinnery, including infamously a copy of a self-portrait by the English artist. As cited in one of the few biographical studies of Lam Qua and his work, Carl L. Crossman refers to a note by "Old Nick," a traveller in nineteenth-century Canton and his description of the rivalry and fallout between Lam Qua and Chinnery. Master and student presented their relationship very differently to outsiders: "To hear Chinnery talk, Lam Qua is a subaltern, a wretchedly bad painter whose sole merit comes from having stolen from him some models and some methods. To hear Lam Qua talk, he was the favourite student, the assistant to the English painter."[3] The breaking point came when Lam Qua undercut Chinnery's

3 Carl L. Crossman, *The Decorative Arts of the China Trade: Paintings, Furnishings and Exotic Curiosities* (Woodbridge: Antique Collectors' Club, 1991), 26.

business by promoting "the novelty of an accomplished work in the Western style by a Chinese artist—and at a fraction of the price."[4] However, the fallout was not simply about business competition. It can also be seen as Chinnery's defence of the cultural superiority of Grand Style oil painting as a uniquely Western artistic genre. A contemporary French critic de la Vollée also commented disparagingly that Lam Qua was "out of his element before an English countenance" and liable to "*China-fy*" Anglo-American faces (albeit with inadvertent originality)."[5] A similar contemporary comment notes, "Talented though he was [Lam Qua] could never entirely eliminate his Chinese mannerisms," even describing his oil paintings as "western art with a strong Cantonese accent."[6] Moreover, Lam Qua's trade paintings were regarded as manufactured products rather than art by his Western contemporaries, who described his workshop as a factory instead of a studio. A French observer notes, "There is no art in this. It is purely a mechanical production."[7]

While Lam Qua's prized oil portraits of Chinese and Western luminaries in the Canton region may not be considered artistically original, he enjoyed regional and international acclaim for his portraits of local taipans and foreign dignitaries. However, it is a series of grotesque, but memorable medical portraits completed in 1836–1852 that consolidates the artist's historical significance. In this series, Lam Qua depicted Chinese men, women, and children, old and young, at various stages in the progression of their tumours. Upon the invitation of an American missionary doctor, Peter Parker (1804–1888), Lam produced 114 paintings that serve as medical illustrations to Parker's case histories of Chinese tumour patients in the Canton region. Born in Massachusetts in 1804, Peter Parker completed his graduate studies in medicine and theology at Yale College in 1834, after which he was ordained to the American Presbyterian ministry and embarked on a journey to Canton as the first Protestant medical missionary to China. In 1835, Parker started the Ophthalmic Hospital, which is also known as *P'u Ai I Yuan* (Hospital of Universal Love). As part of the Presbyterian missionary project in the newly opened up imperial China, Peter Parker and his team provided free medical services to the local patients as part of a program to convert the Chinese population and bring them to spiritual

4 Patrick Conner, "Lam Qua: Western and Chinese Painter," *Arts of Asia* 29, no. 2 (1999): 46–64, here 57.

5 M. de la Vollée, "Art in China," *Bulletin of the American Art Union* (October 1850): 118–119, here 119, qtd. in Stephen Rachman, "Memento Morbi: Lam Qua's Paintings, Peter Parker's Patients," *Literature and Medicine* 23, no. 1 (2004): 134–159, here 140.

6 Larissa N. Heinrich, "Handmaids to the Gospel: Lam Qua's Medical Portraiture," in *Tokens of Exchange: The Problem of Translation in Global Circulations*, ed. Lydia Liu (Durham: Duke University Press, 1999), 239–276, here 244.

7 Qtd. in Rachman, "Memento Morbi," 140.

awakening through scientific advancement. While the hospital specialised in treating eye diseases, in particular performing cataract surgeries, Parker was also renowned for his skilful operations on tumour patients. As the medical portraits by Lam Qua were executed in a meticulous, almost photographic manner, the series remains an extremely rare and invaluable documentation of the local Chinese of the period. These paintings later travelled and were exhibited at Guy's Hospital in London in 1835 as part of a fundraising campaign for the construction of hospitals in Canton. Most of these portraits are now in the collection of Yale University Medical Historical Library. Others are held by the Gordon Museum, Cornell University, and the Peabody Essex Museum.

Parker's medical missionary work took place in Canton, a semi-colony that was the pivot of imperialist economic expansion and opium trade, a precursor of global flows of capital. Parker's free medical services and gospel of charity were an anomaly. Parker's backers expressed concern about his juxtaposition of Christian faith and medical science, even showing displeasure at how Parker's missionary activities were superseded by his medical services. While Parker offered free medical care to bring the Chinese to God and held regular church services at the hospital, The American Board of Foreign Missions maintained that

> [...] the medical and surgical knowledge [...] are to receive your attention only as they can be made handmaids to the gospel. The character of a physician, or of a man of science, respectable as they are, or useful as they may be in evangelising China, you will never suffer to supersede or interfere with your character as a teacher of religions.[8]

It is noteworthy that Peter Parker established his reputation as a miracle worker by healing the visually impaired. Parker's decision to specialise in ophthalmology has several reasons. First, eye surgeries are comparatively simple and less prone to fatal medical errors. Second, the restoration of sight to patients suffering from poor eyesight and living in partial darkness for years is comparable to an awe-inspiring miracle. Soon enough, numerous Chinese patients previously sceptical of Western medicine flocked to Parker's hospital for medical treatment.[9] An early case note from November 1835 records Parker's clinical encounter with Akeen, a thirty-one-year-old visually impaired merchant, telling him (through an interpreter) "of the world in which he may see, though

8 Heinrich, "Handmaids to the Gospel," 255.
9 Michelle Campbell Renshaw, *Accommodating the Chinese: The American Hospital in China, 1880–1920* (London: Routledge, 2005).

never again on earth; that in heaven none are blind, none deaf, none sick."[10] Not only was Parker surgically enabling his near-blind patients to see again, letting in light to their world after years of being shrouded in darkness, his medical prowess and scientific knowledge impressed the local populace as they witnessed and experienced first-hand the superiority of Western medical science and its power to alter and enhance the human body's capacity.

While his medical services were admirable, Parker's medical mission went hand in hand with imperialist capitalism, as China's defeats in the Opium War provided access for missionaries like Parker to the bodies of its population, and venture capitalists to resources and an untapped market. As Eric Hayot argues, sympathy was a currency in the exchange between China and the West in the nineteenth century.[11] Parker refers to the gratitude of Chinese patients as a unit of measuring the influence of Western science and Christianity as forces of enlightenment that the dynastic nation in great decline desperately needed. The missionary doctor was also selling sympathy for backward "natives" to his donors in the West. Similarly, Lam Qua did not charge Parker for the series of medical portraits. The series of portraits also functioned as trade paintings or "hand-painted art products."[12] Lam reportedly remarked "that there is no charge for "cutting", he can make none for painting."[13] To Lam, it was a fair transaction. The artist was also trading on the currency of gratitude. Lam was returning the favours that Parker extended to his nephew, Kwan A-to, Parker's first Chinese apprentice in Western surgery. Parker remarked that "[Lam Qua] is a great lover of the medical profession, and regrets that he is too old to become a doctor himself."[14] Lam may also have been responding to Parker's interest in oil paintings by a Chinese artist by showing his enthusiasm and respect for Western medicine.

In a discussion on the immense impact of Parker's surgical miracles on Chinese tumour patients and their impression towards Western science and religion, Corinna Wagner observes that "[t]he removal of huge tumours radically altered the appearance of the body, thus the bodies of Chinese

10 "Jargon Spoken at Canton," *Chinese Repository* (February 1836): 466, qtd. in Rachman, "Memento Morbi," 142.

11 Eric Hayot, *The Hypothetical Mandarin: Sympathy, Modernity, and Chinese Pain* (Oxford: Oxford University Press, 2009).

12 Winnie Wong, *Van Gogh on Demand: China and the Readymade* (Chicago: University of Chicago Press, 2013).

13 Qtd. in Heinrich, "Handmaids to the Gospel," 49.

14 Heinrich, "Handmaids to the Gospel," 248.

patients would, Parker argued, be "written with indelible characters.""[15] They would bear permanent material "testimony to the superiority of Western medicine and the glory of God."[16] The previously deformed bodies of tumour patients now restored to health and normalcy bear the inscriptions of the power of Parker the healer and his instruments: advanced medical science and Christian charity. Even though there is only one set of before and after painting in the whole series, the grotesque, outsized tumours of the patients as shown in the oil portraits compel viewers to imagine their bodies after surgery, with the tumour removed and replaced by either the absence of a limb or smoothed out body surface.

Hans Belting defines the portrait in Western art as a process "to progress toward a vivid idea of a human being in an image for the society of his own time."[17] A portrait is not only a copy of the face and posture of the sitter. Rather, it is a relational medium that captures how the human figure is sensitive to the changes in the perceived nature of the individual in Western society. Similarly, Richard Brilliant describes portraiture as "the genre that involves the representation of the structuring of human relationships."[18] A portrait captures the moment it was painted and creates paradoxically an impression of timelessness comparable to the iconic image. While portraits promise the endurance of the subject across time, what is recorded is not only an individual but his or her position in a wider socio-economic context. In one of the earliest studies of portraiture as genre and form, Lomazzo (1584) argues that only images of virtuous, high-born subjects should be reproduced as portraits for emulation. In this sense, portraiture also defines the general category of humanity in terms of acceptable appearance and behaviour that constitute normalcy. Traditional portraiture had a limited range of subject matter. The sitter, most of the time the person who commissioned the portrait, is a member of the ruling class. As such, the subject matter of portraiture is especially culturally conditioned and determined by social qualifications. A common subject will be dignitaries expressing their exemplary public roles, such as Lam Qua's stately portrait of Howqua, the most important Hong merchant in the Thirteen Factories in Canton.[19]

15 Corinna Wagner, "Visual Translations: Medicine, Art, China and the West," *Fudan Journal of the Humanities and Social Sciences* 8, no. 2 (2015): 193–234, here 222.

16 Wagner, "Visual Translations," 222.

17 Hans Belting, *Face and Mask: A Double History* (Princeton: Princeton University Press, 2017), 105.

18 Richard Brilliant, *Portraiture* (London: Reaktion Books, 1991), 9.

19 The Thirteen Factories were Chinese, or more specifically Cantonese-style residential and business buildings allotted to Western traders in today's Guangzhou. This enclave was situated within a densely populated Cantonese urban environment and operated through

The formality and stateliness of the sitter and his or her "neutral, studied features gave sitters an air of dignified repose in concentration,"[20] which reflects a consolidation of social status. Their appearances have to conform to public expectations of how a member of the ruling class looks like.

Even though likeness and idealisation are two of the distinctive, though paradoxical, demands of the genre of portraiture, Lam Qua defies both criteria in his medical portrait series. Though Lam made his fortune by producing portraits of the influential and the wealthy, a contemporary observer noted Lam's preference for documentary likeness. Above the door of Lam Qua's shop was a sign that read "Lam Qua, English and Chinese painter,"[21] suggesting the range of styles offered for sale, as well as his international clientele. Another sign read "Lam Qua Handsome face-painter."[22] Osmond Tiffany, Jr. visited Lam Qua's studio in 1844 and mused, "His facility in catching a likeness is unrivalled, but wo [sic] betide if you are ugly, for Lam Qua is no flatterer."[23] Lam Qua's efforts to recreate a documentary likeness of his sitters serve Peter Parker's purpose well. First, Parker's tumour patients are all physically deformed. To recreate likeness, it is impossible to idealise them. Second, to idealise the patients' appearances is to go against the purpose of medical portraiture, which is to record the pathology accurately and precisely, instead of venerating the subject. Remarking on a portrait of Akae, a thirteen-year-old girl afflicted with a sarcomatous tumour on her head, Parker commented on Lam Qua's work: "I am indebted to Lam Qua, who has taken an admirable likeness of the little girl and a good representation of the tumor."[24] Parker's praise of the mimetic quality of Lam Qua's paintings conflates scientific accuracy with artistry. To Parker the doctor, the exactness with which a patient's ailment is copied and reproduced by Lam Qua on canvas is valued above the painter's personal and emotional response to his subject.

In the series of medical portraits of tumour patients, a fidelity towards the style of Western oil portraiture is demanded of Lam Qua. The portraits also have to be empirical evidence of advanced Western medical science that put

much of the later eighteenth century into the 1850s. It was the site of daily cross-cultural encounters and global trade, where Chinese and foreign merchants arranged shipments of luxury goods such as tea, silk, and spices to the West. See Johnathan Andrew Farris, *Enclave to Urbanity: Canton, Foreigners, and Architecture from the Late Eighteenth to the Early Twentieth Centuries* (Hong Kong: Hong Kong University Press, 2016).

20 West, *Portraiture*, 34.
21 Qtd. in Rachman, "Memento Morbi," 138.
22 Qtd. in Rachman, "Memento Morbi," 138.
23 Crossman, *The Decorative Arts of the China Trade*, 27.
24 Qtd. in Heinrich, "Handmaids to the Gospel," 49.

an end to the suffering of patients burdened by their tumours, scientific and technological backwardness, and superstition that deprived them from earlier treatment. One problem that arises when looking at Lam Qua's portraits is the ambiguity of its genre. We expect portraiture to reveal something personal about the subject. Medical images, on the other hand, function by recording and presenting the specificity of a narrowly defined and labelled symptom for general application. While the series of portraits of tumour patients serves as evidence that archives and categorises illness, Lam's choice of form and medium of oil portraiture traverses the assumed dichotomy of intimacy and objectivity, private and public. One of the categories of medical portraiture is the laudatory doctor portrait. Lam Qua also produced a portrait of Peter Parker. He staged Parker in a scene of a clinical encounter between his first Chinese apprentice, Kwan A-to, who was Lam Qua's nephew, and a Chinese patient. Kwan is shown treating the diseased eye of a patient. Seated at the centre of the composition and presenting the work of his apprentice proudly, this doctor portrait portrays Parker as a benevolent and authoritative missionary of scientific enlightenment and religious salvation.

While the conventions of portraiture demand a dignified, impassive portrayal of the sitter in order to maintain and confirm his social stature, medical portraiture demands a documentary portrayal of the sitter. Medical portraits

FIGURE 7.1
Lam Qua, "Dr. Peter Parker,"
ca. 1840s, oil on canvas, 65 cm
x 50 cm
COURTESY OF
MASSACHUSETTS INSTITUTE
OF TECHNOLOGY

have a practical use and serve "specific clinical functions: they were clinical aides-memoire, preoperational and postoperational analytical tools, and a way of bridging the physical absence of a patient when discussing cases at a distance."[25] If portraiture promises to reveal something particular about a person, medical portraiture as instrumental to the medical practice has to primarily engage with the particularity of a patient marked and defined by his or her type of disease. As Sander Gilman notes:

> The image of the identifiable patient as the bearer of a specific pathology arose in European medical illustration as an outgrowth of the medical philosophy of the *Ideologues*, who believed that only single cases could be validly examined and could serve as the basis of any general medical nosology.[26]

In a discussion of Théodore Géricault's portrait series of the mentally ill (1821–1824), Hans Belting notes that the subjects are not able to "lay claim to the representation of a self that forms the basis of every portrait [instead, the portraits] focus on medical cases rather than human subjects."[27] Lam Qua's medical portraits subvert the conventional objectification of patients in the name of scientific objectivity of Enlightenment empiricism. The extant medical portraits are evidence of Parker's patients' endurance and perseverance across time.

Stephen Rachman observes that Lam Qua's paintings are "complex images of cultural confluence and exchange, of East and West, Orient and Occident, portraiture and clinical documentation, Christian and heathen, rich and poor."[28] While Peter Parker's collaboration with Lam Qua and the resultant series of medical portraiture can be viewed as an effort of cultural exchange, the metaphor of exchange is still dependent on dichotomies. Instead, the Parker-Lam Qua project and its unresolved contradictions is a series of transversals of stratified, hierarchical, and dialectical categorical differences and oppositions of categories and domains. To Western audiences in the nineteenth century, Lam Qua's medical portraits show anomalous bodies of the racially other Chinese tumour patients whose bodies and faces are disfigured by their illness to the point of monstrosity. Their bodies are also described by

25 Douglas Hugh James, "Portraits of John Hunter's Patients," *Medical Humanities* 39, no. 1 (2013): 11–19, here 11.

26 Sander L. Gilman, "Lam Qua and the Development of a Westernized Medical Iconography in China," *Medical History* 30, no. 1 (1986): 57–69, here 63.

27 Belting, *Face and Mask*, 106.

28 Rachman, "Memento Morbi," 135.

Parker in his journals in animalistic terms, rendering their afflicted human bodies as hybrids with the species-other. These anomalous ways of embodiment are considered inadequate in terms of "humanness" as measured against the Enlightenment Humanist conception of Man as a ""rational animal" [...] inhabit[ing] a perfectly functional physical body, implicitly modelled upon ideals of white masculinity, normality, youth and health."[29] On the other hand, Deleuze argues that the anomalous is a state of productive in-betweenness. Deleuze reminds us of the important role of the anomalous as a point of convergence that mediates differences:

> We must define a special function, which is identical neither with health nor illness: the function of the *Anomalous*. The anomalous is always at the frontier, on the border of a band or a multiplicity: it is part of the latter, but is already making it pass into another multiplicity; it makes it become, it traces a line-between. This is also the "outsider."[30]

Even though the anomalous may be an outsider, and even a source of terror due to its strangeness, it is not to be understood as difference, as lack, or insufficiency. Rather, as the point in the middle, the anomalous serves as a passageway to other multiplicities. As Nietzsche writes, "What a will wants is to affirm its difference. In its essential relation with the "other" a will makes its difference an object of affirmation."[31] Another way of looking at the tumour patients in Lam Qua's paintings is to understand difference not as a source of fear but an affirmative displacement of negativity in hierarchical and oppositional understandings of categorical differences of race, gender, and health. The anomalous creates the possibility to compose vital and interconnected relations with the multitudes of the racial and gendered other.

To look carefully and record accurately the condition of the patient is central to diagnosis. As such, medical practice requires an acute practice of looking at and analysis of visible and physical signs of pathology as well as aspects of the patient's condition as shown by his or her gestures and demeanour. Foucault writes, "Clinical experience sees a new space opening up before it: the tangible space of the body, which at the same time is that opaque mass in which secrets, invisible lesions, and the very mystery of origins lie hidden."[32] Lam Qua's portrait of a female tumour patient, Leang Yen, shows a patient

29 Rosi Braidotti, *The Posthuman* (London: Polity, 2013), 67–68.

30 Gilles Deleuze and Claire Parnet, *Dialogues II* (London: Continuum, 2012), 32.

31 Gilles Deleuze, *Nietzsche and Philosophy* (New York: Columbia University Press, 1983), 9.

32 Michel Foucault, *The Birth of the Clinic* (London: Routledge, 2003), 150.

concealing her face with a deformed hand laden with a tumour that has grown to the size of her head. In his medical journals, Parker remarks on Leang Yen,

> The diseased hand scarcely looks like a hand at all. The patient's tumours come alive, as if they acquire a life of their own as an unruly beast. The growth takes on a life of its own. Fungoid, disklike protuberances give it a porcine appearance as if the patient held, improbable as it must seem, a pig-faced puppet.[33]

While this statement contains a slight dehumanisation of the patient, as suggested by the description of the body of Leang in animal terms, Lam Qua's literal portrayal of the tumour as a swine-like face suggests a radical levelling of human flesh and animal meat. Normalcy implies a clear distinction between man and animal, the human and the bestial. Yet, in one of Parker's entries, he describes the human flesh with the tumour removed as animal meat: "The best representation of the arm after amputation, so far as its shape is concerned, is that of a large ham of bacon."[34] Lam Qua's portraits suggest human flesh and animal meat are more alike than the viewers would like to believe, boldly unsettling the conflation of the racial and gender other with the species other in Enlightenment Humanism that propounds an exclusively Eurocentric and anthropocentric superiority.

This grotesque but intriguing posture and framing of the patient-sitter is rarely seen in the history of nineteenth-century painting and medical images. Rachman interprets Leang Yen's concealment of her face as an act of shame, as "the suffering is rendered anonymous and becomes emblematic of the raw, direct trauma of illness and the hidden quality of individual suffering."[35] However, this image could also be read in affirmative terms. It shows a patient in defiance of the authority of the doctor's gaze, which in this case is transferred to the painter's scrutiny of his subject matter sent to him by Parker. The conventions of modern clinical representation preserve anonymity by cropping the face or blacking out the eyes. Instead, Leang obscures her identity to resist the authoritative, penetrating gaze of the painter who in turn is closely examining her. This patient-sitter refuses to cooperate by withholding the gaze and the face and not allowing the painter to have access to these features, hence

33 Rachman, "Memento Morbi," 134.

34 Qtd. in Gordon Low, "Paintings from the Cushing/Whitney Library of Yale University. The Eleventh Kenneth Fitzpatrick Russell Memorial Lecture 2012," *ANZ Journal of Surgery* 83, no. 12 (2013): 903–907, here 905.

35 Rachman, "Memento Morbi," 136.

FIGURE 7.2 A woman (Leang Yen?) with a large tumour on her right hand, reclining
and concealing her face, gouache, 18--, after Lam Qua, ca. 1838
COURTESY OF THE WELLCOME COLLECTION (PUBLIC DOMAIN)

crippling the portrait. This painting suggests the artist accepts his defeat and portrays honestly a patient's reluctance to succumb to the authority of a racially and culturally foreign system of Western medical science, as well as the culturally alienating medium of oil painting usually reserved for the upper class. This work demonstrates and confirms the extent of agency of the portrayed patient in the production of his or her own portrait of illness. It also revises the presumed hierarchical and oppressive relationship between the patient, practitioner, and the image maker.

The portrait of Leang Yen alone problematises the social relationships within which medical imaging and portraits are made and scientific knowledge production. This is an especially prescient reminder in the field of critical medical humanities, which questions the mutual exclusivity of sensitivity and scientific objectivity in medical professionalism and the healing profession. In the case of medical imaging, a question that has to be asked is how much individuality of the subject can be retained without forsaking the imperative of faithful representation of the medical condition? There are no extant records of the encounters and conversations between Lam Qua the painter and his sitters. Yet, the highly individualistic faces of these patient-sitters communicate complex feelings of resignation and acceptance, shame and defiance, fear and hope as a life-changing but possibly fatal surgery awaits them. Lam Qua's paintings offer us the patient's account of illness which are often brushed

aside as trivial, childish, or irrelevant: the fears and anxieties before under-
going a strange and alien procedure of surgery and possible death. As we do
not have the patients' side of the story, these paintings become a chronicle of
their experience of illness and health. In these paintings, bodies inflicted by ill-
ness too acquire an eloquence and become bodies articulating what is usually
difficult to verbalise, such as the experience of pain and recovery. Lam Qua's
medical portraits are testimonies of the promise of curability and perfectibility
of the diseased human body. Paradoxically, the perfecting of the body is not
achieved through prosthesis but through surgical mutilation of the decayed
and deformed. To recover and restore health and wellbeing, body parts of tox-
icity have to be removed promptly.

While the portraits of tumour patients serve as visual evidence of Parker's
account of his successful operations in the audience of potential donors over-
seas, there is surprisingly only one pair of before-after images in the whole
series. Ludmilla Jordanova explains:

> Before and after images have long held special appeal. They can display
> the skill of clinicians, for example, and act as visual advocates for par-
> ticular treatments and medical philosophies [...] They are portraits of
> patients that can suggest the heroism of the unseen practitioner.[36]

The sole example of before and after images in Lam Qua's series of medical
portraits depicts a patient called Po Ashing.

Parker describes Po Ashing as "the first Chinese, so far as I know, who has
ever voluntarily submitted to the amputation of a limb."[37] The before image of
Po Ashing depicts the patient framed in a dark, sparse, and flat enclosure (most
likely in a studio) that heightens the brightness of the human figure, especially
the contours of the protruding tumour. On the other hand, the after image is
set in a romanticised landscape derived from the shores of the Pearl River, with
Po Ashing standing in profile and displaying the stump of his amputated arm.
While the stump marks the absence of an arm and the incompleteness of Po
Ashing's body, Lam Qua's placement of the now recovered patient integrated
with the landscape creates a sense of completeness despite the disabled body.
The ceaseless flow of the waves and timelessness of rocks and stones in the
background remind viewers of the regenerative power of nature and its cyclical
temporality, echoing the renewal of Po Ashing's health after years of pain and

36 Ludmilla Jordanova, "Portraits, Patients and Practitioners," *Medical Humanities* 39, no. 1
 (2013): 2–3, here 2.
37 Heinrich, "Handmaids to the Gospel," 259.

FIGURE 7.3
Lam Qua, "Po Ashing," ca. 1830–1850, oil on canvas,
61 cm x 47 cm
COURTESY OF YALE UNIVERSITY HARVEY
CUSHING/JOHN HAY WHITNEY MEDICAL
LIBRARY

FIGURE 7.4
Lam Qua, "Po Ashing," ca. 1830-1850, oil on canvas,
61 cm x 47 cm
COURTESY OF YALE UNIVERSITY HARVEY
CUSHING/JOHN HAY WHITNEY MEDICAL
LIBRARY

struggle with the growing tumour. This pair of paintings are both testimonies of a successful operation and affirmative portraits of life after illness. A patient may lose a limb, but he stands calmly before the flowing waters, exuding a quiet determination and acceptance that this is just a necessary loss. Amputation and fragmentation enable a recovery of wholeness. Confronting the pathological restores the relationality between man and his environment, and above all, transverses negative categorical differentiations that deprive embodiments of the non-white, non-masculine, disabled, and malformed of subjectivity.[38]

38 Acknowledgements: In the preparation of this chapter, the author acknowledges the pioneering scholarship on Lam Qua, visual culture studies, and medical discourses of Ari Larissa Heinrich and Stephen Rachman. I thank the warm encouragement and generosity of Corinna Wagner, who shared with me her work on the artist and cultural translations. I also thank the boundless patience of the editors of this volume and their astute commentaries.

"The Quickening:" Embryonic Stages in Visualising and Understanding Depression and Anxiety

stef lenk

Research on wordless comics and visual narratives is ever increasing, specifically within the area of graphic illness narratives. This can be seen by the continuing growth of the Graphic Medicine movement (USA and Great Britain),[1] the development of the PathoGraphics project (Berlin),[2] and the general rise of interdisciplinary based medical humanities courses attempting to address human medical experience from both artistic and scientific perspectives. In this growing line of research, however, there seems to be a decided focus on content and context rather than the actual creative processes with which people (both artists and non-artists) construct internal personal narratives of their lives.

Visual thinking and drawing provide a unique language with which to convey liminal experiences.[3] Because we do not have a codified dictionary of meaning for images, using them to communicate forces us to start new dialogues based on atypical visual and experiential landscapes. As a result, taking a closer look at graphic narratives made by someone who has themselves experienced depression and anxiety might provide new perspectives and avenues of conversation on the topic. Artworks tend not to be stigmatised in the same way illness is: they provide visual externalisations which can act as non-threatening middle grounds for discussing otherwise uncomfortable topics such as mental illness, initiating new conversations between private (individual/artist/client) and public (reader/therapist), which might lead to de-stigmatisation and/or positive change.

Cognitive scientist David Kirsh in his article "Using Sketching: To Think, To Recognise, To Learn" describes the use of sketching as a fundamental problem-solving strategy. He points out that the more elements there are to a problem, the more projections and associations between elements have to be made within the brain, and the harder it is to keep all that information reliably

1 See graphicmedicine.org.
2 See www.fsgs.fu-berlin.de/pathographics.
3 See Gillian Rose, *Visual Methodologies: An Introduction to the Interpretation of Visual Materials* (London: Sage, 2nd ed. 2007 and 3rd ed. 2012).

structured. Externalising these mental projects through language, images, symbols, or diagrams gives them a reliable anchor in the outside world [and] keeps them from disappearing, making it easier for the individual to successfully process complicated problems. Projection, Kirsh says, "is a way of compensating for the limits of our imagination."[4]

The comic to be analysed in this article, entitled "The Quickening," uses drawing and visual thinking to create a graphic narrative and then to visually analyse it to find perspectives on personal experiences of mental illness. The research process involves examining and evaluating the work at all stages of development in a search for cycles of thought and narrative meaning which might not be evident through mere evaluation of the artwork itself. Also used in the analysis are elements of autoethnography, an approach to research and writing which "seeks to describe and systematically analyse (*graphy*) personal experience (*auto*) in order to understand cultural experience (*ethno*)."[5]

The project has varied goals: 1) to seek connections between the creative process and the process of understanding mental illness; 2) to discuss how illness has been stigmatised in public/personal discourse, and how art can provide a middle ground that moves beyond these stigmas; 3) to demonstrate that visual works can open up new conversations between private (individual/ artist/client) and public (reader/therapist) about mental illness, particularly through taking a closer look at their developmental process; and 4) to encourage increased visual literacy by breaking down artworks in language from conception to completion.

This chapter provides a short description of my art practice followed by a preliminary analysis of drafts and developmental stages of "The Quickening," to examine how imagery changed over the course of the story's development in order to create a comprehensive narrative about a specific aspect of mental illness, namely the potential genetic inheritance of depression and anxiety.

1 "The Quickening,"a Preliminary Overview

The focus of my art practice to date has been the use of narrative drawings to create stories about inner landscapes of human emotion which, due to their

4 David Kirsh, "Using Sketching: To Think, To Recognize, To Learn," in *Thinking Through Drawing: Practice into Knowledge. Proceedings of an Interdisciplinary Symposium on Drawing, Cognition and Education*, eds. Andrea Kantrowitz, Angela Brew and Michelle Fava (New York: Teachers College, Columbia University, 2011), 123–125, here 123.

5 Carolyn Ellis, Tony E. Adams and Arthur P. Bochner, "Autoethnography: An Overview," *Forum: Qualitative Sozialforschung / Forum: Qualitative Social Research* 12, no. 1 (2011). http://www. qualitative-research.net/index.php/fqs/article/view/1589.

FIGURE 8.1 "The Quickening," stef lenk

transient and unreliable nature, potentially blur the lines between reality and fiction. The use of sequential pictures and minimal to no text is intended to recall a time prc-language and to reflect the intrinsic solitude of being an individual trying to psychologically understand the world "from the inside out," as it were. The use of metaphor in fictional narratives allows room for projection

(by the reader/audience) of new interpretations and multiple meanings specific and significant to their own private worlds, which can open up the potential for private stories to take on universal or public meaning.

2 Conception and Beginning Stages

The artistic process begins in a relatively fragmented series of sketches where diverse elements are put to paper and then combined, contrasted, and integrated to begin forming a cohesive narrative. The story is drawn and redrawn, focusing on different visual elements which will eventually have to blend comprehensibly if the chronicle is to be believable as a story.

"The Quickening" (Figure 8.1) was created based on the theme of genetic inheritance of depression and anxiety, addressing both the destructive and the creative nature of that "inheritance." The wordless narrative reflects psychology specifically by establishing a visual similarity between the placenta and the brain, while the contrast between panelled and unpanelled comics distinguishes what happens *in utero* from what happens after birth. Susan Merrill Squier, in her analysis of "The Quickening" (for the exhibition "*Sick! Kranksein im Comic / Reclaiming Illness through Comics*" at the Berlin Museum of Medical History) points out: "As the child struggles to separate from potentially smothering maternal influences, the transformation from umbilicus to pencil implies that the maternal transmission is both damaging (depression) *and* curative (artistic ability)."[6]

Looking beyond the final comic to the process of its creation yields further evidence on how ideas (first framed in language) were developed and integrated into a visual narrative. Preliminary brainstorming on the idea of genetic inheritance brought up associated circumstances such as the development of the foetus, time in the womb, and the nourishment of the embryo by the placenta of the mother. This was then visually extrapolated through illustrations of stages of embryotic development. The placenta, the source of the child's nourishment and development, comes to represent epi/genetically inherited fears, etc. It grows along with the child; their close relationship is visually established through their proximity in the constrained space of the womb and connection via the umbilical cord. Only when the two figures separate from each other, in real life through birth and in the graphic narrative via severance

6 Susan Merrill Squier, Irmela Marei Krüger-Fürhoff, Uta Kornmeier, Nina Schmidt and stef lenk, *Sick! Kranksein im Comic / Reclaiming Illness through Comics*, 1st ed. (Berlin: Patho-Graphics project / Freie Universität 2017), 16–17, here 16; my emphasis. http://edocs.fu-berlin. de/docs/receive/FUDOCS_document_000000028132, accessed 8 January 2018.

of the umbilical cord, does the conflict begin. In the narrative we are made visually aware, however, that the interrelation remains in the guise of a pencil, which will be used as 1) a tool of escape: used to draw the hole through which the child falls; 2) a tool of aggression: puncturing the brain to render it small and harmless; and 3) a tool of creative resolution: used to redraw a navel to "allow" the placenta to be internalised at the end of the comic.

The image of the placenta is representative of "*in utero* nourishment, the growth of the character, [and] the relentlessness of genetically inherited traits."[7] The pencil becomes a metaphor for creativity, drawing, and the child's initial gain, subsequent loss to the placenta, and regaining of control. The growth of the placenta through panels six to ten and its subsequent metamorphosis into a brain demonstrates the growing/overwhelming power of genetically inherited memory. The navel in the last panel of the comic echoes in shape the first panel with the embryo, visually indicating that the cycle has the potential to repeat itself through generations via rebirth.

3 Beyond the Product: Searching for Meaning in Process Materials

Developmental scientist Jaan Valsiner, who investigates mental and affective processes in human development, believes that culture provides the substance from which the mind and society are actualised.[8] He proposed that an individual is "constantly creating meaning ahead of the time when it might be needed—orienting oneself towards one or another side of anticipated experience, and thus preparing oneself for it."[9] Through empathising (positively and/or negatively) with characters in a self-created story, the artist determines at each stage how the narrative will unfold. The artist's mental state also influences this development, therefore each stage of the development of a story can provide clues as to her mental processes which might be significant and/or meaningful in understanding the final artworks. Direct analysis of artistic products is a conventional way of understanding graphic narratives, but what of the developmental process that led to their creation? Can we learn more about the implicit meaning of cultural artefacts through also examining what thought processes went into making them?

Mary-Anne Mace and Tony Ward's grounded theory analysis of creativity in the domain of art-making provides an excellent breakdown of artistic process

7 Squier, "Sick!," 16.
8 Jaan Valsiner, "Culture in Minds and Societies: Foundations of Cultural Psychology," *Psychological Studies* 54 (2007): 238–239, here 238.
9 Valsiner, "Culture in Minds and Societies," 238.

into four phases which will be used as part of the foundation for analysing the work created:

> Phase 1 | *Artwork conception* | [the] process of identifying an implicit or explicit idea that could be a potential artwork [derived from three major sources]: the artist's ongoing art-making enterprise, the interplay of life experience, and external influences.
>
> Phase 2 | *Idea development* | The complex process of structuring, extending, and restructuring a particular artwork idea through a range of decision-making, problem-solving, experimental, and information-gathering activities.
>
> Phase 3 | *Making the artwork* | [The phase where] the work undergoes a transformation from a purely conceptual entity into a conceptual and physical entity. At this point the artwork can also be further influenced by the physical constraints of its making.
>
> Phase 4 | *Finishing artwork and resolution* | An evaluation of the work by the artist resulting in preparing the work for exhibition, publication, etc. or abandoning/shelving the work for further development.[10]

This chapter uses aspects of Mace and Ward's breakdown as a basis for the analysis of the comic.

4 "The Quickening"

The artistic process for the making of this comic begins in a relatively fragmented series of sketches where diverse elements are put to paper and then combined, contrasted, and integrated into a cohesive narrative. The story is drawn and redrawn, focusing on different elements of the narrative which eventually will have to join seamlessly if the chronicle is to be believable.

5 Draft 1

Concerned with the visualisation of an internal world, as well as conveying the beginning phases of human development. At this stage of the comic's development the narrative begins with a close-up of the mother's belly (figure

10 Mary-Anne Mace and Tony Ward, "Modeling the Creative Process: A Grounded Theory Analysis of Creativity in the Domain of Art Making," *Creativity Research Journal* 14, no. 2 (2002): 179–192, here 182–187.

FIGURE 8.2 "The Quickening," stef lenk

8.2). The first two panels would be meant to establish this; in the third panel the mother's hands cover the belly, and in the fourth are removed, revealing a "peephole" inside the body. Subsequent panels "zoom in(side)" the mother's body through the navel to a close-up view of the foetus *in utero*. At this point the mother is still a part of the narrative, even if only a portion of her body is visible.

6 Draft 3

Visualising depression first as an invisible illness without tangible parameters: frantic, black sketchy lines are used which surround the figure, whose despair and frustration is visually reflected through physical posturing in panel two (Figure 8.3). (A similar use of scratchy amorphous lines was also used by Ellen Forney to illustrate her illness in her 2012 comic *Marbles* (about depression and bipolar syndrome)[11] (Figure 8.4), as well as by Katie Green in her graphic memoir *Lighter than my Shadow* (Figure 8.5).[12]

11 Ellen Forney, *Marbles: Mania, Depression, Michelangelo, and Me* (London: Robinson, 2013), 92.
12 Katie Green, *Lighter than my Shadow* (London: Jonathan Cape, 2013), 163.

FIGURE 8.3 "The Quickening," stef lenk

FIGURE 8.4
Ellen Forney, *marbles*
(London: Robinson,
2013), 92

FIGURE 8.5
Katie Green, *lighter than my shadow* (London: Jonathan Cape, 2013), 163

Escape at this draft stage of "The Quickening" presents itself in the guise of a disembodied hand, which uses a pencil to "erase" the panel/border in which the figure is trapped with her thoughts. It then literally draws a three-dimensional environment complete with door through which she can escape. At a later stage the black scribbles will be replaced completely by the placenta, a conscious choice so as to give the illness an actual body, rendering it as something concrete to be fought against rather than something abstract and amorphous.

7 Draft 4

(Figure 8.6) The square-framed panel in which the figure is trapped and the womb begin to come together. The disembodied hand, instead of crafting an escape for the figure, "gives" her the pencil: an act of empowerment. The

FIGURE 8.6
"The Quickening," stef lenk

mother's body/hands are drawn outside the formal comic panel: in subsequent drafts they will disappear altogether. It is visually significant that the mother's body is not a part of later drafts; the comic becomes a story of empowerment by virtue of (the mother's) absence. The womb, in reality a part of another body (the mother's), exists here anonymously; a setting from which the main figure must liberate herself.

8 Draft 5

(Figure 8.7) Developing variations on how the main figure interacts with the pencil: using the eraser to create "a hole in the depression," turning the pencil onto herself, drawing a door as a way out. At this point the figure is in possession of the pencil, that is, the creative force no longer exists disembodied or outside of herself.

FIGURE 8.7
"The Quickening," stef
lenk

9 Draft 7

(Figure 8.8) Anxiety/illness is still represented as a shapeless and chaotic scribble of pencil lines, but also innately connected to the figure via a continuous drawn line. It is interesting to note that the figure is itself of course also comprised of pencil lines, visually reflecting how sufferers of depression can associate their illness with their very identity (often describing their state with "I am depressed" as opposed to "I have depression"). This sort of embodiment can make escape from the illness seem impossible.

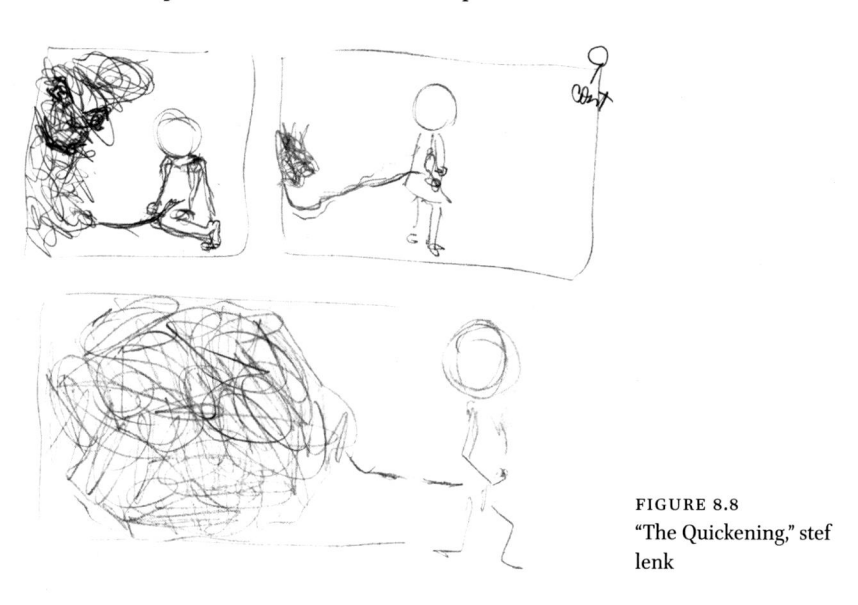

FIGURE 8.8
"The Quickening," stef
lenk

10 Draft 8

(Figure 8.9) Formative sketches changing the panel frame to the shape of a womb, and anxiety manifests in the form of a placenta. The pencil makes possible the creation of an escape route but the ending is still unresolved. The figure is shown in later panels dragging the placenta behind her, but turning to face it in the final panel, just as one has to confront one's problems to solve them.

11 Draft 9 (detail)

(Figure 8.10) Although the hole provides a plausible escape, the illness naturally follows. In this draft the chaos grabs the pencil and redraws the figure in the end in a supine position.

FIGURE 8.9
"The Quickening," stef lenk

FIGURE 8.10
"The Quickening," stef
lenk

12 Draft 13

(Figure 8.11) In this draft, the illness (consciously rendered to be visually reminiscent of a tornado/natural disaster) pursues the figure and diffuses up and around her into a panel frame, trapping her again within its confines.

FIGURE 8.11
"The Quickening," stef lenk

13 Draft 14

(Figure 8.12) This draft further develops the concept of anxiety/negative thought patterns—transforming from a placenta into a natural disaster—which then takes control of the pencil and draws a comic panel to entrap the figure. The last panel has become a padded cell she is stuck inside of; she regains the pencil but is only able to use it to keep track of her time imprisoned there.

FIGURE 8.12
"The Quickening," stef lenk

It is almost always the case in early drafts of creative works that images used to embody meaning are obvious and overstated; without language as a crutch, it is an attempt to ensure understanding of the narrative by making visual metaphors very obvious and direct. After this draft the padded cell idea was discarded: it proved melodramatic and inaccurate—a padded cell in reality would be used for someone with a psychotic degree of mental illness as opposed to someone experiencing general depression and anxiety.

14 Draft 22

(Figure 8.13) Experimenting with panels and placement. The story is divided into two phases: the top row of drawings marks the phase of development within the womb while the lower row presents the phase after the escape (visually expedited by the fall "downwards" through the hole). Panel size is also varied: panel frames get respectively smaller as the placenta gets bigger; eventually the placenta gets so large it takes over the entire panel, leaving the figure no alternative but to attempt an escape. To neutralise the large and overbearing placenta the (now smaller) figure pierces and "bursts" the placenta with the pencil, which shrinks to a once more manageable size in the final panel.

FIGURE 8.13
"The Quickening," stef lenk

15 Draft 23 (detail)

Figure 8.14 shows sketches concerned with visually humanising the placenta. Because the story is about two sentient characters, the placenta is invested with facial features so as to register emotion and reaction: to the child's escape,

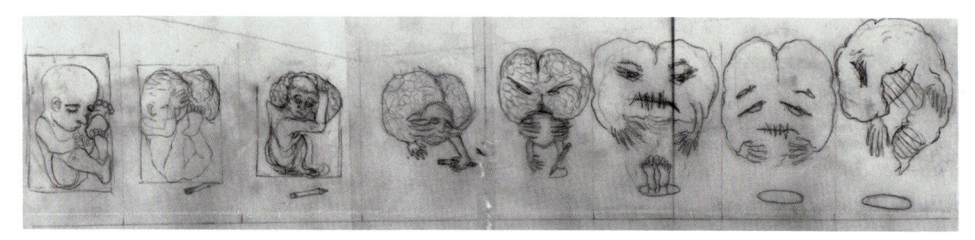

FIGURE 8.14 "The Quickening," stef lenk

the loneliness of remaining alone, the frustration that causes it to follow her. Humanising the placenta is vital in asserting its agency as a character, and to prevent potentially casting blame on the mother for the inherited illness. The anthropomorphised organ is in and of itself harmless, it too feels pain, loneliness, etc. and reacts naturally to being abandoned by following the figure out.

16 Draft 25

Figure 8.15 is similar to the previous draft except with a change in the panel count due to technical considerations. The final comic is to be reproduced in two formats: a one-sheet comic and a twenty-four-page booklet. For the latter the panels will need to span pages which amount to multiples of eight (books are printed in signatures of eight pages, sixteen pages, twenty-four pages, etc.)

FIGURE 8.15 "The Quickening," stef lenk

For this reason, the twelve panels are first increased to sixteen, which accommodates more detailed illustrations of what is happening at each stage. There is also experimenting with the relative size of the figure to the placenta—as the placenta gets larger the figure gets smaller to represent a shift in the power dynamic, and after the escape the size change happens in reverse, marking the figure's regaining of power over her illness.

17 Draft 26 (detail)

(Figure 8.16) Sketches focusing on the expression of the brain/placenta, based on considerations that the predominant emotional reaction should be one of loneliness and confusion as opposed to aggression. Where both characters have an emotional connection to each other this is a more natural reaction to the figure's leaving the womb; it also resonates with the concept of post-partum depression often experienced by mothers after the birth of a child.

FIGURE 8.16 "The Quickening," stef lenk

18 Draft 27

Figure 8.17 shows the first sketches in colour. Colour more accurately illustrates the corporeality of bodies and tends to generate a certain liveliness in illustrations that is not always evident in black/white. Because mental illness does not have a binary solution, black/white drawings would also seem too stark visually.

Coloured pencils (as opposed to watercolour) are used at the sketching stage to save time and sketches are made on vellum paper whose surface takes well to multiple erasures without becoming damaged. The pink of the womb is contrasted with the bruised purples and blues which seep into the panels as the placenta/brain develops.

In this draft, the foetus is already fully formed and recognisable at the start of the narrative. The brain in panel eight is rendered with an arched back

FIGURE 8.17
"The Quickening," stef lenk

reminiscent of a question mark: it realises it has been left behind but not why. What happens to end the comic after the brain is burst and shrinks down is still unresolved. In real life the placenta is disposed of after the birth, so logically it needs to disappear at the end of the story, but for the purpose of this narrative the placenta as metaphor is invested with traits which will not disappear; this also needs to be taken into consideration.

Further considerations revolve around the (as previously mentioned) two intended formats for this comic: a twenty-four-page comic with one drawing per page and a one-page A0 format, submitted for exhibition to the show *Sick! Kranksein im Comic / Reclaiming Illness through Comics* at the Berlin Museum of Medical History at the Charité, organised by the PathoGraphics project in Berlin. The panels are cut up and rearranged to negotiate possible layouts for the one-sheet version so that the drawings fit the space in a logical and visually pleasing manner.

19 Draft 28

At this point the decision is made to add drawings and move from a sixteen to a twenty-four-page panel narrative. The primary motivation for this decision is to "slow down" the story. Scott McCloud points out in *Understanding Comics*

FIGURE 8.18 "The Quickening," stef lenk

that comic panels "fracture both time and space, offering a jagged, staccato rhythm of unconnected moments," and it is via cognitive closure that readers of comics "connect these moments [to] mentally construct a continuous, unified reality."[13] More panels, defined by McCloud as "moment-to-moment transitions,"[14] result in shorter leaps in understanding for the reader. In the case of this comic, additional panels are illustrated which move the beginning of the story further back in time to the nascent stages of the embryo. The number of panels in which the figure and placenta grow and detach from each other is also increased, as well as extra panels clarifying how the pencil detaches from the placenta and is grabbed by the figure, who then uses it to draw her escape route. This is an improvement on draft twenty-seven where the pencil seems to appear out of nowhere in the figure's hand as a drawing tool.

Panel eleven and twelve of this draft involved visually experimenting with the idea of the placenta turning the pencil around and using the eraser to efface the figure's mouth, metaphorically obliterating her voice. This was later discarded in favour of a struggle between the two beings where the placenta tries to strangle the figure: this more aptly visualises the potential severity of mental illness and is also logical with regards to the actual organ (that is, the vasculature of the placenta wrapping around the figure's neck is a more feasible echo of "reality" than the placenta apprehending an eraser on the other end of a pencil with which it can silence the figure).

In this draft rectangular panel frames are discarded altogether, and the perimeters of the womb become the formal borders/frames for each panel. Further re-arrangement of the panels in this draft are still necessary because a blank panel at the bottom right of the format would cause the story to appear unfinished and hence unresolved.

20 Semi-final draft

(Figure 8.19) At a certain point, due to time constraints and a certain exhaustion that comes from a seemingly endless drafting process, the decision is made to begin (what I assumed to be) the final drawings, regardless of what might still be unresolved in the narrative. Solutions (as well as, occasionally, new challenges) present themselves frequently at this stage in the creative process.

13 Scott McCloud, *Understanding Comics: The Invisible Art* (Northampton, MA: Kitchen Sink Press, 1993), 67.
14 McCloud, *Understanding Comics*, 70.

FIGURE 8.19 "The Quickening," stef lenk

Pencil and watercolour were used for what originally was to be the final version of the panel illustrations. The properties of watercolour allow for a multi-layered building up of washes which have a delicate and transparent quality, resonating particularly with such elements in the story as the wall of the womb and the "shadows" of the figure in movement rendered in panels eight and nineteen. It also reflects the delicacy of the embryo itself.

Contemplating how to draw the narrative to a close, I decided that the placenta will have to re-integrate with the figure much in the way thoughts remain a constant factor in a person's mental state. The figure "draws" a navel through which the placenta is able to return to her core, now, however, at a manageable non-threatening size. Since the navel is the physical place of origin of the placenta, returning the placenta there also adds an additional layer of meaning to the narrative: that of the potential recurrence of the same story and conflict through rebirth (this time with the main figure as hypothetical mother).

Rendering the final panels with a close-up/detail of just the main figure's navel, however, presented a new challenge regarding one of the formats of the comic, namely the A0 exhibition format. When the comic is reproduced as a single page with multiple panels, the natural physical boundaries offered by the limits of a page in the book no longer exist, causing the panels with full-spread colour close-ups of the figure's belly to float on the format, creating an inadvertent visual frame where the colour ends. Having made the decision to avoid traditional rectangular panels throughout the comic, the last four panels would have to be redesigned so as to keep consistency with this decision.

I was not satisfied with the style and medium used in the semi-final draft for several reasons. Despite wanting the reader to be able to apprehend the story slowly, I was concerned that the overly painterly style of the watercolour drawings could potentially stop the narrative in its tracks, as it were. Instead of seeing the images as a sequential series, the meticulous rendering of each image might result in apprehending them as "stand-alone" paintings. I was also interested in considerations of what Scott McCloud calls "amplification through simplification."[15] He states that "by stripping down an image to its essential "meaning" an artist can amplify that meaning in a way that realistic art can't."[16] I decided to redo the panels in a reduced iconic style, redrawing them in black ink and colouring them in digitally (Figure 8.1). The simplified colour clarified the visual language of the story, allowing the reader to focus on the images as symbols with cumulative and implicit meaning in a larger narrative rather than individual paintings in their own right.

15 McCloud, *Understanding Comics*, 30.
16 McCloud, *Understanding Comics*, 30.

In the final comic (Figure 8.1) the decision was also made to create a non-rectangular frame (in panel twenty-one) echoing the shape of the navel and creating an organic boundary for the colour in the panel. This frame decreases in size through panels twenty-two and twenty-three until it becomes the size of an actual navel, with the placenta fully internalised and invisible once again. As a result, panel twenty-four becomes (in both colour and shape) a reiteration of panel one of the comic: the closed navel is flesh colour surrounded by white space, which echoes the colour scheme of the embryo in panel one. The final panels' devolution back to the original shape of panel one reflects the story's potential to repeat (just as genetically inherited traits can reappear in subsequent generations). While a mother figure is no longer clearly apparent, the main character of the story and the placenta have become one, which in some sense echoes the presence of an implicit resolution between mother and child.

Other decisions from the semi-final to the final stages of the comic include a return to the metamorphosis of the placenta into a brain in panels seven to eighteen, to make the metaphorical connection with mental illness more evident. The semi-final draft (Figure 8.19) has ghostly renderings of the figure's arm (panel eight) and of her whole body (panel nineteen) meant to visualise movement and clarify the narrative, which were deemed visually confusing and unnecessary so they were removed.

For the final draft of the A0 format comic the panels were redistributed across the five rows on the page; this was done for visual balance. For the book format version of the comic I chose the watercolour version of panel three to be the title page: it is one of the strongest visual expressions of the strange and unfamiliar feelings I imagine to be associated with foetal development, and the alienating predicament of confrontation in the restricted confines of the womb with an organ meant to nourish but instead proving to be a threat. The figure in its embryonic stage looks more like a tiny unusual monster than a human being, emotionally resonating the alienation a person with depression and anxiety can at times feel.

21 The Comic's Title

The initial title given to the comic was "The Beginning," signifying both the beginning of a life and the beginning of what was to be a series of graphic narratives. When ideas of genetic inheritance began to solidify within the narrative the name was changed to "The Inheritance." The title was then changed again to "The Quickening," a term no longer widely used, which means "[to] reach a stage in pregnancy when movements of the fetus can be felt, [or, of

a fetus, to] begin to show signs of life."[17] In the time before X-rays (when this word was more actively in use), the mother-to-be would have the choice at this stage to either announce her pregnancy or keep it secret, which I felt added a vaguely subversive element to the title, not just for the status of empowerment it lends to the figure in the comic but also for the associated secrecy which resonates with the stigmatised nature of mental illness—the secret no one wants to reveal about themselves—the secret that, if neglected, can grow up and unwittingly eclipse its owner's own freedom.

22 Conclusion

Both this chapter and the comic it analyses represent embryonic stages in a larger project examining how visualising anxiety and depression might provide greater understandings of the lived experience of mental illness and how it might be made manifest in works of (comic) art. The theme of genetic inheritance seemed an appropriate starting point: visualising aspects of an illness in the time before birth, when external circumstances have not yet begun to shape an individual's thinking. Examining the development of these creative "adaptations" of pre-existent internal narratives proffers a middle ground for further discussion about the mental states and struggles which inspired them, a middle ground not stigmatised in the same way as traditional discussions about mental health, and which could therefore lead to new insights regarding both graphic narratives and themes of mental illness.

17 See for the term "quickening," *Oxford Dictionary of English*, 3rd ed. (Oxford: Oxford University Press, 2018); and "quicken," *Merriam-Webster.com* (2018). https://www.merriam-webster.com, accessed 26 March 2018.

PART 3

Power, Consumption and the Pathological Body

∵

Capitalism without Desire: Economic Thinking and the Visualisation of the Biomedical Body ca. 1900

Claudia Stein

> A critique does not exist in saying that things are not good as they are. It consists of saying on what type of assumption, of familiar notions, of established, unexamined ways of thinking the accepted practices are based [...] Criticism consists in uncovering that thought [...] making it so that what is taken for granted is no longer taken for granted. To practice criticism is to make harder those acts which are now too easy [...].
> (Michel Foucault, "So is it Important to Think?")[1]

It is well-known that Michel Foucault presented his critiques of contemporary "familiar notions" in the form of histories. In his archaeological and genealogical works on madness and the modern medical body, on the prison and punishment, or on sexuality and ethics, he demonstrated that our ways of thinking and accepted practices were the result of contingent turns of history or the outcomes of rationally and progressive inevitable trends. Rather, his histories (originally inspired by the German philosopher Friedrich Nietzsche) unveiled historical breaks and disruptions and demonstrated that historical necessity and universality did not exist and that things had been radically different in the past.

I want to use Foucault's historical critique as an inspiration to investigate certain fundamental assumptions about human nature in one of the most successful areas of contemporary economic thought and practice: behavioural economics. I am less concerned with the biomedical and mathematical models applied by behavioural economists to test and define the bounds of rationality of human beings in situations of economic decision-making. What I want to uncover are the underlying assumptions of what it means to be human on which the behavioural economists experimentation and theoretical reasoning are generally based. My means will be through the historisation of a specific visual artefact, a commercial poster advertising medical services (the choice of

1 Michel Foucault, "So is it Important to Think?," in *Power*, ed. J. Faubion (New York: New Press, 2000 [1981]), 160–161.

which will become apparent). Uniquely, the history of this striking turn-of-the-twentieth-century poster *can be* retrieved.[2] We not only know who published it and what the intentions of its producers were, but also why it was controversial in a specific socio-political situation.[3] By putting the poster in its historical context, I will show that the anthropological paradigm of a hedonistic human nature promoted by behavioural economics today is specific to contemporary forms of global finance capitalism. But it hardly applies to all forms of modern market capitalist systems and societies. By using the example of leading economists in Germany at the turn of the twentieth century, I will demonstrate that our contemporary notions of a universalist and transhistorical hedonistic human nature as the driving motor of all economic activity is an invention of our times.

On 27 January 1901 the Munich police department, which was responsible for censoring all forms of public announcements, including commercial posters, decided that the poster advertisement for the private laboratory of Ernst and Alfons Schwalm had the potential to "molest and frighten" individuals and the public at large. The threat was borne out—the reason, its "presentation and explanatory text."[4] Despite repeated appeals by Klebs and Schwalm, both of whom had doctorates in chemistry, it was never to be publicly posted.[5] Along with its accompanying correspondence, it disappeared into what today are the holdings of the state archive in Munich.

The visual *content* of the poster is that which most readily invites exploration, since this is what the civil servants in the Munich Police Department primarily engaged with.[6] Clearly at issue in the Police Department's reaction to the

2 For a sustained discussion of the enormous difficulties involved in getting at the "history" of such visual objects, see Claudia Stein and Roger Cooter, "Coming into Focus: Posters, Power, and Visual Culture in the History of Medicine," in *Writing History in the Age of Biomedicine*, Roger Cooter with Claudia Stein (New Haven: Yale University Press, 2013), 112–137.

3 In this paper I am drawing on earlier thinking which was first presented in a joint paper written with Roger Cooter; see Roger Cooter and Claudia Stein, "Die Geschichte des Gesundheits- und Hygieneplakats neu betrachtet. Die ökonomische Neuerfindung des Wissens über das Selbst," in *"Erkenne Dich selbst!" Strategien der Sichtbarmachung des Körpers im 20. Jahrhundert*, ed. Sybilla Nikolow (Köln: Böhlau, 2015), 344–357.

4 Staatsarchiv München, Pol. Dir. München 6646, 27. The poster was first presented at the police office in December 1900.

5 Staatsarchiv München, Pol. Dir. München 6646, 27. For their appeal of January 1901, see fol. 2a. Their last appeal dates from 22 May 1901, fol. 79 f.

6 It is also what art historians and others usually choose to focus on when discussing poster art. For example, Julia Bigham, "Commerce and Communication: Commercial Advertisement and the Poster from the 1880s to the Present," in *The Power of the Poster*, ed. Margaret Timmers (London: V & A Publications, 1998), 173–219; Jeremy Aynsley, *Graphic Design in Germany 1890–1945* (London: Thames & Hudson, 2000); Birgit Doering, "Frühe Warenwerbung im Spannungsfeld von Kunst und Kommerz," in *Die Kunst zu werben. Das Jahrhundert der Reklame*, ed. Susanne Bäumler (Köln: DuMont, 1996), 190–197; and Jürgen Döring, *Gefühlsecht. Graphikdesign der 90er Jahre* (Heidelberg: Edition Braus, 1996).

FIGURE 9.1 Billboard advertisement: Chemisches Labor von Dr. Alfons Schwalm und Dr. Ernst Klebs, Staatsarchiv München, Pol. Dir. München, Plakatsammlung, Plakatsammlung 1800

poster was less its beautiful *Jugendstil* design (Munich at the time being at the German forefront of this new art form),[7] than its public distribution of information about infectious diseases through image and text. This is not the place to trace in detail the history of the organisation of public announcements on the many public billboards and *Litfaßsäulen* (advertisement columns) across the city.[8] Suffice here to say that while advertisements for health and hygiene products and services—such as Klebs and Schwalm's poster—were not illegal, they were often highly contentious.[9] Not only considerations of public health, but also aesthetics were intrinsic to this contentiousness, with commercial posters of any sort being generally deemed visually "to pollute" the city's carefully orchestrated neoclassical architectural appearance.[10] The capital of the kingdom of Bavaria liked to celebrate itself as the German Athens at the river Isar. Practical politics and budgets were also involved, since the city still had vivid memories of how, not long before, it had been brought to a virtual commercial standstill through outbreaks of typhoid and cholera—with contemporaries likening peoples' hysterical reactions to medieval plague epidemics.[11] Of course, too, the causes of infectious disease such as cholera and tuberculosis

7 See Herbert Schindler, *Monographie des Plakats. Entwicklung, Stil, Design* (München: Süd-
 deutscher Verlag, 1972); 116, and Annemarie Hagner, *Das Plakat im Jugendstil* (PhD disser-
 tation, University of Freiburg, 1958). For the history of the poster in Munich see *Plakate in
 München 1840–1940. Eine Dokumentation zu Geschichte und Wesen des Plakats in M*ünchen
 aus den Beständen der Plakatsammlung des Münchner Stadtmuseums. Katalog zur Auss-
 tellung 16. Oktober 1975 – 6. Januar 1976 (München: K.M. Lipp, 1975). On poster culture
 more generally in Germany, see Aynsley, *Graphic Design in Germany*.

8 The German *Litfaßsäule* was invented by the Berlin entrepreneur Ernst Litfaß in 1854. In
 the beginning they were used as urinals; see Wilfried F. Schoeller, *Ernst Litfaß. Der Reklam-
 ekönig* (Frankfurt/M: Schöffling & Co., 2005), 119–157. For the regulations in Munich see
 Plakate in München.

9 On the problems of advertising medical remedies, see Wolfgang Wimmer, *"Wir haben fast
 immer was neues." Gesundheitswesen und Innovationen der Pharma-Industrie in Deutsch-
 land, 1880–1935* (Berlin: Duncker & Humblot, 1995), 47–105.

10 On the legal regulation of public postering in German cities at the turn of the twentieth
 century, see Johannes Kamps, *Plakat* (Tübingen: Niemeyer, 1999).

11 Munich experienced cholera epidemics in 1836–37 and 1853–54, but was spared in 1892.
 For a vivid description of the impact of the cholera epidemic in 1854 on civic life and
 particularly its consequences for Munich's budding tourism industry, see Karl Wieninger,
 Max Pettenkofer: Das Leben eines Wohltäters (München: Hugendubel, 1987), 154–156. For
 the comparison between nineteenth-century cholera epidemics and medieval plague, see
 Carl Flügge,"Die Verbreitungsweise und Verhütung der Cholera auf Grund der neueren
 epidemiologischen Erfahrungen und experimentellen Forschung," *Zeitschrift für Hygiene
 und Infektionskrankheiten* 14 (1893): 122–202, here 123. For the many typhoid fever epi-
 demics in Munich during the nineteenth century and the contemporary discussion on its
 causation, see Christopher Childs, "The History of Typhoid Fever in Munich," *Lancet* 151,
 no. 3884 (1898): 348–354.

were still hotly contested at the time of the poster's printing. Robert Koch's groundbreaking research in the 1870s (in particular his isolation of the agents of anthrax and tuberculosis) dramatically changed the way in which the causation and transmission of infectious diseases came to be understood.[12] But, in Germany as elsewhere, the change was not immediate. It took many years to convince even fellow medical scientists of the unparalleled pathological power of the ubiquitous living organisms that were not visible to the naked eye. Famously, the Munich-based chemist and hygienist, Max von Pettenkofer (1818–1901), Germany's first professor for hygiene (from 1865), contested Koch's theory in 1882 by imbibing (and surviving) a "cholera cocktail" obtained from Koch.[13] He thus lent support to his neo-miasmatic environmentalist theory of good health based on clean water supply, fresh air, and proper sanitation.

Public responses to bacteriology in Germany were not constrained by scientific niceties, however; by 1900 public enthusiasm for the bacteriological idea was unbounded.[14] Thousands of popular journal articles, books, and brochures whetted the appetite for it, as did talks and exhibitions organised often by established chemists, biologists, and doctors. But the public enthusiasm was not for the theory's sake; increasingly, it was grounded in concern over how human bodies could now be perceived as being at the mercy of bacteria—how inside and outside the body these invisible "secret agents" were indiscriminately gunning for illness.[15] Klebs and Schwalm's poster played com-

12 Christoph Gradmann, *Laboratory Disease, Robert Koch's Medical Bacteriology*, trans. Elborg Forster (Baltimore: Johns Hopkins University Press, 2009), 22–114; Anne Hardy, *Ärzte, Ingenieure und städtische Gesundheit* (Frankfurt/M and New York: Campus Verlag, 2005), 313–328; Andrew Cunningham, "Transforming Plague: The Laboratory and the Identity of Infectious Disease," in *The Laboratory Revolution in Medicine*, eds. Andrew Cunningham and Perry Williams (Cambridge: Cambridge University Press, 1992), 209–224; and Thomas Schlich, "Repräsentation von Krankheitserregern. Wie Robert Koch Bakterien als Krankheitserreger dargestellt hat," in *Räume des Wissens. Repräsentation, Codierung, Spur*, eds. Hans-Jörg Rheinberger, Michael Hagner and Bettina Wahrig-Schmidt (Berlin: Akademie Verlag, 1997), 165–190.

13 Silvia Berger, *Bakterien in Krieg und Frieden. Eine Geschichte der medizinischen Bakteriologie in Deutschland 1890–1933* (Göttingen: Wallstein, 2009), 106–110. For the "cholera cocktail" story see also Andrew Mendelsohn, *Cultures of Bacteriology. Formation and Transformation of a Science in France and Germany, 1870–1914* (PhD dissertation, Princeton University, 1996), 442–455.

14 See Berger, *Bakterien*, 77–92. For the rising popularity of the natural sciences more generally in nineteenth-century Germany, particularly among the middling classes, see Andreas Daum, *Wissenschaftspopularisierung im 19. Jahrhundert. Bürgerliche Kultur, naturwissenschaftliche Bildung und die deutsche Öffentlichkeit 1848–1914* (München: R. Oldenbourg, 2002).

15 This point is elaborated in Berger, *Bakterien*, 81–89. Also Olaf Briese, *Angst in den Zeiten der Cholera. Über kulturelle Ursprünge des Bakteriums (Seuchen-Cordon I); Panik-Kurve. Berlins Cholera-Jahr 1831/32 (Seuchen-Cordon II); Auf Leben und Tod. Briefwelt als Gegenwelt*

mercially to this, inviting people to allay their fears by undertaking periodic examination of their phlegm and urine where the agent of such diseases as tuberculosis could be detected early. "Consumption," their poster informed, "is the most widespread disease and unfortunately carries off preferably people in their most virile age. According to the *Kaiserliche Gesundheitsamt* a full third of all people between 15 and 60 dies of consumption." "For all classes of the population the forceful fight against this aggressive slayer of humankind is an extremely important task," the poster continued, "because every sufferer from tuberculosis presents a danger for his environment."[16] The emphasis here was personal, not "scientific." It did not matter that scientists might still be debating Koch's germ theory and that effective treatment was not yet available. Ultimately, however, it was the scientific debate that sealed the fate of Klebs and Schwalm's poster. In May 1901 the police officials submitted it to two military physicians for an independent opinion, and both agreed on its impropriety for conveying "truths" that were still in dispute among medical scientists.[17]

Clearly, the content of Klebs and Schwalm's poster was enmeshed in contemporary debates over the understanding of infectious disease, as well as over ways of visually imagining its causation. Controls over civic space were also involved. But beyond these aspects of what I call the *content* of the poster was the attention it drew (and draws) to the role of business and money-making in the popularisation of modern science and medicine.

Until recently this has been a subject receiving little attention from historians.[18] A notable exception is Nancy Tomes who has examined the place of those persons in late-nineteenth and early twentieth-century America who carved out a living for themselves by inventing products and services around the new science of bacteriology.[19] In Germany, Dresden's Karl August Lingner (1867–1916), the hugely successful manufacturer of the anti-bacteriological mouthwash Odol, is a good example of this kind of "germ entrepreneur" who, early

(*Seuchen-Cordon III*); *Das schlechte Gedicht* (*Seuchen-Cordon IV*) (Berlin: Akademie Verlag, 2003).

16 See the poster inscription München StAA, Pol. Dir, Plakatsammlung, 1800.

17 München StAA, Pol. Dir, fol. 79–81, 22 Mai 1901.

18 For a recent contribution to this literature see Takahiro Ueyama, *Health in the Marketplace: Professionalism, Therapeutic Desires, and Medical Commodification in Late-Victorian London* (Palo Alto, California: Society for the Promotion of Science and Scholarship, 2010).

19 Nancy Tomes, *The Gospel of Germs: Men, Women, and the Microbe in American Life* (Cambridge, MA: Harvard University Press, 1998). Attention to the role of commercial enterprises and advertisements in the spreading of bacteriological knowledge in Germany is referred to in Berger, *Bakterien*, 83–89.

on, grasped the commercial possibilities of bacteriology-based products and heavily invested into national and international campaigns to advertise their virtues.[20] Klebs and Schwalm, in the promotion of their private chemical laboratory, can be considered the same. However, in Germany at the turn of the century, this was not only unusual, it was fiercely contested. Because the processes of industrialisation, urbanisation, and imperialism had lagged well behind those in America or Britain, the reactions to any commercial advertisement were all the more intense. Rapid urban growth, the destruction of traditional social hierarchies and divisions of labour, and the increasing pauperisation of the working classes, all contributed. So too, more manifest, were the much commented on signs of "modernity" such as new modes of transport, commerce, and mass communication. All of these changes were keenly felt, especially by the German bourgeois classes (*Bürgertum*).[21] For them, poster-advertisements in particular became a glaring symbol of the values of the new commodity culture, and modern industrial capitalism in general.[22] Although commercial posters for goods and services had been know before, they had been produced mainly for the *insides* of shops.[23] Their appearance on billboards and *Litfaßsäulen* came to be regarded as a violation of public and private space, so much so that they came to be referred to as "poster noise"—*Plakatlärm*.[24] In the poster collection now held at Munich's state archive there is an abundance of citizens' complaints about these new tools of advertising (*Reklame*).[25] Reflecting

20 See Ulf-Norbert Funke, *Karl August Lingner. Leben und Werk eines gemeinnützigen Großindustriellen* (Dresden: B-Edition, 1996).

21 For the definition of the term and others used at the time, such as "Mittelstand" and "Mittelklasse" and how these differed from the French terms "classes moyenne" and "bourgeoisie" or the English "middle classes," see the excellent discussion in Erik Grimmer-Solem, *The Rise of Historical Economics and Social Reform in Germany 1864–1894* (Oxford: Clarendon Press, 2003), 96–101.

22 Kevin Repp, "Marketing, Modernity, and the "German People's Soul,"" in *Selling Modernity: Advertising in Twentieth-Century Germany*, eds. Pamela E. Swett, S. Jonathan Wiesen and Jonathan R. Zatlin (Durham and London: Duke University Press, 2007), 27–51.

23 For an excellent introduction to the history of advertising in Germany, see Christiane Lamberty, *Reklame in Deutschland 1890–1914. Wahrnehmung, Professionalisierung und Kritik der Wirtschaftswerbung* (Berlin: Duncker & Humblot, 2000).

24 A. Cüddow, "Straßenbild und Reklame," *Das Plakat* 1 (1910): 60–65, here 60. *Das Plakat* (1910–1921) was published by the *Verein der Plakat Freunde* which was founded in 1905 by the Jewish poster collector Hans Josef Sachs (1881–1974). The remaining posters (ca. 4800) of his once massive collection (over 12,000 objects) were held at the German Historical Museum after World War II. They are currently being returned to his family in the United States.

25 Targeted, in particular, were posters advertising medicines and food products, but also advertisements for all sorts of entertainments. Complaints to the police department were either made in person or via anonymous postcards and letters.

the deep unease over them is the evidence of the desire to micro-manage their appearance and distribution.[26] Although perhaps not overtly, the prohibiting of Klebs and Schwalm's poster hinges on this need to control and contain the public place of the commercial poster—, that is, on its *form* as much as its *content*.

It was not only the citizens of Munich and other German cities who had serious issues with the *form* of the commercial poster. As a tool of advertising it was central to many German theorists and critics of modernisation.[27] Most notable here was the national economist and sociologist Werner Sombart (1863–1941).[28] He considered advertising posters loathsome, as American expressions of high capitalism and the signifiers of the artifice of modern capitalistic city life.[29] One aspect of the concern over them that Sombart shared with many of his contemporaries in Germany was their brokering of a new relationship between humans and things. At root, it was this particular uneasiness, I submit, that sealed the fate of Klebs and Schwalm's poster.

I am hardly the first to suggest that a relationship between humans and things changed in Germany over the latter part of the nineteenth century, as it had done earlier in other industrialising countries.[30] Many historians of material culture and consumerism have come to emphasise how swiftly industrialisation in Germany produced not only an enormous variety of new goods, but also dramatically changed the rhythm and speed of their circulation

26 Besides the responses of the Police Department to such citizen complaints, the files also contain copies of legal decisions made in other German cities regarding posters, and newspaper clippings. The sources document how closely the Munich police department followed the development of civic advertisement all over Germany.

27 For this movement see, for example, Kevin Repp, *Reformers, Critics, and the Paths of German Modernity: Anti-Politics and the Search for Alternatives, 1890–1914* (Boston, MA: Harvard University Press, 2000).

28 Friedrich Lenger, *Werner Sombart 1863–1941: Eine Biographie* (München: Beck, 1994); for his economic thinking and ideas on policy see Johannes Glaeser, *Der Werturteilsstreit in der deutschen Nationalökonomie: Max Weber, Werner Sombart und die Ideale der Sozialpolitik* (Marburg: Metropolis-Verlag, 2014), 81–96.

29 Sombart was known for his critical stance vis-à-vis the American-style capitalism in writings such as, *Warum gibt es in den Vereinigten Staaten keinen Sozialismus?* (Tübingen: J.C.B. Mohr, 1906) (engl. *Why is there No Socialism in the United States* (New York: Sharpe, 1976)). His two articles on advertisement and modern exhibition culture created an extensive debate at the time. Werner Sombart, "Die Ausstellung," *Morgen. Wochenschrift für deutsche Kultur* 9 (1908): 249–256. He defended his views in Werner Sombart, "Ihre Majestät die Reklame," *Die Zukunft* 63 (1908): 475–487. The responses are listed in Repp, "Marketing, Modernity," 51. For Sombart's shifting economic and political thinking see also Glaeser, *Der Werturteilsstreit*, 81–96.

30 On the dramatic increase in industrial production and consumer goods in Germany between 1895 and 1913, see, for example, Hans-Ulrich Wehler, *Das Deutsche Kaiserreich 1871–1918*, 7th ed. (Göttingen: Edition Suhrkamp, 1994), 52–55.

(including here commodities and services).[31] Visual aspects of goods and their presentation rapidly began to dominate new physical venues for the interaction between humans and things, such as department stores and the growing number of national and international trade fairs.[32] New and surrogate materials flooded the market, and new forms for their production and distribution accompanied the final demise of the economic and aesthetic unity of traditional craftsmanship.[33] The visibility of consumer products became constitutive of the modern culture of consumption that increasingly equated the value of these goods with the attraction of their visual display. Indeed, the phenomenon of equating the value of a thing only with its visibility (as independent from other economic valuations such as "exchange value" and "use value") merited minting a new word for it in German: *Schauwert* (visibility value).[34]

31 This is a central topic in many recent works on the history of consumerism, most notably (in the English-speaking world) Arjun Appadurai, ed., *The Social Life of Things: Commodities in Cultural Perspective* (Cambridge: Cambridge University, 1986). For Germany's consumer history, see Warren G. Breckman, "Disciplining Consumption: The Debate about Luxury in Wilhelmine Germany, 1890–1914," *Journal of Social History* 24, no. 3 (1991): 485–505; Gudrun M. König, *Konsumkultur. Inszenierte Warenwelt um 1900* (Wien, Köln and Weimar: Böhlau, 2009); Hannes Siegrist, Hartmut Kaelble and Jürgen Kocka, eds., *Europäische Konsumgeschichte. Zur Gesellschafts- und Kulturgeschichte des Konsums (18. bis 20. Jahrhundert)* (Frankfurt/M: Campus, 1997); and Heinz-Gerhard Haupt and Claudius Torp, eds., *Die Konsumgesellschaft in Deutschland 1890–1990. Ein Handbuch* (Frankfurt/M and New York: Campus, 2009).

32 On the history of department stores in Germany, see, for example, Repp, "Marketing, Modernity," 27–38. See also König, *Konsumkultur*, 92–160; Heinz-Gerhard Haupt, *Konsum und Handel: Europa im 19. und 20. Jahrhundert* (Göttingen: Vandenhoeck & Ruprecht, 2003), 65–89; and Hans-Peter Ullmann, "'Der Kaiser bei Wertheim.' Warenhäuser im wilhelminischen Deutschland," in *Europäische Sozialgeschichte. Festschrift für Wolfgang Schieder*, eds. Christof Dipper, Lutz Klinkhammer and Alexander Nützenadel (Berlin: Duncker & Humblot, 2000), 223–236. On exhibitions see Winfried Kretschmer, *Geschichte der Weltausstellungen* (Frankfurt/M: Campus, 1999); Peter H. Hoffenberg, *An Empire on Display. English, Indian, and Australian Exhibitions from the Crystal Palace to the Great War* (Berkeley, Los Angeles and London: University of California Press, 2001); Alice von Plato, *Präsentierte Geschichte. Ausstellungskultur und Massenpublikum im Frankreich des 19. Jahrhunderts* (Frankfurt/M and New York: Campus, 2001); Paul Greenhalgh, *Ephemeral Vistas. The Expositions Universelles, Great Exhibitions and World's Fairs, 1851–1939* (Manchester: Manchester University Press, 1988); and Alexander C.T. Geppert, *Fleeting Cities: Imperial Expositions in Fin-de-Siècle Europe* (Basingstoke: Palgrave Macmillan, 2010).

33 See Wolfgang Ruppert, ed., *Fahrrad, Auto, Fernsehschrank. Zur Kulturgeschichte der Alltagsdinge* (Frankfurt/M: Fischer Verlag, 1993), 29–31. For reactions to this development, such as attempts to resuscitate craftmanship, design, and educate the taste (*Geschmack*) of the modern consumer, see König, *Konsumkultur*, 43–91.

34 It was minted by the journalist, writer, and exhibition maker Alfons Paquet (1881–1944) in his published doctoral thesis *Das Ausstellungsproblem in der Volkswirtschaft* (Jena: Gus-

A keen observer and theorist of this changing relationship between humans and things was the German philosopher and sociologist Georg Simmel (1858–1918), who over the last three decades or so (especially in the Anglo-Saxon world) has achieved exalted status among scholars of consumerism investigating the circulation and value of material goods.[35] In his work on the philosophy of money, *Philosophie des Geldes* (1900, engl. trans. 1978), Simmel tried to provide a systematic account of how economic value is defined in what he styled a "money economy." His theory was intended as a critique of Marxist materialism, but it also engaged with the prevailing economic theory in Germany as elaborated by the so-called Historical School.[36] While Marxists spoke of value in terms of labour ("labour value"), members of the Historical School placed greater emphasis on its exchange value and social value. Simmel, however, argued, that value was never inherent to the thing itself, but rather (thinking of diamonds and other precious stones, for example), was always a judgment made of an object prior to its exchange. It was therefore at root *subjective*, not *objective*, as well as being material. Simmel in fact elaborated an emotional or psychological link between the commodity and the human who wanted to possess it. In effect, he "subjectivised" the relationship between humans and things.[37] For him this was the general trend and trademark of "modernity," a

tav Fischer, 1908). Paquet defined *Schauwert* as the visibility characteristics of a thing as independent from its use value (*Gebrauchswert*). For a definition see Paquet, *Das Ausstellungsproblem*, 7.

35 The cultural anthropologist Appadurai, whose work on globalisation and material objects has been hugely influential among anglophone scholars of material culture, discusses Simmel's work in detail in the introduction to his famous collection of essays, *Social Life of Things*, 3–6.

36 For the economic tradition in which Simmel's thoughts have to be understood, see Jürgen Backhaus, "Tausch und Geld: Georg Simmels Philosophie des Geldes" (1998). http://www.forschungsnetzwerk.at/downloadpub/Tausch_und_Geld_simmels_%20Philosophie_des_Geldes.pdf. Backhaus underlines that Simmel must not be understood as a blind supporter of the emerging Austrian School of Economics. His relation to this group was not unproblematic. Moreover, Simmel shared many of the tenets of the Historical School of Economics and their leader Gustav von Schmoller. Backhaus warns that particularly Anglo-American historians of economics tend to squeeze Simmel's thinking into the tradition of the Austrian School, an instance of which is David Laidler and Nicholas Rowe, "Georg Simmel's Philosophy of Money: A Review Article for Economists," *Journal of Economic Literature* 18, no. 1 (1980): 97–105.

37 Simmel identified modernity with the loss of human contact with the external world. In modernity, he argued, the immediate present was experienced only indirectly and was thus perceived and understood as fragmented and discontinuous. The essence of modernity, Simmel believed to be what he called "psychologism" or subjectivism. He defined it as the experiencing and interpretation of the world in terms of the reactions of our inner life, the fluid element of the human soul, from which all that is substantive is filtered and

perception that thereby turned individual consumers and individual entrepreneurs into central players in a "mature" capitalist economy.

Simmel was not an economist by profession, and his ideas were meant only as philosophical and historical reflection on the role of individual psychology in modern capitalism.[38] Nevertheless, he was re-stoking a debate over the role of the individual in economy that had begun much earlier (in the 1870s) and which had exploded in the 1880s in what came to be known as "the battle of methods" (*Methodenstreit*).[39] This controversy was initiated by the Austrian economist Carl Menger (1840–1921) in his *Principles of Economics* (*Grundsätze der Volkswirtschaftslehre* [1871]), and it erupted big time with his highly polemical *Untersuchungen über die Methode der Socialwissenschaften, und der politischen Oekonomie insbesondere* (*Investigations into the Methods of Social Sciences and of Political Economy in Particular* [1883]), and his openly hostile attack on Germany's then leading economic elite in *The Errors of Historicism in German Economics* (*Irrthümer des Historismus in der deutschen Nationalökonomie* [1884]). In both works Menger sought to investigate the methods of economics, testing their validity and their role in social organisation. Ultimately, his ideas were to shape the so-called Austrian School of Economics, which would later become internationally famous through such disciples as Joseph Schumpeter (1883–1950) and Friedrich von Hayek (1899–1992), the main representatives of what has today been labelled neoliberal economics.[40]

Very much like Simmel's later thinking, Menger's theory of subjective value hinged on the idea that goods or products do not have value in themselves nor gain it through labour or exchange. Rather, he claimed they become

whose forms are merely forms of motion. See David P. Frisby, "Georg Simmel and the Study of Modernity," in *Georg Simmel and Contemporary Sociology*, eds. Michael Kaern, Bernard S. Phillips and Robert S. Cohen (Dordrecht, Boston and London: Kluwer Academic Publishers, 1990), 57–74.

38 See Backhaus, "Tausch und Geld: Georg Simmels Philosophie des Geldes."

39 Much has been published on the *Methodenstreit* from different disciplinary perspectives (e.g. economic, historical, sociological). It is, therefore, not easy to get a clear picture of what happened and what the battle was exactly about. Useful for my purposes was Grimmer-Solem, *Historical Economics*, 246–279.

40 Menger's ideas were in fact far less radical and more in line with the dominant German economic discourse than Schumpeter and von Hayek wanted their readers to believe. See the discussion in Grimmer-Solem, *Historical Economics*, 246–247. See also Yukihiro Ikeda, "Carl Menger's Liberalism Revisited," in *Austrian Economics in Transition. From Carl Menger to Friedrich Hayek*, eds. Harald Hagemann, Tamotsu Nishizawa and Yukihiro Ikeda (Basingstoke: Palgrave Macmillan, 2010), 3–20; Eugen Maria Schulak and Herbert Unterköfler, *The Austrian School of Economics. A History of Its Ideas, Ambassadors, and Institutions* (Auburn, AL: Ludwig von Mises Institute, 2011).

"value-laden" as a result of their relating to human needs and desires.[41] What we attribute to commodities is a "subjective value," he argued in opposition to almost all his contemporaries, and to Marx in particular. Value, he maintained, is grounded only in the subjective valuations of individuals. Thus, the economic organisation of society was held to be the product of the "natural" behaviour of individuals, not something derived from labour-value or the "economising individual" as Marx believed. Menger and his colleagues placed great weight on the desires of individuals and, in particular, on how such desires could be stimulated and guided so as to be useful for economic activity.[42]

Unsurprisingly, it was one of Menger's students, Victor Mataja (1857–1934), who was the first to undertake economic research into the economic value of advertising.[43] Mataja's *Die Reklame. Eine Untersuchung über Ankündigungswesen und Werbetätigkeit im Geschäftsleben* (1910) was the first publication in German to look at it, not from a practical angle, but as an important—indeed "necessary"—asset for a flourishing national economy.[44] Mataja's book was also the first explicitly to deploy and praise the use of the new science of psychology for improving what he called the "art" of advertisement. Due to the lack of any German debate on this topic until then, Mataja drew heavily on American and British advertisers, arguing that knowledge of human nature— achieved, he believed, largely through modern psychological experimentation—could be advantageous for the sale of goods.[45] He argued that,

41 For the following see Grimmer-Solem, *Historical Economics*, 249–250; also Schulak and Unterköfler, *The Austrian School*, 13–20.

42 Schulak and Unterköfler, *The Austrian School*, 21–28.

43 See Lothar Höbelt, Mataja, Victor, in *Neue Deutsche Biographie* (NDB), vol. 16 (Berlin: Duncker & Humblot, 1990), 365.

44 Mataja mentioned that German historical economists generally did not consider *Reklame* worthwhile to deal with. Indeed, they had a negative opinion about its purpose and power. Particularly those who held socialist political views, such as Sombart, considered advertising as a serious problem for Germany's national economy. See Victor Mataja, *Die Reklame. Eine Untersuchung über Ankündigungswesen und Werbetätigkeit im Geschäftsleben* (Berlin: Duncker & Humblot, 1910), 5–58. For Mataja's work and the contemporary discussion of the economic usefulness of advertisement around the turn of the twentieth century, see Lamberty, *Reklame in Deutschland*, 381–391. For the turn-of-the-century debate in Britain, see Graham Wallas, *Human Nature in Politics* (London: A. Constable & Co., 1908); J.A. Hobson, *The Psychology of Jingoism* (London: G. Richards, 1901); and William Stead Jr., *The Art of Advertising: Its Theory and Practice Fully Described* (London: T.B. Browne, 1899). See also James Thompson, "Pictorial Lies? Posters and Politics in Britain, c.1880–1914," *Past and Present* 197, no. 1 (2007): 177–210.

45 "Das letzte Wort der Vertriebskunst heißt Kundenpsychologie" [The last word of the art of marketing is called customer psychology] (Mataja, *Die Reklame*, 167). Among Mataja's sources were Lorin F. Deland, *Imagination in Business* (New York and London: Harper &

we can sell something to someone more easily if we know him in person. But as we are unable to know everyone personally whom we wish to sell something, we thus need to consider whether there exist certain ways of thinking and acting that are common to all human beings or at least to the greater majority of humankind. If we are able to discover the laws which govern the activity of the human mind, we will know, how we have to approach people.[46]

Mataja did not deny that the "art-cum-science" of advertising might be dangerous if applied, for example, to pornography, secret medical remedies, and dishonest money deals that lured customers into buying "bad" or overpriced products. But his emphasis throughout was on advertisements' educational and social merits.[47] He was convinced that its powerful tools, such as the poster, were not only crucial to the stimulation of the German economy, but also, if applied in areas such as health education or social reform, were beneficial to Western civilisation as a whole, enabling it to reach ever higher levels: "Without the vivid language of *Reklame*, without her unremitted preaching, much good could only break its way against greatest resistance. She also inspires the often-sluggish sense among many people for certain standards of health care or any other higher cultural requirements." Quoting an American advertiser, he concluded, "[W]e doubt that any other power, with the exception of the public school system and the press, has done so much for the education of mankind as the Reklame."[48]

Despite Mataja's attempt to direct attention to the potentials of advertising for social reform, however, neither he nor Menger obtained much credibility among established German economists at the time. Their ideas were vigorously refuted by the Historical School of Economics, then under the leadership of Gustav Schmoller (1838–1917).[49] Over methodological questions, such as the role of theory, historical empiricism, and statistics, and over the public

Brothers, 1909); Harlow Gale, *On the Psychology of Advertising* (The author, 1900); Walter Dill Scott, *The Theory of Advertising* (Boston: Small, Maynard & Co., 1903); Hugo Münsterberg, *Psychologie und Wirtschaftsleben* (Leipzig: Barth, 1913); Daniel Starch, *Principles of Advertising. A Systematic Syllabus of the Fundamental Principles of Advertising* (Madison: The University Cooperative Co., 1910); and Bernhard Wities, "Das Wirkungsprinzip der Reklame," *Zeitschrift für Philosophie und philosophische Kritik* 128 (1906): 138–154.

46 Mataja, *Die Reklame*, 335–336.

47 Mataja, *Die Reklame*, 79–81; Lamberty, *Reklame in Deutschland*, 382–384.

48 Mataja, *Die Reklame*, 61.

49 On Schmoller and the Historical School of Economics, see Grimmer-Solem, *Historical Economics*, 54–59; Glaeser, *Der Werthurteilsstreit*, 252–261.

role of economics, and the origins of law and institutions, they were in total disagreement.[50] Crucially, they differed over conceptions of economics in the organisation of society. As Schmoller made clear in his 1883 review of Menger's *Investigations*, the Historical School of Economics rejected the idea that the economic organisation of society was built around supposed natural or psychological laws of individual behaviour.[51] Consequently, the German School also rejected the idea that such lawfulness could be measured and predicted by any kind of transhistorical theoretical-deductive means. Economic life was not simply driven by the satisfaction of individual needs, as Menger thought; rather, it was a process that was deeply embedded in the sociocultural specificities of a given culture, its norms and ethics, at a particular moment in time. Any contrary idea, Schmoller claimed, "based upon the impression that it is concerned merely with methods of satisfying individual needs is mistaken with regards to all the stages of human civilization [...]"[52]

For members of the Historical School human economic behaviour was always about more than simply tracing changing individual human wants through time. Economic life was conceived as the reflection of multivalent sociocultural and ethical interests; the outcome of historically specific and thus changing sociocultural agreements, which economic institutions then came to reflect.[53] Economic behaviour and organisation was therefore variable over time. History was the key to understand the past and the present.[54] Schmoller, a devoted liberal reformer, regarded Menger's suggestion that human needs

50 Again, the self-serving yarns spun by later members of the Austrian School of Economics construed a deeper divide between them and the German Historical School than actually existed. Partly this was due to the fact that the latter never elaborated on their own methodology until Menger's polemics were published. Thus, Schmoller's and Menger's dispute was not one over an existing, well-formulated agenda, but rather, served as a means of clarifying the German School's position. Menger shared many of the German Historical School's views, for example, the anti-Marxist idea of the triumph of human intellect over material constraints in economic organisation, and that the origin and end of all economics was the fulfilling of human needs. See Grimmer-Solem, *Historical Economics*, 246–249.

51 Gustav Schmoller, "Zur Methodologie der Staats- und Sozialwissenschaften," *Jahrbuch für Gesetzgebung, Verwaltung und Volkswirtschaft im Deutschen Reich* 7 (1883): 975–994.

52 Gustav Schmoller, "Studien über die wirtschaftliche Politik Friedrichs des Großen und Preußens überhaupt von 1680–1768," *Jahrbuch für Gesetzgebung, Verwaltung und Volkswirtschaft im Deutschen Reich*, (1884) 8: 15–61, hier 17.

53 Glaeser, *Der Werturtheilsstreit*, 34–36; Peter Koslowski, "Economics as Ethical Economy in the Tradition of the Historical School," in *The Theory of Ethical Economy in the Historical School. Wilhelm Roscher, Lorenz von Stein, Gustav Schmoller, Wilhelm Dilthey and Contemporary Theory*, ed. Peter Koslowski (Berlin: Springer, 1994), 1–11, here 9.

54 For the historicist tradition of the school, see Glaeser, *Der Werthurteilsstreit*, 37; Schulak and Unterköfler, *The Austrian School*, 23; Grimmer-Solem, *Historical Economics*, 124.

could be reduced to the drive for gain or self-interest as something entirely unproven by scientific experimental psychology of his time. While he agreed that all social phenomena were ultimately based on "individual psychic processes," he disputed Menger's tendency to reduce such phenomena entirely to individual self-interest and gain. He detected that this was "the significant gap" in Menger's conception of the study of economics. Menger, he thought, failed to grasp the mutual determination of such factors, or understand that it was not just a matter of the biological "laws" that experimental psychology promised to discover, but was also "the product of an endless variety of selfish and sympathetic feelings and drives."[55] Schmoller was highly skeptical of the application of organic metaphors and biological laws to social phenomena in general. Much social life in history and the present, he argued, demonstrated no such analogies; it was more the outcome of human rational calculation, law, and consensus. Thus, as a method of analysis, organic metaphors were nonsense "as not even to be esteemed the serious refutation of anyone methodological educated."[56]

Rejecting, then, the idea of a rationally driven, transhistorical *homo economicus*—humans "as rational and narrowly self-interested actors who have the ability to make judgments toward their subjectively defined ends"—the Historical School of Economics regarded advertising as a useless and wasteful economic activity.[57] In his *Grundriß der allgemeinen Volkswirtschaftslehre* (§ 16),

55 Schmoller accused Menger of not having kept up with the many scientific advances in understanding "individual consciousness" and "psychic mass phenomena." See Grimmer-Solem, *Historical Economics*, 258. Schmoller was drawing here on the comparative and experimental psychology of Moritz Lazarus (1824–1903) and Wilhelm Wundt (1832–1920) who, according to Schmoller, had demonstrated that sensory perception and human motivation were extremely complex and required detailed empirical and comparative investigation (as, for example, provided by Schmoller's historical economics). See the discussion in Grimmer-Solem, *Historical Economics*, 258–259.

56 See quote in Grimmer-Solem, *Historical Economics*, 259. Grimmer-Solem claims that the organism analogy became the basic pillar of Menger's opposition to interference with and reform of the state, law, society, or the economy: every part of the "organism" had a particular function, which if interfered with, caused disruption of the whole; the organism displayed a wonderous functionality that was not the product of human calculation, agreement, or positive law. See Grimmer-Solem, *Historical Economics*, 255–256. However, there is much debate among historians of economics whether Menger's thinking was related to organic metaphors at all. For an opposing view to that of Grimmer-Solem see Michael Hutter, "Organism as a Metaphor in German Economic Thought," in *Natural Images in Economic Thought. "Markets Read in Tooth and Claw*," ed. Philip Mirowski (Cambridge: Cambridge University Press, 1994), 289–321.

57 Mataja offers an interesting overview on the debate on *Reklame* in German national economics: *Die Reklame*, 55–58. See also Lamberty, *Reklame in Deutschland*, 391–396.

Schmoller acknowledged that advertising was not inherently bad and that, in fact, it was inextricably linked to modern capitalism which, with its mass production, needed to conquer markets by informing consumers about new products. But he believed that the enterprise of advertising (*Reklamewesen*) had become an "impure art" that relied mainly on deceiving gullible and stupid consumers. Advertising was really only successful by spreading lies about products and services, he thought.

For those close to the Historical School, such as Werner Sombart, advertising and its tools such as the poster were held to represent the deceptive character of modern capitalism, which they equated with "Americanism" (*Amerikanismus*).[58] Out of the greed and personal gain that it fostered, modern capitalism tinkered with free will and morality by spreading lies and unrealistic promises.[59] It simply sold dreams and supported a society in which individual egoism eclipsed the need for social reform. For Sombart, advertising was the despicable tool of an egoistic private entrepreneurship that disregarded all wider social concerns; it was sign and signifier of "the unrestrained rioting of the mere search for private profit."[60] Like other forms of advertisements, street posters, Sombart felt, manipulated and undermined the reason and rational decision-making of its onlookers. It dragged them into a false economy, by luring them into purchasing things they did not need.[61] Such was the line of thinking that resulted in the widespread castigation of the Dresden Odol producer Karl Lingner in the German press for his "American-like" exploitation of mass advertising in promoting his bacteriology-based hygienic products.[62]

Klebs and Schwalm's poster of 1900, I contend, similarly fell foul. But whether it did or not is less relevant here than the fact that its dispute with the local police authorities provides an opening for a historisation of the relationship between humans and material things in turn-of-the-century German discourses on industrial capitalism. This is an urgent enterprise because central features of what was then fiercely debated—notably the question of human desire and whether human economic behaviour can be understood through scientific reductionism—have been entirely eclipsed in contemporary economic thinking and practice. Highly abstract mathematical modelling in combination with the latest laboratory experimentations on human perception

58 For the contemporary debate in Germany on "Amerikanismus," see the sources qtd. in
 Repp, "Marketing, Modernity," 47, FN. 18.
59 For a summary of his arguments see Lamberty, *Reklame in Deutschland*, 392–393.
60 Sombart, "Ihre Majestät die Reklame," 481.
61 Sombart, "Ihre Majestät die Reklame," 480.
62 On Lingner as an American-like entrepreneur, see Paul Weindling, *Health, Race and German Politics Between National Unification and Nazism, 1870–1945* (Cambridge: Cambridge University Press, 1989), 229.

and decision-making, randomised control trials (RCTs), or the new technologies of the cognitive neurosciences (fMRI, TMS) have become the bread and butter of an increasing number of today's rational choice economists. Their vision that merges theoretical rational choice economics with the data from the evolutionary biosciences is now "hot stuff," sold through countless popular and scholarly works. At the core of this enterprise is the discipline of behavioural economics.

What is behavioural economics about?[63] To put it very simply, behavioural economics aims to extend the principle of the rational choice model in economics according to which humans always make the economic decisions in their self-interest and on the basis of prudent and logical calculation of benefits and costs involved in their choices. Behavioural economists propose that human decision-making is in fact not that rational but deeply shaped by social and psychological circumstances. Humans rarely act as the hyper-rational *homo economicus*, the famous mathematics-based model of rational choice economics, they argue. First and foremost, humans are passionate creatures who base their market choices largely on what rational choice economics tend to devalue as irrational factors, that is, human emotions, feelings, and moods. In short, behavioural economists strive for a more intuitive account of human economic decision-making (although the mathematics remains central to their enterprise). The evolutionary cognitive sciences have therefore become close partners in behavioural economists' search for what ultimately drives human passions and desires. On the basis of this knowledge, they promise, individual and collective human economic and financial activity can be more accurately monitored and effectively organised. The knowledge produced in behavioural economics, its practitioners celebrate, will provide national economic prosperity, happiness, and wellbeing for each and all of us.[64]

The discipline's rise to prominence is remarkable. In the 1970s, when it was founded by the American psychologist and expert on human decision-making Daniel Kahneman, it was largely ignored or openly dismissed by mainstream rational choice economists.[65] Since the 1990s, however, the discipline has been attracting increasing attention and has turned into one of *the* subjects to inform contemporary economic thinking. Indeed, its potential for the field of economics is so promising that Daniel Kahneman received the bogus

63 For an introduction, see Michelle Baddeley, *Behavioural Economics: A Very Short Introduction* (Oxford: Oxford University Press, 2017).

64 For such promises, see Richard H. Thaler, *Misbehaving: The Making of Behavioral Economics* (London: Penguin, 2015), 3–11.

65 For an interesting first-hand account and the theoretical thinking involved see the international bestseller by Daniel Kahneman, *Thinking, Fast and Slow* (New York: Farrar, Straus and Giroux, 2012).

Nobel Prize in Economics in 1992.[66] Since then the honour has gone to several economists who are either behaviour economists themselves or whose research heavily relies on its insights. Richard Thaler, the Nobel laureate of 2018 (and Kahnemann's most successful student) is certainly correct to claim that behaviour economics is no longer deemed "a fringe operation" in the field of economics. And more than that, Thaler observed with satisfaction, indeed, "behavioural economics is going mainstream."[67]

The growing number of academic and popular works on the subject crowding the shelves of libraries and book stores and the attention the subject receives in the media proves Thaler right. Marketing and advertisement companies increasingly rely on insights from behavioural economics as an intellectual framework to better justify (and charge) for their marketing ideas and generate new ones. Behavioural economics is seriously beginning to shape the social and political experiences and behaviour of citizens in neoliberal democracies as national and international governmental policy-makers are increasingly turning to its research. The basic assumption behind what is called "libertarian paternalism" by its promoters is simple.[68] Effective policy measures, it is argued, need to take into account the heuristics and biases driving individuals' decision-making. Policies must not predominantly appeal to citizen's rational sense and reason, let's say, to explain to them the medical consequences of smoking or fatty foods, in order to make them change their "bad" habits. Rather policy experts must touch, move, and inspire their target group(s) and emotionally "nudge" them into doing what is considered right behaviour and policy from the perspective of the respective government in power.[69] In the US and the UK in particular, so-called government-sponsored "behavioural-insights teams" (so-called "nudge squads") have been mushrooming over the last two decades, using scientific experimental data from behavioural economics to

66 The prize is not awarded by the Nobel Foundation itself but by the Swedish Central Bank
 (since 1968). The economic historian Philip Mirowski has convincingly argued that the
 history of the prize is therefore inseparable from the development and rise of neolib-
 eral economics, which the prize continues to legitimise as the one and only economic
 "science." See https://www.versobooks.com/blogs/2290-what-is-a-nobel-prize-winning-
 economist-philip-mirowski-investigates, accessed 9 September 2018.

67 Thaler, *Misbehaving*, 347.

68 Influential in the area of behavioural economics and public policy is Cass R. Sunstein,
 Simpler: The Future of Government (New York: Simon and Schuster, 2013). Sunstein works
 closely with Richard Thaler, for example, Richard H. Thaler and Cass R. Sunstein, *Nudge:
 Improving Decisions About Health, Wealth, and Happiness* (London: Penguin, 2009).

69 "By giving people simple choices, designing prompts and nudges to lead people's deci-
 sion in more constructive and positive directions, giving frequent feedback so that "good"
 decisions are reinforced and "bad" decisions are discouraged—all these strategies form
 part of behavioural public policy-makers' tool-kit" (Baddeley, *Behavioural Economics*, 118).

redesign taxation, pension, and health insurance forms or set up more "behavioural friendly" internet sites to nudge people into more efficient energy use, recycling, or to change diet and exercise habits.[70]

There is much to say about the ethics of this new fashionable joint venture between the evolutionary cognitive sciences, economics, marketing, and policy-making. Fundamentally, one wonders whether there should not be a difference between a consumer and a citizen? Is and should policy-making be understood as a mere successful marketing stunt? If the answer is yes (as the spreading practices of nudging is clearly suggesting), then one wonders what the difference is between today's "nudging" and popularist "propaganda," practised so efficiently in fascist and communist governments in the past (and present).

These are serious matters worthy of extended treatment. What primarily concerns me here, however, is the "model" of human being (or human nature) with which behavioural economists are working and which underlies even the most complicated of their scientific experimentations. It is precisely the model of human nature that German historicist economists abhorred at the turn of the twentieth century. But interestingly, as we shall see, their "model" has also deep philosophical roots. Daniel Kahneman admits that it stands at the core of what he labels "hedonistic psychology," defined as,

> the study of what makes human experiences and life pleasant or unpleasant. It is concerned with feelings of pleasure and pain, of interest and boredom, of joy and sorrow, and of satisfaction and dissatisfaction. It is also concerned with the whole range of circumstances, from the biological to the societal that occasion suffering and enjoyment.[71]

Kahnemann and co. certainly do not claim that they invented such hedonistic thinking about human nature. They like to see themselves as standing in a long tradition of hedonistic thinking that begins with the ancient Greeks. Central to their "history" are also the moral philosophers and social reformers of the late eighteenth and nineteenth centuries, notably the Englishmen Jeremy Bentham and John Stuart Mill. Their utilitarian philosophies, captured in Bentham's famous saying, "It is the greatest happiness of the greatest number that is the measure of right and wrong," were the first, we are told, who correctly

70 It is worthwhile to read Richard Thaler's autobiographical account of how these units were set up in the UK. Thaler, *Misbehaving*, 323–345. Also, for policy, Cass R. Sunstein, *Why Nudge? The Politics of Libertarian Paternalism* (New Haven: Yale University Press, 2015).

71 Daniel Kahneman, Ed Diener and Norbert Schwarz, eds., *Well-Being: The Foundations of Hedonistic Psychology* (New York: Russell Sage Foundation, 1999), ix.

identified hedonism as a universal human trait, and the first to consequently apply this idea as the basis of a new vision of governmentality based on the idea of a utilitarian free-market society. Evolutionary theory of the later nineteenth century came to support this utilitarian vision in economic thinking. The "marginal revolution" at the end of the nineteenth century firmly moved the consideration of individual human behaviour to the centre of the economic discipline, serving as the foundation of today's rational choice economics. After a few "setbacks" during the first half of the twentieth century, notably, welfarism and socialism, such hedonistic thinking in economics reached wider acceptance among governments and the wider public. The founding of behavioural economics in the 1960s which drew heavily on the contemporary "cognitive revolution" was finally able to prove *scientifically* that human hedonism is hard-wired into the brain structure and chemistry of homo sapiens. Today eighteenth-century utilitarian philosophy has been finally turned into scientific truth.

It is not difficult to see how these claims of a universal utilitarian and hedonistic human nature mirror and justify our post-industrial capitalistic times. Indeed, as the philosopher Miguel de Beistegui observed, the belief in such a human nature has become the new paradigm of human life in all contemporary forms of capitalist societies. As he explains, the system of desire which aims at individual maximising now defines "the very *being* of the *human* being." "[It] is the new anthropological paradigm that claims to speak the truth regarding human life as a whole," he suggests.[72] And he continues, "[w] ere there to be a failure of desire, or a shortage of libidinal investment in the economic system it's the system as a whole that would be threatened [...] It's as if desire has become the condition of possibility and impossibility of our socioeconomic system, that without it it cannot function [...]"[73] "[P]ostindustrial capitalism," Beistegui concludes, "has become something like the World Organisation of Desire (WOD)."[74]

That a capitalistic economic system *could* run successfully without having a utilitarian and hedonistic philosophy of human nature at its very core, this paper has sought to reveal. Looking at some of the turn-of-the-twentieth-century economic debates in the German-speaking world over the philosophical and scientific core of what it means to be human and how this affected the

72 Miguel de Beistegui, "Desire Within and Beyond Biopolitics," in *The Care of Life: Trans-disciplinary Perspectives in Bioethics and Biopolitics*, eds. Miguel de Beistegui, Guiseppe Bianco and Marjorie Gracieuse (London: Rowman & Littlefield, 2015), 241–260, here 252.

73 Beistegui, "Desire," 254–255.

74 Beistegui, "Desire," 253.

relationship between humans and things in industrial capitalism might help to critique in a Foucauldian way what has been taken for granted about this relationship in our own global post-industrial economies. How did it happen that hedonistic "desire" became the lens through which we view and experience the world of things (including our own bodies)?

Much more historical work needs to be done to uncover the historical relationship between biomedical models and economic thought and practice, so that the anthropological paradigm that silently runs today's capitalistic economies becomes clearly visible and can be exposed not as universal but historically specific. Its sociocultural, political, scientific, and economic conditions need to be radically exposed for what they are, namely only one historically grown possibility of understanding human nature under capitalism. As this paper has shown, at the turn of the twentieth century there were other philosophical understandings in serious competition with what was then understood as specifically English utilitarian and hedonistic philosophies of individual and collective human nature. The majority of Germany's leading economists would have probably agreed with Friedrich Nietzsche's rather bold claim. "Men," he argued, "do not strive for happiness; only the Englishman does that."[75]

To understand our contemporary assumptions of what it means to be human as a historical construct is a first step in order to rethink (and possibly change) current economic thoughts and practices. At least that is what Michel Foucault believed in. "[A]s soon as people begin to no longer be able to think things the way they have been thinking them," he wisely opined, "transformation becomes at the same time very urgent, very difficult and entirely possible."[76]

75 Friedrich Nietzsche, *Twilights of the Idols*, trans. R.J. Hollingdale (Harmondsworth: Penguin, 1968), Maxim 44, 37.

76 Foucault, "So is it Important to Think?," 161.

The Pitfalls of Utilitarianism: Capillary Images and Biopolitical Interventionism during the Weimar Republic

Michael Hau

"It became clear that capillary development, its inhibition or abnormality [was] an extraordinarily fine indicator of the maturity and normal development of an individual in general."[1] This is how Walther Jaensch, director of the "Laboratory for Constitutional Medicine" at the Charité, explained the epiphany that led him to develop a system for the diagnosis of "developmental inhibitions" or *Entwicklungshemmungen* in young children. It involved a diagnostic method called "capillary microscopy" that allowed a researcher to obtain images of the structures of capillaries which could be categorised and correlated with other physical or mental conditions. There were many physicians who did not accept his claims because they found them speculative and unfounded. Yet it is remarkable how during a short period of time there was intense interest in Jaensch's work and he could establish himself as a respected researcher and expert in constitutional medicine.[2]

What interests me here are the early debates about the meaning and validity of capillary images. Why were medical researchers interested in the function and structure of capillaries? How did Jaensch adapt their work for the purposes of his own research in the 1920s? Why could he, despite serious criticism of his work, convince senior members of the medical profession as well as government funding bodies to support his work? While not wishing to make an all too presentist claim here, thinking about such issues might enlighten us about the perils of spurious utilitarian claims of scholarship that feeds off and thrives on particular political and institutional priorities. Jaensch maintained

1 Walther Jaensch, "Die Hautkapillarmikroskopie sowie die ersten Erkenntnisse über die Entwicklungsvorgänge an den Hautkapillaren und ihre psychophysiologischen Beziehungen," in *Die Hautkapillarmikroskopie. Ihre praktische Bedeutung für Diagnose und Therapie körperlich-seelischer Individualität im Zusammenhang mit dem Kropf- und Minderwertigkeitsproblem*, ed. Walther Jaensch (Halle: Carl Marhold, 1929), 6–46, here 18.

2 I have discussed the details of Jaensch's career during the Weimar republic and Nazism elsewhere: Michael Hau, "Constitutional Therapy and Clinical Racial Hygiene in Weimar and Nazi Germany," *Journal of the History of Medicine and the Allied Sciences* 71, no. 2 (2016): 115–143.

that he could diagnose and treat children suffering from intellectual disabilities due to "developmental inhibitions" which prevented them from reaching their full mental potential. Governments and science funding bodies found these claims appealing because they were interested in improving the health and performance potential of the German population after the lost war. In this respect Jaensch's work aligned with other Weimar biopolitical strategies that promised to raise the fitness and social utility of German citizens: the improvement of hereditary health through eugenics; the betterment of mother and infant welfare through public health and social welfare; as well as the promotion of mass sports aimed at improving the physical and mental performance capacity of the population as a whole.[3]

1 Otfried Müller and the Examination of Capillary Structures and Functions

The key to Jaensch's diagnosis of developmental inhibitions was capillary microscopy, a methodology that was developed by the professor of internal medicine at the University of Tübingen, Otfried Müller. Müller had established his scientific reputation with the development of a method to assess the distribution of the blood in the human body. As a specialist physician in internal medicine, he focused his research on various aspects of the body's circulatory system. He examined the impact of baths and douches on blood pressure and researched the distribution of the blood in the body using different temperatures as stimuli with the help of a plethysmograph, an instrument for the assessment of blood volume in different body parts. Using this methodology, Müller could demonstrate that the peripheral vascular system reacted in a uniform way whether thermic stimulation was applied to the whole body or only locally. Exposed to cold stimulation peripheral blood vessels and capillaries contracted, exposed to warmth they dilated. According to the assessor of Müller's habilitation thesis, Ernst Romberg, his work demonstrated the important role of the nervous system for the entire cardiovascular system with "unprecedented incisiveness."[4]

3 For recent examples of research on these and related issues, see Melissa Kravetz, *Women Doctors in Weimar and Nazi Germany. Maternalism, Eugenics, and Professional Identity* (Toronto: University of Toronto Press, 2019); and Michael Hau, *Performance Anxiety. Sport and Work in Germany from the Empire to Nazism* (Toronto: University of Toronto Press, 2017).

4 "Gutachten Romberg, 12. January 1905," in Universitätsarchiv Tübingen, 126/455 Personalakte Otfried Müller.

On the basis of this early research Müller quickly established himself as one of the leading German experts on the vascular system. He devoted his attention to the periphery of the system, in particular the functioning of the capillary system in healthy and pathological conditions. It is in this research context that he further developed capillary microscopy to establish the structure and function of capillaries in different parts of the human body.[5] Capillary microscopy involved the observation of the skin through a microscope with a lateral light source. While Müller was not the first one to use such a method to examine the capillaries of the skin—there were others who examined skin capillaries in specific body parts such as the lips, the conjunctiva of the eyes, or the skin on the nail fold—he and his collaborators were the first ones who embarked on a research program that examined the structure and functioning of capillaries on the entire human body.[6] The goal was first to establish the "topography of capillaries on the body surface" and determine capillary structure and function in the healthy body. Based on this research it was then possible, Müller imagined, to develop a comprehensive pathological anatomy and physiology of capillaries for many pathological conditions. By the early 1920s, his research program moved to investigate what he called the "vasomotoric diathesis," a constitutional predisposition which he described as an "irritable nervous weakness of the vascular system" that gave rise to a diffuse set of symptoms and complaints predominantly among women.[7] In addition, he tried to link capillary structures and functions (e.g. their contraction or dilation) to different pathological conditions to see whether diseases and pathological states manifested in changes of the capillary system that could be read as diagnostic signs. His research examined the effects of diseases of the nervous system, problems of the circulatory system, and infectious diseases on the capillary system in different parts of the body surface claiming, for example, that diseases of the kidney were usually accompanied by deformations of the capillaries.[8]

Müller's research program was open-ended. He was wary of premature conclusions and warned that capillary examination should not be regarded as "a diagnostic panacea" but should be critically used in conjunction with other diagnostic methods.[9] Since capillary structures and capillary functions did not

5 Otfried Müller, *Die Kapillaren der menschlichen Körperoberfläche in gesunden und kranken Tagen* (Stuttgart: Ferdinand Enke, 1922).

6 Müller, *Kapillaren*, 42–51.

7 Müller, *Kapillaren*, 71–74, esp. 72.

8 Müller, *Kapillaren*, 127 and 132.

9 Müller, *Kapillaren*, 77.

respond uniformly to physiological or pathological changes, Müller insisted that it was necessary to trace changes in different parts of the body. He, therefore, rejected the idea that it was possible to restrict the examination of capillaries to a single area of the human body such as the skin of the nail fold.[10] This was an area that was comparatively easy to examine which is why it was used by Jaensch to examine a large number of people in mass surveys conducted in the 1920s and early 1930s.

2 Walther Jaensch and Capillary Diagnostics

Jaensch did not heed Müller's warnings about the limitations of capillary microscopy. Instead, he developed a simple system to distinguish between different capillary structures and he correlated these structures with a number of pathological conditions all connected to what he and his collaborators claimed to be the "inhibited" mental development of young children. According to Jaensch, normal capillaries had simple vertical forms with relatively straight venous and arterial "thighs" while abnormal capillaries were often horizontal with irregular slings.[11] Jaensch's was a purely morphological description that ignored possible changes in appearance due to regular or irregular blood flow. In contrast to Müller, who thought that capillaries could change their appearance depending on changes in the neuro-vascular system, Jaensch assumed that the structure of capillaries remained relatively stable and could tell researchers something about people's constitution. He also assumed that it was possible to derive meaningful diagnostic images of capillaries by simply looking at a single area of the body, which made it possible to examine the capillaries of a large number of people in mass surveys. Jaensch's diagnostic method focused on the structures of capillaries in the nail fold of the skin. These, he claimed, could be easily determined and documented by drawings by trained female assistants.[12]

The first of Jaensch's mass surveys was sponsored by the Prussian welfare ministry and involved the examination of primary school students in the city of Kassel from 1920 onwards. Based on this survey, Jaensch and his collaborator Theodor Hoepfner developed what they called a capillary key (*Kapillarschlüssel*, see Figure 10.1) to assess the normal and pathological structures of

10 Müller, *Kapillaren*, 77.

11 Jaensch, "Hautkapillarmikroskopie," 12.

12 Walther Jaensch, "Die praktische Verwendung der morphogenetischen Kapillarmikroskopie (Th. Hoepfner) am Nagelfalz," in *Hautkapillarmikroskopie*, Jaensch, 69–163, here 118–119.

FIGURE 10.1 Capillary structures according to Jaensch and Hoepfner, from: Theodor
Hoepfner, "Ergebnisse kapillarmikroskopischer Untersuchungen an 3100
Kasseler Schulkindern," *Deutsche Zeitschrift für Nervenheilkunde* 88 (1926):
218–226, here 222. Column I: archi-, meso-, and neo-capillaries representing
normal ontogenetic development, e.g. I f and g represent mature neo-capillaries
in healthy youths and adults. Column II: archi-capillaries or archi-pseudo-neo-
capillaries as indicators of arrested development: II b from a case of cretinism
and II c as a case of archi-capillary feeblemindedness. Columns III-V: abnormal
capillaries, e.g. v b-e: cases of feeblemindedness

capillaries. They assumed that different capillary structures represented differ-
ent stages in the ontogenetic development of individuals. They distinguished
between three stages of capillary development. So-called "archi-capillaries"
were "primitive" and irregular forms which could be found in newborns while
"meso-capillaries" represented an intermediate form of human development.
Both could be found in infants and small children up to the age of two, while
so-called neo-capillaries could be found in older healthy children and adults. A
preponderance of archi- and meso-capillaries in the skin of older children and
adults, however, indicated that they suffered from "arrested development." [13]

13 Theodor Hoepfner, "Ergebnisse kapillarmikroskopischer Untersuchungen an 3100 Kas-
 seler Schulkindern," *Deutsche Zeitschrift für Nervenheilkunde* 88 (1926): 218–226, "Kapillar-
 schlüssel" image on 222.

It is important to note here that the assumption that there were "typical" capillary structures that corresponded with specific developmental stages in individuals required a leap of faith. It was one thing to assume—as Müller and his collaborators did—that different forms of capillaries reflected physiological and pathological changes in the body. But it was quite another thing to maintain that it was possible to establish distinct capillary types, reduce them to fixed images, categorise them in a *Kapillarschlüssel*, and then relate them to different stages in people's ontogenetic development.

Jaensch's and Hoepfner's claims were further based on the—hardly original—assumption of Ernst Haeckel's biogenetic rule that organisms recapitulated the phylogenetic development of their species in their development as individuals: "the increasing maturity of the central organ [the brain M.H.] [...] corresponds to that of the *entire* individual" paralleling the "higher differentiation in phylogenetic development."[14] Based on the assumption that the sophistication of the central nervous system would also be reflected in the differentiation of the vascular system and its capillaries, Jaensch argued that the hierarchy of capillary structures which he had identified reflected "the phylogenetic and ontogenetic" hierarchy of different layers of the brain.[15] "Reading" the capillary image of a person, therefore, provided insights into the "concentric layers of the psychophysical personality" and its disturbances.[16]

3 Therapies for the Feebleminded and Deviant

According to Jaensch, the "capillary image" of a person could be interpreted with reference to a simple and stable taxonomy of capillary structures to establish a correlation between developmental inhibitions of various kinds, which he assumed were often connected to a malfunctioning of the thyroid gland. In children suffering from cretinism—a medical condition caused by the hypofunction of the thyroid gland—he frequently diagnosed irregular capillary patterns. Since goiters (an abnormal enlargement of the thyroid gland) were like cretinism linked to a malfunctioning of the thyroid gland, he suspected that "goiter areas" (*Kropfgegenden*) were regions with a lower biological value of the population—one of the reasons why Jaensch's research group selected Kassel as the site of their first large-scale survey of school children.

Jaensch and his collaborators tried to establish a correlation between abnormal capillary development, low intelligence, and moral deviancy whether

14 Jaensch, "Hautkapillarmikroskopie," 22.
15 Jaensch, "Hautkapillarmikroskopie," 22–23.
16 Jaensch, "Hautkapillarmikroskopie," 23.

they were connected to an abnormal functioning of the thyroid gland or not. For this purpose, he compared the capillary structures of students in normal schools with those in so-called "special schools" (*Sonderschulen*) where those students were sent who could not cope with the curriculum in regular schools.[17] Among ten children with cretinism he could identify "capillary inhibitions" that reflected their inhibited mental and physical development. But in a special school in Kassel he had similar findings among students who showed no signs of cretinism, an indication for him that mental "inferiority" or feeblemindedness manifested in similar capillary images whether linked to deficiencies of a person's endocrine system or not. Students of special schools, he claimed, had a significantly higher rate of capillary inhibitions than students in normal schools. Whereas in one special school class two-thirds of students showed primitive capillaries, only a ninth of the students of a normal school class had similar symptoms.[18]

But Jaensch's research program was not content with simply diagnosing feeblemindedness. He believed that there were ways to reverse the retarded development of children with medication. His model case was a sixteen-year-old girl from Kassel suffering from cretinism. She showed the development of a five-year-old who could barely speak and had to be constantly cared for.[19] Yet, after six years of treatment with the thyroid hormone thyroxin, she became almost "normal". Her speaking improved to the extent that she passed the lowest grade of a regular school, and she could help her mother with household chores. While she still exhibited "mental inferiority" she had improved considerably over the six-year period, an improvement which was also reflected in the structure of her capillaries, which had become more normal. If she had been diagnosed in earlier childhood rather than at age sixteen, Jaensch claimed, early therapy might have led to even greater improvements, making her an "individual of significantly higher value."[20]

One collaborator of Jaensch, the director of the asylum Hephata in Treysa, Wilhelm Wittneben, set out to prove that it was possible to significantly improve the condition of mentally inhibited children through a therapeutic regime involving thyroxin and other medications. Wittneben examined the capillaries of all children admitted to his asylum. The children were given a modified version of the Binet-Simon intelligence test before and after they underwent therapy. Developed before the war by the French psychologists

17 Jaensch, "Hautkapillarmikroskopie," 21 and 32–35.
18 Jaensch, "Hautkapillarmikroskopie," 32–35.
19 Jaensch, "Hautkapillarmikroskopie," 14–15.
20 Jaensch, "Hautkapillarmikroskopie," 38–42, esp. 42.

Alfred Binet and Théodore Simon, the tests were designed to identify children with intellectual deficits who could not be accommodated in regular schools and needed special instruction.[21] About 250 of the children responded positively to the therapy, Wittneben claimed. Their physical and mental condition was improved, and their capillary structure became more differentiated and approached the norm. The "elevation (*Hebung*) of the mental condition" was accompanied by a growth spurt and the "elevation of the entire personality" which went hand in hand with the bettering of other pathological conditions. Wittneben found that the IQ of children improved significantly, a change that in most cases went along with changes in the children's capillary structure.[22]

A number of patients, Wittneben claimed, had dramatically improved through thyroxin therapy. In the Binet-Simon system, 1.0 represented an average IQ for a given age and the children admitted to the asylum were always far below that. On average, Wittneben claimed, twenty-seven children had improved from an IQ of 0.55 to an IQ of 0.73: "Out of half intelligences became three quarter intelligences."[23] While it might not be possible to improve children's IQs through pedagogical means—as the psychologist William Stern had claimed a couple of years earlier—Wittneben was excited by the possibility that it seemed possible to achieve such improvements through medical therapy. Improvements were not just reflected in higher IQs. According to one teacher, dull (*stumpfsinnige*) children became fresher, livelier, and more interested in school.[24] Nor were improvements in mental performance the only benefits of the medication, which, apart from thyroxin, might include Lipatren, an iodine compound produced by Behring, and extracts from the pituitary gland.[25] Underdeveloped children experienced growth spurts and so-called psychopaths showed greater psychological stability. In one case, the treatment corrected a "youthful criminal predisposition" in "an aggressive a-social psychopath."[26]

Jaensch and his collaborators maintained that they had found a way to treat deviance and feeblemindedness. While they conceded that the latter often had a hereditary component, they claimed that in many cases mental underperformance was not always the intractable problem it was seen to be.

21 John Carson, *The Measure of Merit. Talents, Intelligence, and Inequality in the French and American Republics, 1750–1940* (Princeton: Princeton University Press, 2007), 139–157.

22 Wilhelm Wittneben, "Die Therapie der kapillarstigmatisierten Entwicklungsstörungen," in *Hautkapillarmikroskopie*, Jaensch, 164–191, here 172–173.

23 Wittneben, "Die Therapie der kapillarstigmatisierten Entwicklungsstörungen," 174.

24 Wittneben, "Die Therapie der kapillarstigmatisierten Entwicklungsstörungen," FN, 172–173.

25 Wittneben, "Die Therapie der kapillarstigmatisierten Entwicklungsstörungen," 179.

26 Wittneben, "Die Therapie der kapillarstigmatisierten Entwicklungsstörungen," 191.

Wittneben thought that he could administer therapies with some precision and turn three-quarter intelligences into children who had their full senses.[27] To prove the precision of his interventions he experimented with suspending medication for some children, whose IQ fell promptly on average from 0.71 to 0.6 after five months but rose again to 0.69 after resuming treatment for three months.[28] An impressive example of medical precision-engineering if it had actually worked.

4 Reading Capillary Images

Jaensch and Hoepfner tried to substantiate their claims through mass examinations of children's capillaries in Kassel in 1925–26.[29] The survey involved 5324 children, a number that only could be examined by confining capillary examinations to one area of the body, the nail fold of fingers. Müller and his collaborators rejected such an approach as unreliable. Since capillaries presented differently in different parts of the body, they rejected Jaensch's assumption that capillaries in one part of the body could be read as an accurate reflection of the capillary system or the constitution as a whole: "the doctoring with fingers (*Fingerdoktorei*)" was not sufficient because its empirical base was too narrow.[30]

Criticism of Jaensch's approach was not limited to his use of capillary microscopy. There were also concerns about the empirical validity of his findings and his theoretical premises. One scientist rejected Jaensch's assumption that capillaries presented a kind of synecdoche in the sense that they could be read as degenerative signs that reflected a hidden truth about a person's entire physical and mental constitution. Hans Delbrück, a doctor at the hospital for psychic and nervous diseases at the University of Göttingen, entertained the possibility that "pathological capillaries [...] could be signs of a certain degeneracy" but only if they were combined with other degenerative symptoms. But he discounted this idea when he found no significant correlation between "archicapillaries" and degenerative signs such as deformities of the palate, ears,

27 Wittneben, "Die Therapie der kapillarstigmatisierten Entwicklungsstörungen," 179.
28 Wittneben, "Die Therapie der kapillarstigmatisierten Entwicklungsstörungen," 175.
29 Theodor Hoepfner, *Die Strukturbilder der menschlichen Nagelfalzkapillaren und ihre Bedeutung im Zusammenhang mit Schilddrüsenveränderungen sowie gewissen Schwachsinns- und Neuroseformen* (Berlin: Richard Schoetz, 1928), 112.
30 Otfried Müller and Walther Parrisius, *Die Blutdruckkrankheit. Klinische, erbbiologische, anthropometrische, biochemische, histologische, kapillarmikroskopische und andere Untersuchungen am Blutumlauf bei Hypertonikern* (Stuttgart: Ferdinand Enke, 1932), 13.

teeth, or other parts of the body.[31] But even more importantly, Delbrück's study of 450 children in Göttingen could not confirm a correlation between intelligence and capillary development.[32] In Delbrück's view, Jaensch's ideas did not constitute a "theory built on known scientific facts" but a loose assembly of "hypotheses and auxiliary hypotheses" which could not be verified because Jaensch never gave precise numbers for the normal and feebleminded children he examined. He also never explained how he diagnosed "neuropathy," a major shortcoming given the fuzziness of this diagnostic category.[33]

Heinrich Brieger, a Prussian district physician (*Kreisarzt*), scrutinised Hoepfner's findings in Kassel and claimed that the relationship between capillary developments and mental inhibitions was not even sustained by Hoepfner's own material. Hoepfner imagined that mental underdevelopment was somehow related to developmental deficiencies of the midbrain (mesencephalon)—for which there was no anatomical proof—but which was nonetheless reflected in capillary development.[34] Brieger pointed out that Hoepfner's claims about differences in capillary inhibitions in different schools were not borne out by his own numbers. The difference, 62.7% of capillary inhibited students in Kassel's normal schools (*Bürgerschulen*) compared to 67.9% in special schools, was not that significant. Brieger further pointed out that the lowest percentage of "capillary inhibited" students could be found in a special school (52%), the next lowest one was a normal school, and the third lowest one was again a special school. Moreover, the highest percentage of the most severe forms of capillary inhibitions could be found in a normal school (19.2%), whereas the worst of the special schools had only 16.1%. It was even more astonishing that Wittneben's asylum, Hephata, an institution that according to Jaensch and associates should have had a particularly high percentage of severely affected children with archicapillaries, had only between 10 to 15% of such patients.[35]

In Brieger's view, the relationship between capillary and mental development could not be sustained, a position which drew rebuttals from Jaensch and Hoepfner. Hoepfner maintained that Brieger's critique was primarily a theoretical one because he had no knowledge about the thorough clinical diagnosis of the relationship between "archicapillary inhibition and constitution," for

31 Hans Delbrück, "Archicapillaren und Schwachsinn," *Archiv für Psychiatrie und Nervenkrankheiten* 81 (1927): 606–629, here 617.

32 Delbrück, "Archicapillaren und Schwachsinn," 619.

33 Delbrück, "Archicapillaren und Schwachsinn," 609.

34 Heinrich Brieger, "Zur Anwendung der Capillarmikroskopie nach Jaensch-Hoepfner-Wittneben," *Klinische Wochenschrift* 8, no. 7 (1929): 296–299, here 298.

35 Brieger, "Zur Anwendung," 297.

which Hoepfner intended to present evidence in the future.[36] Jaensch claimed that Brieger did not take into account all of the evidence.[37] Interestingly, neither of them addressed Brieger's main critique concerning their comparative data on normal and special schools.

5 Capillary Images and Biopolitical Interventionism

The crux of the controversy about capillary images was not so much the validity of Jaensch and Hoepfner's scientific claims but the far-reaching policy conclusions which they drew from their findings. Brieger was motivated in his critique not by the scientific impact of Jaensch's and Hoepfner's work since "the authors have so far found only minor resonance in scientific journals." Brieger was concerned about the interest which their work might find among the broader public and with government officials.[38] This fear was not far-fetched. Jaensch and his collaborators were pushing a broad biopolitical agenda that directly fed into political concerns about the declining health and performance capacity of the German population after World War I.[39]

The economic costs of disability and feeblemindedness were a major issue for the government and leading medical professionals. The Halle medical professor Emil Abderhalden, for example, considered the "capillary microscopic method for the early determination of feeblemindedness" a matter of great importance.[40] Discussions about the threat of the feebleminded were not unique to Germany in the 1920s. As is well known, American eugenicists advocated curbing "the menace of the feebleminded" which allegedly hampered

36 Theodor Hoepfner, "Zur Anwendung der Capillarmikroskopie nach W. Jaensch-Wittneben-Hoepfner. Bemerkungen zu dem gleichnamigen Artikel von H. Brieger," *Klinische Wochenschrift* 8, no. 16 (1929): 741.

37 Hoepfner, "Zur Anwendung," 741.

38 Brieger, "Zur Anwendung," 296.

39 Hau, *Performance Anxiety*, chap. 2; Corinna Treitel, "Max Rubner and the Biopolitics of Rational Nutrition," *Central European History* 41, no. 1 (2008): 1–25. Concerns about national health and efficiency also fed a growing preoccupation with eugenics among doctors and government bureaucrats, albeit with little practical consequences during the 1920s; see Edward Ross Dickinson, "Biopolitics, Fascism, Democracy. Some Reflections on Our Discourse about "Modernity,"" *Central European History* 37, no. 1 (2004): 1–47, esp. 11–15.

40 Referat Emil Abderhalden, "Ueber die Bedeutung des mikroskopischen Kapillarbildes und die therapeutische Beeinflussung abnormer Kapillarbildungen" (November 26, 1928), *Bundesarchiv Berlin-Lichterfelde*, R 4901, Nr. 1463, here Bl. 3.

national health and efficiency.[41] Abderhalden was so impressed by Jaensch's work that he advocated the establishment of "central research and examining institutions" to get a better understanding of the "physical forms of expression of feeblemindedness."[42] While the Prussian Health Council cautioned that it was too early to arrive at a final judgment about the validity of Jaensch's claims, it nonetheless considered the "research results so far so remarkable that [...] the [council] recommends to the state government, [...] to support these investigations by all means."[43] Even before this far-reaching endorsement of Jaensch's research he and his collaborators had few troubles in acquiring funding for their research and biopolitical surveys from a number of Reich ministries, and state and municipal agencies. From 1928 to 1931, the Reich Interior Ministry funded a mass survey of children's capillaries in the government district of Merseburg, which examined about 20,000 children. The Reich Labour Ministry granted money in the hope that capillary images could be used to determine people's working capacity and vocational aptitude. The *Reichswehr* provided some money because the director of its psychological testing department believed that capillary images could indicate "inferior intellectual performance" or "lack of character." In 1932, a Reich Health Office report calculated that Jaensch must have received at least 68,000 Reichsmarks from various government institutions. According to the president of the office, Carl Hamel, this level of support was very rare and could normally only be justified by exceptional circumstances.[44]

Jaensch's critics could not have known the details of government support for his research and surveys. But what they knew worried them enough to scrutinise his work and speak out against him, especially since he and his collaborators articulated very far-reaching demands. Hoepfner maintained that the findings of their capillary-microscopic mass surveys justified "massive state intervention" (*gewaltiges staatliches Eingreifen*) in terms of an "energetic grand therapy" for entire populations, which he envisioned as a supplement to eugenic sterilisation to curb human "inferiority."[45] He demanded that state medical agencies set out to establish the degree of "endemic intelligence deficits" in areas with "endemic capillary inhibitions." The patients at all private and state homes for "idiots and the feebleminded" as well as all institutionalised

41 James W. Trent, *Inventing the Feeble Mind. A History of Mental Retardation in the United States* (Berkeley: University of California Press, 1995), chap. 5.

42 Referat Abderhalden, *Bundesarchiv Berlin-Lichterfelde*, R 4901, Nr. 1463, esp. Bl. 5.

43 "Entschließung Landesgesundheitsrat," *Bundesarchiv Berlin-Lichterfelde*, R 4901, Nr. 1463, here Bl. 5.

44 Hau, "Constitutional Therapy," 125–126.

45 Hoepfner, *Die Strukturbilder*, 160.

welfare recipients should be scrutinised along with students at special schools. Counselling centres for problematic youths and psychopaths as well as marriage clinics should be advised to consider capillary diagnostic findings for their advice. Eventually, "capillary microscopic developmental control" should be extended to the entire German population.[46]

These were far-reaching demands with significant implications for health care and social hygiene, which is why Brieger thought the authors' work required critical scrutiny. He rejected what he considered premature therapeutic applications and popularisations. Jaensch and his collaborators, he claimed, had presented their ideas for years in lectures and training courses for government administrators, childcare and welfare workers, teachers, and nurses. In Brieger's view, these lay audiences did not understand that they were confronted with scientific problems or early research results which needed to be fully investigated and confirmed. Instead, what they took away from these presentations was the belief that they had learned about "established facts and a kind of panacea for developmental inhibitions."[47] Brieger was particularly incensed about the idea of using capillary microscopy for vocational aptitude tests. Apparently, this was a demand voiced in one of Jaensch's training courses for police medical councillors, which Brieger and one of his colleagues could only deflect with great difficulty.[48]

There were other critics. The paediatrician and neurologist Paul Pototzky examined the capillaries of about 1000 children while working at the *Kaiserin-Auguste-Viktoria-Haus*, a specialist hospital for infants in Berlin. He took issue with some of Jaensch's findings as well as the far-reaching biopolitical demands voiced by Hoepfner. In Pototzky's view, there was not enough congruence between cases which showed a preponderance of "archicapillaries," and specific psychiatric and neurological conditions: The ""archicapillary feeblemindedness," which Jaensch claimed to have found, does not exist."[49] While he did not object to research that tried to understand the significance of capillary structure in "neuropathic and mentally abnormal children," he rejected a "one-sided diagnosis solely based on the capillaroscopic image."[50] In Pototzky's view, the results of capillary examinations were too inconsistent to justify training courses in the method for school, city, and welfare physicians, which

46 Hoepfner, *Die Strukturbilder*, 162–163.
47 Heinrich Brieger, "Erwiderung," *Klinische Wochenschrift* 8, no. 16 (1929): 742.
48 Brieger, "Erwiderung."
49 Carl Pototzky, "Die klinischen Ergebnisse der Kapillaroskopie bei neuropathischen und geistesschwachen Kindern," *Monatsschrift für Psychiatrie und Neurologie* 69 (1928): 188–199, here 190.
50 Pototzky, "Die klinischen Ergebnisse der Kapillaroskopie," 195.

the city of Berlin had just introduced, or to support the far-reaching biopoliti-cal demands for mass surveys of entire populations, as suggested by Hoepfner.[51]

Paul Karger from the paediatric hospital of the University of Berlin also expressed scepticism about the validity of Jaensch's claims.[52] Like Pototzky, Karger worried that the diagnostic and therapeutic optimism inspired by Jaensch's work would lead to "exaggerated administrative measures" that were not justified.[53] He examined the capillaries of about 300 neuropathic, "idiotic," or healthy children using Hoepfner's taxonomy. His findings further cast doubt on the claims made by Jaensch and his collaborators: there was "no convinc-ing parallelism between the kind and severity of the mental defect and the capillary image."[54] From this he concluded that the "paramount significance," attributed to capillary findings by some, could simply not be justified.[55]

6 Conclusion: The Pitfalls of Utilitarianism

None of Jaensch's critics denied the possibility that capillary microscopy could prove to be a valuable diagnostic tool. Researchers like Otfried Müller worked on an open-ended research program that tried to establish links between the structure and functions of capillaries and a variety of pathological and healthy states. What critics objected to were the far-reaching and simplistic conclu-sions, which Jaensch drew from capillary images. Jaensch and his collaborators were not interested in capillary function. Instead they privileged morphologi-cal structures fixated through capillary drawings and categorised in a "Kap-illarschlüssel" in order to diagnose developmental inhibitions that allegedly manifested in intellectual and moral deficits. The appeal of their claims lay in the simplicity of their images and in the utilitarian promises which this simplicity entailed. If there was a chance for a simple solution to the vexing problem of feeblemindedness, did this not justify supporting Jaensch's work by any means? Emil Abderhalden and the Prussian State Health Council clearly thought so and so did medical officials, working for the city of Berlin, who favoured the teaching of Jaensch's findings to city and welfare physicians. But of course, things were not as simple as Jaensch and his collaborators claimed,

51 Pototzky, "Die klinischen Ergebnisse der Kapillaroskopie," 196–197.
52 Paul Karger, "Die klinische Bedeutung des capillaroskopischen Bildes am Nagelfalz von Kindern," *Monatsschrift für Kinderheilkunde* 42 (1928): 292–296.
53 Karger, "Die klinische Bedeutung des capillaroskopischen Bildes," 293.
54 Karger, "Die klinische Bedeutung des capillaroskopischen Bildes," 294.
55 Karger, "Die klinische Bedeutung des capillaroskopischen Bildes," 295.

and this was already noted in the 1920s. Still, Jaensch et al. managed to funnel a lot of public resources into their research and surveys. Support for Jaensch's work continued into the 1930s. Until 1934 he even received significant grant money from the Rockefeller Foundation, which helped him keep his research program alive during the Depression. The foundation shared a widespread belief in utilitarian medical-technocratic solutions to social and medical problems such as feeblemindedness and other psychiatric conditions and Jaensch's claims fit the bill. In late 1932, Rockefeller officials were impressed by "the high quality of the research" carried out under Jaensch who was described as "an able and enthusiastic young leader."[56] As evidence for the importance of Jaensch's work they cited the continued financial support he received from Prussian and Reich ministries as well as the health administration of the city of Berlin, despite the financial constraints imposed by the economic crisis. In the eyes of the foundation this demonstrated "splendid evidence of local support under unusually difficult circumstances."[57] It seems that the validity of Jaensch's claims was assessed based on his ability to attract funding from state and city agencies which had fallen for his promises to diagnose developmental inhibitions and cure disabilities.

Acknowledgments

I would like to thank my current and former colleagues Adam Clulow, David Garrioch, Julie Kalman, Paula Michaels, Kathleen Neal, Seamus O'Hanlon, Susie Protschky, and Timothy Verhoeven for commenting on drafts of this chapter.

56 RAC University of Berlin Medical Clinic, R.G.1.1. 717 A, box 11, Folder 73.
57 RAC University of Berlin Medical Clinic, R.G.1.1. 717 A, box 11, Folder 73.

Sex Murder, Photographic Evidence, and the Weimar Cultural Imagination

Birgit Lang

Scholarship on Weimar Germany has long recognised the "criminalistic phantasies" of Weimar society.[1] The end of World War I left Germany in a state of dramatic social disarray. The brutalisation of society—in great parts a consequence of the war, visible in crime statistics and commented on by contemporaries—left the new democracy facing a double challenge: rising actual crime rates as well as the "dominance and prevalence [of crime] as a cultural symbol."[2] For key Weimar avant-garde artists, filmmakers, and intellectuals criminality came to represent the disrupted social order of the time.[3]

This chapter examines a specific moment in the early Weimar Republic when the phenomenon of *Lustmord*, i.e. sexually motivated murder, often of prostitutes, featured prominently in the works of a handful of male visual artists. Both the figure of the sex murderer and those of the murder victims became motifs of artistic exploration. According to the seminal work of Maria Tatar, depictions of sex murders contributed to the ways in which victims were disavowed and erased; she observes an underlying identification not only of popular culture but also of the creative avant-garde with the perpetrators of sex murders.[4] Tatar presents a powerful argument in situating sex murder at the heart of the modernist project and questioning the role the aesthetics

1 Todd Herzog, *Crime Stories: Criminalistic Fantasy and the Culture of Crisis in Weimar Germany* (New York: Berghahn, 2009), 4.
2 Udi E. Greenberg, "Criminalization. Carl Schmitt and Walter Benjamin's Concept of Criminal Politics," *Journal of European Studies* 39, no. 3 (2009): 305–319, here 315.
3 Daniel Siemens, "Explaining Crime. Berlin Newspapers and the Construction of the Criminal in Weimar Germany," *Journal of European Studies* 39, no. 3 (2009): 336–352, here 337. On biologisation, see Richard F. Wetzell, *Inventing the Criminal. A History of German Criminology, 1880–1945* (London, Chapel Hill: University of North Carolina Press, 2000), 125–178. On brutalisation, see Jason Crouthamel, *The Great War and German Memory. Society, Politics and Psychological Trauma, 1914–1945* (Exeter: University of Exeter Press, 2009).
4 Maria Tatar, *Lustmord. Sexual Murder in Weimar Germany* (Princeton, NJ: Princeton University Press, 1995), 6.

of violence played in "managing certain kinds of sexual, social and political anxieties."[5] As one of her reviewers remarks, "[l]ike Peter Gay before her, Maria Tatar creates a new framework to interpret Weimar culture. Where Gay saw a revolt of sons against fathers, Tatar sees sons seeking revenge against women."[6]

This chapter revisits Tatar's argument from a new angle. The careful contextualisation and comparison of criminological photographs and artistic works reveal a complex construction of meaning across the epistemological boundaries of criminology, forensic pathology, photography, and the visual arts. Pepper Stetler has argued that the pragmatic origins of much of New Objectivity's photographic aesthetic developing from the mid-1920s can be traced back to the educational ambitions of photographic archives in early twentieth-century Germany.[7] In the context of sex murder, criminological photographs played a comparable role for the visual arts at a slightly earlier time. This chapter submits that photography and forensic pathology enabled visual artists to expose to view the brutal murder of women and that they did so in contradictory ways.

If New Objectivity's photographic aesthetic in particular focused on image profusion and "the thorough renewal of human vision," quickly developing its own recognisable aesthetic and genres, for a moment in time sex murder and sex murderers captured the imagination of German Dadaists and the representatives of New Objectivity.[8] This chapter discusses the productive, problematic, and diverse uptake of the motif of extreme sexual violence by Georg Grosz (1893–1959), Otto Dix (1891–1969), and Rudolf Schlichter (1890–1955) and highlights the ways in which these artists instrumentalised the photographic archives of criminology. It shows how each of these artists was drawn to and struggled to represent such violent deaths, but that through explanatory details (of little relevance in police photography) they engaged the viewer in different ways to question the images before them.

5 Tatar, *Lustmord*, 6.

6 Julia E. Sneeringer, review of Maria Tatar, *Lustmord. Sexual Murder in Weimar Germany* (Princeton, New Jersey: Princeton University Press, 1995), *H-German* (November 1995).

7 Pepper Stetler, "The Object, the Archive and the Origins of 'Neue Sachlichkeit' Photography," *History of Photography* 35, no. 3 (2011): 281–295, here 282.

8 Olivier Lugon, "'Photo-Inflation': Image Profusion in German Photography, 1925–1945," *History of Photography* 32, no. 3 (2008): 219–234, here 220. An example of the latter is the photobook, most recently discussed in Brian Stokoe, "The Landscape Photobook in Germany: From Neue Sachlichkeit to Nazi Sachlichkeit," *History of Photography* 42, no. 1 (2018): 78–97.

1 Sex Murder, Photography, and the Forensic Gaze

The criminological photographs relevant to our investigation can be traced back to a single source with exceptional status: Erich Wulffen's criminological work *Der Sexualverbrecher* [The sex offender] of 1910.[9] This monograph was the first specialised reference work on the topic of sex offences and its seventy-five photographic images represented a cutting-edge criminological methodology. Two earlier criminological landmark studies by the Austrian Hans Groß (1847–1915) and the Swiss-based German national Archibald Reiss (1875–1929) had first championed photography. Groß's influential *Handbuch für Untersuchungsrichter als System der Kriminalistik* [Handbook for investigating judges as a system for criminology] (1893) was the first to praise the importance of photography for forensic evidence. Groß pointed out that "it is hardly possible to exhaust by complete enumeration the number of cases in which photography may be employed."[10] He highlighted the advantage of photographs in conveying a sense of the scene of an accident or crime to those investigating the crime and a clearer image of observable facts to the judge and state prosecutor; he further underlined the role of portrait photography in the identification of perpetrators.[11] Reiss developed Groß's insight further and founded the first academic forensics program specialising in photographic evidence at the University of Lausanne in Switzerland in 1909.[12] His *La photographie judiciaire* [Judicial photography] (1903) and his renowned *Manuel de police scientifique (technique)* [Manual of police science] (1911), published a year after Wulffen's volume, featured a wide range of photographs from tattoos of criminals to anthropological studies of certain social milieus, along with portraits of criminals. The choice of photography was defined by the topics covered in the manual, which included theft, property damage, professional crime, and homicide and attached to specific cases. The majority of photographs depicted the crime scene and evidence in a wider sense such as footprints and blood spatters, as

9 Erich Wulffen, *Der Sexualverbrecher. Ein Handbuch für Juristen, Verwaltungsbeamte und Ärzte* (Groß-Lichterfelde Ost: Paul Langenscheidt, 1910).

10 Hans Gross and J. Collyer Adam, *Criminal Investigation: A Practical Textbook for Magistrates, Police Officers and Lawyers* (London: Sweet & Maxwell, 1924), 171. *Handbuch für Untersuchungsrichter als System der Kriminalistik* was reissued seven times between 1883 and 1922 and first translated and adapted into English by J. Collyer Adam in 1924. The English adaptations were in turn updated and reissued in 1950 and 1962.

11 Gross, *Criminal Investigation*, 172, 180–184.

12 William J. Tilstone, Kathleen Anne Savage and Leigh A. Clark, *Forensic Science: An Encylopedia of History, Methods, and Techniques* (Santa Barbara, CA: ABC-Clio, 2006), 15.

well as images of murder victims, in an attempt to highlight either specific injuries or the position of a corpse at the scene of a crime.[13]

This also held true for Wulffen's *Der Sexualverbrecher*. Photographs provided both evidence and illustrations of sexual offences in Wulffen's textbook, again always illustrating specific case-based material, the target audience of which was the forensic public denoted in its subtitle: lawyers, civil servants, and physicians. Over half of the seventy-five photographic images depicted were of homicide victims: some at the scene of the crime (20), others of their often naked or scarcely clad, partially visible, severely violated bodies (12), or parts thereof (7). Yet more images relating not only to homicide but other crimes as well included portraits of convicted criminals (10) and photographs of any objects relevant to the reconstruction of the crime and the conviction of the perpetrator. With one exception the depicted murder victims were female; two of them were child victims. Wulffen carefully discussed the meaning of these photographs in the accompanying textual descriptions of each case. This included relevant factual details, criminological explanations, and an elaboration of the use of photography and the viewing methods employed by the police force. The aim of these case studies to which each photograph was tied was to train the forensic public in their understanding of police work. As Wulffen pointed out in a later work, in line with Groß's and Reiss's reasoning, "[photographs] are able to give the desirable vividness especially in this area, which no written word can achieve, let alone replace."[14] These meticulous descriptions also helped to contain the violence of the photographs pictured.

The graphic nature of the images depicted raises an array of ethical questions including the human dignity for the deceased and the protection of privacy for their families. In comparison to other criminologists of his time, Wulffen had shown remarkable insights only a few years earlier in his widely available case study on the Romanian hotel thief and conman George Manolescu, in which Wulffen sought to prevent the secondary victimisation of Manolescu's ex-wife and their daughter, who had suffered domestic violence at the hands of Manolescu.[15] Wulffen carefully tailored the text to his intended readers as a way of protecting unintended readers from exposure—and potential incite-

13 Archibald Reiss, *Manuel de police scientifique (technique)*, préface de Louis Lépine (Lausanne: Payot, 1911).

14 "[S]ie [vermögen] eine gerade auf diesem Gebiete wünschenswerte Anschaulichkeit zu geben, die kein geschriebenes Wort erreichen, geschweige denn ersetzen kann" (Erich Wulffen, *Das Weib als Sexualverbrecherin. Ein Handbuch für Juristen, Polizei- und Strafvollzugsbeamte, Ärzte und Laienrichter* (Berlin: Paul Langenscheidt, 1923), 2).

15 Birgit Lang, "Erich Wulffen and the Case of the Criminal," in *A History of the Case Study: Sexology, Psychoanalysis, Literature*, eds. Birgit Lang, Joy Damousi and Alison Lewis (Manchester: Manchester University Press, 2017), 119–155, here 129.

ment—to criminality; it therefore seems reasonable to assume that, in the context of *Der Sexualverbrecher*, he felt that the volume's pitch to a forensic audience and its pricing would effectively shield victims and their families. The reviewers of the volume seem to have agreed, with one of them attesting that "for forensic physicians" the work would become "a real classic reference book."[16]

2 Visual Transpositions

We know for a fact that Otto Dix was familiar with Wulffen's volume *Der Sexualverbrecher*,[17] but we can only speculate that both George Grosz and Rudolf Schlichter had access to it. The uncanny similarity of Dix's and Schlichter's works in particular to the images in Wulffen's volume seems telling. That the volume would have been discussed more widely in the artistic circles of Berlin and Dresden seems plausible, considering that the Dresden-based Wulffen was a well-known public figure whose work had traction in legal and medical circles in Berlin and beyond. Furthermore, access to police files and crime scene photography of homicides was severely limited for the public at large. Criminological photographs of crime scenes and murder victims were not published in print media, with the exception of the relevant mug shot of perpetrators. This makes *Der Sexualverbrecher* a likely source of photographic imagery for a group of artists who were known to each other and participated in overlapping and at times competing artistic networks located in Berlin and nearby Dresden. The period of their creative convergence falls within the first half of the 1920s, marked by their participation in the First International Dada Fair in Berlin in 1920 and book-ended by the New Objectivity Exhibition in Mannheim in 1925.

3 Beginnings: George Grosz's "Lustmord in der Ackerstrasse"

Grosz's "Lustmord in der Ackerstrasse" provides a helpful contrast to explore the original fascination with the question of sex murder in German artistic circles. His engagement with the subject matter precedes the new modernist

16 "Literaturübersicht, Gerichtliche und Militärmedizin," SLUB, Nachlass des Schriftstellers und Kriminalisten Min.-Direktor Dr Erich Wulffen (1862–1936): Signatur: Mscr. Dres. App. 1477.

17 Lothar Fischer, *Otto Dix. Ein Malerleben in Deutschland* (Berlin: Nicolaische Verlagsbuchhandlung, 1981), 81–82.

aesthetic by about a decade, and coincided with his arrival in Berlin in 1912 and his interest in expressionism.[18] In this and the following year he started to sketch a series of murder scenes depicting male perpetrators after the murder of their female lover/partner, a gendered dynamic that is further underlined by the fact that, while the homicide victims appear naked, their murderers are fully dressed. In the majority of these images the perpetrators are also seen threatening another man, presumably in a fit of jealous rage, perhaps holding a pistol to their head or aiming a rifle out the window.[19] The title given to these images is "murder," or a slight variation thereof, and their gendered dynamic and relational character were trademarks of Grosz's elaborations on this motif.

"Lustmord in der Ackerstrasse," the first work to explicitly use the term "sex murder," was published in 1922–23 in Grosz's first extensive collection of work, *Ecce Homo*. These prints show a depraved Berlin that is "populated exclusively by beggars, black marketeers, whores, pimps, cripples, generals, drunks, panderers, the gluttons and the starving, seducers and the seduced, all killing, drinking, lusting, fornicating in perennial nausea."[20] The collection also contains a drawing titled "Mord" (no. 12) that builds on his earlier sketches on the theme, although important differences pertain even here. While the early "Mord" images were set in a bedroom with little additional detail given, "Mord" (no. 32) depicts a four-storey building with a dead man and a female dog with swollen teats lying on the ground outside, while a bare-breasted woman peers out a window, with the alleged murderer disappearing around the corner.[21]

Both the "Mord" series and "Lustmord in der Ackerstrasse" date from 1916, fashioned after Grosz's return from his second stint in the war. "Lustmord in der Ackerstrasse" shows the interior of a small studio apartment with a room partition partially revealing a washbasin, pitcher, and mirror. If not for the decapitated female in the foreground and her executioner washing his hands in said basin, the scene would convey a sense of exhilaration and fun in a well-cared-for, upper-level, potentially top-floor working-class flat. The title situates the flat in one of the poorest working-class areas of Berlin and the viewer is invited to speculate on whether the woman in question

18 Frank Whitford, *The Berlin of George Grosz. Drawings, Watercolours and Prints 1912–1930* (New York and New Haven: Yale University Press, 1997), 5.

19 "Mord, 1912/13," "Ein Mord 1912/13," and "Mord, 1912/13," in *George Grosz. Leben und Werk*, ed. Uwe M. Schneede (Stuttgart: Gerd Hatje, 1975), 24–25.

20 Ruth Berenson and Norbert Muhlen, "The Two Worlds of George Grosz," in *George Grosz*, ed. Herbert Bittner (New York: Griffin, 1960), 11–28, here 14.

21 George Grosz, *Ecce Homo. 84 Lithographien und 16 Aquarelle* (Berlin: Malik, 1922–23).

would have been able to afford the gramophone, watch, alarm clock, and a half-drunk bottle of wine on the salary of a working-class woman.[22] After all, many working-class women who, due to the war, often took up hard physical labour traditionally seen as men's work, only earned a fraction of male wages.[23] In a time of food rations and soup kitchens, the woman's body appears well fed. It ultimately remains unclear whether she may have risked her safety through sex work. Her body seems draped in an unusual upside-down manner on the chaise longue that is made up as a bed, and her body is mutilated by what could be interpreted as welts; a bunch of birch strips lays suggestively on the chair in the foreground. The woman's missing head, brutally hacked off, becomes the symbol for the ambiguity of meaning in the scene. While the viewer is unwittingly looking for the missing head of the victim, they are being made aware of the fact that the reason for this act of violence remains unresolved.

The unusual amount of detail gives the image a photographic character, yet the drawing sets itself apart from criminological crime-scene photographs through a range of features. These include the perspective—wide-lens technology had not yet been invented in 1910—the presence of the murderer, and the victim's missing head. If the scene depicted in "Lustmord in der Ackerstrasse" had been an actual criminal case, police photographs would have depicted the crime scene with corpse from a close-up perspective, a partial reproduction of the victim's head—if found—and a mugshot of the perpetrator, if he was convicted. Such mugshots were standardised and stylised according to Reiss's new photographic technique of serialisation which was unable to depict any emotions and portrayed a "banality of evil" that underlined the disconnect between the perpetrator and his deeds. It is in this lacuna that Grosz situated his perpetrator. His round body shape does not reveal a jovial nature; rather he looks out from the far-right corner of the image in a somewhat sheepish and haggard manner, while washing his bloodied hands. In contrast to a criminological photograph, Grosz's early depiction reintroduces here a moment of accountability, catching the murderer in, or shortly after the act, and raising a question as to the motivation for the crime, while his later works on the topic are driven by a more Dadaist agenda.

22 Only a few years later and before the publication of *Ecce Homo*, Ernst Friedrich's 1919 novel *Das Mädchen aus der Ackerstraße. Ein Sittenbild aus Groß-Berlin*, published under the pseudonym Hermann Fleischack, chooses the Ackerstrasse as a location for its unfolding social drama of sexual exploitation of an underage girl. The novel was made into a film in 1920.

23 Schneede, *George Grosz*, 141.

FIGURE 11.1 George Grosz, "Lustmord in der Ackerstrasse," in *Ecce Homo. 84 Lithographien und 16 Aquarelle* (Berlin: Malik, 1922–23), 32

4 New Objectivity: Otto Dix and Rudolf Schlichter

Dix's and Schlichter's works differ in crucial aspects from that of the early Grosz. They were increasingly shaped by the distanced gaze of New Objectivity that challenged its viewers with a much less sympathetic and more confronting view of sex murder. As in other fields such as literature a documentary-style method underlined the realistic focus of New Objectivity.[24] The photographs in Wulffen's volume were a great find for Dix and Schlichter in this respect. Whereas Grosz's early works provided a provocative commentary on modern-

24 Richard J. Murphy, "Berlin: Expressionism, Dada, Neue Sachlichkeit," in *The Oxford Handbook of Modernisms*, eds. Peter Brooker, Andrzej Gasiorek, Deborah Longworth and Andrew Thacker (Oxford and New York: Oxford University Press, 2010), 669–686, here 684.

ist life in Berlin, Dix and Schlichter veered away from this more metaphorical understanding of sex murder towards an identificatory understanding of the representation of the subject matter in the visual arts.

In his insightful article on Dix and the topic of *Lustmord*, Olaf Peters emphasises that sex murder "was a subject fit for destroying both notions of art linked to the ideal female body and art itself."[25] Peters understands paintings and collages such as Grosz's *John der Frauenmörder* (1918) as Dadaist attacks on bourgeois art, and sees Dix's self-fashioning as a sex murderer (the lost *Der Lustmörder* (*Selbstbildnis*), 1920) as an attempt to "outdo the Berlin Dadaists aesthetically."[26] There is, however, a larger point to be made about the positionality of these artists, which can be more easily revealed with a focus on the female body. Grosz's murder scenes always depicted men (as perpetrators and victims) and women (solely as victims). His visual dismemberment of the female body *qua* bourgeois art world seems to reject notions of beauty, in line with what Wendy Steiner has considered to be the exile of Venus in modernist art.[27] Dix and Schlichter, however, rather than distancing themselves from bourgeois art and making dismembered female bodies its vehicle, were confronted with a different predicament, that is how to represent the murder of women.

The long tradition of the female nude was invigorated around the turn of the century through the vivid drawings and watercolours of Egon Schiele. Schiele successfully revitalised the image of the Venus Naturalis (opposed to that of the heavenly Venus) and her sensuality.[28] His pictures offered a more direct expression of human experience and challenged the traditional notion of the nude as an idealised Venus. His nudes are depicted in private, and his drawings and watercolours circle around the themes of eroticism, sexuality, and procreation.[29]

Dix and Schlichter, on the other hand, embraced in their depiction of nudity not Eros but Thanatos, not *la petite mort* but death. Rather than commenting on and exploring alternatives to criminological photographs as did the early Grosz, Dix and Schlichter relied on this new realism for which no nude models existed.

25 Olaf Peters, ""Painting, A Medium of Cool Execution": Otto Dix and Lustmord," in *Otto Dix*, ed. Olaf Peters (Munich, Berlin, London and New York: Prestel, 2010), 92–107, here 95.

26 Peters, "Otto Dix and Lustmord," 97.

27 Wendy Steiner, *Venus in Exile. The Rejection of Beauty in Twentieth-Century Art* (New York: Free Press, 2001), 7.

28 Daniela Queiroz Campos and Maria Bernardete Ramos Flores, "Nude Venus: Nudity Between Modesty and Horror," *Revista Brasileira de Estudos da Presença* 8, no. 2 (2018): 248–276, here 249.

29 Gemma Blackshaw and Kathryn Simpson, *Egon Schiele. The Radical Nude* (London: Paul Holberton Publishing, 2014), 7.

FIGURE 11.2 Otto Dix, "Lustmord," in "*Mappenwerk von Tod und Auferstehung*", 1922, in
 Otto Dix, ed. Olaf Peters (Munich, Berlin and London: Prestel, 2010), 149

FIGURE 11.3 Erich Wulffen, *Der Sexualverbrecher. Ein Handbuch
 für Juristen, Verwaltungsbeamte und Ärzte*
 (Groß-Lichterfelde Ost: Paul Langenscheidt, 1910), 455

Dix first explored sex murder in his collection *Tod und Auferstehung*, which like Grosz's *Ecce Homo* was published in 1922. The series of etchings contains a range of macabre themes that encompass suicide, the death of a soldier, and funeral scenes. The collection is widely seen as Dix's attempt to come to terms with and aestheticise his war experience and life in a desolate post-war Germany.

In contrast to Grosz, Dix's exploration seemingly lacks distance from the subject matter. His etching portrays the prostitute victim as the fallen soldier of the modern city. The victim's profession is identified in the image through alcohol and drawing cards painted on the wall as well as through her wearing of shoes. Unlike the police photograph, which draws the focus of the viewer to the gaping vertical wound in the belly of the victim, Dix added a gush of blood from the victim's mouth to emphasise the fact that she was silenced. The two dogs silently copulating in the foreground again symbolise the act of prostitution—the male dog following his primitive instinct to dominate, the white fluffy female dog looking in the direction of but not at the viewer.

Dix's images are surrounded by a discourse of authenticity that allowed him to challenge the mores of his time and the artistic self-concepts of Dadaism, but also include a certain amount of awkward self-aggrandisement. Jay Layne has argued that the sex murderer was "never just a simple figure of horrified refusal or sympathetic identification."[30] When Dix provocatively assumed a position of painter-as-sex-murderer, as he did in his 1920 self-portrait, this not only represented a provocation towards Dadaism but was a complex expression of his artistic self-conception. Dix saw his art as portraying an emotional realism, an authenticity of experience. His trained eye allowed him to easily capture the visual parallels between criminological photographs of the victims of sex murder and the tradition of the nude in art, and to deploy these parallels in his portrayals of the cycle of life and death. It seems that he accepted violence and death as a fact of life and saw his own role in this context as an almost priestlike figure. In line with the thought developed by Wulffen in his criminological psychology and that more broadly of the legal reformers of the International Criminological Association, Dix accepted that every person has the potential to be a criminal.[31] He showed little interest, however, in the assumption of legal reformers that criminals should be punished according to their aptitude for rehabilitation. Rather, Dix drew parallels between the act of representation and crime and provocatively insisted on his own (potential for) criminality.

30 Jay Michael Layne, *Uncanny Collapse: Sexual Violence and Unsettled Rhetoric in German-language Lustmord Representations, 1900–1933* (PhD dissertation, University of Michigan, 2008), 12.

31 Lang, "Erich Wulffen and the Case of the Criminal," 123.

This act of self-aestheticisation reached far into his private life, as can be seen in his 1922 watercolour, *Scene II (Mord)*, that was dedicated to the birthday of his soon-to-be wife, Martha Koch. Karin Schick, the chronicler of Dix's and Martha's relationship, argues that his wife's sexuality was never subject to representation in Dix's artistic oeuvre, but that "a painting with a similar motif [of *Lustmord*] hung in the dining room of the couple's apartment."[32] In the comfort of their own home, such anti-bourgeois provocation might well have been to the taste of both Otto and Martha Dix. The identification of the artist with the sex murderer, however, carried undertones of the all-too-common Weimar romanticisation of criminality and violence, much bemoaned by criminal psychologists such as Wulffen and much later by Tatar.

Rudolf Schlichter's 1924 contribution to the *Lustmord* genre provides another important contrast to the volatility in Dix's black and white etchings. Schlichter's watercolour "Lustmord" humanised the victim: the fact that her body is not undressed provides her with a certain dignity as does the fact that she is lying on her stomach. The shabbiness of the small and impersonal room conveys the victim's socio-economic status and the picture frame and small objects on the cupboard give a fleeting glimpse into her individuality. Schlichter likely modelled his depiction on a crime scene photograph of a robbery and murder carried out by the perpetrator against a prostitute, and there is no further indication of any other motivation for the crime.[33] By using watercolour, Schlichter portrayed the victim's bruised and bloodied body in more vivid colours than the black and white photograph of the police.

What these three impressions by Grosz, Dix, and Schlichter have in common is that they each give importance to the setting of the murder scenes and in doing so provide a commentary on the death portrayed. This sets them apart both from the criminological photographs in which such detail was incidental and often hard to spot, due to the quality of the photographs, but also from the depiction of the nude in art where the focus was solely on the body of the woman portrayed.

5 Viewers

A decade after publication, criminological photographs of sex murder inspired visual artists in the Weimar Republic. The striking visual similarities between forensic photography and these watercolour paintings, drawings, and etchings

32 Karin Schick, *Otto Dix. Hommage à Martha* (Ostfildern-Ruit: Hatje Cantz, 2005), 115.
33 Wulffen, *Der Sexualverbrecher*, 464.

FIGURE 11.4
Rudolf Schlichter,
"Lustmord," 1924, in
*New Objectivity: Modern
German Art in the Weimar
Republic 1919–33*, eds.
Stephanie Barron and
Sabine Eckmann (Munich,
London and New York:
Delmonico Books and
Prestel, 2015), 55

FIGURE 11.5
Erich Wulffen, *Der
Sexualverbrecher. Ein
Handbuch für Juristen,
Verwaltungsbeamte und
Ärzte* (Groß-Lichterfelde
Ost: Paul Langenscheidt,
1910), 464

include the position of, and injuries on, the victim's body. But what is the meaning of this transmedial uptake, beyond sensationalist spectacle, and did these images contain a relevant critique of such discourses? In a wider societal context where other elites, such as psychiatric experts, increasingly argued that individuals' biological predisposition explained their criminality and in doing so, to quote Daniel Siemens, "established a set of arguments that effectively cast offenders as victims," these visual artists' take on the topic shows clear limitations.[34] Tatar's argument mirrors to an extent Hannah Arendt's critique of Brecht's *Threepenny Opera*, which is of the same era. In *The Origins of Totalitarianism* (1951) Arendt argues that

> [t]he play presented gangsters as respectable businessmen and respectable businessmen as gangsters. The irony was somewhat lost when respectable businessmen in the audience considered this a deep insight into the ways of the world and when the mob welcomed it as an artistic sanction of gangsterism. The theme song in the play, "Erst kommt das Fressen, dann kommt die Moral [grub first, morals later]," was greeted with frantic applause by exactly everybody, though for different reasons.[35]

What Tatar finds so troubling about the Weimar fascination with *Lustmord* is precisely this, that it appealed to everyone: to the middle class who embraced psychiatric discourses about perpetrators as well as to avant-garde artists, who all embraced the subject matter and seemingly erased the possibility of an empathetic stance towards its victims.

The implication of Arendt's argument seems to be that the disintegration of the boundaries between moral subject and criminal can offer insights into the subject matter, but that it can also be interpreted as an artistic sanction, part of a more general morbid romanticisation of sex crime. This is further underlined by speculations about the viewers and potential buyers of these images. Watercolours and drawings have long been the currency of the erotic, made for the interested collector to be perused at their leisure. Peters provocatively speculates that Dix's etchings might have been purposefully catering to "a certain market segment of lovers of both art and the subject matter."[36] Yet, such speculation diverts both from the aesthetic of New Objectivity in which

34 Siemens, "Explaining Crime," 344ff.
35 Hannah Arendt, *Totalitarianism: Part Three of The Origins of Totalitarianism* (San Diego, New York and London: Harcourt, 1968), 33.
36 Peters, "Otto Dix and Lustmord," 99.

"figures never shape the space in which they find themselves in" as well as the difficulty of the representation of extreme violence.[37]

Criminologists and visual artists struggled to represent the violent deaths of these women. They were implicated in the construction of a discourse about sexual violence that referenced the visceral and that had the potential not only to educate readers and viewers but to sensationalise violence. Weimar criminologists assumed that they protected victims, their relatives, and friends by limiting access to such images to expert groups or to publications targeted at expert audiences. As I have aimed to show, visual artists also aimed to contain the violence of the very deaths they chose to depict. They did so through explanatory details and engaging the viewer in a process of questioning. While they often re-inscribed violence in heteronormative and gendered ways and perpetuated notions of male perpetrators and female victims, they restrained from depicting maybe the most shocking representations of victims depicted in forensic photography at the time—girl and boy child victims of sex murder—which were never used as models for the visual arts. Sigmund Freud had been the first to comment on the fact that as a result of World War I many citizens felt a disappointment with a "belligerent" state that permits itself acts of violence in World War I. Freud anticipated in 1915 that "the ennoblement of [...] instincts will be restored in more peaceful times,"[38] yet this became a more complex process than he had envisioned. The return to a civil society was a long time coming, with criminologists as well as artists refusing to brush these brutal murders under the carpet with potentially quite ambivalent effects.

37 Sergiusz Michalski, *New Objectivity. Painting, Graphic Art and Photography in Weimar Germany 1919–1933* (Cologne: Taschen, 1994), 159.

38 Sigmund Freud, "Thoughts for the Times on War and Death (1915)," in *The Standard Edition of the Complete Psychological Works of Sigmund Freud*, vol. XIV (1914–1916) *On the History of the Psycho-Analytic Movement, Papers on Metapsychology and Other Works*, trans. James Strachey (London: Hogarth Press, 1955), 273–300, here 286.

Imagining Madness: The Conceptualisation of Mental Illness in Psychiatric Art Collections

Christiane Weller

Psychiatric hospitals have long been interested in collecting and exhibiting psychiatric art, or what is today often called "outsider" or "raw" art.[1] The Prinzhorn Collection in Heidelberg, Germany, is possibly the most prominent of such psychiatric art collections. Other examples include the Museum Dr. Guislain in Gent, Belgium, the Haus der Künstler in Gugging near Vienna, Austria, the Museum Ovartaci in Aarhus, Denmark, the Psychiatry Museum at the Waldau Clinic and the Art Gallery of Bern, Switzerland, the Dax Centre in Melbourne, as well as Het Dolhuys in Haarlem in the Netherlands. Psychiatric art is not collected and exhibited only by psychiatric institutions but, since Jean Dubuffet's endeavours after 1945, also outside of the medical space, for example, by the L'Art Brut museum in Lausanne, Switzerland, and the Outsider Art collection of the Hermitage Museum in Amsterdam.[2] The artworks in these collections seem to suggest a psychological aberration which can be classified and categorised in terms of a psychiatric diagnosis of the artist-patient. The pathology of the artist is therefore a precondition for the art collection, meaning the pathology is kept alive as a guarantor for the work of art in which it apparently finds notable expression. That said, not all of the above-mentioned collections subscribe

1 None of the terms is entirely uncontroversial, but for the purpose of my argument I will preference the term "psychiatric art" to indicate its "origin," i.e. the art production which took place in the mental asylums of the late nineteenth and twentieth centuries, and which formed the basis of the collections discussed in this article. For a definition or description of "outsider art" see Roger Cardinal, *Outsider Art* (London: Studio Vista, 1972). "Raw art," the English translation of Jean Dubuffet's "Art Brut," is, for example, discussed by Colin Rhodes in his study *Outsider Art: Spontaneous Alternatives* (New York: Thames & Hudson, 2000). See also Alexander Wilson for a critique of the terms Outsider Art and Raw Art, which he suggests are outdated, since in today's world the politics of binary oppositions and absolutes has become obsolete ("Pragmatics of Raw Art (For the Post-Autonomy Paradigm)," in *Deleuze and the Schizoanalysis of Visual Art*, eds. Ian Buchanan and Lorna Collins (London: Bloomsbury Publishing, 2014), 57–76).

2 Founded by Colin Rhodes, STOARC (Self-Taught and Outsider Art Research Collection) at the Sydney College of the Arts, the University of Sydney, is an Australian example of an outsider art collection or more precisely a research and study centre into outsider art.

to such a reading. In this chapter, I will investigate the question of how these collections of art by psychiatric institutions pertain to or indeed deconstruct a medical knowledge. While arising out of a psychiatric framework, do they resist psychiatric inquiry, and if so, can they be "read" otherwise, i.e. aesthetically, sociologically, politically, or for that matter, psychoanalytically?

As Derrida suggests in *Archive Fever. A Freudian Impression*,[3] every discipline needs to answer to the question of its foundation, its "archive." A collection or a museum, I would argue, can function as such an archive. It establishes order, sense, and narrative by placing the material in a particular space and a particular epistemic context. Derrida speaks in reference to the archive or collection of the *consignatio*, the consignation, or the gathering together of signs. The aim of such a gathering is to "coordinate a single corpus, in a system or a synchrony in which all the elements articulate the unity of an ideal configuration."[4] This kind of ordered externalisation or ideal allows the archivist to function as *archon*, as the one who becomes the bearer of the law. The psychiatric art collection therefore attempts to formulate a very specific relation between its exhibits and psychiatry as a system and practice of medical knowledge. The artwork on one hand attests to a clinical knowledge which grounds psychiatry as a discipline. These art collections are in many cases maintained and housed in parts of the respective psychiatric institutions which originally assembled them, and they are, for example, in Het Dolhuys, the Museum Ovartaci,[5] and the Museum Dr. Guislain juxtaposed to collections of medical instruments and the general history of psychiatry and/or the particular institution. Such complementary collections—here the artworks of patients, there the medical instruments and medical texts of the past centuries—display a drift in the foundational narrative of psychiatry. The artworks—although selected, framed, and staged—speak of a "force," or as the German psychiatrist and art historian Prinzhorn might have said, a "psychic" and "artistic force," which seem unadulterated by medical practice. The medical displays of historic clinical methods in contrast attest to the impasse or failure of psychiatric understanding and treatments. The former director of the psychiatric centre and current chairman of the Museum Dr. Guislain, Bro. René Stockman, Superior General of the Brothers of Charity, noted:

3 Jacques Derrida, *Archive Fever. A Freudian Impression*, trans. Eric Prenowitz (Chicago and London: University of Chicago Press, 1996).

4 Derrida, *Archive Fever*, 3.

5 Until recently the Museum Ovartaci was housed in a historic building of the psychiatric hospital in Risskov. Due to the relocation of the psychiatry of Aarhus University Hospital, the Museum Ovartaci moved from Risskov to its current location in Katrinebjergvej 81, Aarhus.

Psychiatrists, psychiatric nurses, and welfare workers do not like to look back on their work, or rather on the way it was done in the past, because of the many and sometimes painful mistakes that were made. Their past seems to haunt them. That is a perfectly understandable defensive reflex. However, due to those constant efforts to conceal the past, the past itself has become somewhat of a taboo. [...] The history of mental healthcare is full of despair, malpractice, and even unfounded euphoria. [...] In practice, people have dealt with the history of psychiatry by simply keeping it quiet and boasting triumphantly about the present state of affairs. "Luckily, everything is different and better today!" is a phrase that is full of exaggerated optimism about the progress that has been made, and which conceals the problems that still exist.[6]

The patients' works of art seem to be able to escape the dilemma the exhibition of historical instruments and displays of outdated practices faces by evoking an immediacy. Something here is coming to the fore which seems to be produced by an unregulated, cogent creative force. It appears as if the artist-patient is compelled to express him or herself in this very specific, unique way.[7] This expression is not tied to a past clinical practice, which from our current perspective can only be seen as inadequate. The artwork bypasses or evades the psychiatric approach of the day. It survives because it is outside of the historiographical narrative of psychiatry. These art collections, or better their collectors and curators, point to a hesitation or ambivalence in reference to the foundational paradigms of psychiatry.

When tracing the term *arkhē*, Derrida distinguishes between *commencement* and *commandment*. The principle of commencement refers to a physical,

6 The commentary by Stockman was published on the Museum's website in 2012. http://
 www.museumdrguislain.be/index.php?option=com_content&view=article&id=164%3A
 een-geschiedenis-in-beelden&catid=8%3Aover&Itemid=58&lang=en, accessed 1 September
 2012.

 However, with changes to the website, the comment is now abridged. See http://www.muse-
 umdrguislain.be/en/tentoonstellingen/Details/9094/the-history-of-psychiatry, accessed 6
 December 2018. See also Patrick Allegaert and Annemie Cailliau, "A History in Images. The
 Twintieth [sic] Anniversary of the Dr. Guislain Museum," 1–8. http://online.ibc.regione.
 emilia-romagna.it/I/libri/pdf/psichiatria/allegaert_1par.pdf, accessed 6 December 2018.

7 Eric Cunningham Dax suggested that the creative productions had a foremost therapeutic
 effect for psychiatric patients. They provided emotional relief, but they were also used to
 inform the treating psychiatrist about the condition of the patient. When Cunningham Dax
 discovered that these paintings and drawings were thrown out after they had served their
 therapeutic service, he over two weeks somewhat haphazardly "examined many thousands
 of pictures, and chose about three thousand" (Eric Cunningham Dax, *The Cunningham Dax
 Collection. Selected Works of Psychiatric Art* (Melbourne: Melbourne University Press, 1998), 3).

historical, or ontological beginning, the principle of commandment to law and the lawgiver, divine or human authority. The *arkhē* of commencement can again be further divided, commencement according to nature or *physis*, and commencement according to history, i.e. *thesis, tekhnē*, and *nomos*.[8] The *arkhē* or the archive of psychiatry might then be understood as an *arkhē* of commencement; the exhibition of psychiatric instruments and texts points to the medical/technical history of psychiatry. The collection of artworks, on the other hand, attests to nature or *physis*, something which potentially escapes the impasses and failures of psychiatry's history. The artwork as physical object or material is—as suggested before—tied to the "body" of the patient. Here, the "author" is not "dead"; his or her lived experience of psychosis is evoked again and again—whenever the work of art is exhibited. Making this link between the creative production and its creator explicit, and to elevate the anonymous patient from the asylum to the rank of an artist can be attributed to the two "founding fathers" of the psychiatric art movement, Walter Morgenthaler and Hans Prinzhorn. One might say, this is a "Patient's Turn" *avant la lettre* since the voiceless are given a voice, or at least an artistic stage.[9]

In the following discussion, I investigate how these artworks have been understood initially, and how they were framed in terms of psychiatric epistemology, by focusing on the two seminal texts by Morgenthaler and Prinzhorn respectively. The Swiss psychiatrist and psychotherapist Walter Morgenthaler published his monograph on the Waldau patient and artist Adolf Wölfli in 1921 (*Ein Geisteskranker als Künstler. Adolf Wölfli*)[10] one year before the today more widely known work of Hans Prinzhorn (*Bildnerei der Geisteskranken. Ein Beitrag zur Psychologie und Psychopathologie der Gestaltung*, 1922) came out.[11] Morgenthaler, who trained with Eugen Bleuler at the Burghölzli hospital

8 Derrida, *Archive Fever*, 1.

9 In 1985, Roy Porter had published his seminal article, "The Patient's View: Doing Medical History from Below" (*Theory and Society* 14, no. 2 (1985): 175–198), in which he suggests that medical history needs to take account of the role or the narrative of the sufferer or patient. This "Patient's Turn" fuelled by the critique of psychiatric practice or "malpractice" prevalent since the 1960s has informed many historians of psychiatry; see here Alexandra Bacopoulos-Viau and Aude Fauvel's, "The Patient's Turn: Roy Porter and Psychiatry's Tales, Thirty Years on," *Medical History* 60, no. 1 (2016): 1–18.

10 Walter Morgenthaler, *Ein Geisteskranker als Künstler. Adolf Wölfli* (Wien and Berlin: Medusa Verlag, 1985 [1921]); translated into English by Aaron H. Esman in collaboration with Elka Spoerri as *Madness and Art. The Life and Works of Adolf Wölfli* (Lincoln: University of Nebraska Press, 1992).

11 Hans Prinzhorn, *Bildnerei der Geisteskranken. Ein Beitrag zur Psychologie und Psychopathologie der Gestaltung* (Wien and New York: Springer-Verlag, 1994 [1922]); translated as *Artistry of the Mentally Ill: A Contribution to the Psychology and Psychopathology of Configuration*, trans. Eric von Brockdorff, intro. James L. Foy (New York: Springer-Verlag, 1972).

in Zurich and who also attended Sigmund Freud's seminars in the winter of 1906–07, worked as a psychiatrist at the Waldau Psychiatric Hospital near Bern from 1913 to 1920.[12] The artist Adolf Wölfli, born in 1864, convicted for a string of sexual offences and diagnosed as paranoid-schizophrenic, had been a patient in the Waldau hospital since 1895. In 1899 he started composing, drawing, and writing prose and poetry, working prolifically, and increasingly retreating from any other occupation and any contact with other patients. Morgenthaler encouraged Wölfli's art production, ensuring the provision of material and controlling the distribution or sale of Wölfli's work.[13] Morgenthaler formulates two aims of his detailed study of Wölfli as an artist: firstly, to critically assess and contextualise psychiatric material and make it accessible for other scientific disciplines; and secondly, to uncover structures of the psyche which remain hidden in the mentally healthy.[14] The structures visible in Wölfli, his "otherness" and peculiarity, Morgenthaler suggests, engender his artistry, and while similar structures might be motivating other (mentally healthy) artists as well, they cannot easily be detected in them or in their work. For Morgenthaler there are four aspects in the production of art by Wölfli which require closer examination. The first aspect or phase which destroys the remnants of the old personality, he calls the "chaos"—the catastrophe of the psychotic break, in which the patient suffers from confusion and a reduction of intellectual and affective functioning. In a second phase, the "formation," the patient yearns for order and structure, a way of being able to ground himself or herself again. The third aspect important for the production of art is the material itself, i.e. the psychic material which is developed according to the particular iconography of the patient. Morgenthaler merits Freud and his analysis of the Schreber case with developing the interpretative tools to understand how unconscious psychical material is translated into writing or visual art.[15] However, the dis-

12 Only parts of the rather extensive Collection Walter Morgenthaler are today exhibited within the small psychiatric museum at the Waldau hospital.

13 See here the very detailed analysis of Martina Wernli who investigated the various documents relating to the interaction of Morgenthaler and his patient Wölfli in *Schreiben am Rand. Die "Bernische kantonale Irrenanstalt Waldau" und ihre Narrative (1895–1936)* (Bielefeld: transcript, 2014), esp. 58–67.

14 Morgenthaler, *Ein Geisteskranker als Künstler*, vii.

15 See Sigmund Freud's case analysis based on Daniel Paul Schreber's memoir *Denkwürdigkeiten eines Nervenkranken, nebst Nachträgen und einem Anhang über die Frage: "Unter welchen Voraussetzungen darf eine für geisteskrank erachtete Person gegen ihren erklärten Willen in einer Heilanstalt festgehalten werden?"* (Leipzig: Mutze, 1903), in "Psychoanalytische Bemerkungen über einen autobiographisch beschriebenen Fall von Paranoia (Dementia paranoides)," in *Gesammelte Werke. Werke aus den Jahren 1909–1913*, vol. VIII, ed. Anna Freud et al. (Frankfurt/M: Fischer Taschenbuch Verlag, 1999 [1911]), 237–320.

FIGURE 12.1 Adolf Wölfli, "Allmacht=Rohr," 1,868, 1918. From: Hefte mit Liedern und
Tänzen, Heft 15, 2635. Pencil, coloured pencil and collage on newspaper, 100,6
x 70 / 71,2 cm, A 9294–153 (XV/p.2635)
©COURTESY OF ADOLF WÖLFLI-STIFTUNG, KUNSTMUSEUM BERN

tinguishing aspect of art in general, and of Wölfli's art in particular, is form.
Wölfli's art, according to Morgenthaler, on the one hand combines excess, lim-
itlessness, exaggeration, and destruction of natural forms—a process which

evokes the mystical or the daemonic—with on the other hand normativity, order, and objectivity which at times morph into formalisation and inertia.

Morgenthaler follows Wilhelm Worringer's categorisation[16] when he deems Wölfli's art to be primitive in the sense that it does not concern itself with perspective, or the correct alignment of objects in space and time, or even the distinction between the various forms of expression, i.e. visual, linguistic, or acoustic/musical. Wölfli's art is motivated and driven by rhythm and ornament, a geometrical style, a style which Worringer sees as represented most convincingly in medieval or Gothic art. Wölfli's concern with ornament and patterns attest to his particular attunement to space—Morgenthaler speaks of an "instinct for space"[17]—which allows Wölfli to assemble integrative and harmonic compositions.[18] In assessing Wölfli's ability for ordered or rhythmic compositions, Morgenthaler draws on the work of the experimental psychologist Hermann Ebbinghaus[19] and his notion of "objectivity functions."[20] These functions supposedly enable the individual to order and regulate the psychical content in space and time, in line with considerations of sameness, similarity, difference, unity, and multiplicity, rhythm and number, motion, and change.[21] Art is consequently not produced and defined by the force or the strength of the instinctual drive, but by the artist's abilities in the field of "objectivity functions," meaning their ability to bind and artistically exploit that instinctual drive. For Morgenthaler, Wölfli can be considered an artist because he is able to utilise these "objectivity functions" in structuring and visualising his delusional chaotic perception of the world, in a similar way as a medieval artist would have responded to the at times overwhelming and incomprehensible world of the Middle Ages, i.e. with order, structure, geometrical patterning, and mathematics. Eugen Bleuler, in his study on schizophrenia, makes a similar observation when he suggests that the cognitive processes of the schizophrenic can be compared to those of the medieval man.[22] Morgenthaler's analysis of Wölfli's work therefore attempts to identify the basic or foundational elements of artistic creativity, laid bare through the destruction of logical functioning, and the

16 See here in particular Wilhelm Worringer's doctoral dissertation completed at Bern University in 1907, *Abstraktion und Einfühlung. Ein Beitrag zur Stilpsychologie* (München: Piper, 1908); and *Formprobleme der Gotik* (München: Piper, 1911).

17 Morgenthaler, *Ein Geisteskranker als Künstler*, 79.

18 Morgenthaler, *Ein Geisteskranker als Künstler*, 82.

19 Hermann Ebbinghaus, *Grundzüge der Psychologie* (Leipzig: Veit & Comp., 1905).

20 Morgenthaler, *Ein Geisteskranker als Künstler*, 83.

21 Morgenthaler, *Ein Geisteskranker als Künstler*, 86.

22 Eugen Bleuler, *Dementia Praecox oder Gruppe der Schizophrenien* (Leipzig and Wien: Deuticke, 1911), 355, FN. See also Morgenthaler, *Ein Geisteskranker als Künstler*, 89, FN.

lack of inhibition and cognitive control. This process of dissection reveals the anatomy or the structure of the psychical processes. Morgenthaler compares the artist and for that matter Wölfli to the crystal, i.e. a form which pertains at least in the art theory of the time[23] to both a mystical and mathematical understanding of nature; a pure, untainted reflection or even a concentration or condensation of natural forces.

One year after the publication of Morgenthaler's work on Wölfli, Hans Prinzhorn published his book *Die Bildnerei der Geisteskranken. Ein Beitrag zur Psychologie und Psychopathologie der Gestaltung*. Here, Prinzhorn references the artworks by psychiatric patients which had been collected from a number of psychiatric hospitals within Germany and abroad. Prinzhorn's collection expanded on the initial collection of Emil Kraepelin, former director of the Heidelberg psychiatric hospital, and on the one by the then director of the clinic Karl Wilmanns. Prinzhorn was able to assemble a collection of approximately 5000 objects, which included drawings, paintings, sculptures, notebooks, and textiles. His accompanying study is divided into a theoretical part concerned with the psychological mechanisms of artistry, and an analysis of the work of ten artists from the collection, all diagnosed with schizophrenia, including Karl Brendel (now known as Genzel), Peter Moog (Meyer) and August Neter (Natterer).[24] Prinzhorn takes a very similar point of departure as Morgenthaler, alluding to the schizophrenic mood of modernity and the correspondences between the artworks and the sentiment of the time.[25] He, like Morgenthaler, points to a hesitation, neither wanting to catalogue the works of art in a scientifically descriptive manner, nor wanting to resort to a metaphysical conceptualisation of artistic creativity. This inability to formulate a discipline-based method or approach seems indicative of the difficulty in this crossover area between art and psychiatry. Prinzhorn tries to avoid this pitfall by not clearly identifying the productions of psychiatric patients as art. He resorts to the term "artistry," *Bildnerei*, which in German also evokes the idea of formation (*Bildung*), as well as picture or image (*Bild*). He sees the production of art by patients as a form of expression of something unique, something psy-

23 Crystalline forms feature prominently in literature, art, and architecture at the time, from Bruno Taut's architectural designs, Walter Gropius's theories, Wenzel Hablik's drawings and Paul Scheerbart's novels. For an in-depth discussion of the crystalline form see Danielle Coronel, *Walter Burley Griffin—Philosophy and Design Themes: Correspondences to Early Modern German Aesthetic Theory, Art and Architecture* (PhD thesis, Monash University, 2017), esp. chap. 2, IV, https://doi.org/10.4225/03/599bb810288dd.

24 Prinzhorn disguised the artists' identities by giving them pseudonyms.

25 See Morgenthaler, *Ein Geisteskranker als Künstler*, 89, FN; and Prinzhorn, *Bildnerei der Geisteskranken*, 345–349, on this point.

chical, where the "intellectual" apparatus is not activated. For Prinzhorn, the only function of such expression of psychical content in general is to establish an immediate link between the "I" and the "you,"[26] between the subject and the world around them. Prinzhorn's reference point here is the psychology of expression by the philosopher and psychologist Ludwig Klages,[27] who tried to conceptualise a delineation between the "expressive function" and the "representative function," which in turn informed his theory of graphology. Like Morgenthaler, Prinzhorn evokes the idea of primitivism, or primitive forms of expression, which for Prinzhorn include the tendency to symbolise rather than to rationalise.[28]

However, when the approach to the world and to reality is affective rather than objective, Prinzhorn sees something coming to the fore which he calls "*das Unheimliche*," the uncanny. "*Unheimlich*," or uncanny, is for Prinzhorn the key concept in his investigation of the artistry of psychotic patients.[29] It indicates an excess, the excess of the psychotic experience, which makes it impossible to fully grasp or understand the content of an image by the (non-psychotic) viewer; a strangeness or otherness which Morgenthaler had already highlighted. Freud had published his seminal article on the topic of the uncanny two years earlier in 1919,[30] suggesting that the German word "*unheimlich*" is both the antonym and the synonym of "*heimlich*," i.e. homely versus secretive. Freud therefore concludes that the uncanny points to something which is at the same time both strange and intimately known. The uncanny is the disguise for that which had to be repressed, i.e. castration. Prinzhorn charges some of the artists to intentionally obscure understanding by shrouding the object in secrecy, by imbuing the artworks with a mysterious or mystical meaning. But at the same time, he also deems uncanniness the only marker in the estimation of schizophrenic art or artistry. The artistry of the mentally ill can, according to Prinzhorn, never be decidedly and convincingly distinguished from any other art or artistry, i.e. the scribbling of children, the art of so-called primitive cultures, or the art of earlier historical periods, apart from the experience of the uncanny; a feeling which arises in the viewer when confronted with

26 Prinzhorn, *Bildnerei der Geisteskranken*, 17.

27 See Ludwig Klages, *Ausdrucksbewegung und Gestaltungskraft* (Leipzig and Berlin: W. Engelmann, 1913); and *Handschrift und Charakter. Gemeinverständlicher Abriß der graphologischen Technik* (Leipzig: J.A. Barth, 1917).

28 Prinzhorn, *Bildnerei der Geisteskranken*, 19–21.

29 Prinzhorn, *Bildnerei der Geisteskranken*, e.g. 306, 337, 340.

30 Sigmund Freud, "Das Unheimliche," in *Gesammelte Werke*, vol. XII, ed. Anna Freud et al. (Frankfurt/M: Fischer Taschenbuch Verlag, 1999), 225–268, was first published in 1919 in *Imago*, vol. V.

schizophrenic art. Though this uncanniness does not originate in the moment of reception but has already been experienced by the artist in his or her psychotic break. The absolute and inescapable alienation from the world or reality is translated into the work of art by the artists themselves and only refracted by the viewer. Prinzhorn arrives here at a similar point as Morgenthaler. Whereas Morgenthaler compared the revelation of a psychical force in schizophrenic art to the crystal, Prinzhorn evokes the idea of a prototype or archetype of the formation process, an *"Urform,"*[31] the psychotic artist is invested in. The uncanny for Prinzhorn, not unlike Freud's uncanny, arises when the work of art points to the direction of myth, of mythical or magical thinking. It appears as a kind of mystical knowledge, which Prinzhorn attributes, again not unlike Freud in *Totem and Taboo*,[32] to a pre-civilised, archaic state.[33] The mechanisms of repression, which develop in the process of civilisation and which veil this mystical thinking, are not yet apparent in the imaginations of the psychotic, or in psychotic art productions for that matter.

Prinzhorn assumes that psychiatric knowledge is insufficient in understanding these artworks, but that either psychoanalysis or ethno-psychology might be better suited to shed light on the problem of symbolisation and magical thinking.[34] He concludes his study with a question which remains for him unanswered, namely how signs, symbols, and images originate and develop, and how this process, hidden in normal psychology, is brought to light in mental disorder. Morgenthaler had arrived at a similar conclusion although he afforded psychoanalysis with the interpretative means to read or decipher the psychotic symbolism. For both Prinzhorn and Morgenthaler, psychiatry is not the discipline which is able to "understand" psychiatric images, since its reductionist approach can only focus on deviation and pathology, and not on creativity as a force shared by the mentally ill and the mentally healthy. Why then is the medical or psychiatric gaze trained on them, why do these collections continue to be exhibited by psychiatric museums often alongside historical exhibits?

Returning to my initial considerations of the archival function of psychiatric art collections and adding Prinzhorn's and Morgenthaler's evocation of psychoanalysis as a tool in understanding those artworks, I would like to suggest that these collections mark a slippage, i.e. the need for an "interpretation"

31 Prinzhorn, *Die Bildnerei der Geisteskranken*, 306.
32 Sigmund Freud, *Totem und Tabu*, in *Gesammelte Werke*, vol. IX, ed. Anna Freud et al. (Frankfurt/M: Fischer Taschenbuch Verlag, 1999 [1913]).
33 Prinzhorn, *Die Bildnerei der Geisteskranken*, 348.
34 Prinzhorn, *Die Bildnerei der Geisteskranken*, 304.

FIGURE 12.2 August Natterer, "Hexenkopf," 1913-1917. Collage, pencil,
water colours, ink, 25,9 x 34,2 cm. (Inv. Nr. 184).
Night view (above) and day view (below)
©UNIVERSITÄTSKLINIKUM HEIDELBERG, SAMMLUNG
PRINZHORN

which goes beyond psychiatric diagnosis or purely aesthetic appreciation. If
this art reveals the underlying, possibly unconscious structure which sets in
motion a process of symbolisation, an attempt to attribute signs and images
to the experience of complete alienation, or the loss of world, then one might
ask the question in regard to the logic of such a structure and such a process.
While psychiatry remains descriptive here, psychoanalysis might, as Prinzhorn
and Morgenthaler suggested, be able to offer an understanding of structure

which allows for the "reading" of psychotic art. Jacques Lacan suggested with Freud that the problem of psychotic structure is not so much one of disavowal and repression but one of foreclosure,[35] i.e. it is the foreclosure of the Oedipus, or the refusal to acknowledge castration as threat.[36] Lacan translates this into the realm of language by suggesting that the "paternal metaphor" or the master signifier which enables language to function and thereby the world to be (socially) accessed is foreclosed. The structural solipsism—or autism as Bleuler calls it[37]—of schizophrenia, or psychosis in general, responds to the loss of world by resorting to drawing everything into the process of making new meaning, imbuing or hyper-cathecting every object, every word, every visual sign, with an excess of "meaning," albeit a private or secret meaning, something only the psychotic patient has—supposedly—full access to. Word and object, symbol and thing, become indistinguishable, become immovable by the rigid prosthetic language or symbolisation processes of psychosis. The rhythmic, patterned, or metonymic effects of such psychotic art as Morgenthaler and Prinzhorn have described them, speak of the structural fixity. What then might be created in this art is a cosmic vision, a new universality, albeit psychotic, which constructs a counter-narrative to the one based on disavowal and repression. Prinzhorn's uncanny is not then the recognition of that which has been repressed and is now returning, as it were, but something to which repression has never applied, a spectre of what Lacan called the "Real." This translates into a psychotic logic with radically different symbolisation processes than the ones found in non-psychotic art. Reading the productions following the experience of absolute alienation or the catastrophe of the psychotic break in terms of a logic to be interpreted rather than an aberration might make it possible to go beyond the anxious pleasure with which we encounter these "uncanny" artworks.[38]

Returning to the art collections as they present themselves today, I would suggest that in particular the Prinzhorn Collection but also the Museum Ovartaci attempt to engage with the exhibits not only at the level of aesthetics, but

35 See Jacques Lacan, *Les séminaire de Jacques Lacan, Livre III, Les psychoses* (1955–1956), ed. Jacques-Alain Miller (Paris: Editions de Seuil, 1981).

36 See here too Sigmund Freud, "Neurose und Psychose," in *Gesammelte Werke*, vol. XIII, ed. Anna Freud et al. (Frankfurt/M: Fischer Taschenbuch Verlag, 1999), 385–391, here 390.

37 Eugen Bleuler, "Das autistische Denken," in *Jahrbuch für psychoanalytische und psycho-pathologische Forschungen* 5, no. 1, eds. Sigmund Freud and Eugen Bleuler (Leipzig and Wien: Franz Deuticke, 1912), 1–39.

38 For a psychoanalytic reading of psychotic logic see Christiane Weller, "Adolf Wölfli," in *Praktizierte Intermedialität. Deutsch-französische Porträts von Schiller bis Goscinny/Uderzo*, eds. Fernand Hörner, Harald Neumeyer and Bernd Stiegler (Berlin: transcript, 2010), 53–67.

at the same time as specific psychotic narratives or narratives of illness which can reveal something more than just the general feeling of uncanniness experienced in the psychotic break, and now viewed and "enjoyed" by the visitor to the exhibition. They do at times resort to psychoanalytic paradigms. Most notably the exhibition catalogues for the Prinzhorn Collection are meticulous in their estimation of the artworks. They extensively draw on psychiatric case notes, letters, and diaries of former patients and they do not shy away from an interpretation of these artworks. This approach suggests that ignoring the psychiatric context and the psychic mechanisms and simply resorting to labels like Outsider Art would undermine the value and uniqueness of these collections.[39] The Museum Ovartaci, while insisting on a psychiatric framing juxtaposing the art collection with the historiographical psychiatric collection, allows the visitor where possible to approach these works of art in context, by providing extensive material, consisting mostly of interviews and autobiographical or autofictional writing by the various artists. This includes extensive conversations with the collection's most prominent artist Louis Marcussen, or Ovartaci as he called himself, and his report on his visions and thoughts in reference to his artworks have been recorded and are available in book form. Here it seems the artist-patient is granted space to develop or explore his or her particular logic.[40]

At the other end of the spectrum are Het Dolhuys in Haarlem and the new Outsider Art Museum in the Hermitage, which emphasise the idea of identification. The viewer here is invited to empathise and identify with the exhibits and their creators and possibly explore one's own mental disposition in reference to the lived experience of the artists. The term Outsider Art, as the director of Het Dolhuys Hans Looijen writes, is used here "proudly," because it separates the art from "psychiatric diagnoses or conditions."[41]

In conclusion then, what kind of archive is the psychiatric art collection? In reference to the development of modern art, the psychiatric art collection has served as an instigator and model,[42] disrupting the neat categorisation of cultural, academic and non-academic, outsider or raw art. In reference to

39 On the question of terminology and categorisations, see Thomas Röske, "Wahnsinn sammeln/Collecting Madness," in *Wahnsinn sammeln: Outsider Art aus der Sammlung Dammann/Collecting Madness: Outsider Art from the Dammann Collection*, eds. Thomas Röske, Bettina Brand-Claussen and Gerhard Dammann (Heidelberg: Wunderhorn, 2006 [exhibition catalogue]), 10–21.

40 Johannes Nielsen, *Ovartaci. Pictures, Thoughts and Visions of an Artist* (Ovartaci Fonden: Risskov, 2005).

41 Hans Looijen, "Outsider Art. The Inner Voice in Art," in *Outsider Art Museum: 2016 Catalogue*, ed. Hans Looijen (Amsterdam: Outsider Art Museum, 2016), 11–17, here 12.

psychoanalysis, one might say, the collection of psychiatric art produces a (psychotic) corpus, psychoanalysis might "hear," not unlike the words coming from the couch. However, in reference to psychiatry then, one might say, while these art collections are historically, conceptually, and often spatially tied to psychiatry, they have become its subversive counter-narrative. They continue to unsettle psychiatry by inserting a body of work and by extension the body of the patient-artist into the narrow parameters of clinical practice. The art collection of psychotic art refuses the role of being an archive for psychiatry, since it assembles objects, material, or *psychis* that psychiatry often cannot and possibly does not want to elaborate on. On the other hand, psychiatry deserves credit for allowing these collections to continually unsettle and equivocate any discipline-based knowledge and to continue to unnerve the medical gaze.

42 The works of Wölfli and the Prinzhorn artists inspired Expressionists and Surrealists, including Paul Klee, Max Ernst, André Breton, and Jean Dubuffet. See in this context Herwig Guratzsch, ed., *Expressionismus und Wahnsinn* (München: Prestel, 2003 [exhibition catalogue]), and Thomas Röske and Ingrid von Beyme, eds., *Surrealismus und Wahnsinn/Surrealism and Madness* (Heidelberg: Wunderhorn, 2009 [exhibition catalogue]). Prinzhorn's study itself has been read as a "manifesto" for both expressionism and surrealism; see, for example, Bettina Brand-Claussen, "Prinzhorns *Bildnerei der Geisteskranken.* Ein spätexpressionistisches Manifest," in *Vision und Revision einer Entdeckung* (Heidelberg: Sammlung Prinzhorn, 2003 [exhibition catalogue]), 11–31. For a discussion on the artistic influences and commercial proliferation of psychiatric art and/or Outsider Art see Christiane Weller, "Die Avantgarde in der Heilanstalt: die Entgrenzung des Wahns und der Kunst," in *Kulturrebellen — Studien zur anarchistischen Moderne*, eds. Christine Magerski and David Roberts (Wiesbaden: Springer VS, 2019), 99–115.

Biomedia in the Flesh: Imagining Biomedical Interventions as Horror

Barry Murnane

Dominick Mitchell's 2013 BBC series *In the Flesh* is a post-zombie apocalypse drama set in the isolated village of Roarton in Lancashire, England.[1] The series depicts life after "The Pale Wars" when armed militias of the living waged war with thousands of deceased who were reanimated as rabid undead in what was known as "The Rising." The series focuses on a young character called Kieren Walker, who has been treated with a new medication called Neurotriptyline which kick-starts neurochemical production and hence begins to artificially regenerate the ability of the undead to think rationally and control their murderous urges. Having regained consciousness, Kieren and the other undead are placed back in their communities and left to re-integrate. While there are many stories developed in Mitchell's drama—such as Kieren's homosexuality, depression, and mental illness, questions of war trauma and guilt, and finally neoliberal privatisation and biopolitical normalisation—a key premise of the series is its representation of contemporary medical culture's own uncanny structures.

This chapter examines *In the Flesh* to argue that the series develops a horrifying scenario of biomedical interventions, deploying the figure of the zombie to address concerns relating to contemporary discourses of the posthuman, biotechnological imaginings, and the importance of media—including visual media—to these processes. I will suggest that the zombies of *In the Flesh* are representative of the generation of the undead in contemporary medicine and that the series offers an interrogation of the biomedical and biotechnical interventions on bodies that enable medical research and advancement. They therefore appear as figures through which the ambiguities of medical

1 *In the Flesh. Series One and Two.* Dir. Jonny Campbell, Jim O'Hanlon, Damon Thomas and Alice Troughton. Created by Dominick Mitchell. BBC 2014. DVD. All further references are to this version and will appear in the main body of the essay with series and episode number with relevant time stamps, e.g. here S1, E2.

science's "Remaking of Life and Death" (in the words of Franklin and Lock[2]) are developed. What emerges in this series is an unsettling, slippery slope from life to death in contemporary biomedicine spanning such practices as regenerative medicine and neuropharmacology. The cultural work carried out by the Gothic in relation to contemporary medicine thus revolves around teasing out the uncanny structures within biomedical discourse itself as sources of anxiety and horror, placing them within a discourse of biopolitical normalisation. Following an introduction to Mitchell's construction of the biomedical body as uncanny (1), the chapter will discuss the biopolitical and theoretical contexts for these images in a discussion of media and imaging technologies in biotechnological medicine and posthumanism (2). Finally, it will be argued that the fictional bodies and their stories in *In the Flesh* open up to scrutiny the epistemological function of medical and imaging technologies in biomedicine more generally (3).

1 The Construction of the Biomedical Body as Uncanny

In the Flesh seems to slot neatly into a contemporary entertainment landscape that reveals an increasing prevalence of broadly Gothic narratives. From more underground dystopian fiction and horror movies to mainstream television and Hollywood productions drawing on established tropes such as vampirism, monstrosity, spectrality, and the supernatural, the Gothic has become middlebrow.[3] Initially less prominent than the vampire, the zombie has become a staple component of this newfound popularity of the Gothic in global cultural production. From their ethnological origins in the Caribbean, where they emerged as products of colonial and postcolonial racial and technocratic power structures,[4] the zombie has become one of the monsters of choice in representing Western constructions of selfhood and alterity.[5] Films such as Victor Halperin's *I Walked with a Zombie* (1932) deployed the original Caribbean location as a heterotopic site for representing questions of race and

2 See Sarah Franklin and Margaret Lock, eds., *Remaking Life & Death. Toward an Anthropology of the Biosciences* (Santa Fe and Oxford: School of American Research Press and James Curry, 2003), *passim*.

3 Catherine Spooner, *Post-Millennial Gothic. Comedy, Romance and the Rise of Happy Gothic* (London: Bloomsbury, 2017).

4 Susan Sontag, "The Imagination of Disaster," In *Film Theory and Criticism*, eds. Gerald Mast and Marshall Cohen (Oxford: Oxford University Press, 1974), 422–437.

5 Roger Luckhurst, *Zombies. A Cultural History* (London: Reaktion Books, 2015).

sexuality, but ever since George Romero's *Dawn of the Dead* the zombie has figured within apocalyptic narratives as the embodiment of the casualties of capital, representative of the mindless consumerism of the West.[6]

More recently, novels like Max Brooks's *World War Z* (and its blockbuster film adaptation) and cross-genre "franchises" such as *Resident Evil* or *The Walking Dead* have established the zombie as a mainstream figure in the Gothic's engagement with late-capitalism and neoliberalism, frequently within an infection and apocalypse narrative (the first film in the *Resident Evil* series starts with an infective agent produced by the shady pharmaceutical concern, the Umbrella Corporation, for example). Typically lumbering, shambolic, non-verbal creatures reduced to a basic desire for flesh that is best fulfilled by hunting in animalistic packs, the zombie appears somehow sub-human, its lack of cognitive powers speaking to a monstrosity that while once human has become post/past-human. While recent versions of the zombie such as those in *World War Z* have mysteriously speeded up and begun to develop some form of swarm intelligence, the narrative of a zombie apocalypse remains standard. This is where *In the Flesh* differs: beginning *after* the apocalyptic event itself, Mitchell's series unfolds a medical narrative which enables us to see the zombie not purely as somatic mess, but rather also in possession of consciousness and subjectivity. As such, the series focuses less on the shock moment of the zombies and more on the social, cultural, and political narratives being told around them, offering an examination of the complications of survival for the living and the once-dead posthuman subjects. The economic and social framework of biomedicine in particular are of central importance to Mitchell's zombie narrative.

The opening sequences of *In the Flesh* make it clear that the series emerges from a medical context and that its zombies are medicalised undead.[7] After a zombie attack sequence that is quickly revealed to be Kieren's memories of his zombie violence presented as flashbacks, the viewer is introduced to him as he approaches the end of his rehabilitation in the compound of Halperin & Weston in Norfolk, a public-private biotech and pharmaceutical partnership named after the inventors of Neurotriptyline (and wittily enough, the director of *I walked with a Zombie*). In a sudden cut, the viewer is catapulted from the flashback to a scene featuring Kieren talking to his doctor about traumatic

6 Fred Botting, "Globalzombie: From *White Zombie* to *World War Z*," in *Globalgothic*, ed. Glennis Byron (Manchester: Manchester University Press, 2013), 188–201; Steve Shaviro, "Capitalist Monsters," *Historical Materialism* 10, no. 4 (2002): 281–290.

7 Medicalisation refers to a process of social control in which medical authority is expanded into domains of everyday existence. See, for example, Deborah Lupton, "Foucault and the Medicalization Critique," in *Foucault, Health and Medicine*, eds. Alan Petersen and Robin Bunton (London and New York: Routledge, 1997), 94–110.

visions he has been experiencing, Doctor Sheppard tells him that the visions are actually a good sign, proving that the treatment with Neurotriptyline is taking effect: "Your brain is responding, repairing, that's a positive."[8] In a flyer subsequently distributed to the local health care provider in Roarton we learn that the medication "helps with balancing the chemicals in the brain". It does much more than this, however: it re-balances and kick-starts the neurochemical functioning of the brain stem amongst the undead, generating new brain cells and brain activity, thereby re-creating consciousness: "Neurotriptyline artificially stimulates neurogenesis of Jeel cells, cells that can't reproduce anymore. Jeel cells are vital for proper brain function."[9] In the exchange with Dr Sheppard it is precisely because Kieren doesn't "feel ready" which means he *is* almost ready: "you're feeling again," meaning that his brain and his consciousness are regenerating or recovering.[10] Death has become a matter of medical management in the series and is a matter of contingency, open to negotiation.

Kieren and the other undead like him occupy an almost inconceivable zone of liminality: as *cognisant* and *sentient* they fulfil standard criteria for being alive, but this condition is actually a product of their medicalisation. Whereas we have grown accustomed to speaking of clinical death in contemporary medical contexts, "clinically alive" seems a more apt description of the medicalised and stabilised undead here. *In the Flesh* offers a fictionalised scenario in which neurochemical adjustment and tissue engineering are deployed to stimulate cellular activity and literally produce new neuronal "life" in patients. The treatment used on Kieren and the other patients at the Halperin & Weston facility appears to be a fictionalised version of regenerative medical procedures such as neurogenesis and synaptogenesis that are being developed to treat diseases such as early-onset dementia.[11] The flashbacks are a good sign because "it

8 S1, E1, 1.53–1.58.
9 S1, E1, 27.48–27.58.
10 S1, E1, 1.38–1.44.
11 The capacity for neuronal plasticity, or brain plasticity, was already suggested by William James in *The Principles of Psychology*, vol. 1 (New York: Henry Holt, 1890), 105. From Marian Diamond's experimental proof of brain plasticity in the 1960s, researchers such as Michael Merzenich looking at recovering stroke patients, deafness, and more recently Alzheimer's have advanced this paradigm substantially. In July 2015 Eli Lilly (famous as the producers of Prozac, amongst other drugs) published findings on the successes of precisely such drugs being used to treat Alzheimer's; Solanezumab is an antibody which works to stop amyloid plaques forming between neurons and has seemingly proved effective when deployed in early stage Alzheimer's; see Sarah Knapton, "Have Scientists Found a Drug to Stop Alzheimer's Disease," *The Telegraph* (19 July 2015). http://www.telegraph.co.uk/news/science/science-news/11749641/Have-scientists-found-a-drug-to-stop-Alzheimers-disease.html, accessed 25 July 2017.

means the cognitive circuitry is reacting again, like a computer rebooting,"[12] Dr Sheppard tells Kieren. Consciousness, subjectivity, life, and death are entirely somatised in this scenario, located in the body's biological hardware and ready to be tweaked as necessary.

In the medical model of the series, the conditions of life and identity are conceptualised as being literally in the neural tissue and thus figuratively "in the flesh." It is precisely this somaticisation of cognisance and sentience which enable the troubling slippage between traditional concepts of being "alive" and "dead" at the heart of Mitchell's uncanny representation of the biomedical body. The undead and their bodies are the quintessence of the uncanny according to Sigmund Freud's terminology: they are simultaneously familiar yet strangely different forms of life,[13] recalling the fixation in Freud's essay with the monstrous double,[14] unclear states of animation such as living statues and dead bodies,[15] and with the fear-inducing alterity of his own aged body.[16] As Kieren's father says in Episode 1: "We're living in a world where real monsters exist."[17]

2 Media and Imaging Technologies in Biotechnological Medicine and Posthumanism

From life-extension techniques generating new and confusing states and definitions of living and dying to almost vampiric economies of organ and biological trade, from biotechnological modifications of human bodies to matters seemingly as innocuous as antidepressants and ADHD medication, modern biomedicine has generated a thoroughly real version of Mitchell's medical uncanny with its own categories of prosthetic and surgical monstrosity/normality.[18] Following the "Harvard Ad hoc Committee Report" in 1968, Western medicine has gone about deconstructing the definition of death,

12 S1, E1, 1.28–1.37. For a discussion of the socio-medical contexts of neurogenesis and synaptogenesis in this regard, see Victoria Pitts-Taylor, "The Plastic Brain: Neoliberalism and the Neuronal Self," *Health* 14, no. 6 (2010): 635–652.

13 Sigmund Freud, "The "Uncanny,"" in *Standard Edition. The Standard Edition of the Complete Psychological Works of Sigmund Freud*, vol. XVII, trans. James Strachey (London: Hogarth Press, 1955), 217–256, here 219.

14 Freud, "The "Uncanny,"" 234–236.

15 Freud, "The "Uncanny,"" 225–226.

16 See Freud, "The "Uncanny,"" 247.

17 S1, E1, 30.24.

18 Barry Murnane, "George Best's Dead Livers. Transplanting the Gothic into Biotechnology and Medicine," in *Technologies of the Gothic in Literature and Culture*, ed. Justin D. Edwards (New York and London: Routledge, 2015), 113–126.

thereby generating a twilight zone of so-called clinical death that enables bodies to become circulating commodities dependent on the interpretations of measuring instruments deployed in intensive care medicine.[19] This has generated what Achille Mbembe has described as a necropolitical selfhood, with subjects in ICU wards (and indeed in the unregulated back-street surgeries of the Global South) "kept alive but in a state of injury, in a phantomlike world of horrors and intense cruelty and profanity" as potential sources of organs.[20] These bodies are created or maintained as resources waiting to be converted into circulating commodities as "biocapital."[21] As part of this process, life is encoded as evidence of the capacity for cognitive consciousness, with selfhood becoming solely defined as somatic and protein-based, located in the chemistry of the brain—a clearly materialistic levelling out of the mind/body dualism that has been a central discourse of modernity since Descartes.[22] Scholars such as Melinda Cooper, Margaret Lock, Nikolas Rose, and Eugene Thacker (amongst others) have traced these developments in detail,[23] while Sara Wasson and Roger Luckhurst have developed the uncanny nature of these interventions and redefinitions.[24] As modern medicine and biotechnologies have engaged in "Remaking Life & Death,"[25] they are generat-

19 "A Definition of Irreversible Coma. Report of the Ad Hoc Committee of the Harvard Medical School to Examine the Definition of Brain Death," *Journal of the American Medical Association* 205, no. 6 (1968): 337–340. On these processes see Sarah Franklin and Margaret Lock, "Animation and Cessation. The Remaking of Life and Death," in *Remaking Life & Death*, Franklin and Lock, 3–22; and Dick Teresi, *The Undead* (New York: Vintage, 2012).

20 Achille Mbembe, "Necropolitics," trans. Libby Meintjes, *Public Culture* 15, no. 1 (2003): 11–40, here 21.

21 This is an economic term, which is meant only to emphasise the commercial dimension of organ transplants which is often concealed behind the dominant rhetoric of "donation" and the logic of the "gift"; the benefits of this form of therapy are by no means to be criticised here. On "biocapital" as a concept, see Nikolas Rose, *The Politics of Life Itself. Biomedicine, Power, and Subjectivity in the Twenty-First Century* (Princeton and Oxford: Princeton University Press, 2007), 6 and 133.

22 See Margaret Lock, "On Making Up the Good-as-Dead in a Utilitarian World," in *Remaking Life & Death*, Franklin and Lock, 165–192, here 167.

23 Melinda Cooper, *Life as Surplus. Biotechnology and Capitalism in the Neoliberal Era* (Seattle and London: University of Washington Press, 2008), 51–73; Rose, *The Politics of Life Itself*, 81 and 198–203; Lock, "On Making Up," *passim*; Eugene Thacker, *Biomedia* (Minneapolis and London: University of Minnesota Press, 2004), *passim*.

24 Sara Wasson, "A Butcher's Shop where the Meat Still Moved: Gothic Doubles, Organ Harvesting, and Human Cloning," in *Gothic Science Fiction 1980–2010*, eds. Sara Wasson and Emily Alder (Liverpool: Liverpool University Press, 2011), 73–86; Roger Luckhurst, "Biomedical Horror: The New Death and the New Undead," in *Technologies of the Gothic in Literature and Culture*, Edwards, 84–98.

25 Franklin and Lock, *Remaking Life & Death*.

ing monstrous assemblages, damaged bodies, and *actual* liminal states which demand critical scrutiny.

Any such determination of life and death is impossible without monitoring devices, meaning our concepts of corporeal functionality, the body in life and death, become mediated and constructed in the medicalised scenario. For example, the evidence to support medicine's distinction between "good" (i.e. brain death, still capable of providing living organ donation) and "bad" (i.e. complete and final decay, of no further medical use) types of death depending on its contingent criteria of functional finality is provided by precisely such means of gathering and representing data. It is only due to the development of a careful protocol of tests, which depend on rendering "information" from the body visible and measurable on screens and print-outs that the status of a body as "alive," "brain-dead," or properly "dead" is reached.[26] This dependence on a constructed process and mediatisation of the body allows us to see the body—and life itself—as a biomedical "artefact" (in the terminology of Bruno Latour) rather than as a naturally, self-explanatory object from which truth can be gleaned;[27] rather than focus on information being harvested from a body, we need to consider how a conceptualisation of the body is constructed through the methods, media, and reading of the body in this manner.[28]

A useful framework to describe the artefactual body of contemporary biomedicine is Eugene Thacker's concept of "biomedia." Thacker discusses how emerging fields of biotech are changing common concepts of what it means to "have a body, and to be a body," with theories of life becoming intricately linked to "practices of engineering, programming, and design."[29] For Thacker, contemporary medicine and technology are working to produce a "technical recontextualization of biological components and processes" which is based on the assumption that the biological, biomolecular body is constructed, or

26 See the account of these tests in chapter three, "The Brain-Death Revolution" in Teresi, *The Undead*.

27 This is a central element of Bruno Latour's Actor-Network-Theory of scientific knowledge. See, for example, Bruno Latour, *We Have Never Been Modern* (Cambridge, MA: Harvard University Press, 2007), 63–64, and chapters four and six of *Pandora's Hope. Essays on the Reality of Science Studies* (Cambridge, MA: Harvard University Press, 1999), esp. 196–198.

28 See José van Dijck, *The Transparent Body. A Cultural Analysis of Medical Imaging* (Seattle: University of Washington Press, 2015), esp. 4–6; and Lisa Cartwright, *Screening the Body. Tracing Medicine's Visual Culture* (Minneapolis: University of Minnesota Press, 1995), xiii-ivx. For an insightful account of these problems in relation to cultural production, see Patricia Waugh, "Writing the Body. Modernism and Postmodernism," in *The Body and the Arts*, eds. Corinne Saunders, Ulrika Maude and Jane Macnaughton (London: Palgrave, 2009), 131–147, esp. 136–138.

29 Thacker, *Biomedia*, 1 and 2 respectively.

"compiled"[30] through modes of visualisation, modelling, data extraction, and simulation.[31] From early-modern anatomical illustrations to the development of computer-based imaging, biology and biomedicine have always developed historically differing imaging techniques and images of the body in order to answer the question "what is life?" Although Thacker is mainly interested in newer biotechnical and bioengineering practices, we can also extend his framework to consider the analogue and digital imaging and measuring techniques such as X-ray, MRI, and CT used in everyday clinical environments including, but not limited to, NB ICUs, and hence to the technological and mediated definitions of life and death in contemporary medical discourse.[32]

It is here that the imagining of biomedical intervention of *In the Flesh* approaches the theme of this volume most clearly. The opening sequence of the series provides a first indication of how technological media are involved in constructing the new concepts of the body and life itself. Sitting in Doctor Sheppard's consulting room, Kieren is confronted with MRI scans of his brain's functionality. Both he and the viewer are encouraged to read these scans as objective representations of his animation, of "life itself." The medical evidence Sheppard produces is intended to convince the patient of his physical and mental state despite his own clear discomfort with his sense of self and with his bodily appearance and despite the fact that we objectively know him to occupy a liminal state of being undead. For Sheppard and his colleagues, the images of Kieren's brain activity have become representative of his mental "life," defined, it seems, primarily by his *consciousness* as this is transmuted into visual imagery. These images represent the neuronal "life" of a dead person, however, suggesting that *In the Flesh* opens up a space to think about how neurological and biomedical knowledge is generated through patterns of aesthetic modelling, or *aisthesis*.[33]

30 Thacker, *Biomedia*, 11.

31 Thacker, *Biomedia*, 13.

32 See, for example, chapter five of Cartwright, *Screening the Body*, 107–142; also Michael Hagner, "The Mind at Work: The Visual Representation of Cerebral Processes," in *The Body Within. Art, Medicine and Visualization*, eds. Renée van de Vall and Robert Zwijnenberg (Leiden and Boston: Brill, 2009), 67–90, esp. 86–90, on contemporary techniques of mind-imaging and brain measurement.

33 On the constructive moment of imaging techniques in this respect see Renée van de Vall, "Introduction. The Body Within: Art, Medicine and Visualization," in *The Body Within*, van de Vall and Zwijnenberg, 1–13, esp. 5–6; and van Dijck, *The Transparent Body*, passim. On the concept of aisthesis more broadly, see Wolfgang Welsch, *Undoing Aesthetics* (London: Sage, 1997); and now, Jacques Rancière, *Aisthesis. Scenes from the Aesthetic Regime of Art* (London: Verso, 2017).

According to these images he is clinically alive, although actually dead and this becomes something of a leitmotif with the representation of visuality and visual art playing a particularly important role. In episode one of series two, Kieren visits his local NHS doctor for a check-up, and once again brain scans and other biomedical images are on display. The doctor recaps the features of neurogenesis, explaining that Kieren is suffering soreness in his eyes because pain receptors are now also being generated there. Accordingly feeling,[34] tasting,[35] and seeing[36] play a prominent role in the second series, a reminder of the corporeal and sensual components of aesthetic representation. Viewed alongside each other, these examples are suggestive of how biomedical knowledge is generated through acts of mediatisation and representation of the body and its processes. The fact that Kieren is a zombie opens up a critical space which renders otherwise invisible practices discernible, then.

We have grown accustomed to viewing the body bifocally in this respect: as the species body we occupy and as a body that is mediated through medical discourse, knowledge practices, and compiled through modes of visualisation, modelling, and simulation through technological media.[37] This is a bifocal gaze which is challenged by *In the Flesh*: Kieren and the other undead are repeatedly shown putting on makeup to cover over their pallor, the juxtaposition often deliberately opening up the mediatisation of the body-as-image over the actual sense of corporeal identity to view. As secondary observers of scenes like this, viewers are encouraged to interrogate the epistemic status of this zombie ontology and to think critically about the technology and media deployed in a biomedicine which makes this troubling ontology possible. Shifting between consciousness and deadness, the social and medicalised construction of what

34 Already mentioned in relation to Kieren feeling soreness in his eyes, but most clearly referenced in another character, Amy Dyer, developing the ability to sense touch throughout the entire second series.

35 The undead cannot eat, primarily, but not only, because their digestive tract is unable to process food; this leads to repeated awkward conversations around the dinner table where Kieren and the other undead are forced to pretend to eat and taste food.

36 One of the key physical signs of the zombies are their changed pupils and they are provided with contact lenses made to conceal this. The focus on sight and the eyes is repeatedly present through various narratives of seeing, being seen, and not being able to see clearly, including a POV sequence where Kieren fights against the consciousness-halting effects of a drug called "Blue Oblivion" (S2, E6, 30.00–31.10).

37 I borrow this phrase from Amit Prasad, "Making Images/Making Bodies: Visiblizing and Disciplining through Magnetic Resonance Imaging (MRI), *Science, Technology, & Human Values* 30, no. 2 (2005): 291–316, here esp. 293.

it means to be alive "in the flesh" is at the core of Mitchell's representation of the body and, more broadly, contemporary medicine.

Contemporary biotech underlines the cultural constructions of the body through its actual foundation in technologies of representation: discursive formations such as genomics, pharmacogenomics, and regenerative medicine are all unthinkable without computer, web-based, and digital media. The DNA computing and modelling deployed by these disciplines involve an encoding of "wet" biological material into computational information, which can be modelled, re-coded, re-modelled, and finally potentially actualised on/in reconditioned bodies.[38] Some emphatic concepts of posthumanism have embraced this digitalisation-equivalence uncritically to imagine a complete uploading of personality to generate idealised, upscaled forms of the human body. Oxford-based philosopher Nick Bostrom's transhumanist agenda, for example, sees no essential differences between bodily existence and computer simulation, cybernetic mechanism and biological organism, robot teleology and human goals: everything—including consciousness and identity—is information to him.[39] This is a technophilic and hyperbolic imaginative turn, presenting an ideal image of a posthuman potentiality as information machines.[40] He views the body as little more than a prosthesis we have learned to manipulate and from which we will extract the "core" of our personality, intellect, and "soul" to "outlive" us after death. Natasha Vita-More's "radical body design" *Primo Post-human* (2002) captures such posthumanist imaginings most powerfully. This is a "prototype future body [...] with superlongevity in mind":

> Engineering the human form of Primo Posthuman will occur [...] sequentially by replacing the human body bit by bit with generated parts. [...] From electronic prosthetics and cochlear implants to neurological pharmaceuticals, we are realizing the full potential of the human form, its skeletal system and the brain, with innovative technologies that will reduce the vulnerability of our body and mental processes. [...] Today we talk about digital art as integral to our nature. Yet digital forms resemble the cell structure within our bodies. The algorithms that we send into

38 Thacker, *Biomedia*, 9 and 16 respectively.

39 See, for example, Nick Bostrom, "The Transhumanist FAQ: A General Introduction," Version 2.1. (2003), 14–19. https://www.nickbostrom.com/views/transhumanist.pdf, accessed 8 August 2017.

40 For a criticism in this respect see Jon Seltin, "Production of the Posthuman: Political Economies of Bodies and Technology," *Parrhesia* 8 (2009): 43–59, here 44.

space resemble the neurological activities within our brains. The 24/7 communications we have grown to expect will also reflect the nanotech grid inside our bodies, alerting and informing us of our inner and outer networks.[41]

Primo Posthuman will liberate the mind from its physical "container," the body into a "metabrain," a "nanotech data storage memory system" with an "error correction device, replay and feedback system."[42] Mitchell's medicalised society responds to the uncanny effects of such programs of engineering bodies, brains, and personalities. In explaining what is happening to Kieren, Dr Sheppard uses vocabulary which is remarkably bioinformatical: he speaks of "voluntary recard memory" and the "cognitive circuitry"[43] in his description of how Kieren's flashbacks—and hence cognisance—are physiologically formed, making consciousness sound like a matter of hardware and programming. This type of bioinformatical language is as old as complex IT systems themselves,[44] of course, and especially since the emergence of cognitive psychology in the 1960s. In Mitchell's series, it is shared by the undead themselves. When talking about his depression and suicide, one of the characters, Simon, asks: "Ever been so depressed it felt as though every nerve ending in your body was exposed, red and raw. If I took enough chemicals it would dampen down those feelings a bit. [...] The way I was wired, I guess."[45] That *In the Flesh* should resort to the computer metaphor is hardly surprising when considered as part of a longstanding "mimesis" of such medical discourse and rhetoric in science fiction more generally. It is notable that this rhetoric has become so established that the patients themselves have internalised it, showing an acceptance of the somatisation of mental health. On the other hand, the series shows the origins of this model of brain functionality to lie in violent and brutal experimental techniques under military control and its patient speaking here is a zombie. The language of informatics in this series thus appears as an uncanny refraction of precisely those types of futurological (and in their extreme form,

41 See Natasha Vita-More, "The New[human] Genre. Primo [first] Posthuman." www.natasha. cc/paper.html, accessed 11 July 2016; see also "Radical Body Design "Primo Posthuman"" (2002). https://www.kurzweilai.net/radical-body-design-primo-posthuman, accessed 11 July 2016.

42 Vita-More, "The New[human] Genre."

43 S1, E1, 1.28–1.32.

44 John R. Searle offers a critical reconstruction of this metaphor, dating it back to Turing in his 1990 article, "Is the Brain a Digital Computer?" *Proceedings and Addresses of the American Philosophical Association* 64, no. 3 (1990): 21–37.

45 S2, E3, 35.00–35.12.

transhumanist) imaginations of the body at the heart of emerging biomedical paradigms, simultaneously a re-presentation and displacement of their social and medical valency.

According to Thacker we need to be much more careful than this. Whilst biotechnological medicine does indeed work on the basis of data equivalence, the body here is never completely artificial, rather it is transformatively mediated by technology—as "biomedia" itself: "[T]he practices of encoding, recoding, and decoding are geared both to move across platforms and to always "return" to the biological domain in a different, technically optimized form."[46] In its current state, biotechnological medicine is not exclusively informational *or* biological, but rather an intermingling of computer science and various biosciences.[47] The transhumanist idea that DNA is information there to be decoded and tweaked seems to work on the basis of a rather crude literalisation of a computational metaphor: preconditioned by computer science to view and process data, the biological domain is pre-constructed as an equivalent "code" which can be rendered interchangeable in the corporeal and digital domains.[48] These disciplines are interested in digitally transforming biology, producing different concepts and models of the body; "instead of moving away from the contingencies of the biological domain, biomedia moves towards them."[49] Biotech reveals a very real constructivist link between media and bodies beyond simplistic understandings of a "secondary simulation of an originary [body] object" on which transhumanism bases its arguments: in genome sequencing, gene therapy trials, and genetic drug development we can see shifts across and in the ontological status of the bodies being represented and recoded.[50] What biomedia clearly share with transhumanism is a lack of "body anxiety," however. The processes of modelling and remodelling bodily data seem untroubled by the fact that "the body you get back is not the body with which you began."[51] The return of something familiar but strangely different may be figured without anxiety in biotech itself, but this structural model is almost a verbatim repetition of Freud's concept of the uncanny: "the uncanny is that class of the frightening which leads back to what is known of old and long familiar," and two of the most central examples of this uncanny

46 Thacker, *Biomedia*, 27.

47 Thacker, *Biomedia*, 28.

48 See Thacker, *Biomedia*, 21–3. In a traditional, Friedrich Kittler style of media analysis, we could ask whether this kind of biomedical modelling of the body is not actually enabled by the digital, computer technology in the first place.

49 Thacker, *Biomedia*, 27.

50 Thacker, *Biomedia*, 21.

51 Thacker, *Biomedia*, 6.

for Freud—the artificial lifeform of the automaton or animated works of art, on the one hand, and the return of the dead, on the other—are centrally linked to the aims and goals of biomedia.[52] In the remainder of this chapter I wish to suggest that the cultural work carried out by the Gothic in relation to medicine revolves around teasing out precisely these uncanny structures as sources of anxiety and horror.

3 The Epistemological Function of Medical and Imaging Technologies in Biomedicine

If the zombies of *In the Flesh* are representative of the generation of the undead in contemporary medicine, Neurotriptyline is representative of the media with which biomedical and biotechnical interventions on bodies are achieved. Its development and pharmacological administration incorporate radical practices of enhancement, adaptation, and regulation of the brain's physiology within a biotechnological medical scenario. Neurotriptyline itself is not responsible for the original rising of the undead, but it does stabilise and enable their re-animation as thinking and feeling subjects, thereby becoming (1) the medium through which the unsettling, slippery slope from life to death in contemporary biomedicine is represented; (2) the medium through which the ambiguities of medical science's remaking of life and death are developed; and (3) a tool of biopolitical normalisation, controlling the undead individuals it has rendered possible. Encompassing practices of regenerative medicine and neuropharmacology, Neurotriptyline seems to offer a master metaphor for intelligent drug design, neurochemical enhancement, and current ideas of brain plasticity; it is also worth noting that there *is* actually a tricyclic antidepressant called "Nortriptyline" which is also used to treat various depressive and anxiety disorders, neuropathology, and increasingly also ADHD patients.[53] While this was already visible in the discussion of the conversation between Dr Sheppard and Kieren above (outlining the preoccupation with biotech discourses from the outset of the project), this is most fully developed in series

52 Freud, "The "Uncanny,"" 225 and 246.

53 J.B. Prince et al. "A Controlled Study of Nortriptyline in Children and Adolescents with Attention Deficit Hyperactivity Disorder," *Journal of Child and Adolescent Psychopharmacology* 10, no. 3 (2000): 193–204. See also Pitts-Taylor, "The Plastic Brain," *passim*; Knapton, "Have Scientists Found a Drug to Stop Alzheimer's Disease," *passim*.

two when the introduction of a new character called Simon allows Mitchell to tell the story of Neurotriptyline's discovery.

Besides his role as a rugged love interest for Kieren, Simon's importance for the series lies in the formative role he has played as one of the original bodies used to develop and test Neurotriptyline. In a series of flashbacks throughout series two, Simon is revealed as an actual biomedium in Thacker's sense of the term. Contradicting the transhumanist and technophile rhetoric of a "clean" reconstitution of the body via a "dry lab" of information technology, these flashbacks consist of horrific images of Simon as the "wet" biological body suffering in a real, material fashion necessary to produce this information. He was Halperin & Weston's first success story in the treatment of zombification, but as an undead subject he is the uncanny embodiment of the anxieties which biotechnology's posthuman and transhuman rhetoric seeks to suppress. Where these discursive formations ignore the uncanny status of their procedures by which (in Thacker's words) "the body you get back is not the body with which you began,"[54] *In the Flesh* inserts an actual body capable of suffering and articulating these problems. Simon—as a biomedium—provides a cognisant and sentient voice as he attempts to come to terms both with the suffering that enables the reconstituted bodies of biotechnology and with the new-found uncanny status such a reconstituted body actually occupies. These discourses work with informational abstraction and virtual modelling, but Simon confronts such representational abstraction with real, uncanny, and horrific experience. Moreover, this experience is structurally necessary for the research conducted by doctors Halperin and Weston, as Simon's responses assist them in developing the pharmacokinetics, pharmacodynamics, and administration practices of Neurotryptaline.

Once again, the leitmotif of technology and biomedical imaging techniques plays an important role, with body and brain scans visible in their laboratories in the first flashback scene.[55] Halperin and Weston are hidden behind a computer screen, studying these images intensely, while Simon is shown emerging from a non-cognisant state responding to a new form of chemical treatment. Simon is literally coming back to life, regaining a consciousness that is depicted on the screens in front of the medics. Simon's experience as a biomedium is anything other than devoid of anxiety or horror. This is no "dry lab" and there is a lack of sanitisation with obvious suffering and bodily decay. As a biomedium Simon is treated as though he were a piece of meat—the as-good-as-dead subject described by Mbembe in his account of the necropolitics

54 Thacker, *Biomedia*, 6.
55 S2, E5, 4.42–5.50.

of contemporary society—entirely lacking any of the respect befitting any medical subject, never mind a medical subject whose status is defined by its emerging state of sensation and consciousness. This is not the clean, progress-oriented story without anxiety that the later pharmaceutical company peddles in the educational and marketing material we have previously encountered, and which is told by biotechnological medicine more generally; this is pure horror. It is a horror, however, which emerges from medicine itself rather than from the zombie.

In a second flashback[56] Simon is fixed on a bed-like structure made of a cage with his head fixed to a Frankenstein-type head brace that administers and registers signals or impulses to and from his head. Everything now appears somewhat more professional than in the first flashback, with Simon hooked up to electronic equipment, which seemingly provides data from his body. While one of the doctors stands in another room watching what happens on a computer screen, his colleague tells Simon what is going to happen: "We're going to stimulate the parts of your brain that have reacted to the drug. Get some readings."[57] "Readings" allows us to infer a focus on the representational media here, and while the doctors clearly consider their work in terms of unlocking the truth from the biological body, this is a body which they have already neurochemically modified, meaning that these readings already belong to the realm of biotechnical constructivism. The subsequent scene offers us a powerful representation of the price that is paid in order to produce biotechnology's data: following a close-up of the dials and scales on the doctors' screens which provide the informational representation of the body as "readings," a sudden cut to Simon's face shows him suffering pain from the tests. The sequence ends with Simon going into a brutal seizure.

In a third and final flashback Simon is depicted on a cage with his back cut open and his spine revealed as the two doctors take measurements, revealing a mess of flesh and black congealed blood in a scene of absolute bodily horror and disgust.[58] Whereas biotechnology's biomedia are defined by their derealised ontological status as informational abstractions, the horror of *In the Flesh* seems to draw its affective momentum from Simon's *actual* embodied experience. This is a personalised and highly material rendering of biotechnical and neuropharmacological research, offering a subjective experience of these medical procedures, which develops precisely the kind of anxieties which Thacker sees as lacking in biotechnology's practices of knowledge

<hr>

56 S2, E5, 14.08–15.58.
57 S2, E5, 16.00–16.10.
58 S2, E5, 34.30–35.28.

and models of the body. Simon's ontological status is more traumatic than the doctors wish to suggest, and no amount of objective data can be squared off against his uncanny and horrific experience inside the liminal body of a dead-man-walking.

The visceral horror and abject suffering of Simon's body in the Halperin & Weston compound speaks to a corporeal, personalised experience of biomedical research. It could be argued that this is not a fitting manner of representing the abstract informational extrapolations, simulations, and imaginings within actual biotech practices, however. The fictionalisation of biotechnical and medical interventions in scenes such as this reintroduces the body into the equation and (as such) appears almost Baroque in its anatomical focus as opposed to the "cleaner" computational modelling of biotechnical interventions. Given that biotech is based on a constant vacillating between actual biological material, informational abstractions, and finally controlled experiments on patients, *In the Flesh* may be right to stress this embodied moment, however. Thacker suggests as much in his account of Sean Cubitt's idea of a "digital aesthetics" in "technoscientific," or "post-natural," life.[59] According to Thacker the "fascination and desire for non-corporeal, disembodied life, a life removed from its biological foundations [...] reinterpreted as information, "vital data"" in biotechnology—and particularly in transhumanist fantasies of biotechnology—may suggest a form of posthuman body constructions that deny materiality, but "[b]iomedia returns to the biological in a spiral, in which the biological is not effaced, but [...] optimized, impelled to realize, to rematerialize."[60] If, as Thacker argues in this sense, "the posthuman reserves the right to preserve something called the human as constant and constitutive throughout the process," then the horror of Simon's experiences seem to represent precisely this dignity of the human as it is re-modelled and reconfigured materially by Halperin and Weston.[61]

4 Conclusion

The cultural work of horror, *In the Flesh* suggests, consists of a "troubling doubling" of reality; it appears more of "an extrapolation or exacerbation of [our

59 Thacker, *Biomedia*, 135. See Sean Cubitt, "Supernatural Futures: Theses on Digital Aesthetics," in *FutureNatural: Nature, Science, Culture*, eds. George Robertson et al. (London: Routledge, 1996), 237–255.
60 Thacker, *Biomedia*, 27.
61 Thacker, *Biomedia*, 136.

world] than an alternative to it."[63] However this doubling involves a technique of unfolding and critiquing the anxieties and contradictions that remain unarticulated, bubbling away under the surface of biomedicine's own technological re-conceptualisations and re-formations of the human body. The fictional bodies—such as Kieren, Simon, and their kind—and their stories open up the constructivist epistemological function of medical imaging technologies to scrutiny, at once *re*-presenting current biotechnical and medical conceptualisations of the posthuman and their constituent technologies and media, while also scrutinising and critiquing the biopolitical and theoretical contexts behind these conceptualisations. In doing so, the series enquires about the remnants of humanist categories in this new medical imaginary. As such, we can see horror as a third-degree representation, offering us a diagnostic representation of medicine's reliance on media and visual imaginings of the body in its progress towards literally reconstituting the human body in posthuman medical practices. *In the Flesh* suggests that horror can identify the constructs and contradictions within posthumanist medical discourse, developing suitable forms to represent and critique these practices. Through contrasting the suffering of the body-as-experienced with the discourse of sanitised "readings" or representations within posthumanist medical discourses and practices, horror reveals the intellectual shortcut of equating the body with information to portray biomedia *in the flesh*. While this may seem retrograde or culturally conservative, it enables a form of critical posthumanism in the aesthetic sphere.[64] *In the Flesh* suggests that horror can provide an effective critique of biomedical constructions of the body, including the media and technologies deployed in these constructions.

63 Mark Fisher, *Capitalist Realism. Is There No Alternative?* (Hants, UK: Zero Books, 2009), 2.

64 For an initial account of this approach to posthumanism see Ivan Callus and Stefan Herbrechter, "Critical Posthumanism or, the *Inventio* of a Posthumanism without Technology," *Subject Matters* 3, no. 2 (2007): 15–30; and now Claire Colebrook, "Posthuman Humanities," in *Death of the PostHuman. Essays on Extinction*, vol. 1, Claire Colebrook (Ann Arbor: Open Humanities Press, 2014), 158–184.

Bibliography

Abderhalden, Emil. "Ueber die Bedeutung des mikroskopischen Kapillarbildes und die therapeutische Beeinflussung abnormer Kapillarbildungen." (November 26, 1928) *Bundeasarchiv Berlin-Lichterfelde*, R 4901, Nr. 1463.

Allegaert, Patrick and Annemie Cailliau. "A History in Images. The Twentieth [sic] Anniversary of the Dr. Guislain Museum," 8. http://online.ibc.regione.emiliaromagna .it/I/libri/pdf/psichiatria/allegaert_1par.pdf.

Alpers, Svetlana. *The Art of Describing. Dutch Art in the Seventeenth Century*. Chicago: University of Chicago Press, 1983.

Appadurai, Arjun, ed. *The Social Life of Things: Commodities in Cultural Perspective*. Cambridge: Cambridge University, 1986.

Arendt, Hannah. *Totalitarianism: Part Three of The Origins of Totalitarianism*. San Diego, New York and London: Harcourt, 1968.

Aristotle. *De Anima*, in *The Works of Aristotle*, vol. III. Oxford: Oxford University Press, 1931.

Asselt, Willem J. van. "The Doctrine of the Abrogations in the Federal Theology of Johannes Cocceius (1603–1669)." *Calvin Theological Journal* 29 (1994): 101–116.

Asselt, Willem J. van. *The Federal Theology of Johannes Cocceius*. Leiden: Brill, 2001.

Augustine. *Confessions*. London: Penguin Books, 1961.

Ausfeld, Johann Wilhelm. "Kurze Charakteristik Salzmanns." In *Volks- und Jugend-Schriften*, vol. 1. Christian Gotthilf Salzmann, 50–52. Stuttgart: Hoffmann'sche Buchhandlung, 1845.

Aynsley, Jeremy. *Graphic Design in Germany 1890–1945*. London: Thames & Hudson, 2000.

Backhaus, Jürgen. "Tausch und Geld: Georg Simmels Philosophie des Geldes." (1998). http://www.forschungsnetzwerk.at/downloadpub/Tausch_und_Geld_simmels _%20Philosophie_des_Geldes.pdf.

Bacopoulos-Viau, Alexandra and Aude Fauvel. "The Patient's Turn: Roy Porter and Psychiatry's Tales, Thirty Years on." *Medical History* 60, no. 1 (2016): 1–18.

Baddeley, Michelle. *Behavioural Economics: A Very Short Introduction*. Oxford: Oxford University Press, 2017.

Bahrdt, Carl Friedrich. *Philanthropinischer Erziehungsplan oder vollständige Nachricht von dem ersten wirklichen Philanthropin zu Marschlins*. Frankfurt/M: Eisenberg, 1776.

Bal, Mieke. *Reading "Rembrandt": Beyond the Word-Image Opposition*. Cambridge, UK and New York: Cambridge University Press, 1991.

Baldwin, Robert W. ""On Earth we are Beggars, as Christ Himself was": The Protestant Background of Rembrandt's Imagery of Poverty, Disability and Begging." *Konsthistorisk tidskrift/Journal of Art History* 54, no. 3 (1985): 122–135.

Ballestriero, Roberta. "Anatomical Models and Wax Venuses: Art Masterpieces or Scientific Craft Works?" *Journal of Anatomy* 216, no. 2 (2010): 223–234.

Balzac, Honoré de. *The Country Doctor.* Translated by G. Burnham Ives. Philadelphia, PA: G. Barrie, 1898.

Barck, Karlheinz. *Poesie und Imagination. Studien zur ihrer Reflexionsgeschichte zwischen Aufklärung und Moderne.* Stuttgart and Weimar: Metzler, 1993.

Barker, Francis. *The Tremulous Private Body: Essays on Subjection.* London and New York: Methuen, 1984.

Barron, Stephanie and Sabine Eckmann, eds. *New Objectivity: Modern German Art in the Weimar Republic 1919–33.* New York: Prestel, 2015.

Bear, Jordan and Kate Palmer Albers, eds. *Before-and-After Photography: Histories and Contexts.* London: Bloomsbury, 2017.

Behringer, Wolfgang. "Arena and Pall Mall: Sport in the Early Modern Period." *German History* 27, no. 3 (2009): 331–334.

Behringer, Wolfgang. *Kulturgeschichte des Sports. Vom antiken Olympia bis zur Gegenwart.* München: Beck, 2012.

Beistegui, Miguel de. "Desire Within and Beyond Biopolitics." In *The Care of Life: Transdisciplinary Perspectives in Bioethics and Biopolitics*, edited by Miguel de Beistegui, Guiseppe Bianco and Marjorie Gracieuse, 241–260. London: Rowman & Littlefield, 2015.

Bellis, Delphine. "Empiricism without Metaphysics." In *Cartesian Empiricisms (Studies in History and Philosophy of Science 31)*, edited by Mihnea Dobre and Tammy Nyden, 151–183. Dordrecht: Springer, 2013.

Belting, Hans. *Bild und Kult. Eine Geschichte des Bildes vor dem Zeitalter der Kunst.* München: Beck, 2000.

Belting, Hans. *Bild-Anthropologie. Entwürfe für eine Bildwissenschaft.* München: Fink 2001.

Belting, Hans. *Face and Mask: a Double History.* Princeton: Princeton University Press, 2017.

Berenson, Bernard. "The Effigy and the Portrait." In *Aesthetics and History in the Visual Arts*, edited by Bernard Berenson, 190–200. New York: Pantheon, 1948.

Berenson, Ruth and Norbert Muhlen. "The Two Worlds of George Grosz." In *George Grosz*, edited by Herbert Bittner, 11–28. New York: Griffin, 1960.

Berger, Silvia. *Bakterien in Krieg und Frieden. Eine Geschichte der medizinischen Bakteriologie in Deutschland 1890–1933.* Göttingen: Wallstein, 2009.

Berkhof, Louis. *Systematic Theology.* Grand Rapids: Eardmans, 1996.

Bernett, Hajo. *Die pädagogische Neugestaltung der bürgerlichen Leibesübungen durch die Philanthropen.* Stuttgart: Karl Hofmann, 1960.

Berrios, German E. and Roy Porter, eds. *A History of Clinical Psychiatry. The Origin and History of Psychiatric Disorders.* London: Athlone Press, 1995.

Bialostocki, Jan. "A New Look at Rembrandt Iconography." *Artibus et Historiae* 5, no. 10 (1984): 9–19.

Bigham, Julia. "Commerce and Communication: Commercial Advertisement and the Poster from the 1880s to the Present." In *The Power of the Poster*, edited by Margaret Timmers, 173–219. London: V & A Publications, 1998.

Bihéron, Marie Marguerite. *Anatomie Artificielle.* (Paris, 24 April 1761). [Advertising catalogue].

Blackshaw, Gemma and Kathryn Simpson. *Egon Schiele. The Radical Nude.* London: Paul Holberton Publishing, 2014.

Bleuler, Eugen. "Das autistische Denken." In *Jahrbuch für psychoanalytische und psycho-pathologische Forschungen* 5, no. 1, edited by Sigmund Freud and Eugen Bleuler, 1–39. Leipzig and Wien: Franz Deuticke, 1912.

Bleuler, Eugen. *Dementia Praecox oder Gruppe der Schizophrenien.* Leipzig and Wien: Deuticke, 1911.

Boden, Margaret A. *Mind as Machine: A History of Cognitive Science.* Oxford: Clarendon Press, 2006.

Böhme, Hartmut. *Der anatomische Akt. Zur Bildgeschichte und Psychohistorie der frühneuzeitlichen Anatomie.* Gießen: Psychosozial-Verlag, 2012.

Bostrom, Nick. "The Transhumanist FAQ: A General Introduction." Version 2.1. (2003). http://www.transhumanism.org/resources/FAQv2.pdf.

Bostwick, Homer. *Medical Quackery: Its Origin, Cause and Cure, with Hints to Young Physicians, in Relation to the Important Subject of Consultation.* New York: T. Smith, Mirror Printing Office, 1847.

Botting, Fred. "Globalzombie: From *White Zombie* to *World War Z.*" In *Globalgothic*, edited by Glennis Byron, 188–201. Manchester: Manchester University Press, 2013.

Boulinier, Georges. "Une femme anatomiste au siècle des Lumières: Marie Marguerite Bihéron (1719–1795)." *Histoire des sciences médicales* 35, no. 4 (2001): 411–423.

Bowler, Jacinta. "New Stem Cell Treatment Using Fat Cells Could Repair Any Tissue in the Body." *Science Alert* (5 April 2016). https://www.sciencealert.com/new-stem-cell-treatment-using-fat-cells-could-repair-any-tissue-in-the-body.

Braidotti, Rosi. *The Posthuman.* London: Polity, 2013.

Bramwell, Byrom. "Clinical Remarks on a Case of Sporadic Cretinism." *British Medical Journal* (6 January 1894): 6–11.

Brand-Claussen, Bettina. "Prinzhorns *Bildnerei der Geisteskranken*. Ein spätexpressionistisches Manifest." In *Vision und Revision einer Entdeckung*, 11–31. Heidelberg: Sammlung Prinzhorn, 2003.

Brandes, Ernst. "Ueber den verminderten Sinn des Vergnügens." *Berlinische Monatsschrift* 5 (1790): 421–475.

Breckmann, Warren G. "Disciplining Consumption: The Debate about Luxury in Wilhelmine Germany, 1890–1914." *Journal of Social History* 24, no. 3 (1991): 485–505.

Bredekamp, Horst. *Theorie des Bildakts. Frankfurter Adorno-Vorlesungen 2007*. Frankfurt/M: Suhrkamp, 2010.

Bredekamp, Horst, Christiane Kruse and Pablo Schneider, eds. *Imagination und Repräsentation. Zwei Bildsphären der Frühen Neuzeit*. München: Fink, 2010.

Bredekamp, Horst, Vera Dünkel and Birgit Schneider, eds. *The Technical Image: A History of Styles in Scientific Imagery*. Chicago: University of Chicago Press, 2015.

Brieger, Heinrich. "Zur Anwendung der Capillarmikroskopie nach Jaensch-Hoepfner-Wittneben." *Klinische Wochenschrift* 8, no. 7 (1929): 296–299.

Briese, Olaf. *Angst in den Zeiten der Cholera. Über kulturelle Ursprünge des Bakteriums (Seuchen-Cordon I); Panik-Kurve. Berlins Cholera-Jahr 1831/32 (Seuchen-Cordon II); Auf Leben und Tod. Briefwelt als Gegenwelt (Seuchen-Cordon III); Das schlechte Gedicht (Seuchen-Cordon IV)*. Berlin: Akademie Verlag, 2003.

Brilliant, Richard. *Portraiture*. London: Reaktion Books, 1991.

Bunge, Wiep van. "Cartesian Hermeneutics." In *From Stevin to Spinoza: An Essay on Philosophy in the Seventeenth-Century Dutch Republic*, 74–83. Leiden: Brill, 2001.

Burgess, Thomas Henry. *The Physiology Or Mechanism of Blushing*. London: John Churchill, 1839.

Burgin, Victor. "Looking at Photographs." In *Thinking Photography*, edited by Victor Burgin, 142–153. New York: Palgrave Macmillan, 1982.

Burns, Stanley B. and Elizabeth A. Burns. *Stiffs, Skulls, and Skeletons: Medical Photography and Symbolism*. Atglen: Schiffer, 2014.

Callus, Ivan and Stefan Herbrechter. "Critical Posthumanism or, the *Inventio* of a Posthumanism without Technology." *Subject Matters* 3, no. 2 (2007): 15–30.

Cardano von Mailand, Girolamo. *Eigene Lebensbeschreibung*. München: Kösel-Verlag, 1969.

Cardano von Mailand, Girolamo. *Traumbuch Cardani. Warhafftige / gewüsse und vnbetrügliche vnderweisung / wie allerhandt Träum / Erscheinungen und Nächtliche gesicht / welche uns von der seelen [...] eingebildet und fürbracht werden. Durch den hochgelehrten Hieronymum Cardanum. Jetztunder [...] gantz fleissig vnd auff das treüwlichst verteütscht*. Basel: Petri, 1563.

Carlyle, Margaret. "Phantoms in the Classroom: Midwifery Training in Enlightenment Europe." *Know: A Journal on the Formation of Knowledge* 2, no. 1 (2018): 111–136.

Carson, John. *The Measure of Merit. Talents, Intelligence, and Inequality in the French and American Republics, 1750–1940*. Princeton: Princeton University Press, 2007.

Cartwright, Lisa. *Screening the Body. Tracing Medicine's Visual Culture*. Minneapolis: University of Minnesota Press, 1995.

Caton, Hiram. *The Origin of Subjectivity. An Essay on Descartes*. New Haven: Yale University Press, 1973.

Chastel, André, ed. *The Genius of Leonardo da Vinci. Leonardo da Vinci on Art and the Artist*. New York: Orion Press, 1961.

Childs, Christopher. "The History of Typhoid Fever in Munich." *Lancet* 151, no. 3884 (1898): 348–354.

Clark, Kenneth. *Rembrandt and the Italian Renaissance*. London: John Murray, 1966.

Clark, Stuart. *Vanities of the Eye. Vision in Early Modern European Culture*. Oxford: Oxford University Press, 2007.

Colebrook, Claire. "Posthuman Humanities." In *Death of the PostHuman. Essays on Extinction*, vol. 1, 158–184. Ann Arbor: Open Humanities Press, 2014.

Colie, Rosalie. "Constantijn Huygens and the Metaphysical Mode." *The Germanic Review* 34 (1959): 59–67.

Conner, Patrick. "Lam Qua: Western and Chinese Painter." *Arts of Asia* 29, no. 2 (1999): 46–64.

Cooper, Melinda. *Life as Surplus. Biotechnology and Capitalism in the Neoliberal Era*. Seattle and London: University of Washington Press, 2008.

Cooter, Roger and Claudia Stein. "Die Geschichte des Gesundheits-und Hygieneplakats neu betrachtet. Die ökonomische Neuerfindung des Wissens über das Selbst." In *"Erkenne Dich selbst!" Strategien der Sichtbarmachung des Körpers im 20. Jahrhundert*, edited by Sybilla Nikolow, 344–357. Köln: Böhlau, 2015.

Coronel, Danielle. *Walter Burley Griffin—Philosophy and Design Themes: Correspondences to Early Modern German Aesthetic Theory, Art and Architecture*. PhD dissertation, Monash University, 2017.

Cottingham, John, Robert Stoothoff and Dugald Murdoch, eds and trans. *The Philosophical Writings of Descartes*, vol. 1. Cambridge: Cambridge University Press, 1997.

Coudray, Angélique Marguerite du. *Abrégé de l'art d'accouchement*. Paris: la Verve Delaguette, 1759.

Crossman, Carl L. *The Decorative Arts of the China Trade: Paintings, Furnishings and Exotic Curiosities*. Woodbridge: Antique Collectors' Club, 1991.

Crouthamel, Jason. *The Great War and German Memory. Society, Politics and Psychological Trauma, 1914–1945*. Exeter: University of Exeter Press, 2009.

Csengei, Ildiko. *Sympathy, Sensibility and the Literature of Feeling in the Eighteenth Century*. Basingstoke: Palgrave Macmillan, 2012.

Cubitt, Sean. "Supernatural Futures: Theses on Digital Aesthetics." In *FutureNatural: Nature, Science, Culture*, edited by George Robertson et al., 237–255. London: Routledge, 1996.

Cüddow, A. "Straßenbild und Reklame." *Das Plakat* 1 (1910): 61–65.

Cunningham, Andrew. "Transforming Plague: The Laboratory and the Identity of Infectious Disease." In *The Laboratory Revolution in Medicine*, edited by Andrew Cunningham and Perry Williams, 209–224. Cambridge: Cambridge University Press, 1992.

Cunningham Dax, Eric. *The Cunningham Dax Collection. Selected Works of Psychiatric Art*. Melbourne: Melbourne University Press, 1998.

Cuthbertson, R. Andrew. "The Highly Original Dr Duchenne." In *The Mechanism of Human Facial Expression. Duchenne de Boulogne*, edited and translated by R. Andrew Cuthbertson, 225–284. Cambridge: Cambridge University Press, 1990.

Dacome, Lucia. *Malleable Anatomies. Models, Makers, and Material Culture in Eighteenth-Century Italy*. Oxford: Oxford University Press, 2017.

Danneberg, Lutz. *Säkularisierung in den Wissenschaften seit der Frühen Neuzeit*, Bd. 3, *Die Anatomie des Text-Körpers und Natur-Körpers. Das Lesen im liber naturalis und supernaturalis*. Berlin and New York: de Gruyter, 2003.

Darwin, Charles. *Notebooks 1836–44*, edited by P.H. Barrett. Ithaca, NY: Cornell University Press, 1987.

Darwin, Charles. *The Expression of the Emotions in Man and Animals,* edited by Joe Cain and Sharon Messenger. London: Penguin, 2009.

Daston, Lorraine. "Epistemic Images." In *Vision and Its Instruments: Art, Science, and Technology in Early Modern Europe*, edited by Alina Payne, 13–35. University Park, PA: Pennsylvania State University Press, 2015.

Daston, Lorraine and Katharine Park. *Wonders and the Order of Nature 1150–1750*. New York: Zone Books, 2001.

Daum, Andreas. *Wissenschaftspopularisierung im 19. Jahrhundert. Bürgerliche Kultur, naturwissenschaftliche Bildung und die deutsche Öffentlichkeit 1848–1914*. München: R. Oldenbourg, 2002.

Delaporte, François. *Anatomy of the Passions*. Translated by Susan Emanuel, edited by Todd Meyers. Stanford: Stanford University Press, 2008.

Delbrück, Hans. "Archicapillaren und Schwachsinn." *Archiv für Psychiatrie und Nervenkrankheiten* 81 (1927): 606–629.

Deleuze, Gilles. *Nietzsche and Philosophy*. New York: Columbia University Press, 1983.

Deleuze, Gilles and Felix Guattari. *A Thousand Plateaus*. Translated by Brian Massumi. Minneapolis, MN: University of Minnesota Press, 1987.

Deleuze, Gilles and Claire Parnet. *Dialogues II*. London: Continuum, 2012.

Derrida, Jacques. *Archive Fever. A Freudian Impression*. Translated by Eric Prenowitz. Chicago and London: University of Chicago Press, 1996.

Dickinson, Edward Ross. "Biopolitics, Fascism, Democracy. Some Reflections on Our Discourse about "Modernity."" *Central European History* 37, no. 1 (2004): 1–47.

Didi-Huberman, Georges. *Devant l'image. Questions posées aux fins d'une histoire de l'art*. Paris: Minuit, 1990.

Didi-Huberman, Georges. *Invention of Hysteria: Charcot and the Photographic Iconography of the Salpêtrière*. Translated by Alisa Hartz. Cambridge, MA: MIT Press, 2003.

Dijck, Jose van. *The Transparent Body. A Cultural Analysis of Medical Imaging*. Seattle: University of Washington Press, 2015.

Dobre, Mihnea and Tammy Nyden, eds. *Cartesian Empiricisms (Studies in History and Philosophy of Science 31)*. Dordrecht: Springer, 2013.

Doering, Birgit. "Frühe Warenwerbung im Spannungsfeld von Kunst und Kommerz."
 In *Die Kunst zu werben. Das Jahrhundert der Reklame*, edited by Susanne Bäumler,
 190–197. Köln: DuMont, 1996.

Döhring, Jürgen. *Gefühlsecht. Graphikdesign der 90er Jahre*. Heidelberg: Edition Braus,
 1996.

Douglas, Alexander. "Spinoza and the Dutch Cartesians on Philosophy and Theology."
 Journal of the History of Philosophy 51, no. 4, (2013): 567–588.

Duchenne de Boulogne, Guillaume Benjamin Amand. *The Mechanism of Human
 Facial Expression*. Edited and translated by R. Andrew Cuthbertson. Cambridge:
 Cambridge University Press, 1990.

Dumit, Joseph. *Picturing Personhood. Brain Scans and Biomedical Identity*. Princeton:
 Princeton University Press, 2004.

Dupouy, Stéphanie. "The Naturalist and the Nuances: Sentimentalism, Moral Values,
 and Emotional Expression in Darwin and the Anatomists." *Journal of the History of
 the Behavioral Sciences* 47, no. 4 (2011): 335–358.

Dürbeck, Gabriele. *Einbildungskraft und Aufklärung. Perspektiven der Philosophie,
 Anthropologie und Ästhetik um 1750*. Tübingen: Niemeyer, 1998.

Ebbinghaus, Hermann. *Grundzüge der Psychologie*. Leipzig: Veit & Comp., 1905.

Ebenstein, Joanna. *The Anatomical Venus: Wax, God, Death and the Ecstatic*. New York:
 Distributed Art Publishers, 2016.

Eckart, Wolfgang Uwe and Robert Jütte. *Medizingeschichte. Eine Einführung*. Köln and
 Wien: Böhlau, 2007.

Eichberg, Henning. *Leistung, Spannung, Geschwindigkeit. Sport und Tanz im gesell-
 schaftlichen Wandel des 18./19. Jahrhunderts*. Stuttgart: Klett-Cotta, 1978.

Eisenberg, Christiane. *"English Sports" und deutsche Bürger. Eine Gesellschaftsge-
 schichte 1800–1939*. Paderborn: Ferdinand Schöningh, 1999.

Ellis, Carolyn, Tony E. Adams and Arthur P. Bochner. "Autoethnography: An Overview."
 Forum: Qualitative Sozialforschung / Forum: Qualitative Social Research 12, no. 1
 (2011). http://www.qualitative-research.net/index.php/fqs/article/view/1589.

Enenkel, Karl A.E. *Die Erfindung des Menschen. Die Autobiographik des frühneuzeitli-
 chen Humanismus von Petrarca bis Lipsius*. Berlin and New York: de Gruyter, 2008.

Evans, Jessica and Stuart Hall, eds. *Visual Culture: The Reader*. London: Sage, 1999.

Farris, Johnathan Andrew. *Enclave to Urbanity: Canton, Foreigners, and Architecture
 from the Late Eighteenth to the Early Twentieth Centuries*. Hong Kong: Hong Kong
 University Press, 2016.

Ficino, Marsilio. *De Vita Libri Tres / Drei Bücher über das Leben*. Edited, translated and
 with an introduction by Michaela Boenke. München: Fink, 2012.

Fierz, Markus. *Girolamo Cardano (1501–1576)*. Basel and Stuttgart: Birkhäuser, 1977.

Finlayson, James. *Clinical Manual for the Study of Medical Cases*. London: Smith, Elder
 & Co., 1886.

Fischer, Lothar. *Otto Dix. Ein Malerleben in Deutschland*. Berlin: Nicolaische Verlagsbuchhandlung, 1981.

Fisher, Mark. *Capitalist Realism. Is There No Alternative?* Hants, UK: Zero Books, 2009.

Fix, Andrew. *Prophesy and Reason: The Dutch Collegiants in the Early Enlightenment*. Princeton: Princeton University Press, 1991.

Fliethmann, Axel. *Texte über Bilder. Zur Gegenwart der Renaissance*. Freiburg: Rombach, 2014.

Fliethmann, Axel. "The Body of Imagination and the Technology of Imagery in the Renaissance and in Modernity." *Thesis Eleven: Critical Theory and Historical Sociology* 130, no. 1 (2015): 43–57.

Fliethmann, Axel. "Word and Image: Framing Philology." *Thesis Eleven: Critical Theory and Historical Sociology* 89 (2007): 43–57.

Flügge, Carl. "Die Verbreitungsweise und Verhütung der Cholera auf Grund der neueren epidemiologischen Erfahrungen und experimentellen Forschung." *Zeitschrift für Hygiene und Infektionskrankheiten* 14 (1893): 122–202.

Forney, Ellen. *Marbles: Mania, Depression, Michelangelo, and Me*. London: Robinson, 2013.

Foucault, Michel. "So is it Important to Think?" in *Power*, edited by J. Faubion, 160–161. New York: New Press, 2000 [1981].

Foucault, Michel. *The Birth of the Clinic*. Translated by A.M. Sheridan Smith. London: Tavistock, 1973.

Franklin, Sarah and Margaret Lock. "Animation and Cessation. The Remaking of Life and Death." In *Remaking Life & Death. Toward an Anthropology of the Biosciences*, edited by Sarah Franklin and Margaret Lock, 3–22. Santa Fe and Oxford: School of American Research Press and James Curry, 2003.

Franklin, Sarah and Margaret Lock, eds. *Remaking Life & Death. Toward an Anthropology of the Biosciences*. Santa Fe and Oxford: School of American Research Press and James Curry, 2003.

Frei, Hans W. *The Eclipse of Biblical Narrative: A Study in Eighteenth and Nineteenth Century Hermeneutics*. New Haven: Yale University Press, 1974.

Freud, Sigmund. "Das Unheimliche." In *Gesammelte Werke. Werke aus den Jahren 1917–1920*, vol. XII, edited by Anna Freud et al., 225–268. Frankfurt/M: Fischer Taschenbuch Verlag, 1999.

Freud, Sigmund. "Psychoanalytische Bemerkungen über einen autobiographisch beschriebenen Fall von Paranoia (Dementia paranoides)." In *Gesammelte Werke. Werke aus den Jahren 1909–1913*, vol. VIII, edited by Anna Freud et al., 237–320. Frankfurt/M: Fischer Taschenbuch Verlag, 1999.

Freud, Sigmund. "Neurose und Psychose." In *Gesammelte Werke*, vol. XIII, edited by Anna Freud et al., 385–391. Frankfurt/M: Fischer Taschenbuch Verlag, 1999.

Freud, Sigmund. "Thoughts for the Times on War and Death (1915)." In *The Standard Edition of the Complete Psychological Works of Sigmund Freud*, vol. XIV (1914–1916)

On the History of the Psycho-Analytic Movement, Papers on Metapsychology and Other Works, translated by James Strachey, 273–300. London: Hogarth Press, 1955.

Freud, Sigmund. *Totem und Tabu*. In *Gesammelte Werke*, vol. IX, edited by Anna Freud et al. Frankfurt/M: Fischer Taschenbuch Verlag, 1999.

Frisby, David P. "Georg Simmel and the Study of Modernity." In *Georg Simmel and Contemporary Sociology*, edited by Michael Kaern, Bernard S. Phillips and Robert S. Cohen, 57–74. Dordrecht, Boston and London: Kluwer Academic Publishers, 1990.

Funke, Ulf-Norbert. *Karl August Lingner. Leben und Werk eines gemeinnützigen Großindustriellen*. Dresden: B-Edition, 1996.

Galen. "On the Usefulness of the Parts of the Body" (*De Usu Partium Corporis Humani*), vol. 2. Translated by Margaret Tallmadge May. Ithaca, New York: Cornell University Press, 1968.

Ganz, James A. *Rembrandt's Century*. Munich, London and New York: Delmonico Books, 2013.

Gargam, Adeline. "Marie-Marguerite Bihéron et son cabinet d'anatomie: une femme de science et une pedagogue." In *Femmes éducatrices au siécle des lumières*, edited by Isabelle Brouard-Arends and Marie-Emmanuelle Plagnol-Diéval, 147–156. Rennes: PUR, 2007.

Gelbart, Nina Rattner. *The King's Midwife: A History and Mystery of Madame du Coudray*. Berkeley and Los Angeles: University of California Press, 1998.

Gellhaus, Axel. *Enthusiasmos und Kalkül. Reflexionen über den Ursprung der Dichtung*. München: Fink, 1995.

Geppert, Alexander C.T. *Fleeting Cities: Imperial Expositions in Fin-de-Siècle Europe*. Basingstoke: Palgrave Macmillan, 2010.

Giglioni, Guido. "The Many Rhetorical Personae of an Early Modern Physician: Girolamo Cardano on Truth and Persuasion." In *Rhetoric and Medicine in Early Modern Europe*, edited by Stephen Pender and Nancy S. Struever, 173–193. Farnham, Surrey: Ashgate, 2012.

Gilbert, Pamela K. *Victorian Skin: Surface, Self, History*. Ithaca, NY: Cornell University Press, 2019.

Gilman, Sander L. "Lam Qua and the Development of a Westernized Medical Iconography in China." *Medical History* 30, no. 1 (1986): 57–69.

Gilman, Sander L. *Seeing the Insane*. Lincoln: University of Nebraska Press, 1996.

Gilman, Sander L., ed. *The Face of Madness: Hugh W. Diamond and the Origin of Psychiatric Photography*. New York: Brunner/Mazel, 1976.

Glaeser, Johannes. *Der Werturteilsstreit in der deutschen Nationalökonomie: Max Weber, Werner Sombart und die Ideale der Sozialpolitik*. Marburg: Metropolis-Verlag, 2014.

Gordon, Benjamin Lee. *Medieval and Renaissance Medicine*. London: Peter Owen, 1959.

Gorham, Geoffrey. "Mind-Body Dualism and the Harvey-Descartes Controversy." *Journal of the History of Ideas* 55, no. 2 (1994): 211–234.

Goudriaan, Aza. "Descartes, Cartesianism, and Early Modern Theology." In *The Oxford Handbook of Early Modern Theology, 1600–1800*, edited by Ulrich L. Lehner, Richard A. Muller and A.G. Roeber, 533–549. Oxford: Oxford University Press, 2016.

Goudriaan, Aza. "Die Rezeption des cartesianischen Gottesdenkens bei Abraham Heidanus." *Neue Zeitschrift für Systematische Theologie und Religionsphilosophie* 38, no. 2 (1996): 166–197.

Gradmann, Christoph. *Laboratory Disease, Robert Koch's Medical Bacteriology*. Translated by Elborg Forster. Baltimore: Johns Hopkins University Press, 2009.

Grafton, Anthony. *Cardanos Kosmos. Die Welten und Werke eines Renaissance-Astrologen*. Berlin: Berlin Verlag, 1999.

Green, Katie. *Lighter than my Shadow*. London: Jonathan Cape, 2013.

Greenberg, Udi E. "Criminalization. Carl Schmitt and Walter Benjamin's Concept of Criminal Politics." *Journal of European Studies* 39, no. 3 (2009): 305–319.

Greenhalgh, Paul. *Ephemeral Vistas. The Expositions Universelles, Great Exhibitions and World's Fairs, 1851–1939*. Manchester: Manchester University Press, 1988.

Grimmer-Solem, Erik. *The Rise of Historical Economics and Social Reform in Germany 1864–1894*. Oxford: Clarendon Press, 2003.

Gross, Hans and J. Collyer Adam. *Criminal Investigation: A Practical Textbook for Magistrates, Police Officers and Lawyers*. London: Sweet & Maxwell, 1924.

Grosz, George. *Ecce Homo. 84 Lithographien und 16 Aquarelle*. Berlin: Malik, 1922–23.

Guratzsch, Herwig, ed. *Expressionismus und Wahnsinn*. München: Prestel, 2003.

GutsMuths, Johann Christoph Friedrich. *Gymnastik für die Jugend. Enthaltend eine praktische Anweisung zu Leibesübungen. Ein Beitrag zur nöthigsten Verbesserung der körperlichen Erziehung* (1804). Frankfurt/M: Limpert, 1970.

GutsMuths, Johann Christoph Friedrich. *Gymnastik für die Jugend. Enthaltend eine praktische Anweisung zu Leibesübungen. Ein Beytrag zur nöthigsten Verbesserung der körperlichen Erziehung*. Schnepfenthal: Buchhandlung der Erziehungsanstalt, 1793.

GutsMuths, Johann Christoph Friedrich. *Spiele zur Uebung und Erholung des Körpers und Geistes für die Jugend, ihre Erzieher und alle Freunde unschuldiger Jugendfreuden*. Schepfenthal: Verlag der Buchhandlung der Erziehungsanstalt, 1796.

Habermas, Rebekka. *Frauen und Männer des Bürgertums. Eine Familiengeschichte (1750–1850)*. Göttingen: Vandenhoeck & Ruprecht, 2000.

Hagner, Annemarie. *Das Plakat im Jugendstil*. PhD dissertation, University of Freiburg, 1958.

Hagner, Michael. "The Mind at Work: The Visual Representation of Cerebral Processes." In *The Body Within. Art, Medicine and Vizualization*, edited by Renée van de Vall and Robert Zwijnenberg, 67–90. Leiden and Boston: Brill, 2009.

Haller, Albrecht von. *A Dissertation on the Sensible and Irritable Parts of Animals* (1752), *Bulletin of the History of Medicine*, introduction by Owsei Temkin, 4 (1936): 651–699.

Hardy, Anne. *Ärzte, Ingenieure und städtische Gesundheit*. Frankfurt/M and New York: Campus Verlag, 2005.

Harpur, Patrick. *The Philosophers' Secret Fire: A History of the Imagination*. London: Penguin, 2002.

Hatfield, Gary. "Descartes' Physiology and Its Relation to his Psychology." In *The Cambridge Companion to Descartes*, edited by John Cottingham, 335–370. Cambridge: Cambridge University Press, 1998.

Hau, Michael. "Constitutional Therapy and Clinical Racial Hygiene in Weimar and Nazi Germany." *Journal of the History of Medicine and the Allied Sciences* 71, no. 2 (2016): 115–143.

Hau, Michael. *Performance Anxiety. Sport and Work in Germany from the Empire to Nazism*. Toronto: University of Toronto Press, 2017.

Haupt, Heinz-Gerhard. *Konsum und Handel: Europa im 19. und 20. Jahrhundert*. Göttingen: Vandenhoeck & Ruprecht, 2003.

Haupt, Heinz-Gerhard and Claudius Torp, eds. *Die Konsumgesellschaft in Deutschland 1890–1990. Ein Handbuch*. Frankfurt/M and New York: Campus, 2009.

Haworth-Booth, Mark, ed. *The Golden Age of British Photography 1839–1900*. New York: Aperture, 1986.

Hayot, Eric. *The Hypothetical Mandarin: Sympathy, Modernity, and Chinese Pain*. Oxford: Oxford University Press, 2009.

Heckscher, William S. *Rembrandt's Anatomy of Dr Nicolaas Tulp*. Washington Square: New York University Press, 1958.

Heinrich, Larissa N. "Handmaids to the Gospel: Lam Qua's Medical Portraiture." In *Tokens of Exchange: The Problem of Translation in Global Circulations*, edited by Lydia Liu, 239–276. Durham: Duke University Press, 1999.

Held, Julius. "A Rembrandt Theme." *Artibus et Historiae* 5, no. 10 (1984): 21–34.

Hermand, Jost. "Vorwort. Vom altständischen Reichsgedanken zum deutsch-nationalen Befreiungskriegspathos." In *Revolutio germanica. Die Sehnsucht nach der "alten Freiheit" der Germanen, 1750–1820*, edited by Jost Hermand and Michael Niedermeier, 1–20. Frankfurt/M: Peter Lang, 2002.

Höbelt, Lothar. Mataja, Victor. In *Neue Deutsche Biographie* (NDB), vol. 16. Berlin: Duncker & Humblot, 1990, 365.

Hobson, J.A. *The Psychology of Jingoism*. London: G. Richards, 1901.

Holländer, Eugen. *Die Medizin in der klassischen Malerei*. Stuttgart: Ferdinand Enke, 1913.

Henkel, Arthur and Albrecht Schöne, eds. *Emblemata. Handbuch zur Sinnbildkunst des XVI. und XVII. Jahrhunderts*. Stuttgart and Weimar: Metzler, 1996.

Herzog, Todd. *Crime Stories: Criminalistic Fantasy and the Culture of Crisis in Weimar Germany*. New York: Berghahn, 2009.

Hoepfner, Theodor. *Die Strukturbilder der menschlichen Nagelfalzkapillaren und ihre Bedeutung im Zusammenhang mit Schilddrüsenveränderungen sowie gewissen Schwachsinns- und Neuroseformen.* Berlin: Richard Schoetz, 1928.

Hoepfner, Theodor. "Ergebnisse kapillarmikroskopischer Untersuchungen an 3100 Kasseler Schulkindern." *Deutsche Zeitschrift für Nervenheilkunde* 88 (1926): 218–226.

Hoffenberg, Peter H. *An Empire on Display. English, Indian, and Australian Exhibitions from the Crystal Palace to the Great War.* Berkeley, Los Angeles and London: University of California Press, 2001.

Huber, Hans Dieter. "Bildhafte Vorstellungen. Eine Begriffskartographie der Phantasie." In *Visuelle Netze. Wissensräume in der Kunst,* edited by Hans Dieter Huber, Bettina Lockemann and Michael Scheibel, 165–216. Ostfildern-Ruit: Hatje Cantz, 2001.

Hüppauf, Bernd. "Der Frosch im wissenschaftlichen Bild." In *Frosch und Frankenstein. Bilder als Medium der Popularisierung von Wissenschaft,* edited by Bernd Hüppauf and Peter Weingart, 137–164. Bielefeld: transcript, 2009.

Hutter, Michael. "Organism as a Metaphor in German Economic Thought." In *Natural Images in Economic Thought. "Markets Read in Tooth and Claw,"* edited by Philip Mirowski, 289–321. Cambridge: Cambridge University Press, 1994.

Ikeda, Yukihiro. "Carl Menger's Liberalism Revisited." In *Austrian Economics in Transition. From Carl Menger to Friedrich Hayek,* edited by Harald Hagemann, Tamotsu Nishizawa and Yukihiro Ikeda, 3–20. Basingstoke: Palgrave Macmillan, 2010.

Israel, Jonathan I. *The Dutch Republic: Its Rise, Greatness, and Fall 1477–1806.* Oxford: Oxford University Press, 1998.

Jackson, Mark. "Images of Deviance: Visual Representations of Mental Defectives in Early Twentieth-Century Medical Texts." *The British Journal for the History of Science* 28, no. 3 (1995): 319–337.

Jaensch, Walther. "Die Hautkapillarmikroskopie sowie die ersten Erkenntnisse über die Entwicklungsvorgänge an den Hautkapillaren und ihre psychophysiologischen Beziehungen." In *Die Hautkapillarmikroskopie. Ihre praktische Bedeutung für Diagnose und Therapie körperlich-seelischer Individualität im Zusammenhang mit dem Kropf- und Minderwertigkeitsproblem,* edited by Walther Jaensch, 6–46. Halle: Carl Marhold, 1929.

James, Douglas Hugh. "Portraits of John Hunter's Patients." *Medical Humanities* 39, no. 1 (2013): 11–19.

James, William. *The Principles of Psychology,* vol. 1. New York: Henry Holt, 1890.

Jensen, Erik N. *Body by Weimar. Athletes, Gender, and German Modernity.* Oxford: Oxford University Press, 2010.

Jordanova, Ludmilla. *Defining Features: Scientific and Medical Portraits 1660–2000.* London: Reaktion Books, 2000.

Jordanova, Ludmilla. "Medical Men 1780–1820." In *Portraiture: Facing the Subject,* edited by Joanna Woodall, 101–115. Manchester and New York: Manchester University Press, 1997.

Jordanova, Ludmilla. "Portraits, Patients and Practitioners." *Medical Humanities* 39, no. 1 (2013): 2–3.

Jordanova, Ludmilla. *Sexual Visions: Images of Gender in Science and Medicine between the Eighteenth and Twentieth Centuries.* Madison: University of Wisconsin Press, 1989.

Kahn, Anton Friedrich. *Anfangsgründe der Fechtkunst.* Göttingen: L. Schultze, 1739.

Kahneman, Daniel. *Thinking, Fast and Slow.* New York: Farrar, Straus and Giroux, 2012.

Kahneman, Daniel, Ed Diener and Norbert Schwarz, eds. *Well-Being: The Foundations of Hedonistic Psychology.* New York: Russell Sage Foundation, 1999.

Kamper, Dietmar. *Zur Geschichte der Einbildungskraft.* München: Carl Hanser, 1981.

Karger, Paul. "Die klinische Bedeutung des capillaroskopischen Bildes am Nagelfalz von Kindern." *Monatsschrift für Kinderheilkunde* 42 (1928): 292–296.

Kauffmann, Hans. "Rembrandt und die Humanisten vom Muiderkring." *Jahrbuch der Preußischen Kunstsammlungen* 41 (1920): 46–81.

Kearney, Hugh. *Science and Change 1500–1700.* London: Weidenfeld and Nicolson, 1971.

Kemp, Martin and Marina Wallace, eds. *Spectacular Bodies. The Art and Science of the Human Body from Leonardo to Now.* Hayward Gallery: University of California Press, 2000.

Kirsh, David. "Using Sketching: To Think, To Recognize, To Learn." In *Thinking Through Drawing: Practice into Knowledge. Proceedings of an Interdisciplinary Symposium on Drawing, Cognition and Education,* edited by Andrea Kantrowitz, Angela Brew and Michelle Fava, 123–125. New York: Teachers College, Columbia University, 2011.

Klages, Ludwig. *Ausdrucksbewegung und Gestaltungskraft.* Leipzig and Berlin: W. Engelmann, 1913.

Klages, Ludwig. *Handschrift und Charakter. Gemeinverständlicher Abriß der graphologischen Technik.* Leipzig: J.A. Barth, 1917.

Knapton, Sarah. "Have Scientists Found a Drug to Stop Alzheimer's Disease." *The Telegraph* (19 July 2015). http://www.telegraph.co.uk/news/science/science-news/11749641/Have-scientists-found-a-drug-to-stop-Alzheimers-disease.htm.

Knoeff, Rina. "Animals Inside: Anatomy, Interiority and Virtue in the Early Modern Dutch Republic." In *The Body Within. Art, Medicine and Visualization,* edited by Renée van de Vall and Robert P. Zwijenenberg, 31–50. Leiden: Brill, 2009.

Knoeff, Rina. *Hermann Boerhaave: Calvinist, Chemist and Physician.* Amsterdam: Edita KNAW, 2002.

Knorr Cetina, Karin. *Die Fabrikation von Erkenntnis. Zur Anthropologie der Naturwissenschaft.* Frankfurt/M: Suhrkamp, 1991.

Knudsen, Jonathan. *Justus Möser and the German Enlightenment.* Cambridge: Cambridge University Press, 1986.

König, Gudrun M. *Konsumkultur. Inszenierte Warenwelt um 1900.* Wien, Köln and Weimar: Böhlau, 2009.

Koschorke, Albrecht. *Körperströme und Schriftverkehr. Mediologie des 18. Jahrhunderts.* München: Fink, 2003.

Koslowski, Peter. "Economics as Ethical Economy." In *The Theory of Ethnical Economy in the Historical School. Wilhelm Roscher, Lorenz von Stein, Gustav Schmoller, Wilhelm Dilthey and Contemporary Theory*, edited by Peter Koslowski, 1–11. Berlin: Springer, 1994.

Krämer, Sybille. "Operative Bildlichkeit. Von der "Grammatologie" zu einer "Diagrammatologie". Reflexionen über erkennendes "Sehen."" In *Logik des Bildlichen. Zur Kritik der ikonischen Vernunft*, edited by Martina Hessler and Dieter Mersch, 94–122. Bielefeld: transcript, 2009.

Kravetz, Melissa. *Women Doctors in Weimar and Nazi Germany. Maternalism, Eugenics, and Professional Identity.* Toronto: University of Toronto Press, 2019.

Kretschmer, Winfried. *Geschichte der Weltausssstellungen.* Frankfurt/M: Campus, 1999.

Kristeva, Julia. "Holbein's Dead Christ." In *Black Sun: Depression and Melancholia.* Translated by Leon S. Roudiez, 105–138. New York: Columbia University Press, 1989.

Kromm, Jane and Susan Benforado Bakewell, eds. *A History of Visual Culture. Western Civilization from the 19th to the 21st Century.* Oxford and New York: Berg, 2010.

Kusukawa, Sachiko. *Picturing the Book of Nature. Image, Text, and Argument in Sixteenth-Century Human Anatomy and Medical Botany.* Chicago and London: University of Chicago Press, 2012.

Kutzer, Michael. *Anatomie des Wahnsinns. Geisteskrankheit im medizinischen Denken der frühen Neuzeit und die Anfänge der pathologischen Anatomie.* Hürtgenwald, Stuttgart: Guido Pressler, 1998.

Lacan, Jacques. *Les séminaire des Jacques Lacan, Livre III, Les psychoses (1955–1956)*, edited by Jacques-Alain Miller. Paris: Editions de Seuil, 1981.

Laidler, David and Nicholas Rowe. "Georg Simmel's Philosophy of Money: A Review Article for Economists." *Journal of Economic Literature* 18, no. 1 (1980): 97–105.

Lalvani, Suren. *Photography, Vision, and the Production of Modern Bodies.* Albany, NY: State University of New York, 1996.

Lamberty, Christiane. *Reklame in Deutschland 1890–1914. Wahrnehmung, Professionalisierung und Kritik der Wirtschaftswerbung.* Berlin: Duncker & Humblot, 2001.

Lang, Birgit. "Erich Wulffen and the Case of the Criminal." In *A History of the Case Study: Sexology, Psychoanalysis, Literature*, edited by Birgit Lang, Joy Damousi and Alison Lewis, 119–155. Manchester: Manchester University Press, 2017.

Latour, Bruno. *Pandora's Hope. Essays on the Reality of Science Studies.* Cambridge, MA: Harvard University Press, 1999.

Latour, Bruno. *We Have Never Been Modern.* Cambridge, MA: Harvard University Press, 2007.

Latour, Bruno and Steve Woolgar. *Laboratory Life: The Social Construction of Scientific Facts.* Beverly Hills: Sage Publications, 1979.

Lavater, Johann Caspar. *Essays on Physiognomy*. 3 vols., edited by Thomas Holloway, translated by Henry Hunter. London: J. Murray, 1789–98.

Layne, Jay Michael. *Uncanny Collapse: Sexual Violence and Unsettled Rhetoric in German-language Lustmord Representations, 1900–1933*. PhD dissertation, University of Michigan, 2008.

Lempa, Heikki. *Beyond the Gymnasium. Educating the Middle-Class Bodies in Classical Germany*. Lanham: Lexington Books, 2007.

Lenger, Friedrich. *Werner Sombart 1863–1941: Eine Biographie*. München: Beck, 1994.

Lieske, Pam. ""Made in Imitation of Real Women and Children": Obstetrical Machines in Eighteenth-Century Britain." In *The Female Body in Medicine and Literature*, edited by Andrew Mangham and Greta Depledge, 69–88. Liverpool: University of Liverpool Press, 2011.

Lindeboom, Gerrit Arie. *Descartes and Medicine*. Amsterdam: Rodopi, 1979.

Lindeboom, Gerrit Arie. *Dutch Medical Biography: A Biographical Dictionary of Dutch Physicians and Surgeons 1475–1975*. Amsterdam: Rodopi, 1984.

Lock, Margaret. "On Making Up the Good-as-Dead in a Utilitarian World." In *Remaking Life & Death. Toward an Anthropology of the Biosciences*, edited by Sarah Franklin and Margaret Lock, 165–192. Santa Fe and Oxford: School of American Research Press and James Curry, 2003.

Locke, John. *Essay Concerning Human Understanding* [1689]. New York: Dover, 1959.

Logan, Gabriella Berti. "Women and the Practice and Teaching of Medicine in Bologna in the Eighteenth and Early Nineteenth Centuries." *Bulletin of the History of Medicine* 77, no. 3 (2003): 506–535.

Londe, Albert. *La photographie dans les arts, les sciences et l'industrie*. Paris: Gauthier-Villars, 1888.

Looijen, Hans. "Outsider Art. The Inner Voice in Art." In *Outsider Art Museum: 2016 Catalogue*, edited by Hans Looijen, 11–17. Amsterdam: Outsider Art Museum, 2016.

Low, Gordon. "Paintings from the Cushing/Whitney Library of Yale University. The Eleventh Kenneth Fitzpatrick Russell Memorial Lecture 2012." *ANZ Journal of Surgery* 83, no. 12 (2013): 903–907.

Luckhurst, Roger. "Biomedical Horror: The New Death and the New Undead." In *Technologies of the Gothic in Literature and Culture*, edited by Justin D. Edwards, 84–98. New York and London: Routledge, 2015.

Luckhurst, Roger. *Zombies. A Cultural History*. London: Reaktion Books, 2015.

Lugon, Olivier. ""Photo-Inflation": Image Profusion in German Photography, 1925–1945." *History of Photography* 32, no. 3 (2008): 219–234.

Luhmann, Niklas. *Die Wissenschaft der Gesellschaft*. Frankfurt/M: Suhrkamp, 1990.

Lupton, Deborah. "Foucault and the Medicalization Critique." In *Foucault, Health and Medicine*, edited by Alan Petersen and Robin Bunton, 94–110. London and New York: Routledge, 1997.

Lüthy, Christoph and Alexis Smets. "Words, Lines, Diagrams, Images: Towards a History of Scientific Imagery." *Early Science and Medicine* 14, no. 1–3 (2009): 398–439.

Mace, Mary-Anne and Tony Ward. "Modeling the Creative Process: A Grounded Theory Analysis of Creativity in the Domain of Art Making." *Creativity Research Journal* 14, no. 2 (2002): 179–192.

Maerker, Anna. *Model Experts. Wax Anatomies and Enlightenment in Florence and Vienna, 1775–1815*. Manchester and New York: Manchester University Press, 2011.

Marr, Alexander. "Knowing Images." *Renaissance Quarterly* 69, no. 3 (2016): 1000–1013.

Martin, Craig. "Lodovico Settala's Aristotelian Problemata Commentary and Late-Renaissance Hippocratic Medicine." In *Early Modern Medicine and Natural Philosophy*, edited by Peter Distelzweig, Benjamin Goldberg and Evan R. Ragland, 19–42. Dordrecht, Heidelberg, New York and London: Springer, 2016.

Massey, Lyle. "On Waxes and Wombs: Eighteenth Century Representations of the Gravid Uterus." In *Ephemeral Bodies: Wax Sculpture and the Human Figure,* edited by Roberta Panzanelli, 83–105, LA: Getty Research Institute, 2008.

Mataja, Victor. *Die Reklame. Eine Untersuchung über Ankündigungswesen und Werbetätigkeit im Geschäftsleben*. Berlin: Duncker & Humblot, 1910.

Mazzeo, Joseph Anthony, ed. *Reason and the Imagination: Studies in the History of Ideas, 1600–1800*. New York: Columbia University Press, 1962.

Mbembe, Achille. "Necropolitics." Translated by Libby Meintjes. *Public Culture* 15, no. 1 (2003): 11–40.

McCloud, Scott. *Understanding Comics: The Invisible Art*. Northampton, MA: Kitchen Sink Press, 1993.

McGahagan, Thomas. *Cartesianism in the Netherlands 1639–1676: The New Science and the Calvinist Counter-Reformation*. PhD dissertation, University of Pennsylvania, 1976.

Mendelsohn, Andrew. *Cultures of Bacteriology. Formation and Transformation of a Science in France and Germany, 1870–1914*. PhD dissertation, Princeton University, 1996.

Messbarger, Rebecca. *The Lady Anatomist: The Life and Work of Anna Morandi Manzolini*. Chicago and London: University of Chicago Press, 2010.

Michalski, Sergiusz. *New Objectivity. Painting, Graphic Art and Photography in Weimar Germany 1919–1933*. Cologne: Taschen, 1994.

Middelkoop, Norbert, Petria Noble, Jørgen Waldun and Ben Broos. *Rembrandt under the Scalpel: The Anatomy Lesson of Dr Nicolaes Tulp Dissected*. Mauritshuis, the Hague: Six Art Promotion Amsterdam, 1994.

Miert, Dirk van. *Humanism in an Age of Science: The Amsterdam Athenaeum in The Golden Age, 1632–1704*. Leiden and Boston: Brill, 2009.

Mirzoeff, Nicholas, ed. *The Visual Culture Reader*. London and New York: Routledge, 1998.

Mitchell, William John Thomas. *Picture Theory: Essays on Verbal and Visual Representation*. Chicago: University of Chicago Press, 1994.

Morand, Sauveur-François. *Catalogue des Bronzes et autres curiosités*. Paris: Rémy, 1773.

Morgenthaler, Walter. *Ein Geisteskranker als Künstler. Adolf Wölfli*. Wien and Berlin: Medusa Verlag, 1985 [1921].

Mosse, George. *The Image of Man. The Creation of Modern Masculinity*. Oxford: Oxford University Press, 1996.

Müller, Irmgard and Daniela Watzke. "Gebrauch und Missbrauch der Einbildungskraft in der Medizin des 17. und 18. Jahrhunderts." In *Ordnungen des Imaginären. Theorien der Imagination in funktionsgeschichtlicher Sicht*, edited by Rudolf Behrens, 89–115. Hamburg: Meiner, 2002.

Müller, Otfried. *Die Kapillaren der menschlichen Körperoberfläche in gesunden und kranken Tagen*. Stuttgart: Ferdinand Enke, 1922.

Müller, Otfried and Walther Parrisius. *Die Blutdruckkrankheit. Klinische, erbbiologische, anthropometrische, biochemische, histologische, kapillarmikroskopische und andere Untersuchungen am Blutumlauf bei Hypertonikern*. Stuttgart: Ferdinand Enke, 1932.

Murnane, Barry. "George Best's Dead Livers. Transplanting the Gothic into Biotechnology and Medicine." In *Technologies of the Gothic in Literature and Culture*, edited by Justin D. Edwards, 113–126. New York and London: Routledge, 2015.

Murphy, Richard J. "Berlin: Expressionism, Dada, Neue Sachlichkeit." In *The Oxford Handbook of Modernisms*, edited by Peter Brooker, Andrzej Gasiorek, Deborah Longworth and Andrew Thacker, 660–686. Oxford and New York: Oxford University Press, 2010.

Neuber, Wolfgang. "Locus, Lemma, Motto. Entwurf zu einer mnemonischen Emblematiktheorie." In *Ars memorativa. Zur kulturgeschichtlichen Bedeutung der Gedächtniskunst 1400–1750*, edited by Wolfgang Neuber and Jörg Jochen Berns, 351–372. Tübingen: Niemeyer, 1993.

Nielsen, Johannes. *Ovartaci. Pictures, Thoughts and Visions of an Artist*. Ovartaci Fonden: Risskov, 2005.

Nietzsche, Friedrich. *Twilights of the Idols*. Translated by R.J Hollingdale. Harmondsworth: Penguin, 1968.

Nolan, Lawrence, ed. *The Cambridge Descartes Lexicon*. Cambridge: Cambridge University Press, 2016.

Nuijens, B.W.Th. "Het ontleedkundig onderwijs en de geschilderde anatomische lessen van het Chirurgijns Gilde te Amsterdam, in de jaren 1550 tot 1798." In *Jaarverslag von het Koninklijk Oudheidkundig Genootschap te Amsterdam, 70* (1928): 45–90, https://www.dbnl.org/tekst/_jaa017192801_01/.

Nutton, Vivian. "The Rise of Medicine." In *The Cambridge History of Medicine*, edited by Roy Porter, 46–70. Cambridge: Cambridge University Press, 2006.

Orvell, Miles. *The Real Thing: Imitation and Authenticity in American Culture, 1880–1940*. Chapel Hill: University of North Carolina Press, 2014.

Paquet, Alfons. *Das Ausstellungsproblem in der Volkswirtschaft*. Jena: Gustav Fischer, 1908.

Parker, William Rushton, T. Telford-Smith, John Thomson, Victor Horsley, Fletcher Beach and G.E. Shuttleworth, eds. *A Discussion on Sporadic Cretinism in this Country*. London: British Medical Association, 1896.

Pasch, Johann. *Beschreibung wahrer Tanz-Kunst, Nebst einigen Anmerckungen über Herrn J.C.L.P.P. zu G. Bedencken gegen das Tanzen* (1707). Munich: Reimer Verlag, 1978.

Pater, C. De. "Experimental Physics." In *Leiden University in the Seventeenth Century*, edited by Th.H. Lunsingh Scheurleer and G.H.M. Posthumus Meyjes, 309–328. Leiden: Brill, 1975.

Perlove, Shelley and Larry Silver. *Rembrandt's Faith: Church and Temple in the Dutch Golden Age*. University Park, PA: Pennsylvania State University Press, 2009.

Peters, Olaf. ""Painting, A Medium of Cool Execution": Otto Dix and Lustmord." In *Otto Dix*, edited by Olaf Peters, 92–107. Munich, Berlin, London and New York: Prestel, 2010.

Phillipps, James and James Morley, eds. *Imagination and Its Pathologies*. Cambridge and London: MIT Press, 2003.

Phu, Thy and Linda M. Steer. "Introduction." *Photography & Culture* 2, no. 3 (2009): 235–240.

Pitts-Taylor, Victoria. "The Plastic Brain: Neoliberalism and the Neuronal Self." *Health* 14, no. 6 (2010): 635–652.

Plakate in München 1840–1940. Eine Dokumentation zu Geschichte und Wesen des Plakats in München aus den Beständen der Plakatsammlung des Münchner Stadtmuseums. Katalog zur Ausstellung 16. Oktober 1975 – 6. Januar 1976. München: K.M. Lipp, 1975.

Plato, Alice von. *Präsentierte Geschichte. Ausstellungskultur und Massenpublikum im Frankreich des 19. Jahrhunderts*. Frankfurt/M and New York: Campus, 2001.

Platter, Felix. *Observationes. Krankheitsbeobachtungen in Drei Büchern. I. Buch: Funktionelle Störungen des Sinnes und der Bewegung* [1614]. Bern and Stuttgart: Verlag Hans Huber, 1963.

Poirier, Jean-Pierre. *Histoire des femmes de science en France: Du Moyen Age à la Révolution*. Paris: Pygmalion, 2002.

Porter, Roy, ed. *The Cambridge History of Medicine*. Cambridge: Cambridge University Press, 2006.

Porter, Roy. "The Patient's View: Doing Medical History from Below." *Theory and Society* 14, no. 2 (1985): 175–198.

Pototzky, Carl. "Die klinischen Ergebnisse der Kapillaroskopie bei neuropathischen und geistesschwachen Kindern." *Monatsschrift für Psychiatrie und Neurologie* 69 (1928): 188–199.

Prasad, Amit. "Making Images/Making Bodies: Visiblizing and Disciplining through Magnetic Resonance Imaging (MRI). *Science, Technology, & Human Values* 30, no. 2 (2005): 291–316.

Prince, J.B. et al. "A Controlled Study of Nortriptyline in Children and Adolescents with Attention Deficit Hyperactivity Disorder." *Journal of Child and Adolescent Psychopharmacology* 10, no. 3 (2000): 193–204.

Prinzhorn, Hans. *Bildnerei der Geisteskranken. Ein Beitrag zur Psychologie und Psychopathologie der Gestaltung.* Wien and New York: Springer-Verlag, 1994 [1922].

Prodger, Phillip. *Darwin's Camera: Art and Photography in the Theory of Evolution.* Oxford: Oxford University Press, 2009.

Queiroz Campos, Daniela and Maria Bernardete Ramos Flores. "Nude Venus: Nudity Between Modesty and Horror." *Revista Brasileira de Estudos da Presença* 8, no. 2 (2018): 248–276.

Rachman, Stephen. "Memento Morbi: Lam Qua's Paintings, Peter Parker's Patients." *Literature and Medicine* 23, no. 1 (2004): 134–159.

Rancière, Jacques. *Aisthesis. Scenes from the Aesthetic Regime of Art.* London: Verso, 2017.

Redner, Harry. *A New Science of Representation: Towards an Integrated Theory of Representation in Science, Politics and Art.* Boulder: Westview Press, 1994.

Reiss, Archibald. *Manuel de police scientifique (technique).* Préface de Louis Lépine. Lausanne: Payot, 1911.

Rejlander, Oscar. *Realism, Photography and Nineteenth-Century Fiction.* Cambridge: Cambridge University Press, 2008.

Renshaw, Michelle Campbell. *Accommodating the Chinese: The American Hospital in China, 1880–1920.* London: Routledge, 2005.

Repp, Kevin. "Marketing, Modernity, and the "German People's Soul."" In *Selling Modernity: Advertising in Twentieth-Century Germany,* edited by Pamela E. Swett, S. Jonathan Wiesen and Jonathan R. Zatlin, 27–51. Durham and London: Duke University Press, 2007.

Repp, Kevin. *Reformers, Critics, and the Paths of German Modernity: Anti-Politics and the Search for Alternatives, 1890–1914.* Boston, MA.: Harvard University Press, 2000.

Revius, Jacobus. *Methodi Cartesianae.* Leiden: P. Leffen, 1648.

Rhodes, Colin. *Outsider Art: Spontaneous Alternatives.* New York: Thames & Hudson, 2000.

Rifkin, Benjamin A. "The Art of Anatomy." In *Human Anatomy. Depicting the Body from the Renaissance to Today,* edited by Benjamin A. Rifkin, Michael F. Ackerman and Judith Folkenberg, 6–68. London: Thames & Hudson, 2017 [2006].

Riskin, Jessica. *Science in the Age of Sensibility: The Sentimental Empiricists of the French Enlightenment.* Chicago: Chicago University Press, 2002.

Rosand, David. "Titian's Dutch Disciple." In *Rembrandt and the Venetian Influence,* edited by Kenneth Clark, Frederick Ilchman and David Rosand, 9–22. New York: Salander-O'Reilly Galleries, 2000.

Rose, Gillian. *Visual Methodologies: An Introduction to the Interpretation of Visual Materials.* London: Sage, 2nd ed. 2007 and 3rd ed. 2012.

Rose, Nikolas. *The Politics of Life Itself. Biomedicine, Power, and Subjectivity in the Twenty-First Century*. Princeton and Oxford: Princeton University Press, 2007.

Röske, Thomas. "Wahnsinn sammeln/Collecting Madness." In *Wahnsinn sammeln: Outsider Art aus der Sammlung Dammann/Collecting Madness: Outsider Art from the Dammann Collection*, edited by Thomas Röske, Bettina Brand-Claussen and Gerhard Dammann, 10–21. Heidelberg: Wunderhorn, 2006.

Röske, Thomas and Ingrid von Beyme, eds. *Surrealismus und Wahnsinn/Surrealism and Madness*. Heidelberg: Wunderhorn, 2009.

Rousseau, George. *Nervous Acts: Essays on Literature, Culture and Sensibility*. Basingstoke: Palgrave Macmillan, 2004.

Roux, Johann Adam Karl. *Gründliche und vollständige Anweisung in der deutschen Fecht-Kunst auf Stoss und Hieb*. Jena: Wolfgang Stahls Buchhandlung, 1798.

Ruler, J.A. van. *The Crisis of Causality: Voetius and Descartes on God, Nature and Change*. Leiden: Brill, 1995.

Ruppert, Wolfgang, ed. *Fahrrad, Auto, Fernsehschrank. Zur Kulturgeschichte der Alltagsdinge*. Frankfurt/M: Fischer Verlag, 1993.

Ruskin, John. *Modern Painters I* in *Works of John Ruskin*, vol. 3, edited by E.T. Cook and Alexander Wedderburn. London: G. Allen, 1903.

Salzmann, Christian Gotthilf. *Nachrichten aus Schnepfenthal für Eltern und Erzieher*, vol. 1. Leipzig: Siegfried Lebrecht Crusius, 1786.

Salzmann, Christian Gotthilf. *Nachrichten aus Schnepfenthal für Eltern und Erzieher*, vol. 2. Leipzig: Siegfried Lebrecht Crusius, 1788.

Salzmann, Christian Gotthilf. "Noch etwas über die Erziehung nebst Ankündigung einer Erziehungsanstalt." In *Ch. G. Salzmann. Ausgewählte Schriften. Mit Salzmanns Lebensbeschreibung*, vol. 2. Langensalza: Verlag von Hermann Beyer & Söhne, 1901.

Salzmann, Christian Gotthilf. *Reisen der Salzmannischen Zöglinge*, vol. 6. Leipzig: Siegfried Lebrecht Crusius, 1793.

San Juan, Rose Marie. "The Turn of the Skull: Andreas Vesalius and the Early Modern Memento Mori." *Art History* 35, no. 5 (2012): 958–975.

Sawday, Jonathan. *The Body Emblazoned. Dissection and the Human Body in Renaissance Culture*. London and New York: Routledge 1995.

Schama, Simon. *Rembrandt's Eyes*. New York: Knopf, 1999.

Scheerer, Wilhelm. *Die Turn-Fehde, oder: Wer hat Recht?* Berlin: Krause, 1818.

Schick, Karin. *Otto Dix. Hommage à Martha*. Ostfildern-Ruit: Hatje Cantz, 2005.

Schillace, Brandy. "Of Manikins and Machines: The Evolution of Obstetrical Phantoms." Dittrick Medical History Center. Case Western Reserve University, 26 October 2017. http://artsci.case.edu/dittrick/2013/10/15/of-manikins-and-machines-the-evolution-of-obstetrical-phantoms.

Schiller, Friedrich. *Sämtliche Werke*, vol. 5. Munich: Hanser, 1959.

Schindler, Herbert. *Monographie des Plakats. Entwicklung, Stil, Design.* München: Süddeutscher Verlag, 1972.

Schlich, Thomas. "Repräsentation von Krankheitserregern. Wie Robert Koch Bakterien als Krankheitserreger dargestellt hat." In *Räume des Wissens. Repräsentation, Codierung, Spur*, edited by Hans-Jörg Rheinberger, Michael Hagner and Bettina Wahrig-Schmidt, 165–190. Berlin: Akademie Verlag, 1997.

Schmaltz, Tad M. "The Early Dutch Reception of *L'Homme*." In *Descartes' Treatise on Man and Its Reception*, edited by Delphine Antoine-Mahut and Stephen Gaukroger, 71–90. Dordrecht: Springer, 2016.

Schmitt, Hanno. *Vernunft und Menschlichkeit: Studien zur philanthropischen Erziehungsbewegung.* Bad Heilbrunn: Klinkhardt, 2007.

Schmoller, Gustav. "Studien über die wirtschaftliche Politik Friedrichs des Großen und Preußens überhaupt von 1680–1768." *Jahrbuch für Gesetzgebung, Verwaltung und Volkswirtschaft im Deutschen Reich* (1884): 15–61.

Schmoller, Gustav. "Zur Methodologie der Staats- und Sozialwissenschaften." *Jahrbuch für Gesetzgebung, Verwaltung und Volkswirtschaft im Deutschen Reich* 7 (1883): 1373–1382.

Schneede, Uwe M., ed. *George Grosz. Leben und Werk.* Stuttgart: Gerd Hatje, 1975.

Schneider, Klaus. *Natur, Körper, Kleider, Spiel. Johann Joachim Winckelmann. Studien zu Körper und Subjekt im späten 18. Jahrhundert.* Würzburg: Verlag Königshausen & Neumann, 1994.

Schnitzler, Norbert. *Ikonoklasmus: Bildersturm. Theologischer Bilderstreit und ikonoklastisches Handeln während des 15. und 16. Jahrhunderts.* München: Fink, 1996.

Schoeller, Wilfried F. *Ernst Litfaß. Der Reklamekönig.* Frankfurt/M: Schöffling & Co., 2005.

Schreber, Daniel Paul. *Denkwürdigkeiten eines Nervenkranken, nebst Nachträgen und einem Anhang über die Frage: "Unter welchen Voraussetzungen darf eine für geisteskrank erachtete Person gegen ihren erklärten Willen in einer Heilanstalt festgehalten werden?".* Leipzig: Mutze, 1903.

Schröder, Willi. *Johann Christoph GutsMuths. Leben und Wirken des Schnepfenthaler Pädagogen.* Sankt Augustin: Academia Verlag, 1996.

Schulak, Eugen Maria and Herbert Unterköfler. *The Austrian School of Economics. A History of Its Ideas, Ambassadors, and Institutions.* Auburn, AL: Ludwig von Mises Institute, 2011.

Schupbach, William. *The Paradox of Rembrandt's "Anatomy of Dr Tulp."* London: Wellcome Institute, 1982.

Schwartz, Gary. *Rembrandt: His Life, His Paintings.* New York: Viking, 1985.

Searle, John R. "Is the Brain a Digital Computer?" *Proceedings and Addresses of the American Philosophical Association* 64, no. 3 (1990): 21–37.

Sebald, W.G. *The Rings of Saturn*. Translated by Michael Hulse. New York: New Directions, 1998.

Sellberg, Karin and Ann Sellberg. "Fluid Fat: Considerations of Culture and Corporeality." In *Bodily Fluids*, edited by Karin Sellberg, Kamillea Aghtan and Michael O'Rourke. Special issue of *InterAlia: A Journal of Queer Studies* 9 (2014): 304–318.

Seltin, Jon. "Production of the Posthuman: Political Economies of Bodies and Technology." *Parrhesia* 8 (2009): 43–59.

Sepper, Dennis L. *Understanding Imagination: The Reason of Images*. Dordrecht: Springer, 2013.

Shaviro, Steve. "Capitalist Monsters." *Historical Materialism* 10, no. 4 (2002): 281–290.

Sheehan, Tanya. *Doctored: The Medicine of Photography in Nineteenth-Century America*. University Park, PA: Pennsylvania State University Press, 2011.

Siegrist, Hannes, Hartmut Kaelble and Jürgen Kocka, eds. *Europäische Konsumgeschichte. Zur Gesellschafts- und Kulturgeschichte des Konsums. (18. bis 20. Jahrhundert)*. Frankfurt/M: Campus, 1997.

Siemens, Daniel. "Explaining Crime. Berlin Newspapers and the Construction of the Criminal in Weimar Germany." *Journal of European Studies* 39, no. 3 (2009): 336–352.

Siraisi, Nancy G. *The Clock and the Mirror. Girolamo Cardano and Renaissance Medicine*. Princeton: Princeton University Press, 1997.

Sombart, Werner. "Die Ausstellung." *Morgen. Wochenschrift für deutsche Kultur* 9 (1908): 249–256.

Sombart, Werner. "Ihre Majestät die Reklame." *Die Zukunft* 63 (1908): 475–487.

Sombart, Werner. *Warum gibt es in den Vereinigten Staaten keinen Sozialismus?* Tübingen: J.C.B. Mohr, 1906.

Sommers, Sheena. "Transcending the Sexed Body: Reason, Sympathy, and "Thinking Machines" in the Debates over Male Midwifery." In *The Female Body in Medicine and Literature*, edited by Andrew Mangham and Greta Delpledge, 89–106, Liverpool: Liverpool University Press 2011.

Sontag, Susan. "The Imagination of Disaster." In *Film Theory and Criticism*, edited by Gerald Mast and Marshall Cohen, 422–437. Oxford: Oxford University Press, 1974.

Spooner, Catherine. *Post-Millennial Gothic. Comedy, Romance and the Rise of Happy Gothic*. London: Bloomsbury, 2017.

Squier, Susan Merrill, Irmela Marei Krüger-Fürhoff, Uta Kornmeier, Nina Schmidt and stef lenk. *Sick! Kranksein im Comic / Reclaiming Illness through Comics* [ebook]. Berlin: PathoGraphics project / Freie Universität, 2017.

Stafford, Barbara Maria. *Artful Science. Enlightenment, Entertainment and the Eclipse of Visual Education*. Cambridge: MIT Press, 1994.

Stafford, Barbara Maria. *Body Criticism. Imaging the Unseen in Enlightenment Art and Medicine*. Cambridge: MIT Press, 1991.

Stead, William Jr. *The Art of Advertising: Its Theory and Practice Fully Described.* London: T.B. Browne, 1899.

Steadman, Philip. "Allegory, Realism, and Vermeer's Use of the Camera Obscura." *Early Science and Medicine* 10, no. 2 (2005): 287–314.

Steadman, Philip. *Vermeer's Camera: Uncovering the Truth Behind the Masterpieces.* Oxford: Oxford University Press, 2001.

Steffens, Henrich. *Caricaturen des Heiligsten*, vol. 1. Leipzig: Brockhaus, 1819: 411–451.

Stein, Claudia and Roger Cooter. "Coming into Focus: Posters, Power, and Visual Culture in the History of Medicine." In *Writing History in the Age of Biomedicine*, Roger Cooter with Claudia Stein, 112–137. New Haven: Yale University Press, 2013.

Steiner, Gary. "The Cultural Significance of Rembrandt's "Anatomy Lesson of Dr. Nicolaas Tulp."" *History of European Ideas* 36, no. 3 (2010): 273–279.

Steiner, Wendy. *Venus in Exile. The Rejection of Beauty in Twentieth-Century Art.* New York: Free Press, 2001.

Stephens, Elizabeth. *Anatomy as Spectacle: Public Exhibitions of the Body from 1700 to the Present.* Liverpool: Liverpool University Press, 2011.

Stephens, Elizabeth. "Inventing the Bodily Interior: *Écorché* Figures in Early Modern Anatomy and von Hagens' *Body Worlds.*" *Social Semiotics* 17, no. 3 (2007): 313–326.

Sterne, Laurence. *A Sentimental Journey.* Edited by Ian Jack and Tim Parne. Oxford: Oxford University Press, 2008.

Stetler, Pepper. "The Object, the Archive and the Origins of "Neue Sachlichkeit" Photography." *History of Photography* 35, no. 3 (2011): 281–295.

Stoichita, Victor. *L'Instauration du Tableau: métapeinture à l'aube des temps modernes.* Paris: Meridiens Klincksieck, 1993.

Stokoe, Brian. "The Landscape Photobook in Germany: From Neue Sachlichkeit to Nazi Sachlichkeit." *History of Photography* 42, no. 1 (2018): 78–97.

Stolberg, Michael. *Die Harnschau. Eine Kultur- und Alltagsgeschichte.* Köln: Böhlau, 2009.

Stone, Sarah. *A Complete Practice of Midwifery.* London: T. Cooper 1737.

Sunstein, Cass R. *Simpler: The Future of Government.* New York: Simon and Schuster, 2013.

Sunstein, Cass R. *Why Nudge? The Politics of Libertarian Paternalism.* New Haven: Yale University Press, 2015.

Tagg, John. *The Burden of Representation: Essays on Photographies and Histories.* London: Palgrave Macmillan, 1988.

Tam, Laurence C.S. "Preface" *Late Qing China Trade Paintings*, edited by Laurence C.S. Tam. Hong Kong: Hong Kong Museum of Art, 1982.

Tatar, Maria. *Lustmord. Sexual Murder in Weimar Germany.* Princeton, NJ: Princeton University Press, 1995.

Telford-Smith, T. "The Thyroid Treatment of Cretinism and Imbecility in Children." In *A Discussion on Sporadic Cretinism in this Country*, edited by William Rushton Parker, T. Telford-Smith, John Thomson, Victor Horsley, Fletcher Beach and G.E. Shuttleworth, 4–7. London: British Medical Association, 1896.

Temkin, Owsei. "Introduction." *Bulletin of the History of Medicine* 4 (1936): 651–699.

Teresi, Dick. *The Undead*. New York: Vintage, 2012.

Terry, James S. "Dissection Room Portraits: Decoding an Underground Genre." *History of Photography* 7, no. 2 (1983): 96–98.

Thacker, Eugene. *Biomedia*. Minneapolis and London: University of Minnesota Press, 2004.

Thaler, Richard H. *Misbehaving: The Making of Behavioral Economics*. London: Penguin, 2015.

Thaler, Richard H. and Cass R. Sunstein, *Nudge: Improving Decisions About Health, Wealth, and Happiness*. London: Penguin, 2009.

The Frick Collection. The Montias Database of 17th Century Dutch Art Inventories. http://www.research.frick/org/montias/browserecord.php.

Thompson, James. "Pictorial Lies? Posters and Politics in Britain, c.1880–1914." *Past and Present* 197, no. 1 (2007): 177–210.

Thomson, John. "The Variations in, and the Limits of, the Improvement of Cretins at Different Ages under Thyroid Treatment." In *A Discussion on Sporadic Cretinism in this Country*, edited by William Rushton Parker, T. Telford-Smith, John Thomson, Victor Horsley, Fletcher Beach and G.E. Shuttleworth, 7–13. London: British Medical Association, 1896.

Tilstone, William J., Kathleen Anne Savage and Leigh A. Clark. *Forensic Science: An Encyclopedia of History, Methods, and Techniques*. Santa Barbara, CA: ABC-Clio, 2006.

Ting, Joseph S.P. "Late Qing China Trade Paintings." In *Late Qing China Trade Paintings*, edited by Laurence C.S. Tam, 8–11. Hong Kong: Hong Kong Museum of Art, 1982.

Tomes, Nancy. *The Gospel of Germs: Men, Women, and the Microbe in American Life*. Cambridge, MA: Harvard University Press, 1998.

Tomkins, Silvan S. *Affect, Imagery, Consciousness. Volume II: The Negative Affects*. New York: Springer, 1963.

Treitel, Corinna. "Max Rubner and the Biopolitics of Rational Nutrition." *Central European History* 41, no. 1 (2008): 1–25.

Trent, James W. *Inventing the Feeble Mind. A History of Mental Retardation in the United States*. Berkeley: University of California Press, 1995.

Trepp, Anne-Charlott. *Sanfte Männlichkeit und selbständige Weiblichkeit. Frauen und Männer im Hamburger Bürgertum zwischen 1770 und 1840*. Göttingen: Vandenhoeck & Ruprecht, 1996.

Treves, Frederick. *The Elephant Man and Other Reminiscences*. London: Cassell & Co., 1923.

Tümpel, Astrid and Christian Tümpel. *Rembrandt: Images and Metaphors*. London: Haus Publishing, 2006.

Tümpel, Christian. "Ikonographische Beiträge zu Rembrandt." *Jahrbuch der Hamburger Kunstsammlung* 13 (1968): 95–126.

Ueyama, Takahiro. *Health in the Marketplace: Professionalism, Therapeutic Desires, and Medical Commodification in Late-Victorian London*. Palo Alto, California: Society for the Promotion of Science and Scholarship, 2010.

Ullmann, Hans-Peter. ""Der Kaiser bei Wertheim." Warenhäuser im wilhelminischen Deutschland." In *Europäische Sozialgeschichte. Festschrift für Wolfgang Schieder*, edited by Christof Dipper, Lutz Klinkhammer and Alexander Nützenadel, 223–236. Berlin: Duncker & Humblot, 2000.

Vall, Renée van de and Robert Zwijnenberg, eds. *The Body Within: Art, Medicine and Visualization*. Leiden and Boston: Brill, 2009.

Valsiner, Jaan. "Culture in Minds and Societies: Foundations of Cultural Psychology." *Psychological Studies* 54 (2007): 238–239.

Veegaete, Tim vande. *Naweeën van een concentratiekamp. De humanitaire missie van Belgische studenten geneeskunde te Bergen-Belsen*. PhD dissertation, Ghent University, 1989.

Verbeek, Theo. *Descartes and the Dutch: Early Reactions to Cartesian Philosophy 1637–1650*. Carbondale and Edwardsville: Southern Illinois University Press, 1992.

Vesalius, Andreas. *De humani corporis fabrica libri septem*. Basle, 1543.

Vesalius, Andreas. *On the Fabric of the Human Body. Book I. The Bones and Cartilages* [1543], edited by William Frank Richardson in collaboration with John Burd Carman. San Francisco: Norman Publishing, 1998.

Vieth, Gerhard Ulrich Anton. *Versuch einer Encyklopädie der Leibesübungen*, vol. 2, *System der Leibesübungen*. Berlin: Carl Ludwig Hartmann, 1795.

Vietta, Silvio. *Literarische Phantasie: Theorie und Geschichte. Barock und Aufklärung*. Stuttgart: Metzler, 1986.

Visser t'Hooft, Willem Adolph. *Rembrandt and the Gospel*. Translated by K. Gregor Smith. London: SCM Press, 1957.

Vita-More, Natasha. "Radical Body Design "Primo Posthuman."" (2002). http//:www.kurzweil.net/radical-body-design-primo-posthuman.

Vita-More, Natasha. "The New[human] Genre. Primo [first] Posthuman." http//:www.natasha.cc/paper.html.

Vollée, M. de la. "Art in China." *Bulletin of the American Art Union* (October 1850): 118–119.

Wagner, Corinna. "Replicating Venus: Art, Anatomy, Wax Models, and Automata." *19: Interdisciplinary Studies in the Long Nineteenth Century* 24 (2017): 1–27.

Wagner, Corinna. "Visual Translations: Medicine, Art, China and the West." *Fudan Journal of the Humanities and Social Sciences* 8, no. 2 (2015): 1–44.

Wagner, Darren N. *Sex, Spirits, and Sensibility: Human Generation in British Medicine, Anatomy, and Literature, 1660–1780.* PhD dissertation, University of York, 2013.

Wall, Ernestine van der. "Cartesianism and Cocceianism: A Natural Alliance?" In *De l'humanisme aux Lumières, Bayle et le protestantisme. Mélanges en l'honneur d'Elisabeth Labrousse,* edited by Michelle Magdelaine et al., 445–455. Paris: Voltaire Foundation, 1996.

Wall, Ernestine van der. "The Religious Context of the Early Dutch Enlightenment: Moral Religion and Society." In *The Early Enlightenment in the Dutch Republic, 1650–1750,* edited by Wiep van Bunge, 39–57. Leiden: Brill, 2003.

Wallas, Graham. *Human Nature in Politics.* London: A. Constable & Co., 1908.

Warner, John Harley. "Witnessing Dissection: Photography, Medicine, and American Culture." Introduction to *Dissection: Photographs of a Rite of Passage in American Medicine: 1880–1930,* edited by John Harley Warner and James M. Edmonson, 7–29. New York: Blast Books, 2009.

Warner, John Harley and James M. Edmonson. *Dissection: Photographs of a Rite of Passage in American Medicine, 1880–1930.* New York: Blast Books, 2009.

Warren, Edward. *The Life of John Collins Warren, M.D.* Boston: Ticknor and Fields, 1860.

Wasson, Sara. "A Butcher's Shop where the Meat Still Moved: Gothic Doubles, Organ Harvesting, and Human Cloning." In *Gothic Science Fiction 1980–2010,* edited by Sara Wasson and Emily Alder, 73–86. Liverpool: Liverpool University Press, 2011.

Watson, Katie. "Gallows Humor in Medicine." *The Hastings Center Report* 41, no. 5 (2011): 37–45.

Waugh, Patricia. "Writing the Body. Modernism and Postmodernism." In *The Body and the Arts,* edited by Corinne Saunders, Ulrika Maude and Jane Macaughton, 131–147. London: Palgrave, 2009.

Wehler, Hans-Ulrich. *Das Deutsche Kaiserreich 1871–1918,* 7th ed. Göttingen: Edition Suhrkamp, 1994.

Weidig, Ursula. "GutsMuths-Bibliographie." In *Festschrift zum 200. Geburtstage von Johann Christoph Friedrich GutsMuths,* 97–98. S.l.: Ministerrat der Deutschen Demokratischen Republik, 1959.

Weindling, Paul. *Health, Race and German Politics Between National Unification and Nazism, 1870–1945.* Cambridge: Cambridge University Press, 1989.

Weller, Christiane. "Adolf Wölfli." In *Praktizierte Intermedialität. Deutsch-französische Porträts von Schiller bis Goscinny/Uderzo,* edited by Fernand Hörner, Harald Neumeyer and Bernd Stiegler, 53–67. Berlin: transcript, 2010.

Weller, Christiane. "Die Avantgarde in der Heilanstalt: die Entgrenzung des Wahns und der Kunst." In *Kulturrebellen — Studien zur anarchistischen Moderne,* edited by Christine Magerski and David Roberts, 99–115. Wiesbaden: Springer VS, 2019.

Welsch, Wolfgang. *Undoing Aesthetics.* London: Sage, 1997.

Wernli, Martina. *Schreiben am Rand. Die "Bernische kantonale Irrenanstalt Waldau" und ihre Narrative (1895–1936).* Bielefeld: transcript, 2014.

West, Shearer. *Portraiture.* Oxford: Oxford University Press, 2004.

Westermann, Mariet. *Rembrandt.* London: Phaidon, 2000.

Wetzell, Richard F. *Inventing the Criminal. A History of German Criminology, 1880–1945.* London, Chapel Hill: The University of North Carolina Press, 2000.

Wheelock Jnr, Arthur K. with Peter C. Sutton. *Rembrandt's Late Religious Portraits.* Chicago: University of Chicago Press, 2005.

White, Christopher. *Rembrandt.* New York: Thames and Hudson, 1984.

White, Howard. "Rembrandt and the Human Condition." *Interpretation*, No. 4 (1974): 17–37.

White, Jon. "Fat is a Beautiful Organ." *New Scientist Issue* 2873 (14 July 2012). https://www.newscientist.com/article/mg21528736-100-fat-is-a-beautiful-organ.

Whitford, Frank. *The Berlin of George Grosz. Drawings, Watercolours and Prints 1912–1930.* New York and New Haven: Yale University Press, 1997.

Wieninger, Karl. *Max Pettenkofer: Das Leben eines Wohltäters.* München: Hugendubel, 1987.

Wilson, Adrian. *The Making of Man-Midwifery: Childbirth in England, 1660–1770.* Cambridge, MA: Harvard University Press, 1995.

Wilson, Alexander. "Pragmatics of Raw Art: (For the Post-Autonomy Paradigm)." In *Deleuze and the Schizoanalysis of Visual Art*, edited by Ian Buchanan and Lorna Collins, 57–76. London: Bloomsbury Publishing, 2014.

Wimmer, Wolfgang. *"Wir haben fast immer was neues." Gesundheitswesen und Innovationen der Pharma-Industrie in Deutschland, 1880–1935.* Berlin: Duncker & Humblot, 1995.

Winau, Rolf, ed. *Technik und Medizin.* Düsseldorf: VDI-Verlag, 1993.

Winckelmann, Johann Joachim. "Erläuterung der Gedanken von der Nachahmung der griechischen Werke in der Malerei und Bildhauerkunst." In *Gedanken über die Nachahmung der griechischen Werke in der Malerei und Bildhauerkunst.* Stuttgart: Reclam, 1999.

Winckelmann, Johann Joachim. *Reflections on the Imitation of Greek Works in Painting and Sculpture.* Translated by Elfriede Heyer and Roger C. Norton. La Salle: Open Court, 1987.

Wities, Bernhard. "Das Wirkungsprinzip der Reklame." *Zeitschrift für Philosophie und philosophische Kritik* 128 (1906): 138–154.

Wittneben, Wilhelm. "Die Therapie der kapillarstigmatisierten Entwicklungsstörungen." In *Die Hautkapillarmikroskopie. Ihre praktische Bedeutung für Diagnose und Therapie körperlich-seelischer Individualität im Zusammenhang mit dem Kropf- und Minderwertigkeitsproblem*, edited by Walther Jaensch, 164–191. Halle: Carl Marhold, 1929.

Wong, Winnie. *Van Gogh on Demand: China and the Readymade*. Chicago: University of Chicago Press, 2013.

Worringer, Wilhelm. *Abstraktion und Einfühlung. Ein Beitrag zur Stilpsychologie*. München: Piper, 1908.

Worringer, Wilhelm. *Formprobleme der Gotik*. München: Piper, 1911.

Wright, J. Lenore. "Reading Rembrandt: The Influence of Cartesian Dualism on Dutch Art." *History of European Ideas* 33, no. 3 (2007): 275–291.

Wulffen, Erich. *Das Weib als Sexualverbrecherin. Ein Handbuch für Juristen, Polizei- und Strafvollzugsbeamte, Ärzte und Laienrichter*. Berlin: Paul Langenscheidt, 1923.

Wulffen, Erich. *Der Sexualverbrecher. Ein Handbuch für Juristen, Verwaltungsbeamte und Ärzte*. Groß-Lichterfelde Ost: Paul Langenscheidt, 1910.

Zell, Michael. *Reframing Rembrandt: Jews and the Christian Image in Seventeenth-Century Amsterdam*. Berkeley, Los Angeles and London: University of California Press, 2002.

Zwijnenberg, Robert. "Poren im Septum: Leonardo und die Anatomie." In *Leonardo da Vinci. Natur im Übergang. Beiträge zu Wissenschaft, Kunst und Technik*, edited by Frank Fehrenbach, 57–79. München: Fink, 2002.

Index of Names

Index of Subjects

Printed in the United States
by Baker & Taylor Publisher Services